Gustav Klimt

Painting, Design and Modern Life

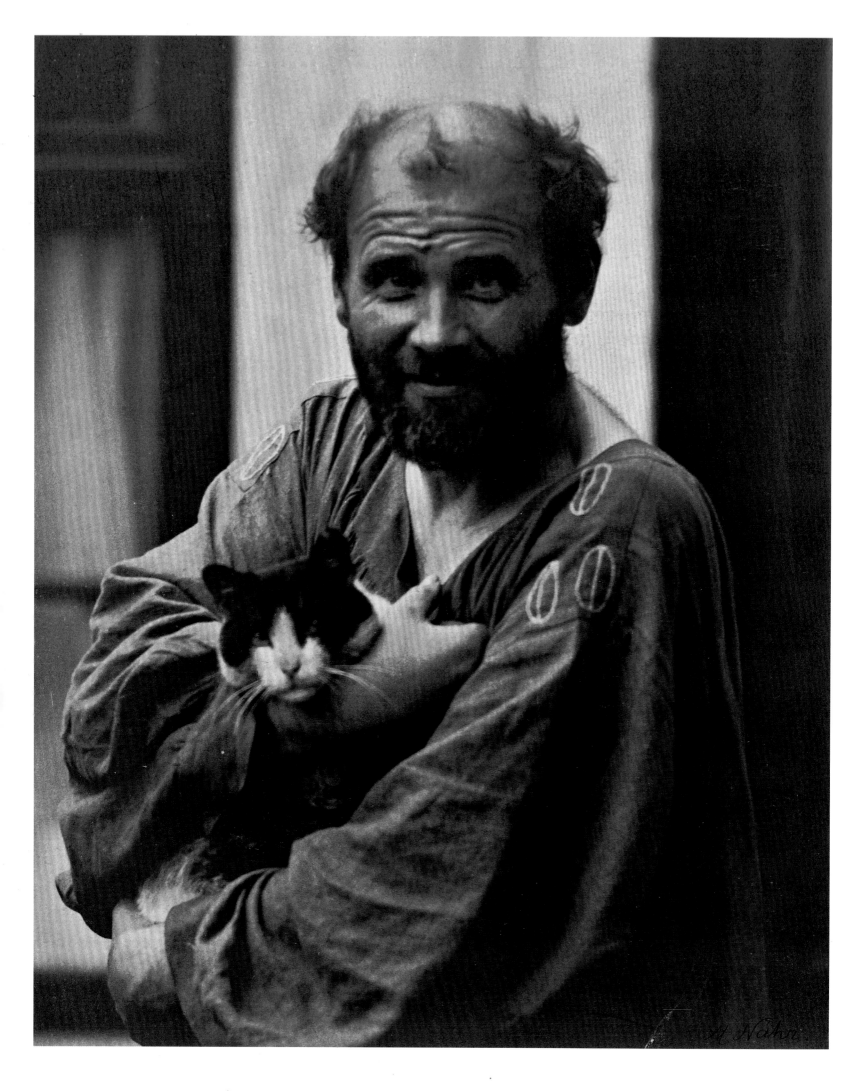

Gustav Klimt

Painting, Design and Modern Life

Edited by Tobias G. Natter
and Christoph Grunenberg

With contributions by
Paul Asenbaum
Elizabeth Clegg
Beatriz Colomina
Esther da Costa Meyer
Christoph Grunenberg
Tobias G. Natter
Eva Winkler

Tate Publishing

First published 2008 by order of the Tate Trustees
by Tate Publishing, a division of Tate Enterprises Ltd,
Millbank, London SW1P 4RG
www.tate.org.uk/publishing

on the occasion of the exhibition
Gustav Klimt
Painting, Design and Modern Life in Vienna 1900

Tate Liverpool
30 May – 31 August 2008

British Library Cataloguing in Publication Data
A catalogue record for this book is available from
the British Library

ISBN 987 185437 735 7

Distributed in the United States and Canada by Harry N.
Abrams, Inc., New York

Library of Congress Cataloging in Publication Data
Library of Congress Control Number: 2008926219

Typefaces and book design by A2/SW/HK

Printed in Italy by Conti Tipocolor, Florence

Front cover: Gustav Klimt, *Water Serpents I* 1904–7
(fig.141, detail)

Back cover: Gustav Klimt, *Litzlberg on the Attersee*
1915 (fig.190)

Frontispiece: Moritz Nähr, *Gustav Klimt wearing his Painter's
Smock in front of his Studio, holding one of his Cats* c.1912, Vintage
albumin print, 38.7 x 30, Imagno/Collection Christian Brandstätter,
Vienna

Measurements of artworks are given in centimetres,
height before width and depth

Liverpool
EUROPEAN
CAPITAL OF CULTURE

Supported by the Liverpool Culture Company
as part of European Capital of Culture 2008

Contents

Sponsor's Foreword

In 2007 we celebrated the 800th birthday of the City of Liverpool. Over those eight centuries the fortunes of this great seaport have ebbed and flowed just like the River Mersey on which the city stands.

For the last twenty years the fortunes of Liverpool have been rising and this period began with the regeneration of Albert Dock, the home of Tate Liverpool. The opening of Tate Liverpool signalled both the completion of the regeneration of Albert Dock and the beginning of a wider renaissance in the city's cultural ambitions. The accolade of Liverpool as European Capital of Culture 2008 is a sign that the city's transformation has been recognised well beyond the banks of the Mersey.

It is probably not an exaggeration to say that without the influence of Tate Liverpool, and the influence of the city's other major cultural organisations, Liverpool would not have been crowned European Capital of Culture. Tate Liverpool's ambition and ability to deliver spectacular projects is crucial to the city's cultural credentials.

I am delighted that in our cultural celebration Tate Liverpool has managed a coup by staging an exhibition of the work of Gustav Klimt, who was active in Vienna, another great city in harmony with one of Europe's great rivers, the River Danube. Klimt was influential in Vienna and Vienna has influenced Liverpool in 2008: St George's Hall hosted gala balls in the Viennese tradition and the Viennese theme will play through our music venues during the year.

This exhibition will undoubtedly be one of the United Kingdom's artistic highlights of 2008. I hope you enjoy the exhibition and take time to explore Liverpool and the wider delights of England's North West region.

Bryan M. Gray
Chairman, Liverpool Culture Company

Foreword

Gustav Klimt: Painting, Design and Modern Life in Vienna 1900 is the first exhibition of Klimt's work to be mounted in the United Kingdom and a highlight of the celebrations to mark Liverpool as European Capital of Culture 2008. It explores the relationship between Klimt as leader of the Viennese Secession and the products and philosophy of the Wiener Werkstätte – a highpoint of twentieth-century architecture and design. Klimt played a critical role in the founding and leadership of the Viennese Secession, a progressive group of artists and artisans driven by a desire for innovation and renewal. Its origin, in 1897, signalled for Klimt and his associates the 'beginning of a new artistic era'. Under the rallying cry 'To the Age its Art, To Art its Freedom', they aimed to redefine the relationship between artist and public. A decade later, in a speech at the opening of the Viennese 'Kunstschau' of 1908, Klimt called for a new unity of art and society, declaring that true artistic appreciation requires 'an ideal community of creators and connoisseurs'.

The Tate Liverpool exhibition addresses the vital issue of the relationship between the fine and the applied arts in the reception of Klimt's work, and the question of the architectural and spatial staging of his paintings. The philosophy of the Secession embraced not only art but also architecture, fashion and design that included the simple furniture and dazzling decorative art objects of the Wiener Werkstätte, demanding the emancipation of both fine and applied art in sophisticated environments. In the rich ornamental works of his 'Golden Period', Klimt created fascinating hybrids of painting and applied art – critics talked of 'mosaic painting' – realised with a goldsmith's attention to detail. Decorative art objects were included in early Secession exhibitions, and the eighth exhibition, in 1900, surveyed innovation in the applied arts across Europe. The architect and designer Josef Hoffmann, Klimt's close friend and collaborator, and a co-founder of the Wiener Werkstätte, created extravagant interiors for many of the painter's most loyal patrons and collectors. His ally and collaborator Koloman Moser emerged as an 'incomparable director of art exhibitions', designing strikingly modern and unified environments of restrained elegance that greatly enhanced the effect of the Klimt works presented in them. The juxtaposition of Klimt's painting with the sophisticated world of the Wiener Werkstätte achieves a synthesis of his art with the artistic and intellectual culture of Vienna around 1900, illuminating the crucial role played by the artist's leading collectors and supporters as part of their search for an identity at the turn of the century.

Charting Klimt's engagement with both the Secession and the Wiener Werkstätte, the exhibition provides a history of patronage and collecting in the cultural hothouse that was Vienna before the First World War. Paintings and drawings are shown in spectacular settings that approximate their original presentation as integral to totally designed environments. Paintings are also reunited with the objects they originally

accompanied. The *Portrait of Hermine Gallia* 1903–4 can be seen in Europe for the first since the 1930s alongside the magnificent silverware and furniture ensembles designed by Josef Hoffmann for the Gallia family. Key works by Klimt, acquired or commissioned by members of such prominent families as the Hennebergs, Wittgensteins and Primavesis are juxtaposed with objects and interiors made by the Wiener Werkstätte for these patrons. What emerges is a fascinating world of both luxurious opulence and refined simplicity: Klimt's erotically charged and highly decorative paintings enhanced through their integration into pioneering modern environments, and their juxtaposition with the reductive geometry and clean surfaces of the Wiener Werkstätte.

It was in Vienna that the idea of the 'Gesamtkunstwerk' (total work of art) experienced its most spectacular realisation, and from Vienna that it was exported all over Europe. Not the individual work but the harmonious interaction of different parts, genres and media subjected to a unified aesthetic and thematic totality was to lead to the realisation of artworks of new relevance and to sensual experiences of an unprecedented intensity. By bringing together fine and applied arts, artists hoped to overcome the much lamented decline in style, taste and craftsmanship and once again reach the pinnacles of creativity that had distinguished previous periods of artistic excellence.

Throughout his career Klimt was actively involved in the formulation of this new integrated aesthetic and the realisation of stunning spatial environments transcending individual artistic disciplines – from his early involvement in decorative schemes for the Burgtheater and the Kunsthistorisches Museum, to his devising of a 'brand identity' for the Secession, his monumental cycle for Vienna University and, of course, his participation in the epoch-making 1902 *Beethoven Exhibition*. Many of the frames of Klimt's paintings were designed by Hoffmann who also collaborated with the painter on private architectural commissions and interiors, most notably on the ornate frieze realised for the Palais Stoclet in Brussels. These totally designed environments were executed to the highest standard and filled with exquisite objects in precious materials and semi-precious stones. Architecture and interiors were not alone in being subjected to the strict and lofty principles of the Wiener Werkstätte. The ambitious transformation of everyday culture extended also to fashion and even to the most mundane household objects, such as cutlery and toilet paper holders, dictating not only a new style but a radically different way of living and behaving.

The exhibition also pays homage to the formative impact of the British Arts and Crafts movement in Vienna at the turn of the century. For Austrian artists, architects and designers of the period, British architecture, design and craft was a constant reference point and stood as a shining example of how the disturbing impact of industrialisation and mass production might be overcome, critics going

so far as to praise Britain as the only country upholding
the noble traditions of Greece. Gustav Klimt himself evoked
William Morris in his 1908 Kunstschau speech. The entre-
preneur, collector and co-founder of the Wiener Werkstätte,
Fritz Waerndorfer provided a vital link between Vienna and
the pioneering ideas of William Morris and his followers.
Waerndorfer had visited the United Kingdom as part of his
professional training, but he had also effectively received
his artistic education there, spending time in Manchester
and bidding for pictures at auction in Liverpool. In 1900 he
invited Charles Rennie Mackintosh and the other members
of the Glasgow Four, along with Charles Robert Ashbee,
to participate in the highly influential eighth Secession
exhibition. The relationship between Glasgow and Vienna
was confirmed in 1902 when Mackintosh was commissioned
to design a music room for the Villa Waerndorfer.

This exhibition is not, however, simply a historical
investigation of Gustav Klimt's oeuvre within the context
of the architecture and design of his period. It also builds
on the current revival of interest in Klimt, demonstrating
the continuing relevance of his work as reflected in
contemporary attempts to create total experiential spaces
and virtual worlds that transcend the traditional separation
of genres and media. We hope that this exhibition and
book are a fittingly sumptuous tribute to the achievement
of an extraordinary artistic innovator, to a revolutionary
movement in architecture and design, and to the enduring
idea of the total work of art.

Christoph Grunenberg and Tobias G. Natter

Acknowledgements

Any project of the scale and ambition of *Gustav Klimt: Painting, Design and Modern Life in Vienna 1900* is only possible with the generous support and cooperation of a large number of institutions and individuals. We have been privileged to receive help from many sides and would wish to express our gratitude to those who have contributed to the success of this exhibition at Tate Liverpool.

Above all, this exhibition could not have been realised without the generosity of the many lenders, parting with fragile, rare and valuable objects for an extended period of time. This has been a truly international project and many institutions, galleries and private collectors from across the globe contributed enormously by making key works of art, design and documents available to us. In particular we would like to thank Masanori Ichikawa and Miho Mabuchi, Aichi Prefectural Museum of Art, Nagoya, Japan; Dr Klaus Albrecht Schöder, Dr Marian Bisanz-Prakken, Dr Margarete Heck, Dr Heinz Widauer and Sonja Eiböck, Albertina, Vienna; Peter Backhausen, Reinhard Backhausen and Ursula Graf, Backhausen Interior Design, Vienna; Michael and Wolfgang Bauer, Bel Etage Kunsthandel, Vienna; Dr Agnes Husslein-Arco and Dr Alfred Weidinger, Österreichische Galerie, Belvedere, Vienna; Dr Christian Brandstätter, Vienna; Günther Stefan Asenbaum, London, and Dr Paul Asenbaum, Dr Christian Witt-Dörring and Dr Sachiko Kubo-Kunesch, Decorative Arts Consult, Vienna; Professor KR Karlheinz and Agnes Essl and Andrea Wintoniak, Sammlung Essl, Klosterneuburg; Dr Maria Vittoria Marini Clarelli, Galleria Nazionale d'Arte Moderna e Contemporanea, Rome; Dr Renate Trnek, Gemäldegalerie, Vienna; Professor Julius Hummel, Vienna; Ewen Smith and Professor Pamela Robertson, Hunterian Museum and Art Gallery, Glasgow; Claudia Klein-Primavesi, Vienna; Dr Matthias Haldemann, Dr Marco Obrist, Dr Christine Kamm-Kyburz and the late Peter Kamm, Kunsthaus Zug, Switzerland; Stella Rollig and Dr Elisabeth Nowak-Thaller, Lentos Kunstmuseum Linz; Professor Dr Rudolf Leopold, Elisabeth Leopold, Peter Weinhäupl and Mag. Nicola Mayr, Leopold Museum, Vienna; Peter Noever and Mag. Kathrin Pokorny-Nagel, MAK – Austrian Museum of Applied Arts/Contemporary Art, Vienna; Yves Macaux, Gallery Yves Macaux, Brussels; Professor Giandomenico Romanelli, Musei Civici Veneziani, Venice; Toni Stooss and Susanne Greimel, Museum der Moderne Salzburg; Richard Nagy and Giovanna Grassi, London; Dr Tomáš Vlček, Professor Milan Knížák, and Dr Magda Nemcova, Národní Galerie, Prague; Charles Saumarez Smith, Christopher Riopelle, David Jaffé and Simona Pizzi, National Gallery, London; Earl A. Powell III, Dr Jeffrey Weiss and Stephanie Belt, National Gallery of Art, Washington; Dr Gerard Vaughan, Janine Bofill, Amanda Dunsmore, and Ieva Kanepe, National Gallery of Victoria, Melbourne; Dr Johanna Rachinger and Mag. Peter Steiner, Österreichische Nationalbibliothek, Vienna; Dr Hans Petschar and Mag. Uwe Schögl, Österreichische Nationalbibliothek – Bildarchiv, Vienna; Professor Dr Wilfried Seipel, Kunsthistorisches Museum, Vienna, and Dr Thomas Trabitsch, Österreichisches Theatermuseum, Vienna; Dr Hansjörg Krug, Antiquariat Christian M. Nebehay, Vienna; Dr Katja Schneider and Wolfgang Büche, Staatliche Galerie Moritzburg, Halle (Saale); Glenn D. Lowry, John Elderfield, Cora Rosevear, and Stefanii Ruta Atkins, Museum of Modern Art, New York; Dr Ernst Ploil, Vienna; Dr Wolfgang Meighörner, Dr Günther Dankl and Dr Eleonore Gürtler, Tiroler Landesmuseum, Innsbruck; Mitsuhiko Tera and Norie Nishazaki, Toyota Municipal Museum of Art, Japan; Professor Patrick Werkner and Mag. Silvia Herkt, Universität für angewandte Kunst, Vienna; Mark Jones, Eric Turner, Rebecca Wallace and Liz Wilkinson, Victoria and Albert Museum, London; Willard Holmes and Mary Herbert-Busick, Wadsworth Atheneum Museum of Art, Hartford, Connecticut; Dr Wolfgang Kos, Dr Ursula Storch, Mag. Christiane Rainer and Mag. Katrin Sippel, Wien Museum, Vienna; Matthias Herrmann, Urte Schmitt-Ulms and Ulrike Winkler-Hermaden, Wiener Secession, Vienna, as well a number of important lenders who wish to remain anonymous.

Gustav Klimt: Painting, Design and Modern Life in Vienna 1900 is one of the highlights of the celebrations in the year of the European Capital of Culture 2008 and we are most grateful for the sponsorship received from the Liverpool Culture Company, whose collaboration ensured that this event received the widest exposure possible. We also acknowledge the support of *The Times*, media partner for this exhibition, and thank them for the positive partnership. The accompanying publication and programme of the exhibition has received additional support from the Austrian Cultural Forum, London. The exhibition also benefited hugely from the UK Government Indemnity and we are grateful to the Department of Media, Culture and Sport/Museums, Libraries and Archives Council for their support.

We have been fortunate to receive critical advice and support from a number of institutions and individuals, in particular Guy Bennett, Jessie Fertig, Joy McColl, Christie's, New York and London; Ambassador Dr. Emil Brix, Vienna; Professor Esther Coen, Rome; Melanie Clore, Helena Newman and Patrick Legant, Sotheby's, London; Franz Eder, Salzburg; Dr Gerbert Frodl, Vienna; Dr Matthias Frehner and Judith Durrer, Kunstmuseum Bern; Max Hollein, Schirn Kunsthalle and Städel Museum, Frankfurt am Main; Sarah Lenton, London; Dipl. Kfm. Mag. Christoph Mai, Vienna; Dr Johannes Wimmer of the Austrian Cultural Forum in London has been most generous with his advice and support. Further promotional support has been received from the Austrian Tourist Office. We should also like to thank the Royal Liverpool Philharmonic Orchestra and in particular Mick Elliott and Andrew Cornell for the musical programme enhancing the exhibition.

We would like to express our thanks to Jamie Fobert Architects and Kevin Allsop whose refined exhibition design entirely accords with the spirit of elegance and simplicity

of Vienna at the turn of the century. The British Museum, Manchester Museum and Victoria and Albert Museum generously made vintage display cases available to us. We would also like to thank Henrik Kubel and Scott Williams of A2/SW/HK, London for developing such an imaginative and elegant catalogue design. We would like to express our thanks to the authors of the catalogue, Elizabeth Clegg, Beatriz Colomina and Esther da Costa Meyer, as well as to Paul Asenbaum and Eva Winkler, who contributed exciting new scholarship on the subject of Klimt, the Secession and the Wiener Werkstätte. Essential research assistance was provided by Angelika Linner and Dorothee Böhm.

In realising the Klimt exhibition we are, as ever, indebted to the energies and talents of Tate staff. We would like to thank in particular Nicholas Serota, Stephen Deuchar, Caroline Collier, Matthew Gale, Ian Warrell and Catherine Clement, who offered unwavering support for this ambitious project. The team at Tate Publishing worked tirelessly on the exhibition catalogue and we would like to thank the catalogue's editor Nicola Bion as well as Anna Ridley, Celeste Stroll, Beth Thomas and Roz Young. Acknowledgements are also due to Gerry Alabone, Mary Bustin, Sara De Bernardis, and Jo Gracey from Tate Conservation for their support of the exhibition in Liverpool.

We are especially grateful to the staff of Tate Liverpool, who approached this project with their usual energy and enthusiasm. Darren Pih was at the heart of the control centre for this complex project and has to take credit for effectively and sensitively managing all aspects of the organisation with his usual devotion and intelligence. In the Exhibitions Department we are grateful to the diligence and commitment of our Exhibitions and Displays Coordinator Wendy Lothian who managed the demanding logistics of this large-scale project. Jemina Pyne, Stacey Arnold and Jennifer Cawkwell provided an exciting marketing and communications platform for the exhibition. Our art-handling team skilfully managed the intricate installation and we would like to thank Ken Simons, Barry Bentley and Wayne Phillips. The project presented considerable operational and logistical challenges and we are indebted to Sue Grindrod, Rachel Carr and Dawn Brady and their teams, as well as our London colleagues Dennis Ahearn, Martin Bawden and Piers Warner, for providing the most pleasurable visitor experience possible. The Development Team helped to secure the funding for this exhibition and managed the relationships with our supporters. We express our sincerest thanks to the Learning Team for the extensive interpretation and educational events accompanying the show. Finally, we would like to express our appreciation of all staff members at Tate Liverpool who contributed to making this exhibition at Tate Liverpool a success.

Christoph Grunenberg
Tobias G. Natter
Andrea Nixon

1
Gustav Klimt
Judith I 1901
Oil on canvas, 84 × 42
Belvedere, Vienna

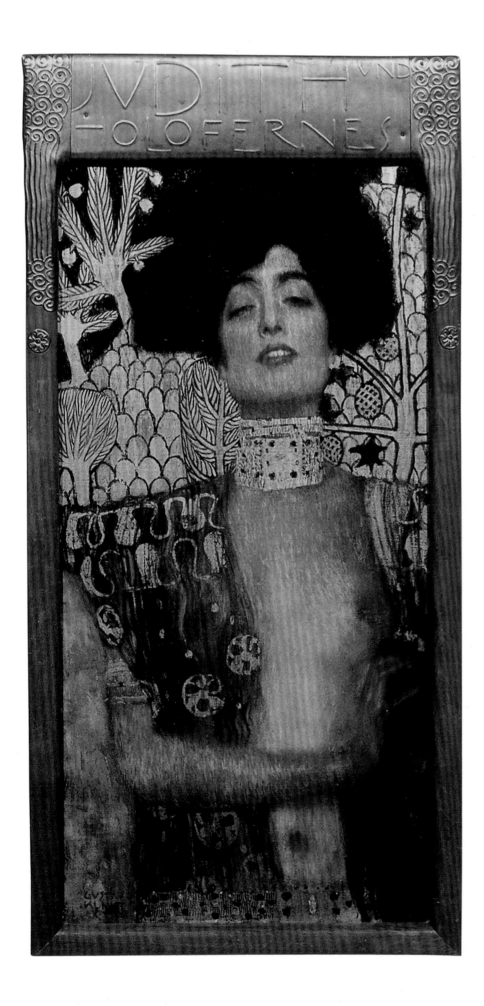

Gustav Klimt: No More Than a Goldsmith?

The Cross-Pollination of Painting, Architecture
and the Applied Arts in Vienna around 1900

Tobias G. Natter

When the Director of Tate Liverpool invited me to curate
a Gustav Klimt exhibition, it was clear from the outset that
rather than presenting yet another overview exhibition,
I wanted to respond to the *genius loci* and to make the
connection with the British Arts and Crafts Movement which
resonated so powerfully and fruitfully in *Wien um 1900* –
Vienna around 1900. The pioneering British approach to the
applied arts struck a chord in Vienna where the increasing
convergence of painting, architecture and applied art
culminated in the idea of the Gesamtkunstwerk, as it was
known. The happy consequence of this was that in the early
1900s the Austrian capital was able to make – in the best
sense – an extreme and lasting contribution to the history
of modern art.

But paradoxically, it is at exactly this point that there is
a blank space on the map of Viennese modernism. No matter
the vast quantity of literature devoted to Vienna around
1900 or the fact that academic research into the concept
and substance of Viennese modernism and the phenomenon
of the Gesamtkunstwerk is by no means a new venture.
While each of the the three sister arts – painting, architecture
and applied art – are individually well explored, art historians
have also successfully avoided embarking on any real inter-
disciplinary research in this field. It seem that no one heeded
the words of the Klimt-expert Gustav Nebehay nearly four
decades ago: 'So far no groundbreaking work has been done
on the far-reaching mutual influence [of these different art
forms].'[1]

Klimt and the Wiener Werkstätte

The founding of the Viennese Secession in 1897 is generally
regarded as the moment when Viennese modernism was
born; this was the 'beginning of a new artistic era'[2] and the
trigger for the developments that are the focus of this essay.
The president of this artists' association was the painter
Gustav Klimt. With their chosen motto 'Der Zeit ihre Kunst,
der Kunst ihre Freiheit' [To the Age its Art, To Art its Freedom],
he and his supporters were determined that art should once
again be of its own time and should be reintegrated into
contemporary life.

The aspirations of the Secession were wide-ranging,
to say the least, and went far beyond the mere production
of first-rate paintings. An early highpoint in the reform
of art praxis came in 1900 with the eighth exhibition of
the Secession, devoted to the applied arts in Europe. This
exhibition is also worthy of mention in the present context
because it reinforced the connections with Great Britain
that had already been very much in evidence just a few years
earlier in Vienna in the exhibition *Der bürgerliche Haushalt*
(The Bourgeois Household). At the same time, there were
also disturbing new role models appearing on the horizon
in Vienna and soon the 'English disease' was the talk of the
town.[3] Nevertheless, in the eighth Secession exhibition artists

such as Charles Rennie Mackintosh and the other members
of the Glasgow Four featured prominently along with Charles
Robert Ashbee. Inspired by John Ruskin and William Morris,
Ashbee set up and ran the Guild of Handicraft in Essex House
in London's East End.

Enterprises of this kind in turn paved the way for the
founding of the Wiener Werkstätte [Viennese Workshops]
in 1903 by the architect Josef Hoffmann and the designer
Koloman Moser, both close friends of Klimt, with all three
being co-founders of the Viennese Secession. The third
founding member of the Wiener Werkstätte was the financier
Fritz Waerndorfer, who took on the role of commercial
director. Waerndorfer, born into an important family in the
textile industry, had received his main aesthetic education
in Great Britain where he had been sent by his father to study
the cotton industry. But he was much more interested in
the latest trends in British art than in his prescribed studies.
With this background, and having made numerous contacts
across the Channel, on his return to Vienna he quite naturally
became the main intermediary cultivating the connections
between Britain and Austria and specifically between the
Mackintoshes and Vienna.

The Wiener Werkstätte, set up as a 'productive
cooperative society of artist-craftsmen', was explicitly
established along very different lines to the mass-production
methods commonly used at the time in the art industry which
had suffered so severely from the advent of mechanisation
and pressure to reduce costs. In order to maintain a high
standard of production, the Wiener Werkstätte – organised
as a cooperative society – proposed much closer collaboration
between the artists designing pieces and the craftsman
executing their designs.[4]

The extent of Gustav Klimt's involvement in the run-up
to the founding of the Wiener Werkstätte is not known.
However, he was in close contact with the main protagonists
Hoffmann, Moser and Waerndorfer, not just as President
of the Secession. Klimt, who tended to work extremely slowly
and thoughtfully, had much in common with the ethos of
the Wiener Werkstätte: 'Better to spend ten days on one
thing than to produce ten things in one day.'[5] And this ethos
was explained by one of the co-founders Josef Hoffmann:
'It just isn't enough to buy paintings, however wonderful
they are. As long as our towns, our houses, our rooms,
our furniture, our utensils, our clothes and our jewellery, our
language and our feelings do not reflect – elegantly, simply
and beautifully – the spirit of our own time, we are living at
a level far beneath that of our forefathers and no equivocation
can disguise these weaknesses.'[6]

One of the few to whom the founders turned for advice
was Charles Rennie Mackintosh. In his response, Mackintosh
had his eye firmly on the future. Waerndorfer wrote to
Josef Hoffmann citing Mackintosh's reaction: 'Of course
we will keep the project to ourselves as long as you wish …
If Hoffmann and Moser and the rest have a large enough

circle of admirers who want to do more than just admire and are willing to actively help – through their support and influence – then, the sooner you set up the Workshops, the sooner you will achieve your glorious aim.'[7] In view of their ambitious aims, Mackintosh encouraged his Viennese colleagues to create a 'brand' that would be known for its 'individuality, beauty and precision production'. That every piece should moreover be produced for a 'specific purpose and place'[8] takes on a particular importance in the context of the Klimt paintings destined for the salons of his elite clients.

Even a cursory glance at this situation shows that on a number of levels – both individual and structural – there are points of contact between the aims of the Wiener Werkstätte and Klimt's artistic will as a painter. To this day these connections are perhaps most evident in the paintings by Gustav Klimt that have frames made by the Wiener Werkstätte, or to put it in the words of Josef Hoffmann, wherever we see 'paintings, however wonderful' that reflect the 'spirit of our own time' and are accordingly framed 'elegantly, simply and beautifully'. It was not by chance that the frame – both in the literal and the metaphorical sense – took on such importance. The picture frame soon came to symbolise the new interest in the Gesamtkunstwerk and could even be read as an exemplary cipher for the new kinship of 'high' and 'applied' art. One of the most beautiful examples of Klimt paintings with original Wiener Werkstätte frames is his immensely sophisticated *Water Serpents I* of 1907 (fig.141).[9] For Ludwig Hevesi, faithful chronicler of the Vienna Secession, it is 'a work of extraordinary delectability', which only fully develops its 'special appeal' thanks to the frame.[10] Early commentators were in fact quick to observe that the frame, most probably designed by Josef Hoffmann, casts the painting in a dialectically different light. Hevesi points out that the frame for the painting on parchment turns it, on the one hand into a 'movable wall painting' and, on the other, into 'a piece of jewellery'.[11]

The notion of doing away with existing distinctions between a painting and a piece of jewellery takes on new dimensions in Klimt's hands. Another new factor in the equation is the financial value of the painting including its frame; this is recorded in unusual detail in the case of *Water Serpents I*. On 28 March 1907 Klimt delivered the painting to the Viennese Galerie H. O. Miethke, which exclusively represented his work.[12] It was first shown in the gallery in autumn of that year; in the following summer it was shown at the 1908 Kunstschau where it caught the eye of the captain of industry and art patron Karl Wittgenstein, father of the philosopher Ludwig Wittgenstein. With a down payment of 10 per cent of the sale price he secured first approval on the painting and subsequently bought it for a total of 8,000 crowns. Klimt received 5,000 crowns for the painting plus an additional 460 crowns for the frame.[13] As a point of comparison: the young Egon Schiele, a student at the same time at the Art Academy in Vienna, received five crowns a week from his guardian to cover all his living expenses.[14]

This costly level of attention paid to the selection of a picture frame was nothing new in Jugendstil circles, where the focus of interest was not so much on the originality of the frame as on a redefinition of the interplay between a painting and its frame.[15] There are various accounts of the high expectations Klimt had when it came to framing a picture. He even not infrequently designed the frames he wanted himself, as in the case of his ultimate portrayal of a femme fatale, *Judith I* of 1901 (fig.1). This case is all the more interesting because, on the one hand, Klimt treated the picture and

the frame as a single entity from the outset, as we can still see from numerous sketches. And the frame is so important to the picture that this particular painting – endlessly reproduced – is always pictured with its frame. On the other hand, the painting of *Judith I* is an example of Klimt specifically choosing to collaborate with an artist-craftsman – in this case his brother Georg Klimt, a goldsmith by trade, who executed the frame in tooled copper.

These concerns about framing attest to the artist's deeper deliberations. Besides interacting with the picture, the frame also marks the internal and external limits of the painting. And this Jugendstil sensitivity to aesthetic markers of this kind is closely related to Jugendstil artists' confidence that they could also create the right frame for everyday life. In this sense, the frame also became a leitmotif for the architect Josef Hoffmann and for the members of the Wiener Werkstätte – not only in a literal sense, but also in a metaphorical sense when they were commissioned to design whole interiors and to create schemes for private dwellings and rooms. In order to demonstrate the creative acumen of some of the Gesamtkunstwerk schemes, a number of these rooms are replicated in spirit in the Liverpool exhibition.

The examples on show also include photographs of Gustav Klimt's studio. This was one of the first interior design commissions entrusted to the members of the Wiener Werkstätte and was realised 1903–4, in the first year of its existence. But Klimt was, from the first, very suspicious of what might be the outcome of allowing others to do as they chose in his private retreat where he had hitherto worked undisturbed. Initially he was not at all pleased by the proposal, put forward by an anonymous benefactor, to have the studio repainted at his own expense and furnished with items from the Wiener Werkstätte. Klimt, who was away from Vienna at the time, enjoying the summer air elsewhere and only heard about the proposal from his housekeeper by chance, had the renovations delayed for six months, officially because of pressures of work.[16] As it turned out, the benefactor was none other than Fritz Waerndorfer, the business director of the Wiener Werkstätte (fig.94).[17]

In the end Klimt found himself the owner of a large, black-stained oak sideboard in which he stored his Asian collection; he also acquired a half-height cabinet for painting utensils, a group of chairs and an array of other smaller objects, all of which can still be seen in photographs from the time. Today these objects, designed by Josef Hoffmann and used by Klimt until the end of his life, are mainly in private collections (figs.172ff.).[18]

Of course these items of furniture were not the only Wiener Werkstätte objects that featured in Klimt's daily life. His tiepin with its own Wiener Werkstätte box, a pair of cufflinks and a signet, all now owned by the family, hint at a much larger number of items.[19] There are also other clues to the same effect elsewhere, such as the name of Gustav Klimt in the order books from the Wiener Werkstätte even as early as 1903, when he bought a piece of jewellery, designed by Koloman Moser, as a Christmas present for his companion Emilie Flöge,[20] and again in 1911 when he ordered two ceiling lights designed by Josef Hoffmann for his studio.[21] The name Emilie Flöge (fig.2) calls to mind yet another point of contact between Klimt and the Wiener Werkstätte. At the same time as Klimt's studio was being renovated, Emilie Flöge – a successful businesswoman in her own right – had her fashion salon completely redesigned and refurbished by the Wiener Werkstätte. No doubt she consulted with Klimt on these matters.

2
Gustav Klimt
Portait of Emilie Flöge 1902
Oil on canvas, 181 × 66.5
Wien Museum, Vienna

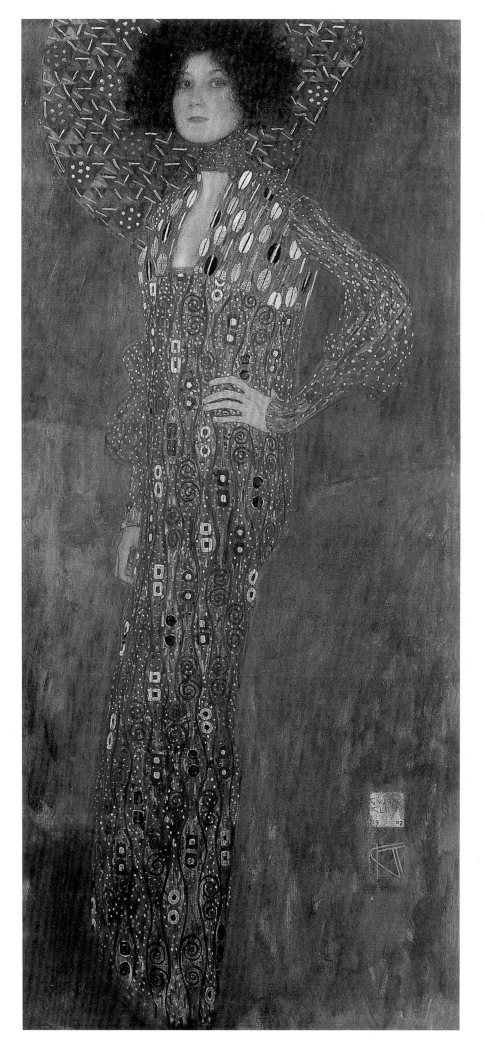

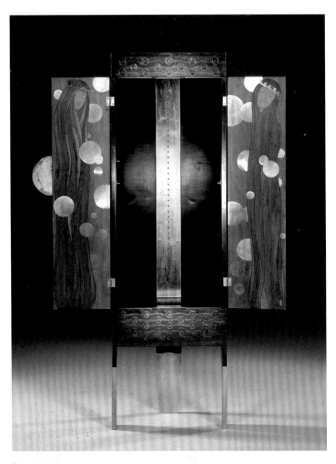

3
Koloman Moser
*The 'Enchanted Princess' Cabinet
shown in the Eighth Secession
Exhibition, Vienna* 1900
Private Collection

It is clear that there were numerous points of contact between the products of the Wiener Werkstätte and Gustav Klimt. As a souvenir of this connection, in 1912 the members of the Wiener Werkstätte made a tooled metal biscuit tin, which they gave to Klimt as a present on his fiftieth birthday (fig.78).

The Designer Gustav Klimt and the 'Spirit of the Age'

This biscuit tin raises a number of questions. One concerns the gratitude expressed through this gift by the members of the Wiener Werkstätte. It is clear that the source of this gratitude goes deeper than the sporadic contacts listed above or Klimt's temporary role as a Member of the Board of the Wiener Werkstätte.[22] In all probability, this gift is in its essence about Gustav Klimt's position as a 'role model'. In addition to the human qualities that attached to Klimt, and his unique status as a pioneer of modernism in the Viennese art world, there were also the qualities he brought to his work as a professional artist. The latter has two distinct sides: firstly there was the direct collaboration between Klimt and the Wiener Werkstätte. As an 'off-shoot' of the Viennese Secession and a newcomer in the art market, the Wiener Werkstätte benefited greatly by association from their collaborations with the 'big name' artist Gustav Klimt.[23] Secondly, artist-craftsmen in Vienna, and the Wiener Werkstätte in particular, discovered Klimt the painter and President of the Secession as a rich source of inspiration.

However, despite the evident importance of the two sides to Klimt, it is equally important to remember that he was never a designer in the narrower sense of the word. And when his contemporary, the journalist Berta Zuckerkandl, reported in 1905 that Klimt had become a 'permanent member' of the Wiener Werkstätte, this is not to be taken too literally.[24] Her account alludes rather to the extent and complexity of the production process of one of the most important collaborations between the Wiener Werkstätte and Klimt: the Stoclet Frieze.

This frieze is still in situ in the Brussels house it was designed for, which has been occupied by the Stoclet family ever since it was built. Work on the Stoclet family home took six years in total. It was originally supposed to have been built at the Hohe Warte artists' colony in Vienna, but when the client – Baron Adolphe de Stoclet – had to return to Belgium following the sudden death of his father, the project was relocated to Brussels. Stoclet gave the architect Josef Hoffmann carte blanche. Untroubled by financial constraints, Hoffmann was able to engage the best artistic minds for this Gesamtkunstwerk. For Hoffmann, and no doubt for his client too, it was clear from the outset that this project should be realised in collaboration with the most important members of the Wiener Werkstätte. Accordingly, Hoffmann asked his friend and colleague Gustav Klimt to create a wall decoration for the dining room in the new building. Klimt was allowed to give his 'decorative imagination' free rein and it was left to him to decide whether to work 'on a fresco, on a mosaic, or on a relief'.[25] Having created the overall design, he set about producing templates and sketches, with Emilie Flöge helping out whenever he came up against a stumbling block.[26] The project was beset by a series of delays. Even the final execution of the frieze, meticulously supervised by Klimt in person, took members of the Wiener Werkstätte, working together with students from the Wiener Kunstgewerbe-schule, a year and a half to complete.

The Stoclet Frieze has a particular significance in terms of Klimt's own oeuvre, for it is in this piece that we see his figures at their most ornamental – more so than in any other

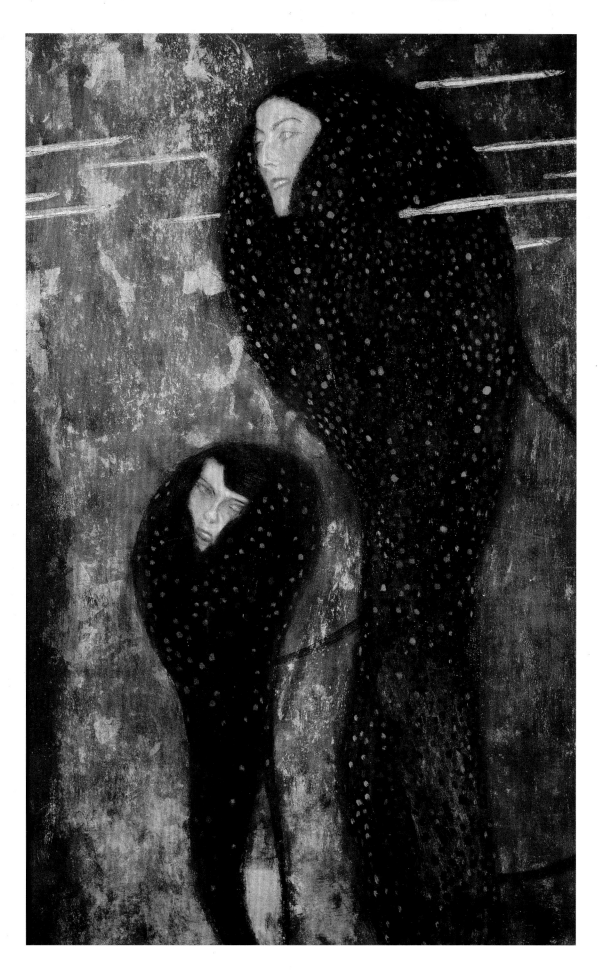

5
Rudolf Stumpfe
Design for a Cigarette Case
Published in *Kunst und
Kunsthandwerk*, Vienna 1905

6
Siegmund Skwirczynski
Caricature of Gustav Klimt's
Portrait of Adele Bloch-Bauer I
Published in *Die Muskete*,
Vienna 1908

work. At the same time, this collaboration with the Wiener Werkstätte stands as one of the most important contributions to the art of the mosaic in the twentieth century. In view of the ongoing exchange of artistic ideas between Klimt and Hoffmann, the 'abstract' centre section of the three-part frieze is particularly interesting. Commentators have generally read this as a counterpart to the remarkably early abstract reliefs that were seen above one of the doorways in the Viennese Secession's Beethoven exhibition in 1902.[27]

The second major project that Klimt realised with the Wiener Werkstätte also came relatively early on in their history. In terms of both content and technique, it bore no relation to the Stoclet Frieze, and as such attests to the variety and range of work that the Werkstätte could undertake. The project in question was a new deluxe edition of *The Dialogues of the Hetaerae* by Lucian. Klimt contributed fifteen illustrations and designed the small metal plaque set into the front cover of the book. The overall cover design and layout were in Josef Hoffmann's hands, and members of the Wiener Werkstätte masterminded the elaborate production process. The end-result was one of the most outstandingly beautiful books to be produced in the Jugendstil era in Europe.[28] As it happens, it is worth taking a closer look at the parts played by the various participants in this scheme, above all because – significantly – Klimt did not create the wonderfully appropriate illustrations specifically for this book, but for the most part at least, submitted images that he had made at some earlier point in time. This 're-use' of existing materials is prototypical of the interplay between Gustav Klimt, his work, and the applied arts in Vienna.

Another example of Klimt's remarkable ability to straddle high art and applied art, so to speak, is the magnificent portrait he painted of his companion Emilie Flöge in 1902. The self-assured, full-length figure is wearing a 'peacock blue gown decorated with silver sequins',[29] 'as though looming out of a brilliant blue world of majolica and mosaic'.[30] The dress is in the style known as 'reform clothing' and would be worn without a corset. Nevertheless, it is hardly in keeping with the fashions of the day, and was devised by Klimt partly as a masterpiece of ornamentation but also as an abstract, non-corporeal sheath. Numerous commentators have pointed out that this is the only dress that the supposed 'fashion maker' Gustav Klimt actually 'designed'.[31] For all the intensity of his interest in fabrics, clothes and patterns, Klimt only ever came up with fabric designs in his paintings.[32] But these often not only inspired fashion designers, they were even used by the latter as templates for real clothes.

To date there have been few studies of the aesthetic reception of the inspirational role of the phenomenon of Gustav Klimt for a highly active following of artist-craftsmen – despite the fact that it is not hard to identify examples of exactly this. A particularly striking one shows how pictorial motifs from a work by Klimt are adapted in a different context – in this case, in furniture design. The case in question concerns a corner cupboard designed by Koloman Moser that went into production in 1900 at the Viennese firm of Portois & Fix. Named 'Die Verwunschenen Prinzessinnen' ['The Enchanted Princesses'], it has striking similarities in its décor with Gustav Klimt's painting *Water Nymphs (Silverfish)*, which was made just one year earlier (figs.3, 4).

There are no records of any comments made by Klimt concerning this kind of adaptation, bringing together art, applied art and manufacturing. But all the participants in this and similar processes must have been well aware that Klimt's

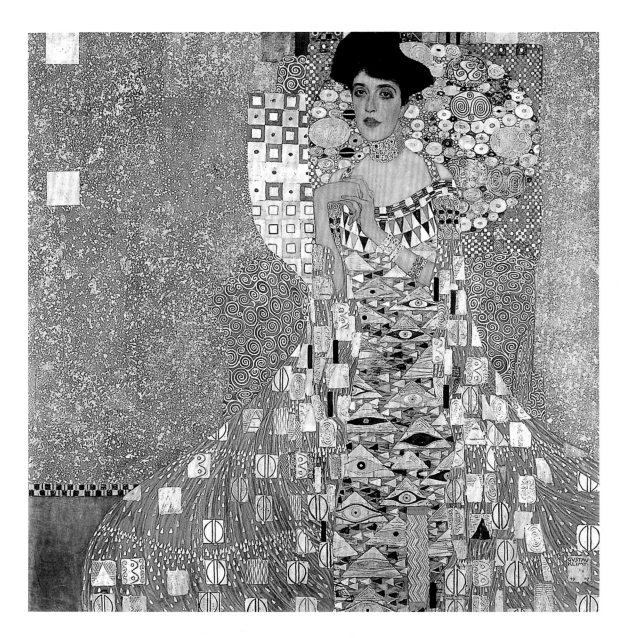

7
Gustav Klimt
Portrait of Adele Bloch-Bauer I 1907
Oil and gold on canvas, 138 × 138
Neue Galerie, New York.
This acquisition made available
in part through the generosity
of the heirs of the Estates of
Ferdinand and Adele Bloch-Bauer

design principles – stylised natural forms, accentuated planarity, ornamentalisation and avoidance of spatial illusion – in effect ensured that his pictorial cosmos would find its way into the hands of Vienna's artist-craftsmen and women. A main contributing factor to the ongoing appropriation of Klimt's designs for inlays, jewellery and stained glass windows was the common 'language' of ornament, the importance of which in 'Vienna around 1900', can hardly be overestimated. Ornament, as an abstract entity that 'creates its own imaginary realm by continually transforming the existing limits of form into multi-layered transitions,'[33] became a hallmark of Viennese modernism.[34]

The idea of the osmosis of ornament between 'high' and 'applied' art had become such common currency in Vienna around 1900 that it coloured art discourse in other contexts, too, and perfectly naturally flowed into the observations by the Viennese art historian Josef Strzygowski which he published in his 'everyman's-book' on the art of the day, *Die Bildende Kunst der Gegenwart. Ein Büchlein für Jedermann.* Strzygowski, who was appointed to a chair at the Viennese Institute for Art History in 1909, argued that 'the strangest connections can be made with ornament as a point of comparison, such that a person – noticing a negative feature, a decorative patch in a painting – might cry out: "What divine furniture!" By which he means that the curvature of the lines in question would perfectly suit a modern item of furniture,

or, vice versa, that the form of a piece of jewellery, for instance, could make a very striking impact in a painting.'[35]

Another example of this – indebted to Klimt's underwater world, like Koloman Moser's corner cupboard – is found in the realm of metal and household items. In 1905 the journal *Kunst und Kunsthandwerk* published an illustration of a cigarette case, albeit one in which imitation runs the risk of becoming trivialisation.[36] All that is left of the female figures undulating gently in the water of Klimt's *Water Serpents I* (fig.141) are a few grotesque lianas and a coarse relative of the fish entering the composition from one side (fig.5).[37]

Here the act of transformation has been detrimental in just the way that Hevesi feared. For Klimt, any motif presented him with endless possibilities; he could take the ingredients of his paintings and infinitely extend them like chains of molecules, like the patterns in a kaleidoscope that never ever recur – 'But of course, that's Klimt through and through'. But beware 'when hordes of imitators devour his ideas and adeptly and heartlessly start Klimtifying everything in sight. It will soon be a positive epidemic.'[38] The danger identified by Hevesi has not gone away. On the contrary, the heedless 'marketing' of Klimt, his pictorial ideas and motifs, is currently more of an issue than ever before. Any random internet search yields thousands of examples where the situation is getting out of hand. Even in museum shops across the world, the merchandising of 'Klimt'

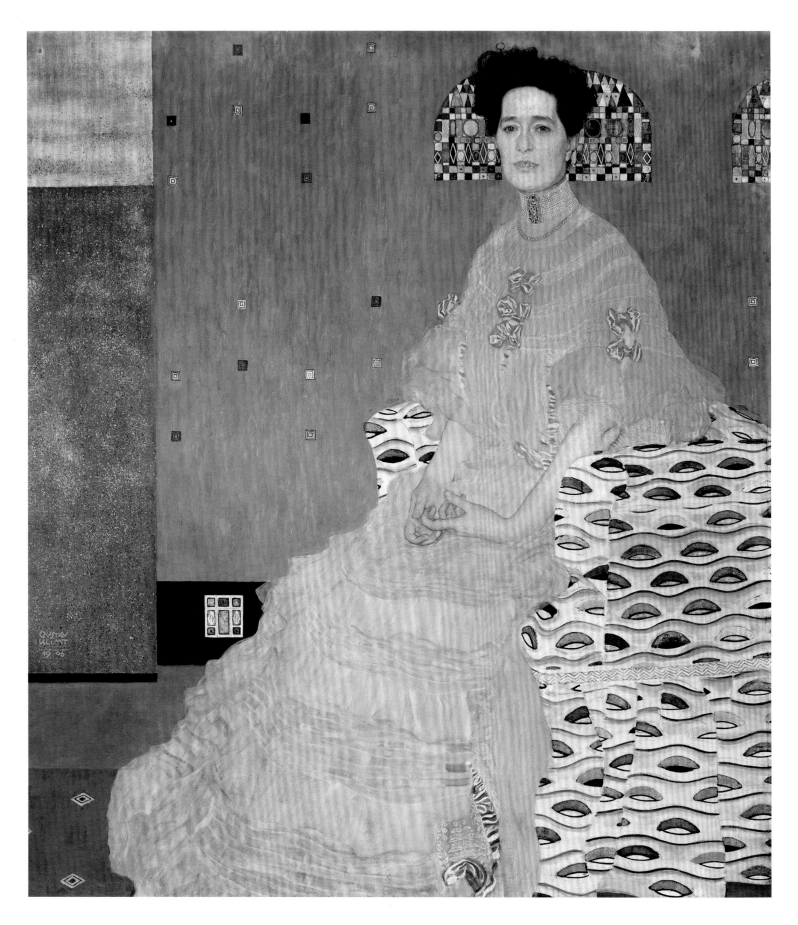

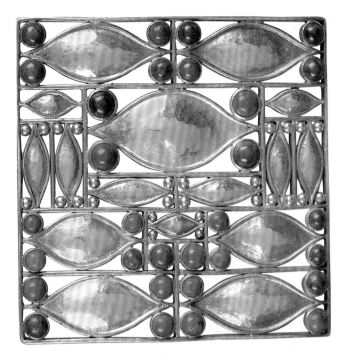

products is not always undertaken with the necessary respect. And the suppliers of these products of course are always particularly eager to 're-use' Klimt's portraits of women, with little thought for the real intention behind these portraits and the apparent transcendence of these figures: '[These models] embody a deep longing to rise above the daily round ... with a beauty that can no longer be plucked and destroyed by Life's grasping hands.'[39]

Klimt and the 'Painted Mosaic'

But to return to the golden ground of Gustav Klimt's craft. The mosaic has a whole range of meanings for Klimt. In the case of the Stoclet Frieze it represents an art form that is characterised both by the planarity of painting and the materiality of sculpture, combined here in glowing colours and luxurious materials. Gold, copper, semi-precious stones, enamel, ceramics, coral and more were all inlaid into the white marble panels of the frieze. But the 'mosaic' also has a notional presence in Klimt's work, specifically in a number of oil paintings that fall into the same period as the Stoclet Frieze, and were presented to the public as 'painted mosaics' ['Malmosaike']. Interestingly, these are by far his best-known works today.

The life-size portrait of Fritza Riedler (1906) is one such painting. The most famous of all is the portrait of Adele Bloch-Bauer (fig.7), completed a year later. Recently this same painting hit the headlines as the most expensive painting of all time, when it was widely reported that the New York art lover Ronald S. Lauder had bought it for 135 million US dollars. It seems that nothing can now topple it from its cult status as an icon of fin-de-siècle Vienna.

In its composition this painting echoes the traditions of Greek-Orthodox icon painting. As many have observed, in this portrait – reminiscent of Byzantine images of the saints – only the face and hands of the subject are visible. The relationship between the naturalistic elements of the composition and the pictorial geometry is indeterminate, as Klimt demonstrates his perfect mastery of that realm midway between Nature and ornament that is his domain, and that thrives on a 'whimsical interplay of the animated and the inanimate, of plane and body, of organic and artificial'.[40] This portrait of Adele Bloch-

Bauer is one of the outstanding masterpieces of Klimt's 'golden style'. More so than in any other painting, here the artist – with no need of the magic of a wider colour spectrum – works almost exclusively in metallic gold. In terms of the technique involved, it is worth noting in passing a fact that has hitherto largely been overlooked and that probably has a direct relevance to the history of the Wiener Werkstätte: 'A book binder's assistant is said to have helped him [Klimt] when he was applying the golden decorative finish so very tastefully to the surface of his paintings.'[41] For Ludwig Hevesi, a long-standing friend of Gustav Klimt, this painting marks a 'striking innovation', 'possibly even a system of planar ornamentation that will have its own future. I certainly believe this to be the case, for I have seen it approaching for years and becoming ever more systematic in the process.'[42]

Not everyone viewed this new departure so positively. Many commentators felt that Gustav Klimt had lost his way and regarded the portrait of Adele Bloch-Bauer as the image of an 'idol in a golden shrine',[43] or even some unwelcome hermaphrodite that was neither wholly painting nor applied art. When the painting was put on public display for the first time, in Mannheim in 1907, together with the portrait of Fritza Riedler – which in many respects paved the way for the golden portrait of Adele Bloch-Bauer – both were listed in the accompanying catalogue as 'mosaic paintings'.[44] Critics jumped at this term only to turn it into a pejorative description, and talked of 'mosaic-like wall-grotesqueries' while others dismissed the two paintings as 'absurdities', 'vulgarities' or simply 'bizarre'.[45] The gibes continued unabated the following year when the painting was presented to the Viennese public for the first time. Some chose to deplore what they regarded as the loss of individuality in the subject and spoke disparagingly – albeit with playful wit – of a portrait with more 'Blech than Bloch' [more 'lead' than 'wood'].[46] Harsher critics accused Klimt of endangering the autonomy of painting. And after 1918, when the painter's status largely declined following his death, this was the accusation most often levelled at him: 'He extracted from Nature everything that could serve his decorative purpose and in so doing took almost exactly the same route as the artisans. His paintings are for hanging on walls like decorative tapestries.'[47] To put the phenomenon we are looking at here in a nutshell: suddenly

the term 'decorative art' seems to be used as freely of the work by this famous painter and son of a goldsmith as it was as a synonym for 'applied art'. This same point was made very vividly in a caricature that decries the portrait of Adele Bloch-Bauer as no more than the work of a goldsmith (fig.6).[48]

Klimt and Spatial Art

The first showing of the portraits of Fritza Riedler and Adele Bloch-Bauer had taken place not in Austria but in the German town of Mannheim, which made a name for itself in 1907 as the venue for a serious-minded, much-admired international art exhibition. The only participant invited from the Austro-Hungarian capital was the Wiener Werkstätte; the paintings by Gustav Klimt only made a 'guest appearance' in the room dedicated specifically to the work of the Werkstätte.[49] What particularly stunned visitors to the exhibition – the Werstätte never having been seen in Germany before – was the very evident affinity that existed between the paintings, the space, and the works produced by the artist-craftsmen.

Numerous photographs of this exhibition in Mannheim have survived (fig.16). The Wiener Werkstätte room was designed by Josef Hoffmann at the height of his purist phase when his work tended markedly towards accentuating all things constructive and reducing designs to a minimum of basic geometric forms. The portrait of Fritza Riedler hung on one of the short walls, on the other short wall opposite it was the portrait of Adele Bloch-Bauer. Arranged symmetrically to left and right in front of them were the only other guest items, two Kneeling Boys by the contemporary Belgian sculptor Georges Minne, whose work was highly respected in Vienna. It was as though these sculptures actively echoed the edgy angularity of the position of Adele Bloch-Bauer's hand and arm. By the same token, the two flower containers, with their undulating reliefs and ocular motifs, seemed to continue the painted ornamentation. These and similar resonances gave the room as a whole a very particular coherence.

The concordance between Klimt and Hoffmann was evident both in general terms and in individual motifs. A very telling example is to be found in the portrait of Fritza Riedler (fig.8) in the square embellishment next to the signature, which is a perfect match for a Wiener Werkstätte brooch designed at almost exactly the same time by Josef Hoffmann (fig.9). The pictorial architecture and the construction of the brooch obey the same laws: strictly articulated planes, colours restricted to gold and silver, emphatically clear contours. One detail deserves special attention. An old photograph of an earlier state of the portrait of Fritza Riedler shows it without the intricate, interlocking silver-blue ornamentation in the background, which thus appears to have been painted later.[50] This later addition is strikingly similar to Hoffmann's decorative wall designs for the Kunstschau in Vienna in 1908. It therefore seems perfectly reasonable to suggest that retrospective corrections were made under the influence of Hoffmann's concept.

An important factor in the cross-pollination of painting and the art of building was Hoffmann's deep understanding of architecture, which paved the way for the lively exchange of ideas that existed between himself and Klimt. Both artists benefited from Hoffmann's ability to resize items almost at will: 'Hoffmann monumentalised small craft forms and minimalised large architectural forms ... Hoffmann polarised architectural and applied arts forms in such a way as to create a conduit between their different sizes and qualities. Nothing could have been further from his mind than a sterile antithesis separating architecture and the applied arts.'[51]

A fundamental question arises from this concordance: Who was influencing whom? Is this Klimt? Is this Hoffmann? Could there ever be a definitive answer to this question? Carl Moll is a particularly useful eye witness in this connection. As a fellow-artist, an omnipresent art impresario in Vienna and a personal friend of both Klimt and Hoffmann, he could not have been better informed. But even Moll would not commit himself and pointed instead to the constant dialogue between two like-minded personas and saw 'a perfect balance in their artistic collaborations. Klimt's influence was as palpable in the Wiener Werkstätte as was theirs on Klimt in the middle period of his artistic career.'[52]

Others, with some justification, regarded Josef Hoffmann as the driving force. 'The mighty talent of Hoffmann urged Klimt on in the direction of the applied arts – but no blame is to be laid at either Hoffmann or Klimt's feet. At times this held the painter back, while the interior designer developed all the more splendidly ... '[53] For all the points of comparison in their work, there is something more fundamental at play here than the connections already described and other phenomenological affinities. A greater shared whole comes to light when the obligatory two-dimensionality of 'planar art' apparently paradoxically transmutes into three-dimensional 'spatial art'.

Ever since the founding of the Vienna Secession its members had favoured a form of exhibition design that soon came to be known as 'modern spatial art'. The intention was to draw different art forms together in an attempt not just to display works of art or to present them as products, but to incorporate them in a coherent mise en scène.[54] To the detriment of the individual work – as many would have it – spatial art revolutionised the nature of exhibitions and, by placing equal importance on the exhibits and the presentation, it created a new kind of interior, where every last detail is designed as part of a single entity.

These developments inevitably brought conflict with them. As early as 1905 this turned into uproar when they fuelled irreconcilable differences within the Secession, which, in turn, led to a crucial vote and the subsequent departure of the Klimt faction. The causes of this key event were many and varied; one important factor was the mistrust of the 'pure' painters around the founder member Josef Englehart on the one hand, and the spatial artists and so-called 'stylists' on the other. Looking back later, Koloman Moser described the ensuing schism in terms of the 'departure of the artisans'.[55]

The Mannheim exhibition of 1907 similarly prompted some very grave concerns in the minds of some with regard to the 'spatial art' presentation. Karl Scheffler, editor-in-chief of the influential Berlin journal Kunst und Künstler. Illustrierte Monatsschrift für Kunst und Kunstgewerbe was in no doubt: 'There is one thing that the organisers of art exhibitions cannot be too aware of: either an art exhibition or an applied arts exhibition. Not the two together.'[56] Only where Klimt's works were involved was Scheffler prepared to make an exception: 'Whatever snobbery comes into play, the room devoted to the Wiener Werkstätte, with paintings by Klimt, appears relatively organic; it is acceptable there because Klimt's paintings are themselves applied art.'[57]

The Community of Creators and Connoisseurs

Whatever the contemporary response to the new common cause of painting, architecture and applied art, the picture would be incomplete without the support of the collectors and the inclusion of the consumers. The importance of

the latter was demonstrated most tellingly at the 1908 Kunstschau in Vienna. This exhibition, which one critic at least described as a 'ceremonial gown around Gustav Klimt',[58] was a unique tour de force by the Klimt group. It showed art for every area of life, from artistically designed children's toys to tombstones, art for every stage from the cradle to the grave.

In his opening speech, Gustav Klimt defined the underlying ethos of the work.[59] First and foremost he made the case for the Gesamtkunstwerk; he also talked of applied arts and the fine arts, of the relationship between 'high' art and 'low' art. He cited William Morris: 'even the most insignificant thing, if it is executed perfectly' can help 'to multiply the beauty of this earth', if only it were possible to bridge the distance between artist and society.[60] Three years before this, in 1905, the members of the Wiener Werkstätte had addressed this point in their 'mission statement': 'We want to establish a deep contact between the public, the designer and the craftsman.'[61] But now Klimt went further and put forward a new definition of the term 'artist'. His wholly radical proposal was that the same status should be enjoyed by both the artist and the recipient. Significantly, the unashamedly hedonistic painter referred to the latter as the *Genießender*, which has its roots in the verb 'to take pleasure': 'And we interpret the term "artist" just as widely as the term "work of art". Not only those who create art but also those who appreciate and take pleasure in art are worthy of this name, all those who are able to be capable of feeling and of valuing the artistic creation. In our minds the "art world" is an ideal community of creators and connoisseurs.'[62]

Without this community, 'Vienna around 1900' would never have come about. It was the art lovers, a handful of collectors, who purchased Klimt's work – rich enough to be able to afford them. Among the most important Klimt collectors and patrons of his art were the Waerndorfer family, the Wittgensteins, the Zuckerkandls, the Lederers and the Primavesis. Of the approximately 140 oil paintings that Klimt sold between the founding of the Vienna Secession in 1897 and his death in 1918, more than a third were initially purchased by the above families. In addition to this, they not only repeatedly commissioned works from Gustav Klimt, they were also Josef Hoffmann's most important clients and the most influential customers for the Wiener Werkstätte.[63] Recent research has shown that the Wittgenstein and Waerndorfer families alone (including their immediate kin and relations by marriage) acquired at least 450 silver and silver-plated items from the Wiener Werkstätte during the course of its first three years – in other words, a quarter of the total of the metalwork produced by the Werkstätte.[64]

There were of course others who chose to speak out against these developments: against Klimt's way of painting, against the intermingling of different genres, against Josef Hoffmann's concept of space, against the Kunstschau, against financial exclusivity and the elitism of the Wiener Werkstätte. One of the most clamorous voices – refusing to be assuaged – was that of the architect and cultural critic Adolf Loos. In the year of the Kunstschau he published his *Ornament and Crime*. The very title makes clear his opposition to the Wiener Werkstätte and Josef Hoffmann, his favourite sparring partner and the preferred butt of his censure.[65] Loos, determinedly opposed to the notion of the Gesamt-kunstwerk, emphatically supported the making of a clear distinction between a 'work of art' and a 'household item'. What separated him above all from Josef Hoffmann was their fundamentally different concept of space: 'Space as a framework of action that is defined by human beings and serves them, or as an aesthetic

Gesamtkunstwerk that conditions them.'[66]

After the Vienna Kunstschau of 1908 Klimt changed direction in his painting. In his opening speech there had already been a hint that he felt he was at a crossroads: 'And once the exhibition has been opened, those of us who have spent many weeks together preparing it will say our farewells and each will go his own way. But this is not to say that we won't come together again before too long in some other configuration for some very different purpose.'[67]

By now the new status of the applied art – neither 'high' nor 'low' – could no longer be revoked. It was Klimt himself who was a major player in these developments. Both in his own work and indirectly as a role model and inspiration to others, he dared to promote a unique expansion of the possibilities of artistic creativity. The ground had been laid by the idea of the Gesamtkunstwerk and it was the friendship and likeminded genius of Gustav Klimt, Josef Hoffmann and Koloman Moser that really allowed it to come into its own. Broadly speaking, in the context of Viennese modernism there was a move to relocate and raise the status of the work of the artist-craftsman now that the divisions between 'free painting' and the applied arts had started to shift.

This achievement has never been forgotten. In 1950, on the occasion of his eightieth birthday, Josef Hoffmann received a letter of congratulation from the renowned Swiss architect Siegfried Giedion. In it Giedion explicitly refers to Gustav Klimt and continues: 'We have not forgotten that at a time when there seemed to be no hope of such a thing coming about, the Wiener Werkstätte endeavoured to establish a real connection between painting and architecture … and to cleanse the forms in people's immediate surroundings.'[68]

In the Liverpool exhibition, outstanding interiors which once belonged to early collectors and patrons of the Wiener Werkstätte will be on show with objects and paintings that have long since been dispersed according to type, and which are normally scattered across the entire world. The exhibition will have achieved its goal if it can convey at least a sense of the Viennese contribution to European modernism that arose from what Klimt himself called the 'community of creators and connoisseurs'.

Translated from the German by Fiona Elliott

*Friedricke Maria Beer, in a
Housecoat designed by the Wiener
Werkstätte, in the Apartment
decorated for her by Josef
Hoffmann c.1914*
Imagno/Austrian Archives

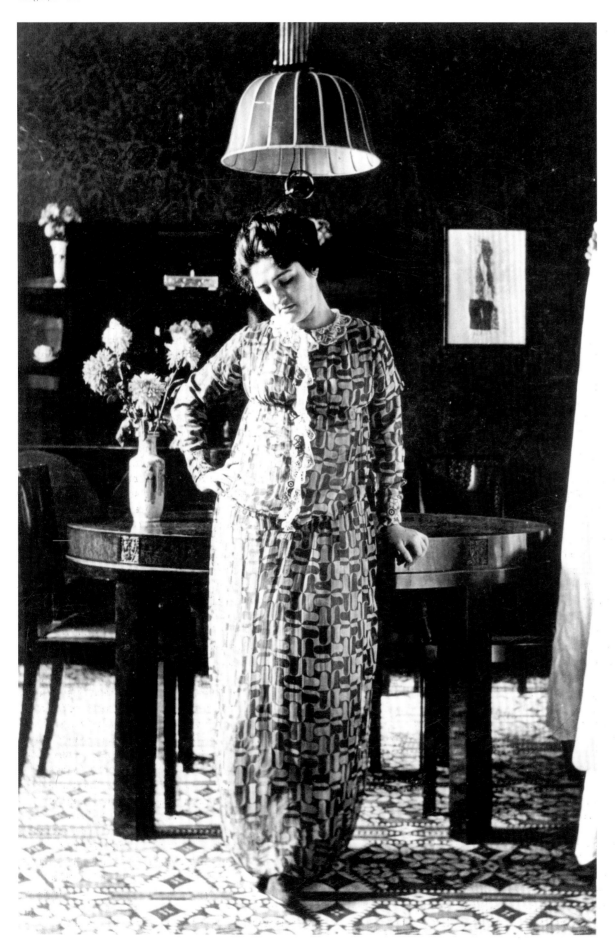

Gesamtkunstwerk, or the Politics of Wholeness

Esther da Costa Meyer

Every Gesamtkunstwerk, wrote Éric Michaud, is 'a reaction to the division of the social body'.[1] Throughout the nineteenth century, a time of nationalist aspirations and wars of independence, the search for a seamless plenitude to heal social, political and cultural fissures, assumed various forms, particularly in art. It was Richard Wagner (1813–1883) who articulated this yearning with his notion of the Gesamtkunstwerk in *The Art-Work of the Future* and the essay 'Art and Revolution', both written in 1849. These are the works of a revolutionary, penned in exile in the aftermath of the 1848 uprising in Dresden, where the composer, the city's *Hofkapellmeister* (music director), had helped man the barricades along with the architect Gottfried Semper, the poet Heinrich Heine and the Russian anarchist Michael Bakunin.[2] The concept of Gesamtkunstwerk thus took shape at a critical moment in history, in the burning memory of an aborted revolution and in straitened personal circumstances. Aglow with the romantic nimbus of persecution and unencumbered by jobs, employers, or any institutional allegiance, Wagner was free to think on a grand, utopian scale.

Wagner belonged to a generation of Romantics who tried to promote the unification of German culture after the debacle of the Napoleonic wars, and his ambitious notion of an operatic Gesamtkunstwerk was freighted with social, political and artistic meaning. His models were the tragedies of Sophocles and Aeschylus which he, like many of his contemporaries, believed had been sung from beginning to end, thus bringing together architecture, dance, words and, as he wrongly thought, music. In his unorthodox reading, ancient Greek drama was a communal art form, consubstantial with the country as a whole: 'It was the nation itself – in intimate connection with its own history – that stood mirrored in its art-work, that communed with itself and, within the span of a few hours, feasted its eyes with its own noblest essence,' he wrote in 'Art and Revolution'.[3] Aesthetically, Wagner's exuberant and epiphanic vision attempted to transform the ancient Greek theatre festivals with their throngs, brilliant colours, sounds and dances into an emphatically German art form that would displace the pallid aesthetics in vogue in his day.

In the great synthesis of the future, the Greek nation-state was to be replaced by the community of the *Volk* (people) as both the addressee and the mystical embodiment of the new 'Artist of the future'.[4] Only the *Volk* could bring the total work of art into being, a collaborative project capable of reflecting the aspirations of the nation. As representatives of the still-to-come unified Germany, the people would undertake what Wagner saw as the redemptive mission of art.[5] But the true *Volk* did not yet exist, he argued. Instead of nurturing the labouring classes, those in power, led by utilitarian goals, treated the untutored masses with disdain; subordinated to the soulless and demeaning work of the machine, these were but the artificial product of an unnatural culture.[6] Given the fallen state of the *Volk*, he rarely

used the term Gesamtkunstwerk, which he had not coined, preferring the more realistic 'art-work of the future' that acknowledged the fact that conditions for a synthesis of the arts were not yet ripe.[7] If Wagner espoused wholeheartedly the socialist view of the industrial revolution and the dehumanising effect of the machine, he was no Luddite, being equally critical of handicraft, that modern-day product of guilds and journeymen and narrow specialisation that had lost sight of higher goals.[8] It was not by chance that both Baudelaire and Nietzsche would later call him – angrily, in the case of Nietzsche – the epitome of modernity.[9]

Wagner's indictment of the society of his day, already dominated by the production and consumption of luxury goods, held profound theoretical implications for design. With the division of labour, workers were reduced to an extension of the machine that manufactured goods for the rich: 'our modern factories,' he wrote, 'afford us the sad picture of the deepest degradation of man, – constant labour, killing both body and soul, without joy or love, often almost without aim'.[10] Modern means of production curtailed the full potential of the human being by reducing labour to mechanical and repetitive gestures. This compartmentalisation reflected in turn that larger fragmentation of the arts that had taken place with the demise of the Greek polis.

If the barriers separating the arts could be breached, it was because the audience was capable of taking in new forms of expression that entailed the participation of all the senses at once. To reinstate what Wagner called the senses' 'perceptive rights' constituted the emancipatory goal of the art of the future.[11] Wagner thus situated the body, or at least its sensory apparatus, at the centre of art-producing faculties. This hard-won unity would finally permit the sublation of the arts, and consequently the ascent from the individual and idiosyncratic to the universal. Only an art that could transcend the different senses of the human being could attain freedom.[12] Wagner's theory was predicated on the historicity of the sense organs which were subject to evolution, an idea that would later be theorised by thinkers as different as Georg Simmel and Sigmund Freud.[13] German Romanticism, as Wagner well knew, had already tried to empower the senses by encouraging collaboration among the arts. Synaesthesia, one of the dreams of Ludwig Tieck, Novalis, August Schelling, and the Schlegels, formed part of their own political project for a unified Germany. Their artist friends Caspar David Friedrich, Philipp Otto Runge, and Carl Gustav Carus, all of whom had lived in Dresden, appropriated their ideas for the visual arts in paintings that evoked musical themes through iconography. Semper was well-acquainted with one member of this circle, Carl Gustav Carus, physician, physiologist, painter and poet, whose important psychological treatise of 1846, *Psyche*, first introduced the notion of the unconscious.[14] An important precursor to Freud, Carus already intimated the centrality of the self which was to be crucial to the Viennese conception of the synthesis of the arts.

11
Gottfried Semper and
Carl von Hasenauer
Imperial Forum 1869,
aerial view
Austrian State Archive,
Vienna

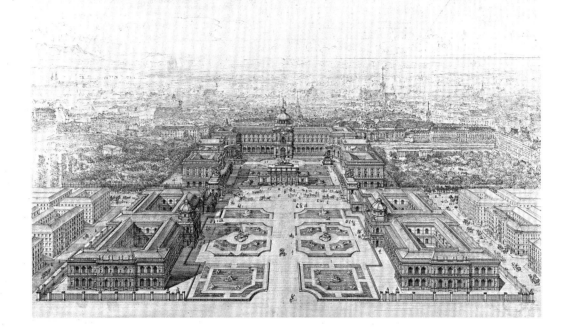

Wagner's notion of the Gesamtkunstwerk initially spread among his closest friends. Chief among these was Gottfried Semper (1803–1879), who arrived in Dresden in 1834, eight years before Wagner, to take up a position as professor of architecture in the academy.[15] In Semper, Wagner found a perfect interlocutor for ideas that would later make their way into *The Art-Work of the Future*. After studying mathematics and Greek history and culture at the university of Göttingen, Semper moved to Paris to pursue a career in architecture, and was there at the height of the debates concerning polychrome in Greek architecture and sculpture. Stimulated by the polemic, he spent three years studying archaeological remains in Italy and Greece (1830–33), and later published a controversial pamphlet on polychrome.[16] What he had to say about ancient Greek temples and theatres was bound to interest Wagner. After building the Royal Theatre in Dresden, where Wagner's early operas would be staged, Semper began a monograph on the theatre and was thus deeply involved in issues close to Wagner's heart. Semper also shared Wagner's republican ideals and distinguished himself designing and supervising barricades in the revolution of 1848, a fact that led to his own extended exile in various European cities.

In the past, critics had always pointed to Semper's debt to Wagner's great evocation of Greek drama as a communal form, his emphasis on the interaction of the arts, and his view of classical drama as a foil to a utilitarian society that prized materialism and instrumentality over art. These ideas found an echo in Semper's conception of the ludic origins of architecture in the ancient festivals and their dynamic interplay of colour, form, sound, 'covered with decorations, draped with carpets, dressed with boughs and flowers, adorned with festoons and garlands, fluttering banners and trophies'.[17] Yet Wagner's ideas kindled an interest that was already there, based on first-hand knowledge of Greek architecture. Recent scholarship has shown that the borrowing ran both ways, that Wagner himself was influenced by Semper and had read Semper's essay on polychrome.[18] Moreover, the two met several times during their years in exile. In Paris, in February 1850, Wagner asked Semper to read the draft of *The Art-Work of the Future*.[19] Semper's interpretive audacity and highly original reading of architectural form in terms of symbolism struck a sympathetic chord. Both men had a visual imagination. Wagner wanted to make music visible; Semper wanted to transform architecture into an all-enveloping spectacle that elicited a powerful response from viewers (fig.11).

The hermeneutic significance Semper attached to textiles, basketry, carpentry, and metalwork, and his ability to coax historical meaning out of the smallest fragment or artefact, helped call attention to the importance of the applied arts. This approach resonated strongly in institutions such as schools of architecture and museums, through collections and curricula that came to be moulded according to his ideas. In Vienna, where Semper designed both the Naturhistorisches and the Kunsthistorisches Museums (in collaboration with the architect Carl von Hasenauer), his theories had an effect on the Secessionists, who inherited his view of architecture as embracing all the other arts. Likewise, his sensitivity to urban context and his capacity to orchestrate large-scale ensembles by the siting as well as the design of his buildings influenced Viennese architects like Camillo Sitte and Otto Wagner, who took from Semper the idea of the city as theatre. From the start, the focus of the Gesamtkunstwerk was always on reception, on the audience's ability to absorb spectacle collectively with its senses.

Semper's decisive shift of architecture from its traditional union with painting and sculpture to a new classification with music and dance which were equally abstract, helped the radical concept of the Gesamtkunstwerk take hold across Europe.[20] The Crystal Palace exhibition of 1851, which Semper attended, and to which he had contributed designs, served as an important catalyst for change. By holding up for comparison and instruction a huge array of industrialised goods and craftsmanship, it fostered the creation of art schools to educate designers, and of the South Kensington Museum (now the Victoria and Albert), the first permanent display of applied arts. Not surprisingly, the new emphasis on education wedded to the exhibition of beautifully designed objects and household goods attracted the attention of major figures, and eventually led to the emergence of the Arts and Crafts movement that brought architecture and the decorative arts together in a new way.

At stake was a new kind of relationship between artists and the fruits of their labour. Guided by social and utopian ideals, figures like William Morris, Charles Robert Ashbee, A.H. Mackmurdo and Walter Crane founded guilds where workers received artistic guidance and adequate compensation for their endeavours. With the Arts and Crafts, women designers entered the profession side by side with men to create and promote new forms of interior design. Shunning the shoddy manufactured goods that were flooding the market, artists tried to revive proven methods of craft production, occasionally aided by the machine. In Scotland, the architect Charles Rennie Mackintosh – often in collaboration with his wife, gifted designer Margaret Macdonald Mackintosh – conceived a bold and original amalgam of architecture and design that attracted a great deal of attention on the continent (fig.12). Ambivalent if not fearful of the modern city, the exponents of the Arts and Crafts would never quite resolve the contradictions between their social agenda and the realities of capitalism. To the alienation and social conflicts of an urban environment disfigured by the Industrial Revolution they responded with an insistent focus on domesticity, reconfiguring the home as a bulwark against the impersonal forces of the metropolis. Ultimately, however, the movement remained trapped within the laws of the marketplace: in the industrial age craft cost far more than mass-produced goods, and was accessible only to cultured elites.

By the turn of the century, the legacies of both Wagner and Semper had begun to flourish across Europe, particularly in the north. In Germany, the emergence of various *Künstler-kolonien* (artist colonies) revealed the enthusiasm with which the synthesis of the arts was received, criticised, and reinvented. Belgium, France and Scandinavia saw a surge of creativity in the applied arts that owes something to Semper if not to Wagner.

In Vienna the idea of the Gesamtkunstwerk was manifest in urbanism, in the arts, and on stage.[21] Wagner himself had lived in Vienna in 1861 in the hopes of producing *Tristan and Isolde*. For the young students who constituted his greatest admirers, Wagner stood for an idealised pan-Germanism which they saw as an antidote to the old-fashioned,

multi-ethnic Austro-Hungarian empire burdened by problems of self-identity.[22] Semper too was often in residence while at work on his two museums, as well as the Burgtheater and the theatre depot. The two saw each other again in Vienna in 1875, at an elaborate reception given in Wagner's honour by the artist Hans Makart, whose own work embodied elements of the Gesamtkunstwerk. Makart's frescoes for the interior of Semper's museum of fine arts, left unfinished on his death in 1884, were completed by other artists, including the young Gustav Klimt. In these grand and opulent spaces, architecture, sculpture and painting come together in quasi-operatic splendour.

It was in architecture and interior design that the Gesamtkunstwerk would score its greatest success in Vienna. Camillo Sitte (1843–1903), known primarily as an architect and urbanist, assumed the directorship of Vienna's State School for the Applied Arts in 1883. Sitte admired Semper, whose ideas on city planning were the subject of his first exhibition as head of the School of Applied Arts in Vienna.[23] But it was Wagner who laid claim to his greatest enthusiasm. In 1876, Sitte had met both the composer and Semper at the inauguration of Wagner's opera house in Bayreuth, the Festspielhaus. The culture-forming role of the *Volksgeist* (spirit of the people), implied by Wagner's theory, reinforced Sitte's own interest in the urban vernaculars that grew anonymously over time. *Raumkunst*, or the art of space, was the summation of urban principles left behind by successive generations that gradually transformed space into place. In *City Planning According to Artistic Principles* (1889), Sitte analysed the city as a work of art, a Gesamt-kunstwerk created over time, and attempted to distill aesthetic principles from this slow sedimentation of urban forms.[24] In his view, the Ringstrasse's free-standing buildings destroyed the legato of the old historic fabric where streets formed continuous walls enclosing small, *gemütlich* (cozy) squares. This extraordinary sensitivity to the qualities of local, as opposed to abstract, space was informed by his abiding interest in sensory perception, which he shared with his fellow Viennese. However, Sitte's fascination with Wagner had also to do with his own deep-seated belief in a specifically German destiny for Austria.[25] City planning, he held, 'is really

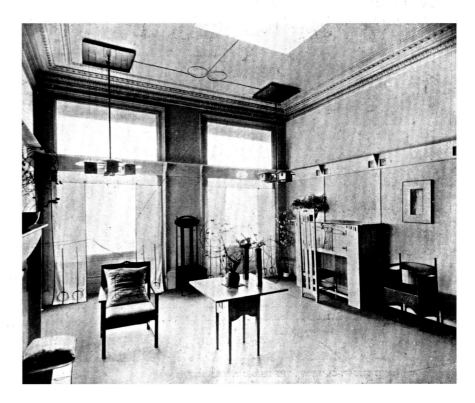

12
Charles Rennie Mackintosh and
Margaret Macdonald Mackintosh
*Drawing Room, 120 Mains
Street, Glasgow* 1900
Hunterian Museum and Art Gallery,
University of Glasgow

part of a great and true art of the people, a fact that is the more important because our times lack just such a popular synthesising of all the visual arts in the name of an all-encompassing and unified national work of art [*nationales Gesamtkunstwerk*]'.[26]

Another prominent Viennese who helped shape modern views of the Gesamtkunstwerk was the architect Otto Wagner (1841–1918), who succeeded Carl von Hasenauer, Semper's Viennese partner, as professor in Vienna's Academy of Fine Arts. Wagner's career would follow a long and brilliant trajectory that led from unadventurous neo-Renaissance buildings, through the Secession, to a stripped-down modern idiom. In his view, Sitte's nostalgia for old historic cities with their human scale and picturesque streets and squares, failed to take into consideration the needs of the metropolis, its rising population and increasing traffic. Instead, Wagner espoused the very uniformity Sitte loathed, with its unbroken forms and fearful symmetries, expressive of new materials and technologies. 'The modern eye has also lost the sense for a small, intimate scale; it has become accustomed to less varied images, to longer straight lines, to more expansive surfaces, to larger masses,' he wrote in his influential *Moderne Architektur* (1896).[27] From Semper he learned to orchestrate his architectural masses so that they formed a harmonious urban composition punctuated with monumental anchoring points, and characterised by clarity and legibility (fig.13). Using infrastructure – bridges, viaducts, railways – in counterpoint to architecture, Wagner wove mobility and stasis into a new kind of Gesamtkunstwerk in which passing trains on suspended viaducts cut through railroad stations: Semper's conflation of stage and city without the affect. In many commissions such as Vienna's urban rail system, the Postal Savings Bank, or the church at Steinhof, Wagner designed furniture, stained glass, metalwork and sculptural pieces, treating the applied arts with the same high standards as his architecture. Although he only joined the Secession two years after it was founded, he was supportive from

13
Otto Wagner
*View of the Park of the Future
Twenty-second District of Vienna*
From Wagner, *Die Grossstadt*,
Vienna 1911
Wien Museum, Vienna

14
Ernst Mach
From *The Analysis
of Sensations*, 1886

If Mach closes his right eye the ridge of his eyebrow, nose and moustache form a continuum with the environment.

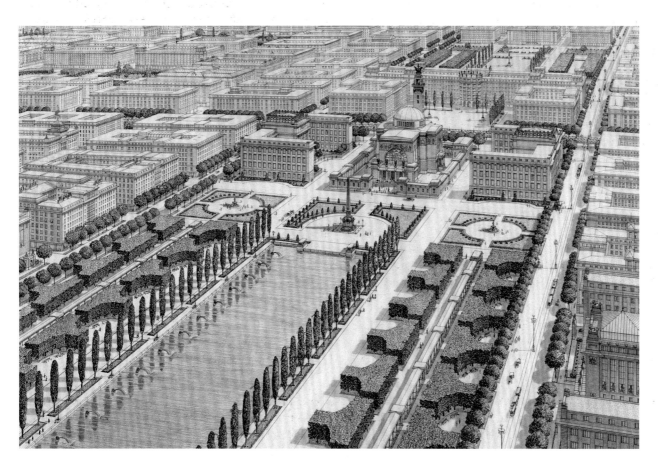

the beginning, and trained some of its best architects and designers such as Joseph Olbrich and Josef Hoffmann, either in his classes or in his studio.

At the same time, new theories from other fields challenged the grand scale of the Gesamtkunstwerk as conceived by Wagner, Semper, Sitte or Otto Wagner, whose goal was the 'big picture', aimed at the masses. The Gesamt-kunstwerk could contract as well as expand, embrace nations or retreat into the ego and its immediate environment. Vienna's pre-eminence in psychology and philosophy affected all levels of the city's intellectual life. With depth psychology, the thirst for wholeness moved inwards, heralding a marked shift from the body politic to the self. Self-identity, not nation building, became the goal to which new forms of the Gesamtkunstwerk were harnessed. When the philosopher-physicist Ernst Mach published *The Analysis of Sensations* in 1886, he described the ego [*Ich*] as a passive, porous vehicle for impressions, almost dissolving into the surroundings (fig.14): 'The antithesis between ego and world, between sensation (appearance) and thing, then vanishes, and we have simply to deal with the connexion of the elements'[28] Although these theories had nothing to do with the Gesamt-kunstwerk, they met it half way, so to speak, and had a pronounced impact on the arts through literature and art criticism. In his famous essay, 'The Ego cannot be saved' [*Das unrettbares Ich*], the critic Hermann Bahr, who championed the Secession, observed that '[W]e seek above all the synthesis of the external and the internal, world and ego, the wildest force (brutal and unrestrained) and the most fragile, over-sensitive refinement.'[29] There were, of course, dissenting voices among the Viennese intelligentsia. For Freud, this vague yearning for wholeness or 'oceanic feeling' constituted 'a shrunken residue of a much more inclusive – indeed, an all-embracing – feeling which corresponded to

a more intimate bond between the ego and the world about it,' the infant's inability to separate himself from his surroundings.[30] Nevertheless, the obliteration of boundaries between subject and object, and the location of the self in a seamless continuum that incorporated the environment helped create a cult of the self that underlay the creations of Art Nouveau in its various incarnations in different countries.[31]

Vienna's Secessionists and their offshoot, the Wiener Werkstätte, owed much to these solipsistic theories. As the self expanded, the outer world shrank, and the problematic and idealised notion of the *Volk* was replaced by the equally problematic elite, which appropriated the Gesamtkunstwerk for exclusionary, class-driven purposes. Unfortunately, wrote Hoffmann in 1901, 'it is no longer possible to convert the masses. Thus it is all the more urgent to satisfy the few who appeal to us [...] They must feel that we have devoted our lives to their happiness, they must sense our priestly dignity and believe in our sincere inspiration.'[32] Art became a surrogate religion in a secular society, and the artist a messianic figure. Richard Wagner's 'redemption by Art' is not far off, though placed at the service of an affluent minority.[33]

Impressed by the unpretentious elegance of the British Arts and Crafts, its effort to transform the domestic environment into a meaningful whole, and the manner in which architects collaborated with craftsmen to overcome the division of labour, the Secessionists repeatedly stressed the equality of the fine and the applied arts in their writings and exhibitions. Their dream of a total work of art found a fitting and sumptuous formulation in the beautiful headquar-ters designed by Olbrich, where architecture, sculpture and text come together in a unified whole. Ignored by the city's tradition-bound Academy of Fine Arts, the Secessionists took refuge in the *Kunstgewerbeschule* or School of Applied Arts, where Hoffmann and the artist Koloman Moser taught and trained young craftsmen and –women who would give shape and form to their ideas.[34] If the Wiener Werkstätte produced what are arguably some of the most beautiful objects of the modern period, these came at a price. Despite lip service to the Arts and Crafts, their work revealed a radical change in ideology. They did not agonise over the destinies of man-kind, as did Morris and his friends. To be sure, craftsmen retained control over their products, and were allowed to sign their pieces, but the old empire's respect for the status quo overshadowed the socialist leanings of the British.

When Hoffmann, Moser and the industrialist Fritz Waerndorfer founded the Wiener Werkstätte in 1903, they were particularly enthralled by Mackintosh, whose work had been shown to great acclaim in the Secession's important eighth exhibition of 1900. His unusual Symbolist-inspired palette, the tensile linearity of his furniture, and the way he and his wife Margaret Macdonald elevated the room to an art form made a strong impression on Hoffmann and Moser. Recent trends in Belgium, France and above all Japan also left their stamp on the Wiener Werkstätte. Yet for all their borrowings, there is a traditional Viennese intimacy in these interiors, an almost Schubertian delicacy and light-fingered grace that owed something to their own *Biedermeier*.[35] The collaboration of different artists and craftsmen allowed for the firm's gorgeous, finely calibrated designs, enriched by the know-how of different practitioners. The presence of architects as designers of household goods was decisive. An architect like Hoffmann imparted to small-scale objects the structural rigor of his buildings based on a clear differentiation between load-bearing and supported parts linked by elegant joinery.

Klimt often collaborated with Hoffmann, providing works of art expressly designed to fit the luxurious surroundings, as he did with the magnificent mosaic panels in the Palais Stoclet in Brussels. Sometimes, it was Hoffmann who designed rooms around paintings by Klimt, as he did in his Villa Ast, built in Vienna on the Hohe Warte, a house later owned by Alma Mahler. The son and brother of goldsmiths, Klimt had been trained at the Kunstgewerbeschule rather than the academy, and occasionally used metal frames and semi-precious stones in his paintings, narrowing the gap between the fine and the decorative arts.

Just as Wagner opposed the Gesamtkunstwerk to the grasping materialism of his day, so too the Wiener Werkstätte envisioned it as a protective shield against the levelling threat of the metropolis and of mass production. In the same year as the Wiener Werkstätte was founded, 1903, Simmel published his great essay 'The Metropolis and Mental Life', showing that as society became ever more impersonal, the individual felt a greater need to assert and even exaggerate peculiarities to compensate for the de-individualising forces of the modern world.[36] To offset the discontinuities of big-city life, the Wiener Werkstätte refashioned the interior as a miniature Gesamtkunstwerk, a seamless whole that held out the promise of an illusionary and ephemeral closure. Instead of the demotic commodities resulting from mass production, it offered auratic consolations embodied in unique, unrepeatable pieces. It was a defensive modernism, a modern form of resistance to the forces unleashed by modernity, a retreat from the public sphere to the private realm and, ultimately, an art of social and political disengagement.

Freed from the dross of utilitarian aims, Hoffmann's bejewelled spoons could flaunt their true function as markers of conspicuous consumption. Use-value had given way to exhibition-value in this hothouse culture of pure interiority. With the aesthetisation of everyday life, all sutures were papered over. Furnishings became a soothing analgesic that appeased the restless nerves injured by the assault of modernity. Rooms were so carefully coordinated in colour, form and texture that each piece was custom-made and site-specific. As Mackintosh wrote to Waerndorfer in 1903: 'every object which you pass from your hand must carry an outspoken mark of individuality, beauty and most exact execution. From the outset your aim must be that every object which you produce is made for a certain purpose and place.'[37] It was just this frozen perfection beyond the reach of time and change that a purist like Adolf Loos combated from an equally conservative position. In his essay 'The Poor Little Rich Man' (1900), Loos subjected Secessionist interiors to a withering critique: 'Wherever he [the rich man] cast his glance was Art, Art in each and every thing. He grasped Art when he took hold of a door handle; he sat on Art when he settled into an armchair; he buried his head in Art when, tired, he lay it down on a pillow; he sank his feet into Art when he trod on the carpet.'[38] Even the electric chimes in his rooms, Loos added, played motifs from Beethoven and Wagner.[39] When the Wiener Werkstätte began to design dresses for their clients in 1911, some saw this as the ultimate reification of the user, who was treated as an accessory, a decorative clotheshorse (figs.89–91).

In reality the situation was far more complex than such reductive reading would allow. One cannot deny the women who commissioned these dresses and supported the Secession a form of agency and empowerment, nor conflate the designers' intentions with the clients' motivations. For the wealthy men and women who patronised the Wiener Werkstätte, many of them Jewish, beautiful objects and avant-garde clothing also addressed issues of identity and assimilation. Politically conservative did not mean socially irrelevant: for those who could afford it, the firm's designs served as a medium for self-fashioning and self-affirmation. World War I spelled the end of this class of munificent patrons that sustained the Wiener Werkstätte and its economic infrastructure, though it struggled to remain afloat until 1932, just after the Depression. Crafted with luxurious materials and finishes, their exquisite products were labour-intensive and hence costly. Resistance to mass production hastened the Werkstätte's demise.[40]

The Secession and the Wiener Werkstätte were not the only modern groups that embraced the Gesamtkunst-werk. The historic avant-gardes themselves were affected. In his address to the students of the Weimar Bauhaus in 1919, Walter Gropius declared, with the expressionist pathos typical of the post-war years, that 'a universally great, enduring, spiritual-religious idea will rise again, which finally must find its crystalline expression in a great Gesamtkunst-werk. And this great total work of art [Kunstwerk der Gesamtheit], this cathedral of the future, will then shine with its abundance of light into the smallest objects of everyday life … '[41] Kandinsky's early works, the Ballets Russes, De Stijl, the experimental theatre of Max Reinhardt and Erwin Piscator, all reveal different aspects of the Gesamtkunst-werk, increasingly divorced from its original sources, and eroded by the countervailing pull of its opponents within modernism.

Reactions against the Gesamtkunstwerk now form part of its own history.[42] To a certain extent, modernity would be defined by these two opposing camps: the desire for ever greater interaction of the arts made possible by modern technologies of sound and image, and the suspicion of the intoxicating potential of all spectacle. It was the later Wagner, enshrined in his temple-theatre in Bayreuth, a site of pilgrimage for the secular religion of art, who generated the most virulent opposition. Abstract and anti-dramatic performances, premised on distance rather than elated absorption, would be the hallmarks of one current of opposition which first emerged during Wagner's lifetime and within his own circle of friends. The young Nietzsche, a philologist specialising in ancient Greek, initially embraced the idea of a Dionysian synthesis of the arts in his first book, *The Birth of Tragedy out of the Spirit of Music* (1872), originally dedicated to Wagner. Nietzsche had also read Semper whom he knew personally, and even quoted from Semper's *Der Stil* in an early essay on Greek music drama.[43] But in later texts Nietzsche turned violently against the Gesamtkunst-werk: 'It is plain that I am essentially anti-theatrical: confronted with the theatre, this mass art par excellence, I feel that profound scorn at the bottom of my soul which every artist today feels.'[44] Nietzsche had no illusions as to the irresistible novelty of this tautological conjoining of the arts, these 'opiates of the senses' that he so bitterly denounced.[45]

For high modernism, deeply suspicious of theatricality, large audiences were signs of inauthenticity. Fear of losing individual autonomy, of visual and aural seduction that subdued the masses like a narcotic, and the rejection of excess and immediacy, equated with instinct rather than intellectual reflection, led to its repudiation of the Gesamtkunstwerk. In Wagner, wrote Theodor Adorno, 'the radical process of integration, which assiduously draws attention to itself, is already no more than a cover for the underlying fragmenttion'.[46] Faced with the escalation of grand multi-media spectacles, the late twentieth-century critics would be equally categorical in their dismissal of spectacle, packaged

and marketed by Capital, and aimed at uncritical consumption like any other commodity.[47] Yet modern-day reactions to the Gesamtkunstwerk were also motivated by its terrifying success during the years preceding the Second World War when forces of an altogether different nature were massing on the horizon, preparing a Gesamtkunstwerk to end all syntheses: the totalitarian state.

It was during his years in Vienna from 1906 to 1913, that Hitler, fresh from Linz, had a chance to indulge his passion for Richard Wagner's music at the Court Opera where he attended Gustav Mahler's last performances. His passion for Wagner soon grew to embrace the more loathsome aspects of the composer's ideology, from anti-Semitism to an exacerbated belief in German cultural imperialism. Architecture was perhaps the strongest of Hitler's artistic interests.[48] Awed by the Ringstrasse's grandiloquent buildings, which he considered the quintessence of great architecture, Hitler developed a life-long admiration for the work of Semper, whose sketches he copied, and whose work later served as inspiration for his megalomaniac projects.[49] Yet Hitler's presence in Vienna also coincided with the heyday of the Secession, and he was not entirely blind to its alluring merger of the arts. Years later, in a speech given in 1920, he called attention to a work given pride of place at the Secession's Beethoven multi-media exhibition of 1902 which he probably knew from illustrations: 'Do we really believe that, for instance, Klinger's statue of Beethoven doesn't reflect an inner experience and true feeling, or that a Beethoven symphony isn't also a reflection of an inner experience, a genuine inner experience,' he asked his early followers.[50] The Secessionists' aestheticisation of life cannot be seen as leading directly and undialectically to the aestheticisation of politics. Nazism took from the vilified art and architecture of modernity whatever suited its needs.

Nowhere is Hitler's debt to the Gesamtkunstwerk greater than at the Nuremberg rallies where architecture, sculpture, light and sound, carefully synchronised thanks to modern technology, embodied the Nazi goal of politics re-conceived as a work of art.[51] The rallies were not planned by Hitler, but by a cohort of Nazi collaborators, first and foremost the architect Albert Speer. It was Speer who designed the architecture and sculptural motifs, aided by assistants responsible for lighting, music and the choreography of the slow-moving multitudes in lockstep. Here, according to Siegried Kracauer's famous analysis, the masses assumed an ornamental role, whether marching solemnly, or petrified in stiff, hieratic blocks, as they listened to their Führer in rapt attention (fig.15).[52] The goal was not the synthesis of the arts per se, but this ductile and docile crowd of thousands, moulded to specification by its dictator-artist.

To return to Éric Michaud, the Gesamtkunstwerk responds to the divisiveness of the modern world 'by means of the unity of a great body, at once organic and mystic'. Against the historicity demanded by democracy, it presents 'the phantasm of an end of history'.[53] Whether the search for wholeness is in fact concomitant with the fractured nature of modernity, or whether it echoes an older impulse, an attempt to recapture uterine bliss, the dream of the Gesamtkunstwerk was corruptible, a siren's song that continues to seduce.

15
Albert Speer, *Lichtdom,
Zeppelinfield, Nuremberg
Rallies* 1938
State Archive, Nuremberg

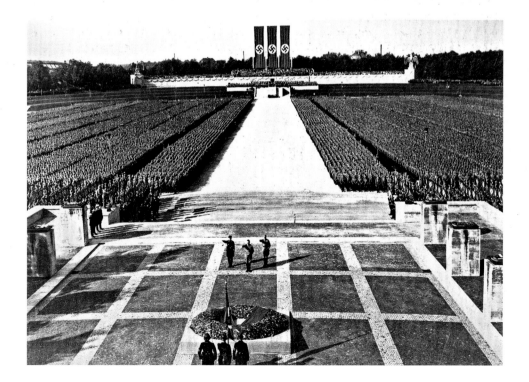

Josef Hoffmann
*Room of the Wiener Werkstätte,
Internationl Exhibition,
Mannheim* 1907
Anonymous photograph
published in *Deutsche Kunst
und Dekoration*, vol.xx, 1907

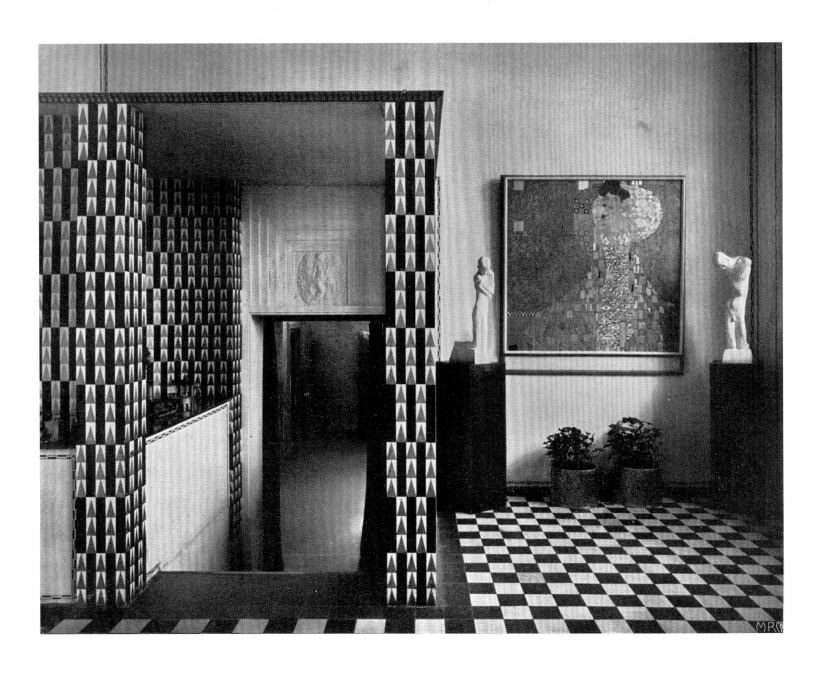

Luxury and Degradation: Staging Klimt

Christoph Grunenberg

'The more exquisite the packaging, the more dubious the content.'
 Karl Kraus, 1907[1]

In the introduction to the catalogue of the Viennese Secession's inaugural exhibition in March 1898, the responsible committee laid out three primary objectives: 'to offer the audience an elite exhibition of specifically modern art', to overcome its 'sweet innocence about the powerful art movement abroad', and to be pioneering 'in the field of artistic arrangement', so that art lovers were no longer forced 'to wander through gallery after gallery until one has, disheartened by the tangled mass of mediocrity, lost one's freshness-for the appreciation of what little good there may be'.[2] In the early revolutionary phase of the Secession, exhibitions were its primary platform of exposure and a forceful demonstration of its determined break with the past, effectively conveying the emergence of a new style and *Kunstwollen*. The twenty-three exhibitions staged by the Secession from 1898 until the split with the so-called Klimt Group in 1905 are the pinnacle of what at the time was termed *Moderne Raumkunst*, the art of spatial or architectural arrangement subjugating all art forms under a greater whole or, as was stated in 1902, 'a coherent unified connection ... of alien elements integrated harmonically'.[3] From that year on, the members of the Secession decreed that exhibitions should be more than just tastefully arranged displays of the latest domestic and foreign products of artistic activity, but were to have either 'gallery or Raumkunst character'.[4] Considerable resources were expended on this ambitious mode of temporary presentation, frequently lasting only four to six weeks, and employing the services of rising architects such as Joseph Maria Olbrich, Josef Hoffmann, Koloman Moser and others. They provided an opportunity not only to present the new style as a unified movement to a broad public but also to experiment without the restraints imposed by public and private patronage, functional considerations and, to a degree, limited budgets.

For the first time, the business of exhibitions was considered not just a subdivision of interior architecture or a necessary support of commercial activity, but as an important branch of modern artistic creativity in itself. The critical importance of exhibitions as the Secession's principle means of disseminating its ideas and artistic output is reflected in the comprehensive documentation of these events. The Secessionists self-consciously constructed an artistic argument and immediate historical narrative, capturing artistic progress in a carefully presented documentary form that offered an immediate simulacrum of these epoch-making presentations. As with every other aspect of their creative universe, the mundane installation shot was elevated to a work of art, frequently reproduced in intensely tinted hues in the elegantly laid out pages of *Ver Sacrum*, the association's luxurious publication and official mouthpiece.

For the Secession, nothing less than a radical historical departure would suffice in engineering a new dawn through the regenerating force of art, the 'sacred spring' evoked in the motto of *Ver Sacrum*, the movement propelled by the 'spirit of youth through which the present always becomes "modern"'.[5] Exhibitions became the principal exercise ground of the avant-garde, the place where ideas were first realised on a grand scale and offered to an eager audience and to potential private and public patrons. The Secession intended to operate these presentations 'not as markets and also not as advertisements of any artistic tendency', but to realise first and foremost a strong didactic mission: 'courses that follow a well-considered, ambitiously devised, faithfully maintained plan, developing from the particular to the general, and which shall educate artists and laymen alike to a shared ownership of a living culture'.[6] Despite this laudable rhetoric, the foundation of the Secession also had concrete economic and practical reasons, increasing its members' visibility and chances for commercial success.

Gustav Klimt himself saw exhibitions only as a temporary compromise, and 'by no means the ideal way of establishing contact between artist and audience; the realisation of grand, public artistic responsibilities, for example, would be for this purpose far more desirable'.[7] However, following the scandal surrounding his University paintings in 1900 to 1901, and the cooling off of high-level political support and public commissions, the Secession artists and designers of the Wiener Werkstätte increasingly relied on Vienna's enlightened haute bourgeoisie for patronage and support. While continuing to further the cause of a distinctively Austrian interrelationship of art and design in national and international exhibitions, the Gesamtkunstwerk began to retreat from the public limelight and found its culmination in private commissions and the sphere of collectors' homes.

The reforms implemented by the Secession and the Wiener Werkstätte transformed exhibitions into strikingly modern installations that, in retrospect, seem direct precursors of the so-called White Cube, the archetypal minimalist exhibition space, which, since the 1960s, has become the international standard of presentation of contemporary art. We are now accustomed to focusing on the reductive elements of the Viennese exhibitions and environments, neglecting their functional and persistently ornamental character. Installation techniques comparable to modern ones only emerge around 1903 under the leadership of Josef Hoffmann and Koloman Moser, as the Wiener Werkstätte entered its most purist phase. The unadulterated white wall as such was absent, 'abstraction' always derived from architectural ornament, such as border framing or geometric surface decoration. We can ultimately trace the origins of the White Cube to these installations. However, as so often in artistic revolutions, its emergence is based on a selective appropriation and historical misreading, emphasising its minimal features – white walls, clean lines and bright spaces

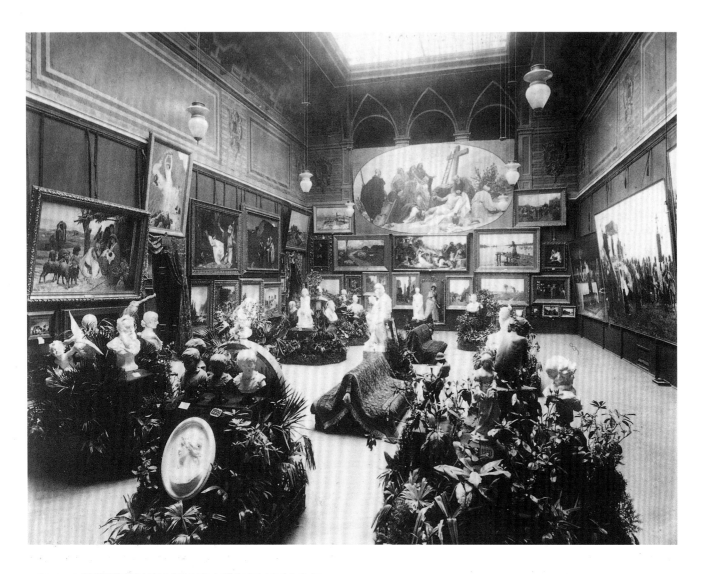

17
Jubilee Exhibition,
Künstlerhaus, Vienna 1888
Kunstverlag Wolfman, Vienna

18
Postcard of the First Secession
Exhibition, Vienna 1898
Private Collection

with works of art presented in splendid isolation – while ignoring its traditional elements.

An Artwork in the Modern Taste': The First Secession Exhibition

The Secession's inaugural exhibition took place in the spring of 1898 (fig.18) in spaces especially designed by Olbrich and Hoffmann with the assistance of a Decoration Committee.[8] The accumulated dust of centuries was blown away by the modern, curvilinear interior architecture and elegantly applied ornamentation. Ludwig Hevesi, one of the principle chroniclers of Vienna art life around 1900, observed: 'The arrangement of the exhibition ... is in itself already a work of art in the modern taste.'[9] 'Modern taste' at this time meant a fully developed Jugendstil (Art Nouveau), which stood in stark contrast to the traditional exhibitions held in historical interiors with their typical material profusion of draperies, furniture, floral arrangements and penchant for triple hanging of artworks on dark walls and in dimly lit spaces, as practiced in the Künstlerhaus (fig.17). As the principle architect, Olbrich faced a particular challenge in 'artistically' transforming the 'the vulgar "Moorish" interiors' of the Horticultural Society where the show was held.[10] The successful makeover of the space owed much to stage design, with a generous wooden arch separating the main exhibition hall, large-scale ornamentation on the walls, and flowing wall hangings regulating the lighting and cleverly obscuring the unfashionable architecture. Olbrich skilfully reversed the association of floral arrangements with old-fashioned displays, creating a visual and metaphorical analogy between the rich flowering of modern ornament (originating in the stylisation of vegetable forms) and the genesis of a new era; the flowers 'especially cultivated and bred in the nursery of the Sophienbad ... bloomed on the day of the opening.'[11]

The key innovation of this exhibition was in the selection of the art shown, above all the introduction of a cross-section of internationally leading painters and sculptors including Arnold Böcklin, Pierre Puvis de Chavannes, Marc-Antoine Charpentier, Walter Crane, Fernand Khnopff (twenty works), Max Liebermann, Constantin Meunier (twenty-nine pastels and bronzes), Alphonse Mucha, Auguste Rodin (fifteen works), John Singer Sargent, Giovanni Segantini (twenty-eight works), Franz von Stuck and James McNeill Whistler (twelve lithographs). The foreign masters were juxtaposed with a selection of Secession artists, including Klimt with six works. Hermann Bahr praised the exhibition in *Ver Sacrum* as absolutely revolutionary for Vienna, 'a miracle' in its range and quality, presenting 'a summary of all of modern painting' and thus fulfilling the organisation committee's declared mission to educate the Austrian artistic community and interested audiences.[12]

The installation of the inaugural exhibition appears to modern eyes still fraught with the old-fashioned vices of historicism: an abundance of overwhelming floral arrangements; chairs, benches and pedestals in a variety of exotic styles; heavy, dark draperies; and a liberal mixing of furniture, sculpture and painting. The hanging, however, mostly avoided the multiple stacking of pictures, concentrating on the most favourable presentation of each single work: 'Each was hung at moderate height so that the old battle for the cimaise [the most favourable position] was avoided. The various works of an artist are united in a group so that his art is presented in an organic context. The wall coverings provide advantageous backgrounds; pictures in pale colours develop their full atmospheric potential in front of pleated white fabrics; walls sprayed in calm dark red or dark green appear lighter than smoothly whitewashed ones ... These are truly modern galleries.'[13] Hoffmann was responsible for the room devoted to the *Ver Sacrum* magazine, which already signalled a more progressive and restrained direction in interior design, juxtaposing slender and filigree cabinets with unadorned walls mostly void of displayed objects. The ambitious exhibition and its sophisticated presentation catapulted the Secession and Vienna to the forefront of the European avant-gardes, introducing not only the leading artists of the time but paving the way for the comprehensive integration of art, architecture and design.

The Secession Building

The foundation of the Secession in 1897 and the opening of its own exhibition building in November 1898 mark a pronounced juncture between the nineteenth and twentieth centuries, between historicism and burgeoning modernism, between the evocation of idyllic Biedermeier life and the realities of the industrial revolution and the bewildering complexities of contemporary urban existence. For Klimt, the year 1897 signified a similar Janus-faced division as he embarked on 'the process of desublimating art by employing pre-classical symbols'.[14] His paintings continue to feature classical goddesses that, however, increasingly abandon their static postures and come alive, assuming the shocking contemporary appearance of ordinary and vulnerable human figures. *Pallas Athene* 1898, presented in the second exhibition of the Secession, which inaugurated the new building, evokes the ancient patron of the arts 'as an obvious Secessionist of today ... as a living Pallas ... of its time, its place, its creator' (fig.45).[15] The Secession building itself was caught in this schism between past and present, evolving from a neo-Baroque palace into a strikingly modern Jugendstil structure with its interior governed by rigorous considerations of functionality and flexibility.

Designed by Olbrich, with considerable simplifying input from Klimt, and with the collaboration of Moser on the decoration and fitting out, the Secession building was erected in a record time of only six months. It was celebrated as a truly modern structure, responding to contemporary needs for simplicity, adaptability and even lighting: 'Here everything is ruled by purpose alone ... This building does not pretend to be a temple nor a palace, but a space which allows works of art to develop to their greatest effect.'[16] The structure's simple '"proto-cubistic" stereometry', with its expanded, unadorned white façade, indeed seems programmatic, announcing a resolute departure from past models by the way of pre-classical architecture (Egyptian and Assyrian sources were mentioned, one critic describing the building as 'the tomb of the Mahdi').[17] The gleaming purity of the architectural mass and stark flat surfaces are mitigated by copious, if formally restrained, ornamental detail (masks, snakes, owls, figurative and floral friezes), and a complex classical iconographic programme culminating in the gleaming laurel crown topping the central tower. Modernity here thinly veils an antique symbolism that locates artistic aspiration in an Arcadian utopia of the classical past, promising elevation through spiritual and physical purification.

Olbrich did indeed think of an ancient temple rather than a modern machine for viewing pictures, a sanctuary, however, devoted to the art of its time as the motto over the entrance emphatically declared: 'To the Age its Art, To Art its Freedom.' The architect emphatically described his lofty ambitions: 'The walls shall be white, shining, sacred and chaste. Solemn

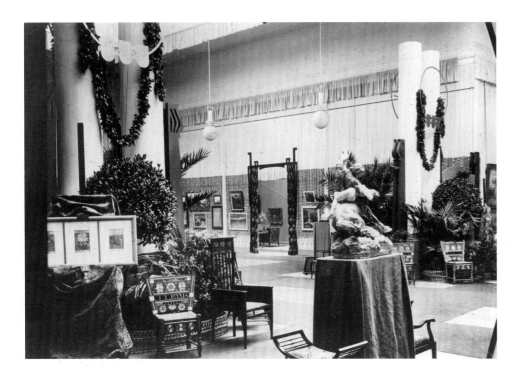

19
*The Main Room of the Second
Secession Exhibition, Vienna* 1898
Secession Archive, Vienna

20
*The Main Room of the Second
Secession Exhibition, Vienna* 1898
as illustrated in *Ver Sacrum*
vol.II, 1899
Albertina, Vienna

dignity shall pervade everything. Pure dignity as it seized me as I stood alone, shuddering, in front of the unfinished temple in Segesta!'[18] Bahr, who had so enthusiastically praised the pure functionality of the galleries, proposed a similarly reflective method of artistic contemplation. Entering the building was described as a process of 'purification of the soul'. After the act of artistic worship, 'before we return to life, we may dwell pensively in the presence of art's sentiments, to contemplate it, to compose ourselves. We would like here to absorb art's afterglow. Then we may be released.'[19] The Secession was to provide a refuge for the modern soul retreating from the pressures of metropolitan life while, at the same time, displaying the creative manifestations of exactly that contemporary hurried spirit the visitor was to escape from:

> It was to be an exhibition building that reminds us that we are children of our time, restless and of great capacity of absorption. We do not love rapid change and easy pleasures because we have become more superficial, but because we are ourselves the manifestation and the product of our lives, the bustling, rushing, scintillating life that surrounds us, the multiple reflections which we seek in art, in order to find a moment's rest and to commune with our own soul.[20]

The modern building and its avant-garde content seem strangely at odds with the method of presentation and the prescribed method of reception. A forward-looking, proto-modernist embrace of utility and order is contrasted with the grandiloquent incantation of earnest dignity, spiritual cleansing and brooding worship of the artist's expressive subjectivity. The installation of the second exhibition seemed similarly caught between two worlds, presenting the art of its time on wall hangings covered in floral ornament, on skilfully draped easels and on pedestals surrounded by an inconsistent assembly of chairs, benches and stools, a true forest of palm and laurel trees, not to mention festive, lyre-shaped garlands wrapped around fake columns. Nevertheless, the display was welcomed as decidedly modern, with paintings 'naturally hanging only at eye level. Any overcrowding has been avoided.'[21] This apparent rupture

between the art and its staging, between avant-garde rhetoric and portentous adherence to classical allegory, significantly seemed to escape the contemporary critics. It is symptomatic for Vienna at a crossroads, praising the machine, the speed of modern life and abstraction, while romantically yearning for a state of refined sensibility and for a unified style in all the arts, manifesting itself in the grand proposition of the Gesamtkunstwerk. It was through the continuous approximation of the art and its presentational context that exhibitions were to be transformed into a truly *Moderne Raumkunst*.

From the Page to the Wall

Over the course of the next decade, the Secession exhibitions would reveal how much Olbrich's building was conceived as a structure *of* the present and for the future, as the installations slowly shed all historical and decorative ballast to reveal progressively simplified and modern presentations. It was in this environment that the total integration of so-called 'free' and applied arts, including music, theatre and literature, into a Gesamtkunstwerk was first exercised, based on the dynamic relationship of an individual work of art to its architectural and decorative context. A rapid cycle of exhibitions in Vienna, but also at world expositions and major international art exhibitions, provided an opportunity for the Secession and Viennese design to demonstrate their leadership. Each exhibition received its unique and elaborate treatment, with Hoffmann and Moser as the leading practitioners of *Moderne Raumkunst*. While Hoffmann's architecture for the Austrian representation at the Paris World Exposition of 1900 was still largely dominated by the elegant and expansive spatial gestures of Jugendstil (fig.31), this had almost disappeared by the end of the year. The genealogy of modern installation techniques has its origins in the innovations of Jugendstil, its excessive, form-dissolving ornament being 'straightened out' and reduced to its structural and functional elements. A more restrained formal language had already been applied in Paris in the galleries reserved for the presentation of paintings and watercolours, concentrating on the architecture's ordering and supportive elements, with a clear preference for right angles and minimal

internal ornamentation. By 1901, plain (though still coloured) backgrounds made their appearance. By 1903, what has been called the 'constructive phase' in Viennese architectural design, with its emphasis on structural elements, the rectilinear organisation of space, flat surfaces and a commitment to material honesty, had become the dominant mode of interior design.

The elegant juxtaposition of empty field and work of art was first exercised in Vienna on the printed page in publications such as *Ver Sacrum*, the critic Ludwig Hevesi admiring 'the mastery with which image and text, blank and full plane has been combined'.[22] Ultimately we can trace the origin to English examples of Arts and Crafts graphic design. Large unadorned areas of white paper communicate as much restraint in design as luxurious abundance, highlighting the graphic motif or illustrated work of art. The exuberance of Jugendstil design was emphasised and simultaneously contained by the stark opposition of the blank page with the highly stylised ornamentalism of floral forms, female figures and flowing veils. In time, these ornaments were to develop into near abstract patterns, abandoning references to their origins in vegetable form, architectural elements and symbolism (fig.21). Graphic and architectural ornament was progressively reduced to a framing role, the blank white plane spreading from its function as background or margin to a central compositional feature as, for example, in Gustav Klimt's poster for the First Secession exhibition in spring 1898. Klimt's design makes the link from the printed page to built architecture, framing the purposeless expanse of white (only featuring the artist's diminutive signature) with a frieze at the top, a supporting caryatid and text panel at the bottom. Klimt's poster clearly mirrors his own early sketch and Olbrich's first plans for the façade of the Secession building, complete with figurative frieze at top and a pair of female figures guarding the entrance to the temple of art. In Olbrich's executed design the female attendants flanking the entrance have disappeared, while the two symmetrical planes of the façade have become even more prominent, protruding over the main structural body of the architecture.[23]

Already in 1898 Hermann Bahr had predicted the logical progression from the so-called *Flächenkunst* (planar or ornamental art) to *Raumkunst*.[24] The same principles of reductive order and strict geometric arrangement were

applied in both two-dimensional and three-dimensional media, inventively integrating, but also containing, ornament as surface decoration. Olbrich's architecture was described poignantly as 'built book decoration', while Hoffmann's *Ver Sacrum* room was called 'a room as a placard'.[25] Equally, each volume of *Ver Sacrum* was said to be carefully 'curated', the publication as a whole conceived as a Gesamtkunstwerk, its editor Alfred Roller writing to Klimt: 'I continue to be of the opinion, that each VS issue is a small, but that the whole VS is a large exhibition.'[26] All of the Secession's public manifestations were subjected to the same rigorous stylistic treatment, not just as decorative, non-essential set design, but as integral elements in an all-compassing aesthetic manifestation that subjected each element to a total impression.

From Horror Pleni to Amor Vacui

Almost completely white and unstructured walls were first introduced by Koloman Moser in his designs for the seventeenth and in particular eighteenth exhibition of the Secession in 1903. The latter was the magnificent Klimt exhibition featuring forty-eight paintings and thirty drawings, the installation constituting an absolute highpoint of the sympathetic integration of painting and architecture (fig.22). Moser created what can be justifiably called a genuine precursor of the modern White Cube, the main gallery space featuring not only high white walls, but also a muslin-covered ceiling providing bright lighting, and a light-coloured floor. Architectural ornament was pushed back completely to the margins of the space, elegantly framing the wall surfaces with a thin linear border in grey and gold that emphasised as much the planar qualities of the wall as the stereometric qualities of the space. The only other architectural ornament was provided by the simple white doors, white Purkersdorfer chairs and white ceiling grids in the smaller galleries. The presentation was as remarkable for its concentrated architectonic framing as for the spacious hanging of the paintings. Moser was praised as an 'incomparable director of art exhibitions', in particular for his 'strict economy of the distribution … if possible with only one picture on a wall and the few works in a room coordinated according to colour harmony. The environment is thus kept as still and discreet as possible.'[27] Featuring delicate golden frames, the portraits of Sonja Knips and of Hermine Gallia were presented isolated on a wall each echoing the format of the painting and thus doubling as an extended spatial surround. The consistent format employed by Klimt, especially for landscapes, was used to create a modular hanging system, which approximated the works themselves to square ornaments on the wall, so typical for the Wiener Werkstätte.

The room of the Wiener Werkstätte at the *Internationale Kunstausstellung* in Mannheim in 1907 (fig.16) further extended the dynamic interrelationship between painting, ornament and design in a complete (though not purpose-built) environment: 'The feeling as if space and picture, space and sculpture were created for each other and were formed in one throw … cannot be more emphasised,' one critic commented.[28] Three major recent paintings by Klimt (*Portrait of Adele Bloch-Bauer I*, *Fritza Riedler* and *The Three Ages of Woman* – figs.7, 8, 207) were framed by sculptures by Georg Minne and reliefs by Richard Luksch, as well as by a row of identically framed Klimt drawings. The black and white pattern of the floor and Hoffmann's simple geometric design of the door surrounds reflect not only the predominant design principles of the Wiener Werkstätte, but also Klimt's increasing use of architecturally structured backgrounds, effectively contrasted

with the dissolution of figure and pictorial space in organic ornamentation, executed in gold and silver, one critic of the Mannheim exhibition labelling his paintings 'themselves decorative art'.[29] Hoffmann never quite relinquished the predominance of architecture in the service of painting as Moser did, believing that painting was to be considered 'only as helper and complement of the architectonic intentions'.[30] However, his exhibition designs ultimately provided the perfect enhancement of his collaborator and close friend's art through a corresponding architectural framework. The strong symmetry and careful integration of the works into the overall design of the space (paintings hung at exactly the same height as the elaborate door frames) generated an atmosphere of cultivated splendour ('snobbism' was a less complimentary description[31]) and almost pious reverence for the paintings put on display in altar-like settings.

The 'amor vacui'[32] of the 1903 Klimt exhibition was to remain an extreme manifestation of reductive gallery presentation, one that Moser himself did not repeat with the same severe resolution. These installations have been defined as Galeriekunst (gallery art) – totally designed exhibitions in which architecture fulfils a powerful yet ultimately subservient role, enhancing the individual easel painting.[33] In the end, they lack the Gesamtkunstwerk's mutual interdependency of art and architectural frame under the aegis of an overall theme as exemplified by the Beethoven exhibition of 1902. Accordingly, painting in this context cannot be classified as *Raumkunst* or 'decorative painting', that is as an equal and integral part of a bigger whole, but remains 'easel painting', following Max Klinger's definition of 1902.[34]

An integrative approach to painting remained the key distinction and focus of the Secession and was the reason for the eventual split of the Klimt Group from the Secession and its *Nur-Maler* (only painters) into a 'a style group and a realistic group. One considers "art" as a unity, as a great decorative continuity of architectonic, pictorial and applied genres; the others have no interest in the subjugation, the harmonisation of the work of art under a totality.'[35] The 1908 *Kunstschau* (fig.23) was intended as a forceful demonstration of the Klimt Group and its progressive avant-garde position,

21
Spread from Ver Sacrum,
vol.IV, 1901
Albertina, Vienna

22
*Eighteenth Secession
Exhibition* 1903
Main hall, interior design
by Koloman Moser
Austrian National Archive,
Vienna

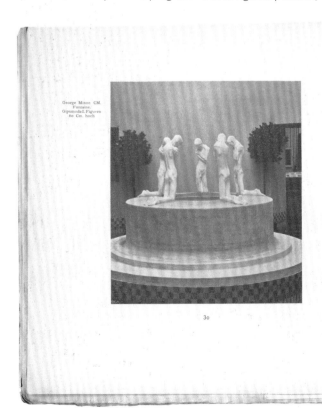

George Minne CM.
Fontaine.
Gipsmodell. Figuren
60 Cm. hoch

Für V. S. gezeichnet
von Kolom. Moser OM.

GEORGE MINNE.

MAN hat merkwürdige Sachen in Wien über die Minne=Ausstellung gelesen und gehört; deprimie=rend merkwürdig, grotesk und leider so roh, als wären wir noch in der Zeit der Kreuzzüge. Wo bleibt der berühmte Fortschritt? Man fährt immer schneller, man hört, man sieht, man lebt immer schneller. Wann wer=den unsere lieben Kritiker etwas schneller oder etwas lang=samer zu denken lernen? Und dass es bei diesem Minne erst des Denkens bedarf, dass selbst einem Kritiker beim Anblick dieser starken Nacktheit nicht etwas wie Er=bauung durch die löschpapierene Seele geht, dass es ihn nicht vor diesem Brunnen auf die Kniee zwingt wie selbst den Gottlosen in einem schönen Tempel = das ist das Merkwürdige. ☺☺☺

30

31

bringing together painting and sculpture with the most distinguished manifestations of decorative arts in a sprawling exhibition complex especially designed by Hoffmann. It attempted to realise environments conducive to the Group's expressed desire for a unified and coherent style penetrating all aspects of life (a so-called Stilkunst), overcoming the separation between the artist and consumer. The contemplation of an artwork was to be an act of creative consumption, as Klimt stated in a rare speech given on occasion of the opening of the *Kunstschau*: 'And we interpret the term "artist" just as widely as the term "work of art". Not only those who create art but also those who appreciate and take pleasure in art are worthy of this name, all those who are able to be capable of feeling and of valuing the artistic creation. In our minds the "art world" is an ideal community of creators and connoisseurs.'[36]

The *Kunstschau* signalled a turning point in the history of Raumkunst. It failed to inspire the same controversy as earlier exhibitions; its decline in popular appeal was in direct relation to the broad acceptance of the achievements of the Secession and the Wiener Werkstätte. The exhibition further contained the germ, as Carl Schorske argued, for 'an explosive reassertion of painting as the medium of instinctual truth', which emerged between the first and second *Kunstschau* in the following year and coincided with the emergence of the Expressionists Kokoschka and Schiele.[37] In the *Kunstschau*, painting and the decorative arts remained largely separated with displays devoted either to fine or to applied art. It was only in the ambitious staging that architecture, painting and ornament came together. Moser's Klimt gallery did not revive the extreme purism of the 1903 presentation but instead

presented Klimt's recent work on white walls with a regular background grid of small squares in addition to elaborate geometric sopraporta ornaments evolving from the artist's stylised monogram. The restrained classicism of the installation creates a supportive decorative background without competing with the works of art, anchoring the paintings in space while powerfully enhancing the *Flächendekor* (two-dimensional décor) of *The Kiss* 1907–8, and recent portraits, including *Portrait of Adele Bloch Bauer I* 1907. In these paintings, the human figure is ensconced in expansive, almost monochrome colour fields, setting cold architectonic order against the 'decorative-ornamental sensuality' and the 'protean element, the ornamental principle in itself'.[38]

The Decline and Fall of the Gesamtkunstwerk

The *Kunstschau* exposed the looming failure of the Gesamtkunstwerk project in turn-of-the-century Vienna in the face of political, economic and social realities. In his review in the *Fackel*, Otto Stoessl blamed the democratisation of taste for the withering of 'the great monumental instincts of art … he yearns for the unification to a political, religious, philosophical total architecture and finds everywhere the chaos of a starving and discordant mass'. Instead of an amalgamated whole of all the arts under a common banner, he detected 'isolation, refinement of all technical means, atomisation of conception', which make 'the synthesis forever rare and challenging'.[39] The Viennese intelligentsia was acutely aware of living through a 'transitional period par excellence', characterised by 'absentmindedness, interior as well as exterior squandering, confusion of ideas, nebulous

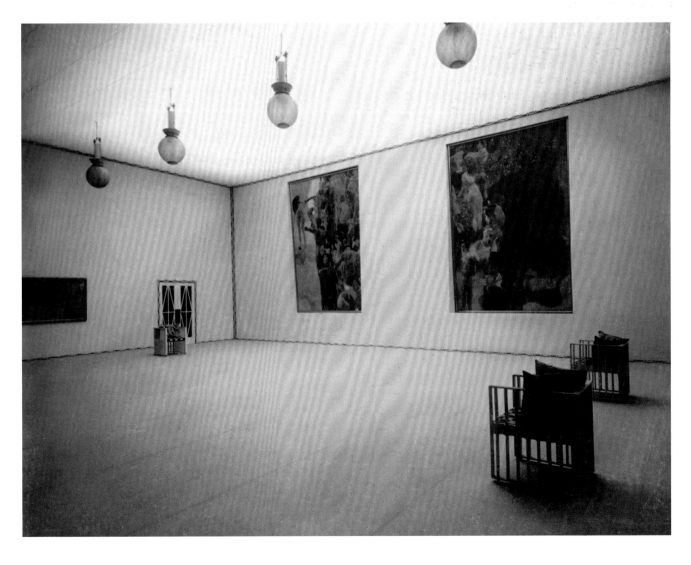

Weltanschauung'.[40] The diversification of manufacturing, acceleration of modern travel and the excitements and pressures of metropolitan life subjected the modern individual to a constant onslaught of sensual stimuli and multiple impressions. Perception itself changed and the primary mode of experiencing the world was one of nervous distraction with the visual senses increasingly prevalent.[41] The modern interior might provide a temporary reprieve from this merciless attack on the senses – a cultivated oasis of order and taste – but seemed to lack a genuine ambition for a truly grand design that was to transcend the perimeters of the designed space, exhibition, building or performance. Significantly, *Raumkunst* was also known as 'interior art', an art focused primarily inward without extending its aesthetic mission to include wider social or political reform.[42]

The grand utopian dream of moral and spiritual renewal through the penetration of every aspect of life by a new and unified style was dangerously close to the aesthete's decline into a state of oversensitive decadence and retreat into the collector's cabinet. While gallery design from the 1920s onwards was driven by an impetus for purification and abstraction in line with the nature of the displayed works of art, the primary purpose of the Wiener Werkstätte and its patrons seems to have been the elevation of the interior and, by extension, its inhabitants, to a state of cultivated aesthetic and spiritual sophistication. The architect's task was to instil in his clients a new 'refinement of perception',[43] overcoming the corrupting influences of the exterior world with its vulgar temptations of cheap commodities, gaudy colours and superficial entertainments in a process of mental and physical cleansing, of 'spiritual hygiene'.[44] In the first decade of the twentieth century, the reversal of the aesthetic codification of wealth and power from historicist opulence (with its

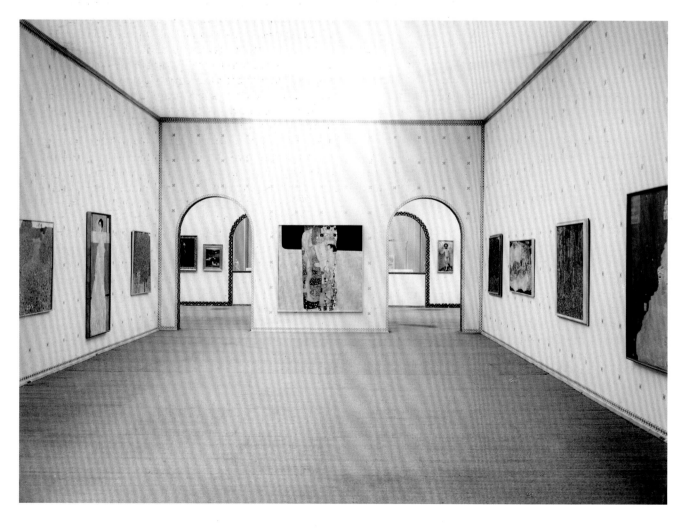

entropic proliferation of objects, surface ornament and material goods – 'harmful and taste-corrupting luxury', one architectural writer castigated it)[45] to empty spaces, reductive design and isolated objects had been successfully concluded. Few of Klimt's and the Wiener Werkstätte's patrons, however, felt inclined to subscribe to Peter Altenberg's equation of formal simplicity with the renunciation of material goods and an ascetic regime of life, the writer demanding: 'May health and purity of body and soul become your only luxury!'[46] The coldness and abstract simplicity of the spaces ultimately felt too uncomfortable for the enlightened Viennese upper classes who supplemented the material and spiritual void through an exalted finesse in taste and use of precious materials as permissible indicators of social status and wealth.

The Aristocracy of Taste

Berta Zuckerkandl appropriately identified Josef Hoffmann as the leading force in the 'aristocratisation of taste, the ennoblement of the world of luxury'.[47] Design no longer communicated a revolutionary simplification and complete integration of the arts, but appeared overburdened with detached sophistication and extravagant elegance, leading to a questioning of the authenticity and relevance of the Secessionist and Wiener Werkstätte interior. Critics detected signs of moral corruption in the luxurious display of exuberant ornamentation on simple backgrounds, Hevesi observing a 'certain waste' in the generous layout of *Ver Sacrum* while Berta Zuckerkandl spoke of the 'royal squandering of space' in Moser's installation of the eighteenth Secession exhibition.[48] Karl Kraus, as always, went furthest in his critique of the Wiener Werkstätte, condemning the Cabaret Fledermaus for its 'furnishings fraud', revealing the very ambiguity inherent in the make believe of elaborate exhibitions and environments.[49] There is indeed a preciousness in the extreme juxtaposition of highly stylised ornaments against the empty, undecorated surface, announcing an advanced state of aesthetic superiority but also revealing a subliminal repression of individuality. The initially cathartic liberation from the weight of material possession and freeing of the body through the reform dress had become supplanted by a proscriptive tyranny of taste.

Architecture and architectural ornament increasingly began to fulfil a regulative function, containing the excesses of decorative painting, drawing and design and the ostentatious displays of precious objects. In this uncompromising configuration of the interior, the life of its residents came to be dominated by a sense of repressive claustrophobia: expressions of personal individuality or even traces of human presence were limited by a strict prescriptive aesthetic, by immovable built-in furniture and by exacting decorative systems in austere geometric and black-and-white systematically structuring walls and spaces. This dictatorship of taste subjected the inhabitant to a form of aesthetic but also social 'slavery', 'in which the resident is kept by the interior architect. Sometimes this coincides with another type of slavery … in which those persons assembled for a social event find themselves held by their host or by their own collective presence.'[50] In this controlled atmosphere, only commodities seemed to develop a life of their own, demanding respect rather than quietly serving, dictating the inhabitant's behaviour like an army of Grandville's animated commodities: 'Cupboards expressed their interior life, chairs asserted their human rights: and the human being had become a functional article used by the furniture. Things were taken over by a liveliness of the desperate kind.'[51] Real life was substituted

with the projection of values, emotions and desires onto tasteful inanimate possessions in sophisticated interiors, providing a comforting autocracy of style that protected the inhabitants from a true awareness of the material conditions of those less fortunate.

The strict ordering of every aspect of space in a rigid compositional order and pervasion of abstract ornament led the distracted individual into an artificially stable environment, creating an escapist 'dream world': 'In particular it is the primitive geometric relationships … which … have proven against the concrete wealth of reality, especially against the hardly elementary-geometric forms of the human body, more a dream than a reality.'[52] This dream world needs to be animated and Klimt introduced an essential element of élan vital into these purist and anaesthetised environments, his 'mosaic painting' entering into a dynamic, mutually enhancing relationship with the architectural setting. Klimt's animated ornament continues the tradition of the regenerative and narcissistic self-involvement of Jugendstil ornament, which 'corrects the inadequacy of reality, in which real life seems to be missing, and fills it with imaginary or dreamed interior spaces'.[53] At the same time, this elemental spirit is kept under control by highly stylised and rigid ornamental composition and geometric architectural backgrounds, Klimt's subjects arrested in motion as much as the individuals confined to their domestic versions of the Gesamtkunstwerk.

Hoffmann and Moser in particular provided the perfect environments for Klimt's orphic codification and allegorical reinterpretation of universal love and primal sexual energy, elevating his 'ornamentalisation of the body' into something 'sacral-elevated'.[54] The erotically charged and excessive ornamentation of the female body in Klimt's paintings is accentuated and powerfully enhanced (while, at the same time, also always contained) by the pale backgrounds, restrained colour schemes and strict modular ordering of space in the Wiener Werkstätte interiors. Liberated from distraction, attention can be directed to the few objects of visual stimulation and colour present, allowing the intense engagement with art in harmonious union with architecture and design that Klimt had advocated in his 1908 *Kunstschau* speech. Creative consumption is enhanced by the juxtaposition of aesthetically opposing and stylistically diverging elements, setting the rapture of the Dionysic forces of life against the restraining influence of rationality, hygiene and order: organic ornament in painting is productively contrasted with essential form as manifested in 'abstract' architectural form and decoration[55]; domesticity and its association with the female is suppressed through a strict implementation of an institutional aesthetic in the private sphere; and the endemic spread of the generational disease of nervousness is cured through the deprivation of perceptual and sensual stimuli. Klimt provides a counterpoint and release for forbidden sensual pleasures and transgressive sexual fantasies enhanced by the psychopathological dynamic between (male) rational abstraction and candid displays of (female) sensuality. Aesthetic gratification now was produced not through an indulgence in formal exuberance and material excess but operated through the powerful tool of withholding the pleasures of colour, touch, surface decoration and material possession. An erotic play of accentuation and restraint, excess and discipline, exaltation and control is played out in contrasting aesthetically restrained form and material opulence of ultimate refinement with Klimt's explicit visualisations of female erotomania and hysterical intemperance in his Nietzschean scenarios of the cycle of birth, degeneration, death and rebirth.

24
*Poster for the Second Issue
of Adolf Loos's Journal*
Das Andere, Vienna 1903
15.1 × 30.3

DAS ANDERE

EIN BLATT ZUR EINFUEHRUNG
ABENDLAENDISCHER KULTUR
IN OESTERREICH : GESCHRIEBEN
VON ADOLF LOOS I. JAHR

Nr. 2 ENTHÄLT UNTER ANDEREM:

**ÜBER DEN GEBRAUCH DES
KLOSETTPAPIERS**

MODERN ODER SEZESSIONISTISCH?

ABENDLÄNDISCHE RESTE IN WIEN

GESCHLECHTSVERKEHR
ODER MASTURBATION
: ASYL FEUERSTEIN :

TRISTAN und ISOLDE

VENEDIG IN WIEN —
EIN FAMILIENPLATZ?

BRIEFKASTEN FÜR

FORM
KLEIDUNG
WOHNUNG

IN ALLEN TRAFIKEN 20 h

Wilhelm Fischers Buchdruckerei, Wien, IX.

Sex, Lies and Decoration

Adolf Loos and Gustav Klimt

Beatriz Colomina

I.

Adolf Loos is the only architect of his generation whose thinking is still influential today. In this he may have fulfilled his own prophecy that his work would last longer than that of his contemporaries because it would be passed on by word of mouth rather than by photographs in architectural journals.[1] Loos was a humorous, mordant and prolific writer whose theories were organised by a radical opposition to the Viennese Secession and the Wiener Werkstätte (fig.24). The essence of what he said over three decades of polemical arguments in leading newspapers and journals, public lectures and manifestoes is that art did not have anything to do with the everyday utilitarian object: 'Everything that serves a purpose,' Loos wrote, 'should be excluded from the realms of art.'[2] The practice of artists and architects of his time of designing everyday objects was illegitimate. Those objects were already being designed by craftsman, who perfected them over time in an anonymous, continuous, collective process of design. The 'objet type' of le Corbusier, the 'objet trouvé' of the Surrealists, Duchamp's 'readymade', the 'as found' of Alison and Peter Smithson, and so on, are anticipated in Loos's appreciation of the generic wine glass, the American bathtub, the Thonet chair, and the English raincoat.

> When, after an absence of three years (in America), I appeared in Vienna in the year 1896 and saw my colleagues again, I had to rub my eyes: all the architects were dressed like 'artists'. Not like other people, but – from an American point of view – like buffoons … People laughed, but the government, which was advised by journalists, made all of them Doctors and Professors. I was in favour of the old Viennese carpentry, tradition and quality – their work was like their clothing. I was left out of their circle. I was no artist, as was demonstrated by my clothing.[3]

Loos may have had in mind Gustav Klimt, who went around dressed in a long artist's smock even when he wasn't painting. In the group photograph of the Secession members taken in their building in 1902, Klimt is the only one wearing a robe (fig.25). He was the 'undisputed leader' of the Secession and yet for all Loos's continuous and virulent attacks on that institution and what it represented, the figure of Klimt remains surprisingly untouched. Loos never criticised Klimt by name, as he did with Josef Hoffmann, Joseph Maria Olbrich and Koloman Moser. On the contrary, during the controversy over Klimt's University paintings (1897–1905),[4] Loos came to his defence: 'With the Klimt affair we saw a band of professors ally themselves with the haranguers from Naschmarkt whose motto was "Down with individuality."'[5] Loos, the great defender of anonymous form, sided with the unique individual.

Why this unexpected solidarity with Klimt? Why was the leader of the Secession exempt from Loos's usual devastating critique? Why protect the very figure that most exemplified the tendencies he so famously denounced? Why, throughout all of Loos's extensively published writings, are there no references to Klimt, the most renowned and controversial artist of his day? Why would Klimt's extraordinarily rich and intricate layering of color, pattern and symbolism not offend the formulation that ornament is a crime because it is not of our time? The architect, so proud of his muted Goldman and Salatsch suit and the austere exterior of his buildings, stands unusually silent before the flamboyant, loud, overly sexualised, technicolour artist in a smock.

Klimt is also one of the rare subjects about which Loos was not in agreement with the critic Karl Kraus, his great friend and ally in the campaign against the Secession. Kraus had repeatedly criticised Klimt in the pages of *Die Fackel*, holding him up to scorn: 'Now the same gentleman [Hermann Bahr] proclaims that a picture by Klimt in the Secession (the "Schubert") is simply the best picture ever painted by an Austrian. Well, the picture is really not bad at all. And the good Herr von Dumba, who in his old age has had his living room decorated by the Secession, only needs to hang it in a dark corner.' About one of the University paintings, Kraus wrote that Klimt, 'who had already painted over the pale cast of his thought with luminous colours, wanted to paint "Jurisprudence" and [instead] symbolised criminal law.'[6]

What was at stake in this argument was two rival ways of rejecting pseudo-historical styles, two modernities. Kraus accused the Secessionists of a 'false modernity', of 'fighting the wrong antiquarianism for the propagation of an inauthentic modernity'[7]:

> A dramatic revolution has occurred in Viennese artistic taste: the salons of our wealthiest men are no longer furnished by Sandor Jaray, but by Olbrich or Hoffmann; and instead of the youngest Ninetta by Blass or the oldest invalid by Friedlander, they are adorned with the newest creations of Klimt and Engelhardt. What does this mean? Simply that those gentlemen who today are rich and tomorrow might be poor always take care to buy commodities that are as marketable as possible whenever they invest a part of their fortune in art.[8]

The Secession group, which had split from the art establishment (the Künstlerhaus) on the grounds that art should not be ruled by the market ('the Künstlerhaus is a mere market hall, a bazaar – let the traders set their wares there'[9]) was now criticised in precisely those terms – the market of the art fair replaced by that of interior decoration. As with Loos, Kraus's critique of the Secession is bound up with a critique of the new Viennese bourgeoisie, the 'Poor Rich Man' of Loos's famous story, who had commissioned a house from a Secessionist and was afraid to go from room to room because the clothes designed for one room were not appropriate for the next.[10] Everything down to his slippers was

designed by the architect and could only be used in the designated room. As Karl Kraus put it: 'They have the dirt off the streets in their homes, and even that is by Hoffmann.'[11]

II.

The clients and supporters of the Secession and the Wiener Werkstätte were primarily young, progressive and Jewish, and the critique of the Secession is bound up in racial stereotypes if not in anti-Semitism. Karl Kraus, born to a prominent Jewish family, had renounced Judaism in 1899 – the same year that he started the magazine *Die Fackel*[12] – reported that the great success of the Viennese Secession at the 1900 World Exhibition was due to the fact that Parisians had called the style 'un goût juif' (a Jewish taste).[13] This is also how Hermann Bahr described the reception of Klimt's *Philosophy* (1900), one of the polemical University ceiling paintings.[14] In a number of texts that were excluded or edited from Loos's volumes of writings (*Ins Leere Gesprochen* [Spoken into the Void], 1921, and *Trotzdem* ['Nevertheless'], 1931), he explicitly associates the Secession with the Jewish bourgeoisie, even arguing that the new ornate gilded interiors constituted a new 'ghetto'. In an article entitled 'The Emancipation of Judaism', Loos writes that the interiors of Hoffmann and Olbrich 'betray' their owners as much as their new names do: 'Surely there must be Moritz and Siegfried who are Aryans, just as there are Aryan owners of interiors by Hoffmann. They are exceptions.'[15] Having abandoned their caftans sometime ago, Loos argued, they end up wearing a new one. The Secessionist interiors are 'no more than masked caftans'. Loos, like Kraus, was in favour of the assimilation of Jews and saw it as a key symptom of modernity. 'Every sympathiser of the emancipation of Judaism, every person hostile to the ghetto, therefore every person favourable to our culture, must suffer seeing how the Jews create a new ghetto for themselves.'[16] Most of Loos's clients, his collaborators, his students and his friends were Jewish intellectuals, and two of his wives were also Jewish.[17] In place of the pseudo-modern caftan of the Secession interior, Loos offered with his architecture an alternative form of clothing to his clients – an English raincoat.

Loos's critique of the Secession and Wiener Werkstätte was also gender loaded. His association of ornament with femininity and Jewish ambition remains unexplored, perhaps because of the reverence that Loos stills inspires in architects, but it clearly organises his polemics. In a lecture delivered by Loos in Vienna in the Spring of 1927, 'Das Wiener Weh (Die Wiener Werkstätte): Eine Erledigung' ('The Viennese Woe [The Wiener Werkstätte]: A Settlement of Accounts'), Loos criticised the Austrian Pavilion at the Paris exhibition of 1925, which had been designed by Josef Hoffmann and filled with Wiener Werkstätte objects, in these terms:

> I warn Austrians against identifying themselves with the Wiener Werkstätte movement. The modern spirit is a social spirit, and modern objects exist not just for the benefit of the upper crust but for everybody ... To bring us first-rate work no architects are needed, no arts and crafts students and no painting, embroidering, potting, precious-material-wasting daughters of senior civil servants and other *Fräuleins*, who regard handicrafts as something whereby one may earn pin-money or while away one's spare time until one can walk down the aisle.[18]

Loos's attacks on 'daughters of senior civil servants and other *Fräuleins*' were not without foundation, as Werner J. Schweiger has pointed out:

25
Members of the Vienna Secession inside the Secession Building 1902
Österreichische Nationalbibliothek – Bildarchiv, Vienna

From left to right: Anton Stark, Gustav Klimt (in armchair), Kolomon Moser (in front of Klimt, with hat), Adolf Böhm, Maximilian Lenz (reclining), Ernst Stöhr (with hat), Wilhelm List, Emil Orlik (seated), Maximilian Kurzweil (with cap), Leopold Stolba, Carl Moll (reclining), Rudolph Bacher

The WW had been numerically dominated by women even since the initiation of the workshops in 1913, and after the deaths of Dagobert Peche in 1923 and his successor Julius Zimpel in 1925, there were practically only women left as designers, except for Hoffmann and Max Snischek. Ten out of the thirteen members exhibiting in Paris were women.[19]

Loos was warning Austrians against identifying themselves with women's work, with the effeminised world of interior decoration. The figure of modernity for Loos, as for most writers of modernity, was emphatically male.[20] Women and children were primitive, ignoble savages, as distinct from the heroic figure of modern man as primitive noble savages. The heroic male figure – energetic, cool and detached – was the figure of architectural modernity. Architectural order here, the control of the senses, was first and foremost social control.

For Loos, 'the lack of ornament is a sign of intellectual power'.[21] 'The *Critique of Pure Reason* could not have been created by a man wearing five ostrich feathers on his hat, the *Ninth Symphony* did not spring from one wearing a ring around his neck the size of a dish.'[22] But this intellectual power, which is presented here as above the 'brutalities' of the 'savage', seems in other passages to be an exclusively male attribute, as when Loos writes: 'Ornament at the service of woman will last forever … The ornament of woman … answers, at bottom, that of the savage; it has an erotic meaning.'[23] The ornament, which for 'the child, the Papuan and the woman' is a 'natural phenomenon', for modern man is a 'symptom of degeneration':

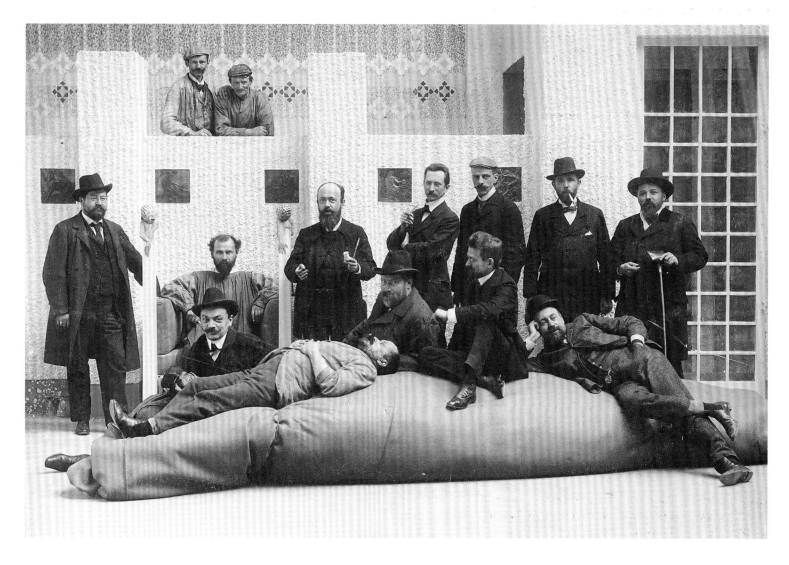

The first ornament that came into being, the cross, had an erotic origin. The first work of art ... was in order to rid himself of his natural excesses. A horizontal line: the reclining woman. A vertical line: the man who penetrates her. The man who created it felt the same urge as Beethoven ... But the man of our time who daubs the walls with erotic symbols to satisfy an inner urge is a criminal or a degenerate.[24]

And when this 'degeneration' of the masculine into the feminine becomes associated with homosexuality, Loos's raid against ornament is not only gender-loaded but openly homophobic. The main target of Loos's attack becomes the effeminate architect, the Secessionist and Wiener Werkstätte figure of the 'decorator', Joseph Maria Olbrich, Koloman Moser, Josef Hoffmann: all these 'dilettanti', 'fops' and 'suburban dandies' who buy their 'pre-tied ties in the women's fashion displays'.[25]

More than any other member of the Secession, Klimt created a cult of the feminine, and was the favourite artist of the Jewish bourgeoisie. Most of his clients were women and he produced increasingly eroticised images in which women, clothing, ornament and walls became fused together in symbolic narratives – images often literally filled with gold as if the very emblem of Loos's target. Yet Klimt is absent from Loos's critique. Perhaps Loos's position was similar to that of his close friend, the poet Peter Altenberg, who wrote: 'Gustav Klimt, you are at once a painter of vision and a modern philosopher, an altogether modern poet. As you paint, you suddenly transform yourself, fairy-tale-like, into the most modern man, which perhaps you are not in daily life.'[26] Separating the personal from the public, Klimt becomes a 'modern man' through his art. But what is it that makes Klimt modern despite his embrace of the very things that hide modernity for Loos? Not eroticism as such, since for Loos 'all art is erotic', as he wrote in 'Ornament and Crime'. Rather the question is the relationship between this sensuality and the design of objects of everyday use, including buildings. In the end, it is the line between art and architecture that Loos wants to draw, and as long as Klimt remains on the side of art, he can be exempt from criticism. As Loos wrote:

The work of art is the private affair of the artist. The house is not ... The work of art is answerable to no one; the house, to everyone. The work of art wants to shake people out of their complacency. The house must serve comfort. The artwork is revolutionary, the house conservative.[27]

III

The clues to Klimt's unique status for Loos can perhaps only be found in what he says about the figures he denounces the most. Loos's real enemy is not Olbrich, as it is commonly believed, or even the Secession itself, but Hoffmann, Klimt's closest friend and collaborator. This did not escape his contemporaries. As Richard Neutra wrote: 'Hoffmann was the professor whom Loos demolished in my eyes, or had tried to demolish in the eyes of his generation.'[28]

The intensity and lifelong repetition of Loos's attacks on Hoffmann seem to be driven by the fact that they began so close. Loos and Hoffmann were both born in the same year, 1870, only five days apart, and in the same place, Moravia, then part of the Austro-Hungarian Empire, and after the war to become part of Czechoslovakia. They attended secondary school (Gymnasium) at Iglau (Jihlava) together, where they were friends and where Hoffmann failed the

fifth year twice, resulting in a 'feeling of inferiority that never left me'.[29] Hoffmann was later able to enrol in the State Technical School at Brünn (Brno) in 1887 (a school that Loos also attended from 1888 to 1889), where he distinguished himself but nevertheless felt that 'he was not taken seriously because of his failure at the Gymnasium'.[30] Hoffmann went on to study at the Academy of Fine Arts with Carl von Hasenauer and Otto Wagner, and won the Roman Prize, allowing him to spend a year in Rome. Loos, who was not a very good student either, went on as auditor to the Technische Hochschule of Dresden (Dresden College of Technology), was in the military and then travelled to America for three years between 1893 and 1896, coinciding with the Chicago Exhibition. Both ended up in Vienna around 1896.

Loos had been initially sympathetic to the Secession, agreeing with their revolt against the use of historical styles and with their support for the architecture of Otto Wagner. He even contributed to the Secession journal *Ver Sacrum*, where he published 'Potemkin City', his famous critique of the buildings on the Ringstrasse.[31] He was also on good terms with Hoffmann, writing somewhat positively of his work[32] and even commissioning him to do the illustrations for his two articles in *Ver Sacrum* ('Die Potemkin'sche Stadt' and 'Unsere Jungen Architeckten').[33] He only broke with Hoffmann when the latter prevented him from doing the interiors for the 'Ver Sacrum-Zimmer', the small meeting room in the Secession building.[34] Loos wrote about this rejection in 1913: 'Fifteen years ago, I approached Josef Hoffmann to ask that I be allowed to design the conference room of the Secession building, a room which anyway the public would never see and on which only a few hundred Kronen were to be spent. I was turned down flat.'[35] From that moment on a life-long battle was launched, an asymmetrical conflict in which Loos never tired of accusing Hoffmann, but Hoffmann never responded in kind. On the contrary, he praised Loos's Kärntner bar as a 'jewel'[36] and, as if to make up, invited him to partici- pate in the Austrian Pavilion at the Paris exhibition of 1925, the very exhibition that Loos later savagely criticised. Loos, who was then living in Paris, declined the invitation on the grounds that 'he never wished to have anything to do with Vienna and Austria again'.[37] Loos was invited to, and attended, Secession openings (apparently even giving advice to custom- ers on what to buy), and was even offered the opportunity to exhibit his work there, which he declined: 'They have asked me to exhibit in the Secession. I shall do so when the dealers have been driven from the temple. The dealers? No, those who prostitute art.'[38]

Despite this animosity, the different attitudes that Loos and Hoffmann reveal in their architecture can be understood as different ways of negotiating the same dilemma: the modern split between private and public, the difference in the metropolis between the space of the intimate and the space of the social. Both Loos and Hoffmann recognised that being in society involves a kind of schizophrenia between one's private and public self. Both responded to this estrange- ment by understanding architecture as primarily a social mechanism, like dress or manners, a way of negotiating social situations. Hoffmann confronted the split in the modern individual between his private and public being in a different way to Loos. For him the house was to be intentionally designed to be in harmony with the 'character' of its inhabit- ants. There is nothing as personal as character. But the client could not add objects to the house on his own account, nor could he hire another artist to do so for him,[39] as if one only had one character for an entire life! This was the object of Loos's criticism. Loos believed that the house grows

with one, and that everything that goes on inside it is the business of its inhabitants.[40] This same point, on the other hand, was to be a reason for praise on the part of Peter Behrens. For Behrens, the house was a work of art. He added that Hoffmann's houses acquire meaning in social life,[41] and this remark clarifies any possible misunderstandings about the character with which the house was to be in harmony. Hoffmann was speaking about a social character. The individual cannot leave his traces on his own house because the house is in accordance with that part of his character that does not belong to him privately: the forms of social convention.

When Loos wrote, 'The house does not have to say anything to the exterior; instead, all its richness must be manifest in the interior,'[42] he had recognised a limit to architecture in the metropolis, the difference between *dwelling* in the interior and *dealing* with the exterior, but at the same time he had formulated the very need for this limit, which has implicit in itself the need for a mask. The interior does not have to say anything to the exterior (figs.26, 27). This mask is not, naturally, the same as the one which he had identified as being fake in the façades of the Ringstrasse, the face of equivocal, fictitious language, which implied that nobility was living behind the walls, whereas in reality the inhabitants were deracinated upstarts.[43] To be uprooted, Loos believed, was nothing to be ashamed of; it was part of the modern condition. The silence he prescribed was no more than the recognition of schizophrenia in metropolitan life: the inside has nothing to say to the outside because our intimate being has split from our social being. We are divided between what we think and what we say and do.

The house's silence vis-à-vis the outside represents the impossibility of communication; but it is also this very silence that protects its incommunicable intimacy. At this moment, silence is also its mask. It is a Simmelian mask. The mask, Georg Simmel writes in his essay 'Fashion', allows the interior to be intimate. 'Over an old Flemish house there stands the mystical inscription: "There is more within me."'[44] It is precisely in Simmel's terms that Loos speaks about fashion:

> The person who runs around in a velvet suit is no artist but a buffoon or merely a decorator. We have become more refined, more subtle. Primitive men had to differentiate themselves by the use of various colours, modern man needs his clothes as a mask. His individuality is so strong that he cannot express it any longer through his clothing. The lack of ornament is a sign of intellectual power. Modern man uses the ornament of past and foreign cultures at his discretion. He concentrates his own power of invention on other things.[45]

Where is 'he' who has assumed the condition of the modern to find an identity? This was Loos's question. No longer protected by the fixed and the permanent, by the things that speak, modern man now finds himself surrounded by objects without meaning. In no way, Loos said, can he make use of these things, force them to speak an invented language, or to construct a false pedigree, precisely what he was accusing the artists of the Secession and the Wiener Werkstätte of attempting. The modern, like the artist and the primitive, can only restore an order in the universe and find a place in it by reaching within himself and his own creation. But the modern, like the primitive, needs a mask to make this possible.

Modernity implies a return to the function of the mask. But as Hubert Damisch has noted, whereas in primitive societies the mask gave social identity to its bearer, modern man uses the mask to conceal any difference, to protect his identity.[46] Kraus did not exclude the artist from that predicament: 'No doubt, the artist is other. But precisely for that reason in the exterior it has to comply. It cannot live alone if it does not disappear in the crowd ... The more the artist is other, the more necessary it becomes that he uses common clothing as mask.'[47] For Loos, every member of the crowd has to comply on the surface by masking his interiority, his sexuality, but also his creativity, his 'power of invention'. Everyone is a new 'primitive', everyone has to wear a mask, a modern mask, a form of protection, a cancelling of differences on the outside, precisely to make identity possible, and this identity is now individual rather than social. The mask constructs the private.

IV.
Paradoxically, Loos's architecture of the mask was conceived from inside out, while Hoffmann's architecture of personality was conceived from outside in. Sigfried Giedion, always so perceptive, said laconically of Hoffmann's Palais Stoclet that 'the flat surfaces of this banker's home are made up of white marble slabs, but they are treated like framed pictures'.[48]

The most notable thing about this house when one looks at it in photographs is the moment of doubt as to whether what one is seeing is a built thing or a model. It has no weight; it floats; it lacks corporeal existence; it is a box, walls surrounding space, not an empty hole dug out of building material. There is nothing – to use a concept of that moment – 'sculptural' about it (fig.27).[49]

The confusion with the cardboard model is not only to do with a conception of space. With this house, something occurs that is similar to what happens with those cutouts that are used to make paper architecture: more important than whether a wall is internal or external, than whether a surface corresponds to the roof or to the kitchen floor, than the differences in the materials covering those surfaces, more important than whether an element is supporting or supported, are the contiguities between those cutouts. One can understand this very clearly when they are still on the paper, before having been cut out. Everything is related to what is adjacent, as in a line of writing where a word relates to the one following it. Everything appears to be sewn, just like a treacherous narrative that links the most disparate things, and which in the cutouts is represented by a seam of black dots marking the line where the paper is folded.

In the Palais Stoclet, the 'narrative' is the metallic cable moulding that tirelessly follows the border of every plane it recognises, indifferent to whether it is ascending along an edge or turning a corner (therefore sewing together two right-angled planes); whether it is crowning a façade as a sort of cornice engaging en route every single window it encounters; windows which are in turn also framed by this banding; whether this ubiquitous cable surrounds the well of the staircase and in so doing stitches up the superimposed plans like a pocket sewn to a jacket; or, alternatively, it descends until it recovers a horizontal datum, thereby implying the suggestion of a plinth. All this suggests another game: how can one form such a figure without ever taking the pencil off the paper?

In the Stoclet interior 'a whisper made itself felt'. Peter Behrens remarked that it was the hall that impressed him most, that it made him feel 'as though one must not speak too loudly within its walls. Here, notwithstanding the diversity of their origin, a thousand lines, forms and colours were combined to form a uniform whole.' Here again the same banding goes up and down piers, dividing the balcony into compartments and making it look as if it were not a balcony

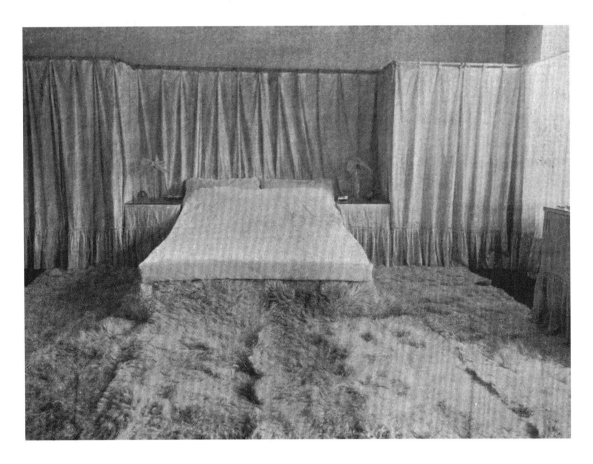

but slabs hovering between the piers.[50] The same rhetoric appears in the hanging lamp and in the carpeting of the floor with square tiles, which, even more than indicating the way one should move, ends up giving the impression that it is not oneself who is moving but that which is underneath one's feet. Nothing is left to be itself. Furniture is made to take on the same quality as the spaces themselves; there is nothing 'sculptural' about it, nothing that reveals any contrast between the space and its occupant. For Hoffmann, space and furniture are part of the same whole. They are its inhabitants. One is one's mask.

The walls of the Palais Stoclet are like Giedion's 'framed pictures', they are flat surfaces, independent in the sense that their 'frames' delimit them as elements. But since in these walls the frame coincides with the edges that delimit them as planes, differentiating them from adjacent planes, they are at once independent and yet linked to those that are contiguous with them. The same moulding, the same metal band that gives them their existence by framing, also links them to adjacent surfaces thereby forming a three-dimensional object, a box.

All this creates a tension at the edges of the box, and in so doing, weakens the whole and produces in the observer the impression that the walls could well unfold, losing the condition of stability which had been guaranteed to them by the cube that they formed; a premonition of unfolding by which they would recover their original condition as cutouts. (The same impression is given by one of Hoffmann's chairs; namely that it has been designed without taking the pencil off the paper.) On the very same plane or sheet of paper are now to be found at once wall, roof and floor plans. Each one corresponds to its opposite on the paper. Across from the interior is the exterior. It is a notion of space that is in accordance with the universe of technics – railways, photography, electricity, reinforced concrete. It is a space that neither closes nor opens, but establishes relations between points and directions.

Klimt designed a mosaic frieze for the dining room of the Palais Stoclet. It was made in gold and silver with enamel, coral and semi-precious stones, and runs the whole length of the room from the sideboards right up to the ceiling.[51] The frieze is set right into the walls in such a way that it becomes one with Hoffmann's white marble walls. The planar, two-dimensional nature of Klimt's work is in consonance with Hoffmann's planar architecture. As Hoffmann does with his walls, Klimt frames his images with carefully drawn geometrical limits, which act as a kind of architecture. The line between painting and architecture moves into the painting itself, the architecture turning into painting and the painting into architecture. When Klimt's frame coincides with Hoffmann's, the painting completely takes over the space, defining it, shaping it in the same way that Gottfried Semper argues the decorative weave of hanging tapestries defines space.

Loos was influenced by Semper's theories from his year in the Dresden Technische Hochschule, where Semper had been a professor between 1834 and 1849, and remained a strong voice. In 'The Principle of Cladding' (1898), Loos's most Semperian text, he wrote:

> The architect's general task is to provide a warm and liveable space. Carpets are warm and liveable. He decides for this reason to spread one carpet on the floor and to hang up four to form the four walls. But you cannot build a house out of carpets. Both the carpet on the floor and the tapestry on the wall require a structural frame to hold them in the correct place. To invent this frame is the architect's second task.[52]

For Loos, architecture was a form of covering. But it is not simply the walls that are covered. Structure plays a secondary role, and its primary function is to hold the covering in place. In those terms, Klimt's friezes are a form of architecture. In the end, Klimt is as much the architect of the Palais Stoclet as Hoffmann. His work is an integral part of the design.

26
Adolf Loos
Lina Loos Bedroom
Österreichische Nationalbibliothek –
Bildarchiv, Vienna

27
Josef Hoffmann
Palais Stoclet, Brussels c.1911
Österreichische Nationalbibliothek –
Bildarchiv, Vienna

In fact, Klimt had begun his career as a successful architectural decorator in the Ringstrasse. Even before he left the School of Applied Arts in Vienna (Kunstgewerberschule), where he had studied since he was fourteen years old, he started a workshop called the Künstler-Compagnie, with his brother Ernst and another student from the school, Franz Matsch, which was very successful in obtaining commissions for the decoration of public buildings. Among other things, the team completed the decorations of the Burgtheater (imperial Court Theatre, 1886–8) and the staircase of the Art History Museum (1890–1).[53] On becoming the leader of the Secession, Klimt drew some architectural sketches of the new building (fig.28). While Olbrich ultimately designed the building, Klimt's sketches were clearly influential. It was apparently his idea to have a blank façade without openings, rather than the columns that Olbrich's sketches proposed, and to have the entrance centred and elevated from the street level by a set of steps. Klimt's sketches precisely demarcate the proportions and entrance of a possible temple of the arts. As the President of the Secession, Klimt countersigned all of Olbrich's plans, sections and elevations for the new building. It could be argued that Klimt's most significant architectural works, the University paintings, the Beethoven frieze and the Stoclet frieze, never left behind the logic of architectural decoration he had employed early on at the Ringstrasse. At the Secession, Klimt tended to associate himself less with the other painters than with the architects Hoffmann

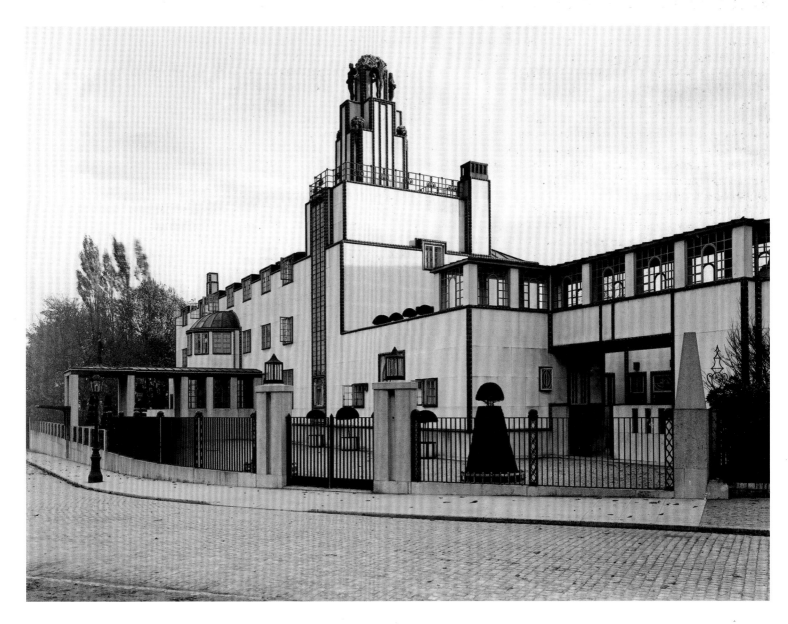

and Moser.[54] He engaged in multiple collaborations with those architects removing, as he had already done in the Ringstrasse, the line between art and architecture.

Loos therefore could not exempt Klimt from criticism simply because he was an artist, rather than an architect. Klimt operated as an architect in the very Semperian sense that Loos embraced in his own work. Furthermore, Klimt committed all the crimes Loos indicts in Hoffmann: he designed catalogues and posters for the Secession exhibitions, covers for *Ver Sacrum* (fig.35), applied wall decorations and even created dresses and textile designs for Emilie Flöge and the fashion house Schwestern Flöge (Flöge Sisters) (figs.89–91). Loos's silence about Klimt seems louder than ever.

In fact, Loos and Klimt may have identified with each other. They both were the target of virulent and moralising critiques. Klimt was portrayed by the Viennese press as a pornographer, flaunting public lewdness, particularly with regard to the paintings for the university, where, symptomatically, Loos came to his side. Loos's work was also the subject of a prolonged and heated controversy during the construction of his Goldman & Salatsch building in the Michaelerplatz (1901–11), involving municipal councillors and newspapers such as the *Neue Freie Presse*, the *Extrablatt* and the *Kikeriki*, on the one hand, and Karl Kraus, Otto Wagner and Paul Engelmann, on the other. [55] It was precisely in this context that Loos had conveniently invoked the memory of the Klimt University paintings scandal, comparing it to the one then exploding around the Looshaus in the Michaelerplatz. Loos's persona was also questioned. In the 1920s there were already a number of articles in the Viennese press attacking his moral character.[56]

Both Loos and Klimt had complicated private lives that became public scandals. Klimt, who lived with his mother and two sisters all his life and had a long Platonic relationship with his partner Emilie Flöge was, at his death, facing fourteen paternity suits from the women he had used as models. Loos spent four months in prison accused

of pederasty, having had a succession of child-like wives and other affairs with women who never seemed young enough. [57] He shared this interest with his friend Peter Altenberg (also suspected of child molestation), who used the term Kind-Mädchen (child-girl) to described the women they were attracted to.[58] As Loos's ex-wife Elsie Altmann-Loos put it:

> I have always been a woman-child and this is what Loos loved in me. But all of a sudden, he finds that I don't have sex appeal, and moreover, that my legs are too short. If I had longer legs, he said, it would change my life. So Loos decided to take me to a surgeon who would break my two legs and elongate them.[59]

Loos's public moralism denouncing ornament as a savage perversion is perhaps a pathological symptom of what it attacks, a disguise, a displacement. Loos could never object to Klimt's overt sexual intensity. Rather, he effectively credits Hoffmann's abstract black and white patterns with sexual degeneracy by making Hoffman his emblem of Secessionist crime.

In the end, Loos's silence about Klimt, like the silence he advocated for modern identity, remains a mask, perhaps disguising feelings stronger than those he felt towards Hoffmann. There is no reason to think that Loos had any strong negative feelings about the person he continually attacked. Like a school bully, he simply sensed weakness and used it strategically to promote his arguments. The consequence of Kraus's and Loos's position was precisely that public statements don't reveal personal feelings. On the contrary, they hide them. Hoffmann was just a convenient prop to make an argument that remains surprisingly influential today.

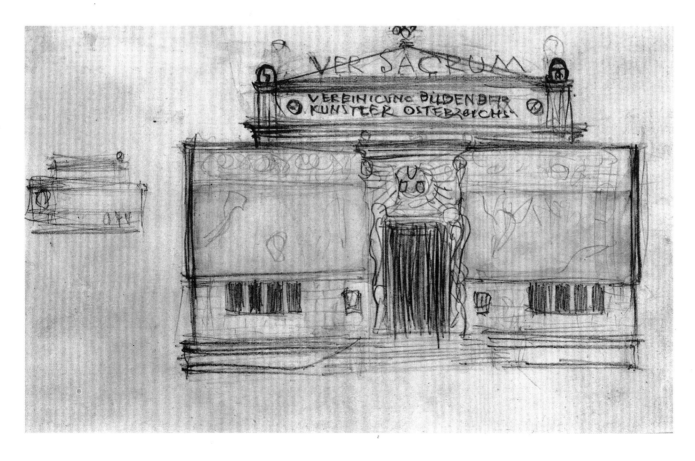

28
Gustav Klimt
Design for the Secession Building
1897
Crayon and watercolour
on paper, 11.2 × 17.7
Wien Museum, Vienna

29
Adolf Loos
House Horner, view from the Garden 1930
Österreichische Nationalbibliothek –
Bildarchiv, Vienna

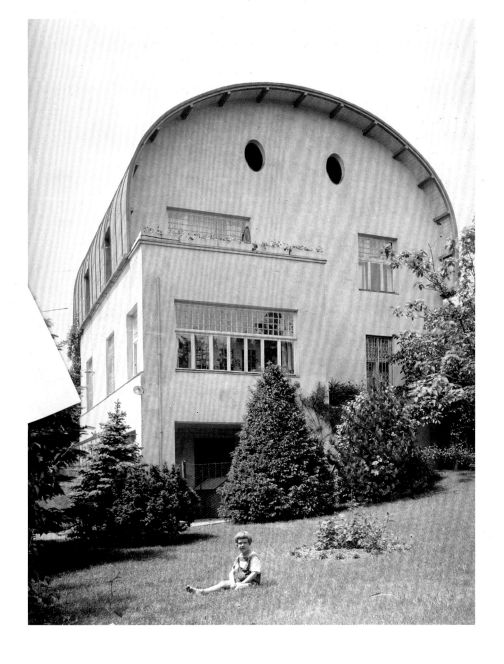

*The June Opening of the
Exhibition* Kunstschau Wien, 1908
Photograph by Emma Teschner
(detail)
Österreichische Nationalbibliothek –
Bildarchiv, Vienna

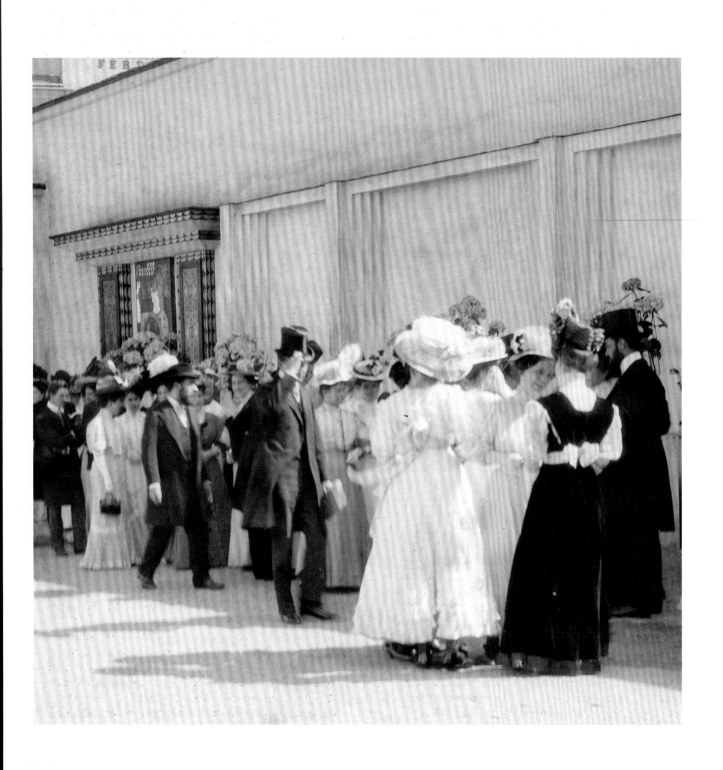

'Austrian Art' on the Move

The Cultural Politics of International Exhibiting 1900–1918

Elizabeth Clegg

At the heart of the collaborative enterprise of Gustav Klimt, Josef Hoffmann and their mutual patrons, as explored in this exhibition, was an artistic expression of elective personal/familial identity and its carefully controlled projection onto the shifting social fabric of Vienna and its hinterland. For Klimt, as for Hoffmann, this venture ran parallel with a much larger undertaking: an artistic expression of the elective identity of Austria and its carefully controlled projection into the evolving cultural-political arenas of a series of Europe's capitals.

As at the personal/familial level, so too at that of the state, the resort to an elective identity and to its projection was both a compensatory response to the difficulties of the past and a means of seizing the opportunities that beckoned in an apparently more settled and auspicious era. Austria, the sprawling, gradually accumulated Habsburg territories, once a unitary Empire and acknowledged 'first among equals' within the German Confederation (the early nineteenth-century successor to the Holy Roman Empire of the German Nation), had in 1866 been ejected from that body by an aggressively ambitious Prussia on its way to forging a Second German Empire. The Austrian Empire had thereupon been constrained both to divide, in 1867 forming a Dual Monarchy with Hungary, and to devolve a good deal of internal administrative responsibility to assemblies representing each of the fifteen Austrian Crownlands.

In many respects, Austria now endured as little more than an already fissiparous Austrian half of the Dual Monarchy – and this was especially true of its cultural life. In the final decades of the nineteenth century, bracketed between the cultural dynamism of a largely autonomous, ever more self-assertive Hungary and the cultural pressure attendant upon reconciliation, since the 1870s, with an equally buoyant Germany, Austria had as much reason as any of the (once) Great Powers of Europe to consider very carefully the face it should henceforth present to the world.

Among those formally appointed as arbiters of cultural life in Austria after the formation of the Dual Monarchy, and whose deliberations and resolutions touched it at every level,[1] there had evolved a consensus on those distinguishing Austrian characteristics that might most profitably be 'spun' into positive virtues as a basis for the international projection of elective identity. First, there was Austria's multi-ethnicity (Germany being far more ethnically uniform and Hungary set upon a course of uncompromising Magyarisation):[2] viewed optimistically, this could be interpreted as a guarantee of cohesive cultural diversity. Second, there was the historical anomaly of Austria's sheer endurance in a continent transformed by revolution and dissolution: somewhat paradoxically, this was glossed as proof of a continuing capacity for self-renewal and hence a fundamental commitment to modernity. Third, there was the evident accessibility, on many different social and cultural levels, of a rich 'living tradition': rather more reasonably, this might be viewed as the source of a unique and unfailing sense of aesthetic quality.

Three stages in the international projection of the elective identity of Austria through presentations of 'Austrian Art' designed to emphasise one or more of these supposed virtues – and with Klimt and Hoffmann much in evidence – are briefly considered in this essay. Spanning two decades, from the festive Parisian spring of 1900 (and a newly forceful Austrian presence at the *Exposition Universelle*, fig.31) to the wartime winter of 1917–18 (with 'Austrian Art' as 'peace propaganda' touring neutral Scandinavia, fig.33), this account seeks to convey something of the broader cultural-political context in which Klimt, Hoffmann and their associates were in each case operating, the range of approaches they adopted, and the varied and often unpredictable outcome of their endeavours.[3]

Brand Recognition: Paris 1900

During the later 1890s the art world across Austria was unprecedentedly energised by the convergence of three factors: the cultural-political challenge implicit in the scale and exuberance of the Hungarian Millennial Celebrations of 1896; the availability of generous state subsidies for initiatives deemed appropriate for nominal linkage with the Imperial Jubilee of 1898 (the fiftieth year of Franz Joseph's reign); and the prospect of participation in an especially ambitions international exhibition in Paris marking the advent of a new century and affirming France as the true champion of Progress. One of the most far-reaching outcomes of this momentary wealth of motivation was the more or less simultaneous emergence, in 1897–8, of dynamic Secessionist exhibiting societies in three of Austria's principal cultural centres: Vienna (the imperial capital), Prague (capital of the north-western Crownland of Bohemia), and Cracow (second city in the north-eastern Crownland of Galicia). All three new entities – respectively, the Union of Austrian Artists (Secession), the Czech artists' society Mánes and the Polish artists' society Sztuka[4] – would be formally invited to represent 'Austrian Art' at the *Exposition Universelle* opening in Paris in April 1900.

The presence in Paris of these cultural *arrivistes* had less to do with their capacity to supply a true account of 'Austrian Art' than with their eagerness to provide a vigorous reinterpretation likely to capture international attention. The foundation of what proved to be their great suitability as exhibitors in this context lay firstly in their novel operating style as artists' societies, and secondly in the wider cultural-political resonance of their ambitions.

Crucial to their formation, albeit in varying proportions, had been an essentially elitist process of selection and simplification, a grasp of the wide appeal of the agenda and the manifesto, an ear for the intriguing title, and an eye for the appealing logo. They were also explicitly 'national' in orientation, not least in defining themselves in contrast to the long-established local or regional bodies from which their founders had separated – respectively, the Viennese

Artists' Society, the Prague-based Art Union of Bohemia, and the Cracow Society of Art Lovers.[5] All, moreover, were 'national' in a way that either contradicted current political realities, as in the case of Mánes and of Sztuka, or that tolerated the coexistence of incompatible objectives, the line adopted by the Union of Austrian Artists (Secession), which lost no time in seeking to recruit leading Czechs and Poles from the other two groups, and with some success.

The exhibiting arrangements for 'Austrian Art' in Paris did not at first seem to augur well. The space allotted to Austria as a participant in the chief Paris display of contemporary art, the *Exposition Décennale* in the galleries of the newly opened Grand Palais, was to be shared, in the interests of conventional hierarchy and international diplomacy, between the long-established Viennese Artists' Society, the new Union of Austrian Artists (Secession), and an ad hoc grouping of 'Austrian artists living in Paris'.[6] Mánes and Sztuka were allocated galleries in the Pavillon de l'Autriche on the Quai d'Orsay, Ludwig Baumann's neo-Baroque *hommage* to Fischer von Erlach.[7] Yet this dispersal of talents did at least guarantee the Union of Austrian Artists (Secession) a more or less direct, profile-sharpening comparison with the Viennese Artists' Society.

Nothing, however, was left to chance. The Union of Austrian Artists' display, installed by Josef Hoffmann, comprised only forty-two works by twenty-four artists (as opposed to 107 by fifty-five in that of the older association, installed by a budding Viennese rival, the architect and designer Josef Urban): fourteen oils, a pastel and two sculptural pieces in an octagonal main room (fig.31), the remaining items, primarily works on paper, in an adjacent rectangular space.[8] While dominated by its largest exhibit, Klimt's *Philosophy* (fresh from a controversial first showing in Vienna, but in Paris due to win a *grand prix*), the octagon was intended to impress as a whole, both harmonious and harmonising. Opulent colour was in itself a feature (grey

31
Installation of the Octagonal Main Room of the Display by the Union of Austrian Artists (Secession) in the Grand Palais at the Paris Exposition Universelle 1900
Design by Josef Hoffmann
Anonymous photograph published in *The Studio* in November 1900

Visible here are paintings, from left to right, by Max Kurzweil, Józef Mehoffer and Gustav Klimt, and a sculpture by Edmund Hellmer.

32
View of the Sculpture Court of the 'Austria' Pavilion at the Rome Esposizione Internazionale 1911
Pavilion designed by Josef Hoffmann
Anonymous photograph published in *Die Kunst für Alle* in November 1911
Staatsbibliothek, Berlin

Chief sculptures visible here are by Anton Hanak and Jan Štursa.

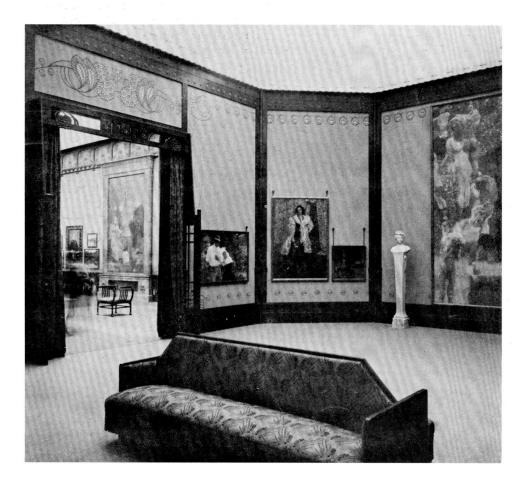

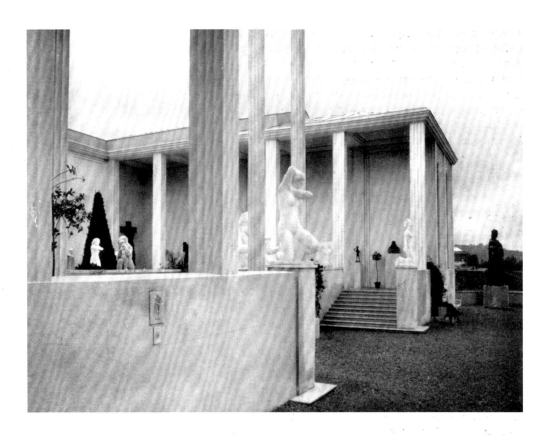

wall fabric pointing up purple-stained woodwork and gold-yellow silk drapery and upholstery in a Koloman Moser design),[9] while a suggestively balancing hang was at its most effective in the motivic and chromatic 'pairing' of Klimt's portrait of Sonja Knips (out of shot to the right in fig.31) and Józef Mehoffer's much admired *Singer*, a portrait of Wanda Janakowska.[10]

It was above all this presentation that achieved for 'Austrian Art' in 1900 something akin to what we might now understand as international 'brand recognition'. And the 'brand' in question had two aspects: aesthetic and ideological. The display by the Union of Austrian Artists (Secession) had demonstrated that 'it takes art to present art' – a lesson now rapidly absorbed by other artists' societies across Austria.[11] Equally, the felicitous juxtaposition of outstanding works from opposite geo-cultural extremes of Austrian territory had made a powerful case for the contention that 'Austrian Art' need not relinquish its legacy of cultural diversity as it embraced an internationalist modernity.

Variety Show: Rome 1911

Evolving attitudes to the international presentation of 'Austrian Art' during the 1900s, culminating in the unprec-edentedly large display filling the 'Austria' pavilion at the Rome *Esposizione Internazionale*, or *Cinquantennio*, of 1911 (fig.32),[12] reflect the profound impact upon Austria of two of the chief ideological currents of this decade: social democratisation and ethnic polarisation. The approaches adopted can also be seen to accommodate the new complexities in Austria's geo-political situation: ever more tightly locked into its alliance with Germany, but increasingly at odds with Hungary, it was now of necessity more cognisant of the growing demands of its majority Slavs.

Austro-Hungarian rivalry found a clear reflection in the Venice *Biennale* presentations of 1901 to 1910.[13] But it was during this decade that Austria may be said to have truly embraced its own artistic diversity, leading to demands for greater inclusiveness and local/regional 'authenticity', and

a widespread scepticism towards what was now perceived as the undue elitism and internationalism of the Viennese and other chief Austrian Secessions. The debilitating schism at the first of these (with the departure of Klimt and his associates in 1905) greatly altered the dynamics of art life in Vienna and beyond, ensuring a much higher profile for groups such as the Viennese Hagenbund and its allies across Austria, as signalled in their prominent joint contribution to the Imperial Jubilee celebrations of 1908.[14] It is telling that the informal Klimt Group should itself propose to offer on this occasion, in its own *Kunstschau Wien 1908* (fig.30), 'a true account of the present state of culture in our Empire'.[15] But this in fact rather less than pan-Austrian event was to be of more significance as a model for exhibiting 'Austrian Art' abroad in grouping its numerous sections around a double 'core' of rooms devoted to Klimt and to the German-Bohemian sculptor Franz Metzner as complementary peaks of Austrian artistic achievement.[16]

Marking fifty years of unified Italian statehood, the exhibition in Rome occupied many sites across the city (in addition to a substantial 'annexe' in Turin); but its important *Belle Arti* component was located in the verdant Valle Giulia, north-west of the old centre, where ten separately housed 'national' displays were grouped around the principal interna-tional presentation. The autonomously exhibiting entities were required to showcase themselves as idealised cultural communities, the manifestation of 'creative forces', a notion somewhat over-literally interpreted in the massive figural group commissioned as a symbol for Austria from the German-Moravian sculptor Anton Hanak. Rather more effective, and more readily admired, was the pared-down Neo-Classicism of Josef Hoffmann's 'exemplary' pavilion. Refining his repeated alternation of open and closed spaces for the 1908 *Kunstschau*, a central sculpture court was here flanked to east and west by broad, stepped arcades, which in turn gave on to a single sequence of eight galleries (fig.32).[17]

In order to do justice to the requisite 'historical' component of a display for the *Cinquantennio*, Hoffmann collaborated with Friedrich Dörnhöffer, recently appointed

first Director of the Viennese Moderne Galerie. 'Austrian Art' in Rome opened with a lovingly recreated Biedermeier Room, but its presentation of contemporary work also clearly benefited from the combined insights of curator and designer. Smaller, regionally specific groupings alternated with larger sections each devoted to a particular type of art but assembling contributions from across Austria. The aforementioned sculpture court, dominated by Hanak, also featured other Austro-Germans (notably Ferdinand Andri and Franz Metzner) and a number of Czechs (most prominently Jan Štursa). A large transverse gallery housed some of the most assuredly 'modern' paintings on show (among them interiors, allegories, landscapes and portraits by Carl Moll, Albin Egger-Lienz, Alois Kalvoda and Wojciech Weiss), as a prelude to the apsidal space reserved for Klimt. Marking the pavilion's southern limit, this complemented Hanak's command of its northern perimeter.

This was the fourth such solo display by Klimt within a large exhibition in as many years.[18] Yet, on account of its concision, its quasi-retrospective character, its several loans from public collections (including *The Kiss* from the Moderne Galerie), the solemn authority of certain images (*Jurisprudence*, *Death and Life*), and the allusively 'sacral' space itself, it was by far the most daring exercise to date in elevating Klimt's oeuvre into an epitome of 'Austrian Art' – a move with which the Rome awards jury was more than ready to concur.[19] In assuming this role, however, Klimt's display did not undermine the status of the 'Austria' presentation as an affirmation of cultural diversity. Its cool, museal adumbration of the view from posterity served, rather, as a foil for the bustling, as yet unsifted variety of what was soon to prove an aesthetic, cultural-political and even world-historical turning point.

Charm Offensive: Stockholm/Copenhagen 1917–18

The *Austrian Art Exhibition* shown at the Liljevalchs Konsthall, Stockholm, as *Österrikiska Konstutställningen*, in September 1917 and, in a smaller version, at Den Frie Udstilling, Copenhagen, as *Østrigsk Kunstudstilling*, from mid-December 1917 to late January 1918 (fig.33),[20] was the star attraction in a multi-faceted programme of wartime 'peace propaganda'. Devised at ministerial level, this was intended as a key cultural component in the pursuit of a separate, negotiated peace for Austria (and Hungary) – a change of tack long favoured on the war-weary Home Front and informally adopted on the accession, in November 1916, of a new Emperor, Karl I.[21] The overall aim was to disseminate, among states still neutral in the conflict, an image of Austria as both fundamentally pacific and daringly creative. Potentially at stake here was Austria's fortune in the post-war world.

When plans for a touring show got underway, in the early spring of 1917, Stockholm had recently been chosen as the venue for an international Peace Conference sponsored by the Social Democratic movement. While this event was in fact to be repeatedly postponed and finally cancelled, a succession of related talks and subsidiary conventions filled the city with an incessant buzz of excitement at unfolding world events and swelled the potential audience for the Austrian display. By the time this had reached Copenhagen, the hopes of pacifists and Austrians alike were rising at news of the start of peace negotiations at Brest-Litovsk between representatives of the Central Powers and of newly Bolshevist Russia. In Copenhagen, as in Stockholm, popular opinion was nonetheless gradually shifting from tacit sympathy for Germany and its allies to informal support for the Entente.

At both Scandinavian venues the *Austrian Art Exhibition* was the central shaft in a three-pronged 'charm offensive', if more obviously so in Sweden, where the opening week coincided with the Stockholm début of the Wiener Symphonie-Orchester (excerpts from *Zauberflöte* and Lehár's *Zigeunerliebe* and a selection of Strauss waltzes) and Viennese fashion shows at two of the city's best hotels.[22] Taking advantage of pre-existing contacts and local enthusiasms, Josef Hoffmann's installation at both exhibition sites gave prominent positioning to a large applied arts component with an emphasis on ceramics, glass and textiles. The Wiener Werkstätte contribution included items by some of its youngest recruits, among them the emerging ceramic sculptor Vally Wieselthier, who also designed several appealing advertisements for the Danish press (fig.33).[23] The fine arts section (240 works by fifty-five exhibitors in a dozen rooms in Stockholm, 142 by twenty-nine in five rooms in Copenhagen) showed six established artists in some depth, even-handedly alternating old(er) and young – Albin Egger-Lienz, Anton Faistauer, Anton Hanak, Oskar Kokoschka, Gustav Klimt, Egon Schiele – and expressly proposing no single dominant figure.[24] But it also readily acknowledged the work of an eager throng of emerging talents, among them Hans Böhler, Felix Albrecht Harta and Georg Merkel, and it made a feature of the decorative illustrations and stylish fashion drawings of Otto Lendecke as a mediator between the fine and the applied arts.

Of additional significance was the presence in Stockholm, along with Hoffmann, Hanak, Faistauer, Böhler and others, of the team's 'ideological spokesman': the Vienna-based German-Silesian cultural geographer Erwin Hanslik. In press interviews and public lectures he tirelessly urged that the exhibition be viewed as an encapsulation of the 'Austria' extolled in his own writings: an environmentally conditioned, slowly evolving, harmoniously multi-ethnic whole (though the show was, perforce, overwhelmingly Austro-German), threatened by the 'sickness' of separatist nationalism but truly a model for the peaceful future of humanity.[25]

Critical response, as if to demonstrate its range of sympathies (though clearly also taking hints from incidental emphases in presentation), was most consistently favourable towards artists located at opposite extremes of the Austrian cultural spectrum: the Tyrolean Egger-Lienz (whose stocky peasant protagonists and sombre rural Symbolism reminded many of Ferdinand Hodler or Juho Rissanen) and the Salzburg sophisticate Faistauer (whose colourist refinement in portraits and still lifes was approvingly identified as 'Austrian Art' at its most 'francophone').[26] The consensus that Kokoschka was here the chief exponent of a passionate 'ultra-modernism' occasioned diverse reactions, in which there generally prevailed a reluctant admiration (especially for the recently completed *Émigrés*).[27] Schiele, likewise, struck some as intolerably morbid (above all on account of the large and disturbing canvases *Resurrection* and *Transfiguration*), and others as the most excitingly 'path-breaking' artist in the show.[28]

Klimt, whose Stockholm display of late(ish) portraits and landscapes grouped around the now re-worked *Death and Life* was reprised in summary in Copenhagen,[29] brought forth the most eloquent, and the most ambiguous, commentaries. At both venues critical imaginations were stirred by the several elegantly swathed female figures posed against enigmatic 'oriental' backgrounds.[30] Youthful enactments of the exquisite fragility of 'old Austria', these became a leitmotif of the 1917–18 venture: 'Austrian Art' at its most seductively ambassadorial.

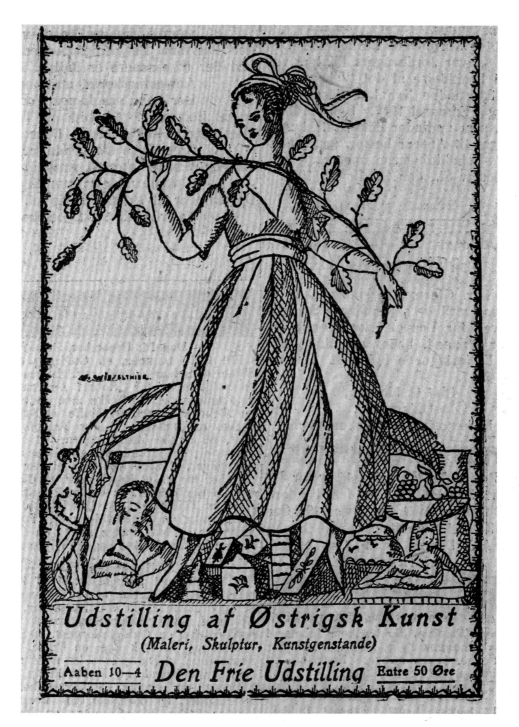

Udstilling af Østrigsk Kunst
(Maleri, Skulptur, Kunstgenstande)
Aaben 10—4 Den Frie Udstilling Entre 50 Øre

33
Press Advertisement for the Copenhagen Østrigsk Konst-udstilling *of 1917–18, incorporating a Design by Vally Wieselthier*
Published in *Nationaltidende* in December 1917

34 (overleaf)
Anonymous Photograph of the Naschmarkt in Vienna with the Secession Building on the right c.1900
Albumin on paper, 16 × 22.5
Private Collection, Vienna

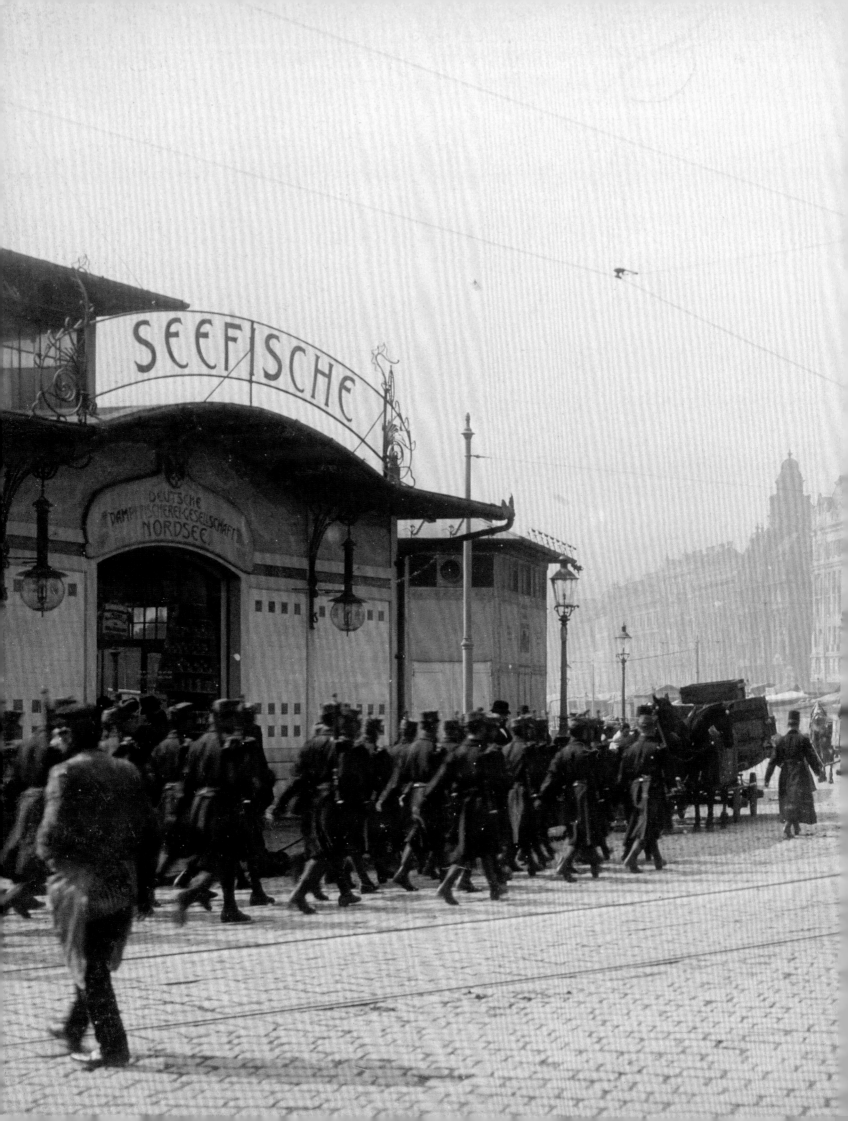

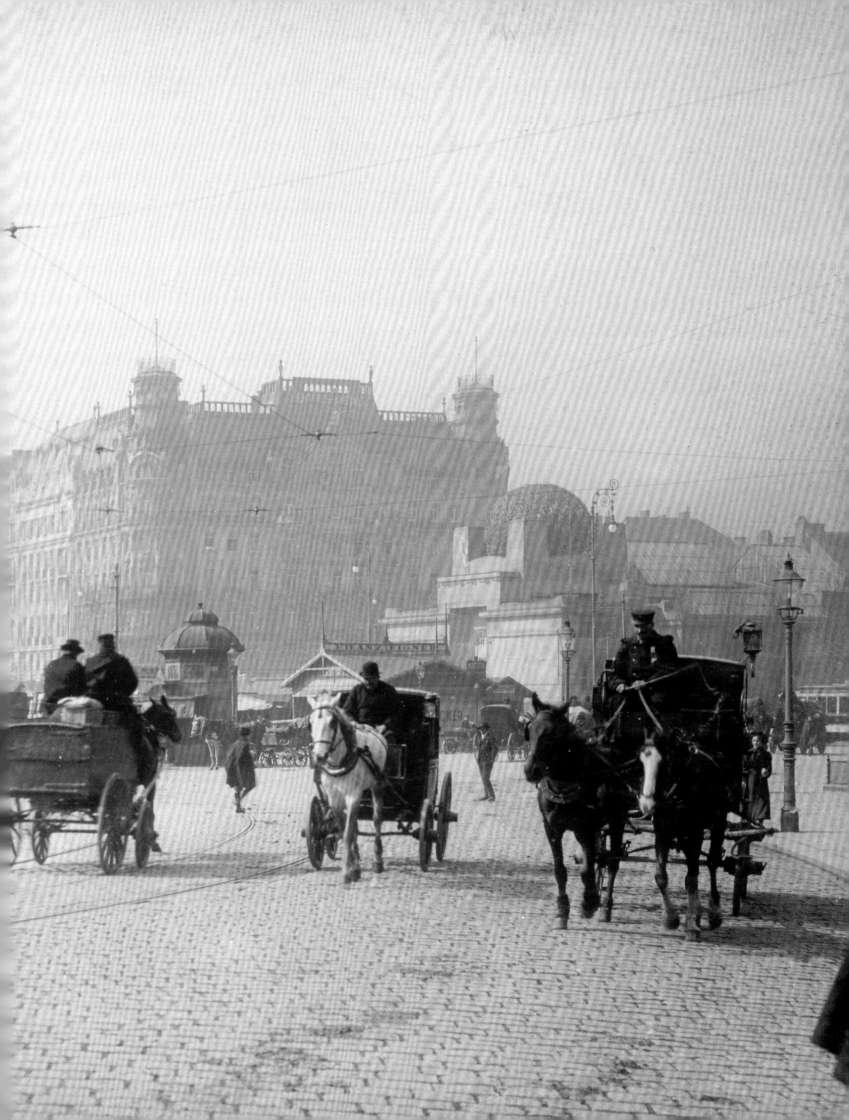

The Foundation of the Viennese Secession

The Secession founded in Vienna in 1897 was, in essence, a form of protest against the 'establishment' in the city's art life of that time, which took the form of the influential Viennese Artists' Society (Genossenschaft bildender Künstler Wiens). Itself founded in 1861, this was based from 1868 at the Künstlerhaus, a large, richly decorated, neo-Renaissance exhibiting building on Karlsplatz, just off the Ringstrasse. Membership of the Society was widely viewed as something of a professional obligation: around four hundred belonged when Gustav Klimt joined, in 1891.

By this date, however, the unopposed heyday of the Künstlerhaus shows had passed. For those predisposed to find fault with them, they presented an ever more obvious target – be it on account of their sheer scale, their blatant commercialism, or the relative paucity of truly exciting 'modern' work among exhibits from abroad. Objections were raised both within the Viennese Artists' Society, above all from its younger members (drawing encouragement from their Munich counterparts who had formed a Secession in 1892), and outside it, most eloquently from members of the Young Vienna (Jung-Wien) literary circle around the critic, essayist and dramatist Hermann Bahr, one of the first to insist on the urgent need for a 'reawakening' of art life in Vienna.

The gathering momentum of desire for change was such that, by the winter of 1896–7 (as first reported by another early supporter, the critic Ludwig Hevesi), the malcontents at the Viennese Artists' Society had not only evolved a plan to found a separate, proactive group within the parent association, but had also entered into negotiations regarding the site for a new exhibiting venue of their own. The formal constitution of a Union of Austrian Artists (Vereinigung bildender Künstler Österreichs), with Klimt as its first President, at a meeting on 3 April 1897, was shortly thereafter reported to the Committee of the Viennese Artists' Society in a letter signed by Klimt. This emphasised above all a desire to bring Austrian art life into a much more 'vigorous relationship' with progressive developments abroad. But the coolly sceptical spirit in which this announcement was received left little scope for either compromise or reconciliation, prompting Klimt and a further twelve members of the new Union of Austrian Artists to break definitively with the Viennese Artists' Society on 24 May. It appears that it was the recognised significance of this break that encouraged both commentators on and members of the Union to append the bracketed term 'Secession' to its full title as originally formulated.

The Union of Austrian Artists (Secession) initially defined itself, not least in relation to the Viennese Artists' Society, through strict adherence to the implications of its full title and through the character of its (invited) membership. It was explicitly intended as an association accessible not only to artists primarily based in Vienna, but to those active in any of the Crownlands of the Austrian half of the Empire. Among the founding members and those invited to join within the first few months were leading Czechs (as well as Germans) from Bohemia and Moravia and some highly talented Poles from Galicia. Even more significant was its international dimension: the first exhibition was to be dominated by work from abroad and, by the summer of 1898, the sixty-two 'corresponding' members (those from outside the Empire, and comprising a veritable international elite) outnumbered the fifty-three 'regular' members.

As was also soon to become apparent, the Viennese Secession was distinguished (from its earlier Munich counterpart, as also from the Secessions founded more or less simultaneously in Prague and in Cracow) by the prominence of architecture and design as the chief concerns of some of its initial leading figures, among them Josef Hoffmann and Koloman Moser, and by the importance that the design of its own exhibition installations (fig.54) would rapidly assume. This, the Secession's most important and widely influential achievement, was also to become a matter of bitter internal disagreement and, in 1905, one of the chief causes of an irreparable schism.

As its champions were tireless in asserting, the Secession achieved something remarkable and novel for Vienna in addressing each of the three practical goals it set itself during its first eighteen months. Its journal,

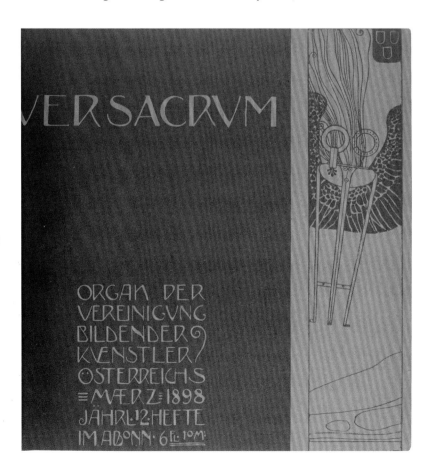

35
Cover of the Viennese Secession journal Ver Sacrum, March 1898, the Klimt issue. Design incorporating drawing and lettering by Gustav Klimt. Österreichische Nationalbibliothek – Bildarchiv, Vienna

36
Catalogue of the First Secession Exhibition 1898, with the figure of Pallas Athene by Gustav Klimt Kunsthaus Zug, Stiftung Sammlung Kamm

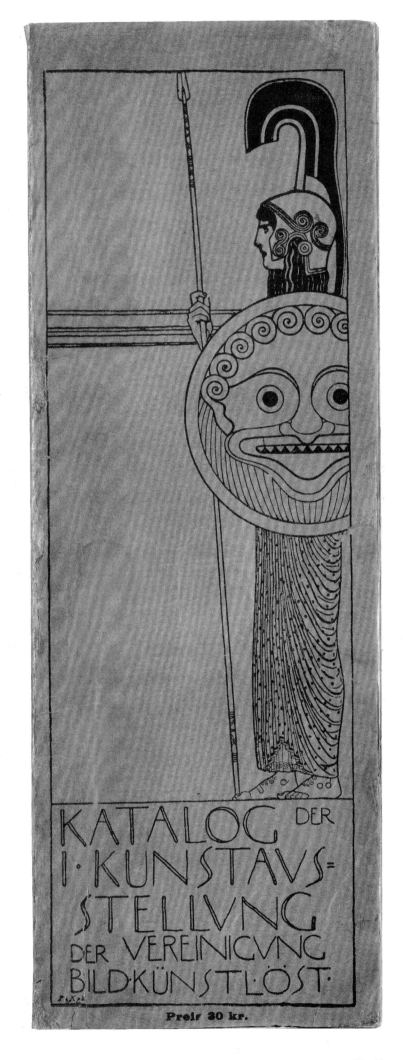

Ver Sacrum (Sacred Spring) established new standards in graphic design: its unusual square format and deft deployment of page layout, decoration and typography in combination towards a desired end (largely the achievement of Moser and Alfred Roller) were in themselves an advertisement for what soon became known as 'Secession style'. The special issues illustrated largely with the work of a single artist – including Klimt, in March 1898 (fig.35) – reinforced the impact of that artist as exhibited at the Secession. Of particular importance was the regular publication in *Ver Sacrum* of installation photographs of Secession shows (fig.20), making the journal a key vehicle in the wider dissemination of an emerging, highly distinctive installation style.

The first exhibition to be mounted by the Secession, inventively installed in a hired venue by Hoffmann and the architect Joseph Maria Olbrich and advertised with a poster designed by Klimt (figs.46, 48, 49), fully justified the generous assistance received from the Austrian Ministry of Religion and Education. With nearly 60,000 visitors, numerous approving reviews and a very high rate of sales, it allowed the Secession, as always intended, to begin acquiring exhibited works for donation to the collection of a proposed public Moderne Galerie for Vienna.

The inauguration of the exhibiting pavilion built for the Secession on a site not far from the Künstlerhaus, with some regional state funding but more substantial assistance (around 100,000 crowns) from one of Klimt's chief early patrons, the industrialist Karl Wittgenstein (see also pp.162–81), was to reveal the true scope of Olbrich's inventiveness. Already startling in its external appearance – its formidable, almost mausoleal, mass crowned with a laurel bush in gilt openwork wrought iron (figs.50–2) – it was at its most innovative in the rigorously 'functionalist' arrangement of its interior. With the roof supported on only six piers and internal partitions movable or removable as required, it was possible to alter the sequence and interrelation of gallery spaces with every presentation.

The two highpoints of Klimt's association with the Secession as an exhibitor there were achieved with the *Beethoven Frieze* he contributed to a collaborative installation for the fourteenth exhibition, in April–June 1902 (see pp.80–99), and his individual retrospective that was the eighteenth show, in November–December 1903 (fig.22). But Klimt first came to prominence, and indeed notoriety, in this capacity through the critical and public response to the display, at the seventh exhibition, in March–June 1900, of *Philosophy* (subsequently shown in Paris, fig.31, extreme right), one of the three large allegorical canvases commissioned for the ceiling of the chief assembly hall of Vienna University's new building on the Ringstrasse.

Already familiar and popular in pre-Secession Vienna as an accomplished, if still essentially conventional, decorative painter and as a highly competent and sometimes subversive allegorist (figs.38, 39), Klimt had attracted positive critical commentary for the work he showed in the early Secession exhibitions as a seductive portraitist (*Sonja Knips* 1898 appeared at the second), a provocative reinventor of ostensibly 'traditional' themes from Classical mythology (*Pallas Athene*, fig.45, and *Nuda Veritas*, fig.44, were at the second and the fourth respectively), and for his 'atmospheric' landscapes (*Calm Pond*, fig.99, featured at the seventh); and he had also exhibited at the fifth presentation, devoted to prints and drawings.

The outcry provoked by *Philosophy* brought Klimt, and the Secession, an altogether new degree of attention, and led to prolonged and heated debate. This took in the cultural-political aspect of the work (the responsibilities of state patronage and the obligations of the artist so 'favoured'), philosophical issues (in particular the Schopenhauerian pessimism of Klimt's interpretation of his theme), and fundamental aesthetic questions (most notably concerning the concept of supposed 'ugliness' in art), as well as stirring satirists and caricaturists into boisterous action. It also set the tone for what was to prove an exceptionally difficult commission and one from which Klimt was to withdraw, in the spring of 1905, vowing henceforth to embrace artistic 'independence'. In much the same spirit, and only shortly afterwards, Klimt and his closest associates, including Hoffmann, Moser and Roller, broke with the Secession. Its original pioneering spirit was thereafter better preserved in the intermittent undertakings of their informal Klimt Group (Klimt-Gruppe).

Elizabeth Clegg

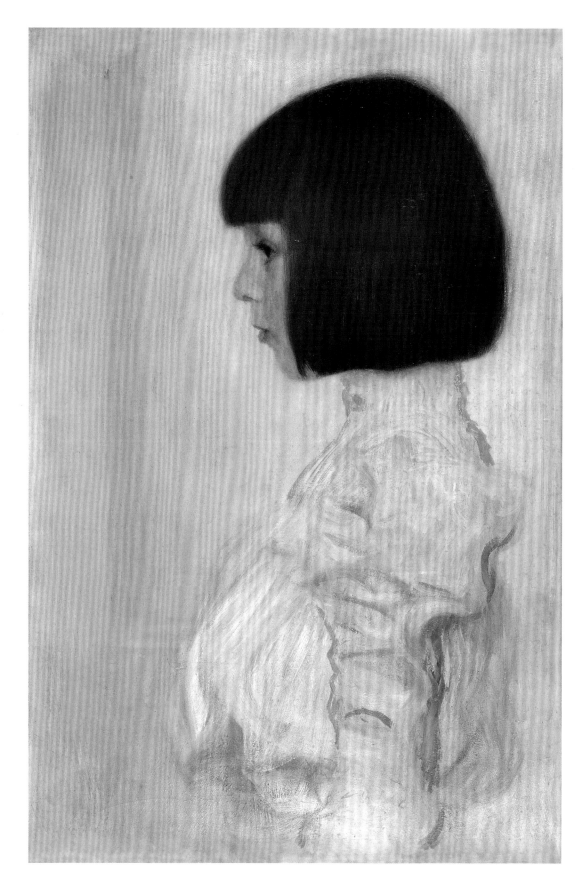

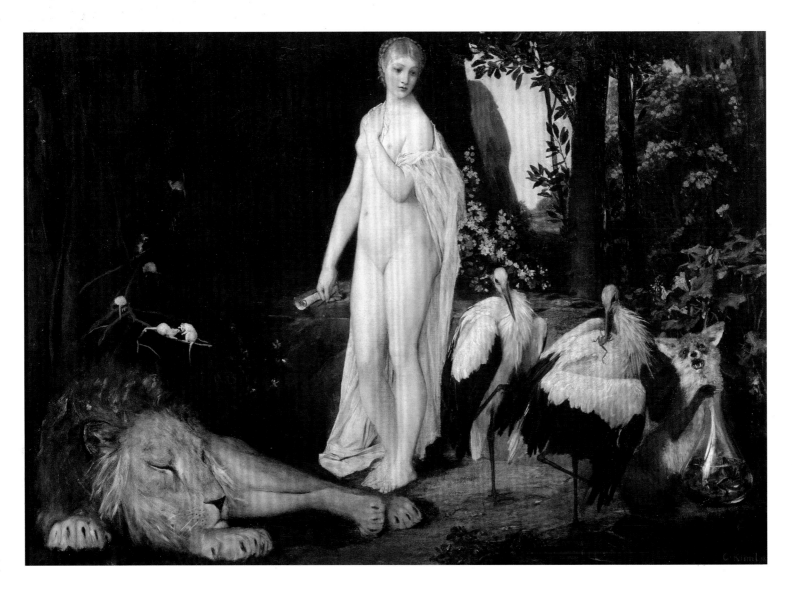

39
Gustav Klimt
*Final Drawing for the
Allegory of Sculpture* 1896
Black chalk, pencil and wash,
with gold highlights, 41.8 × 31.3
Wien Museum, Vienna

40
Gustav Klimt
*Final Drawing for
The Fairy Tale* 1884
Black chalk, ink and wash, with
white highlights, 63.9 × 34.3
Wien Museum, Vienna

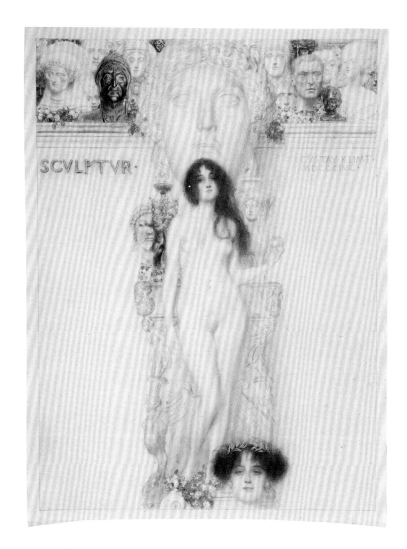

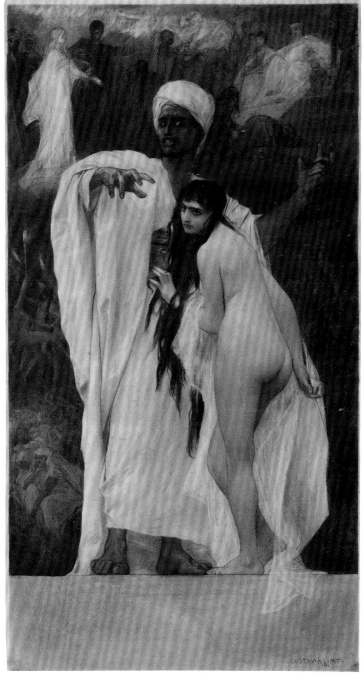

41
Gustav Klimt
Two Girls with an Oleander
c.1890–2
Oil on canvas, 55 × 128.5

Wadsworth Atheneum Museum
of Art, Hartford, Connecticut.
The Douglas Tracy Smith and
Dorothy Potter Smith Fund and
The Ella Gallup Sumner and Mary
Catlin Sumner Collection Fund

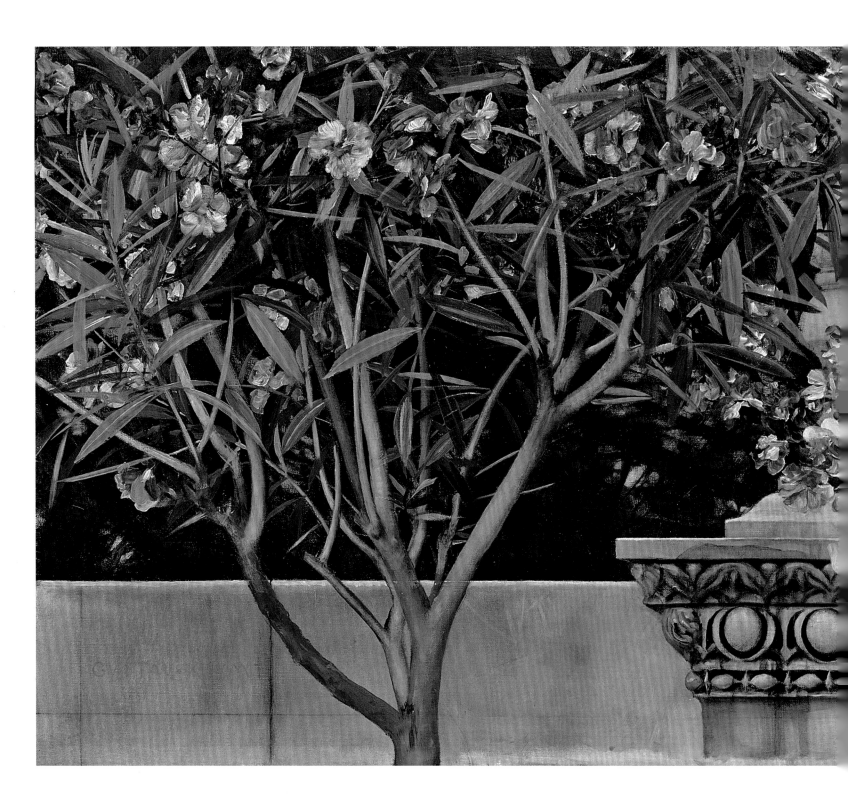

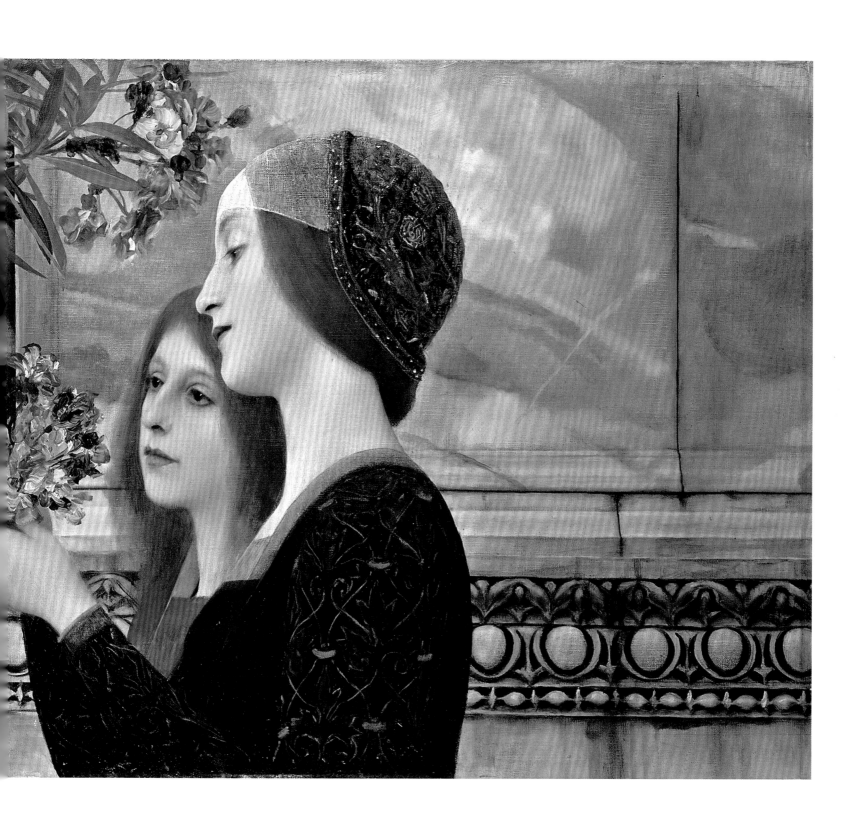

42
Gustav Klimt
Portrait of a Lady
*(Frau Heymann)*c.1894
Oil on wood, 39 × 23
Wien Museum, Vienna

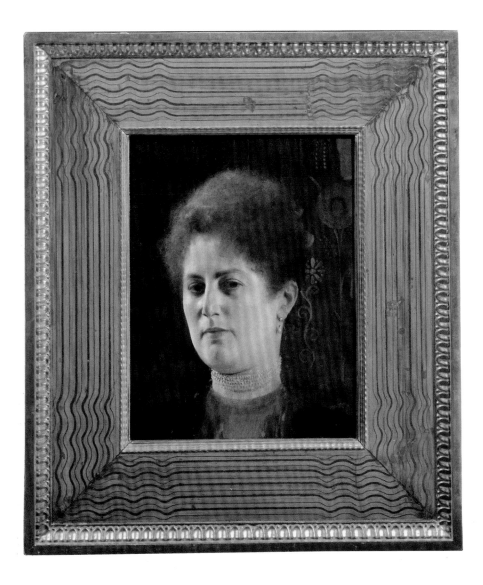

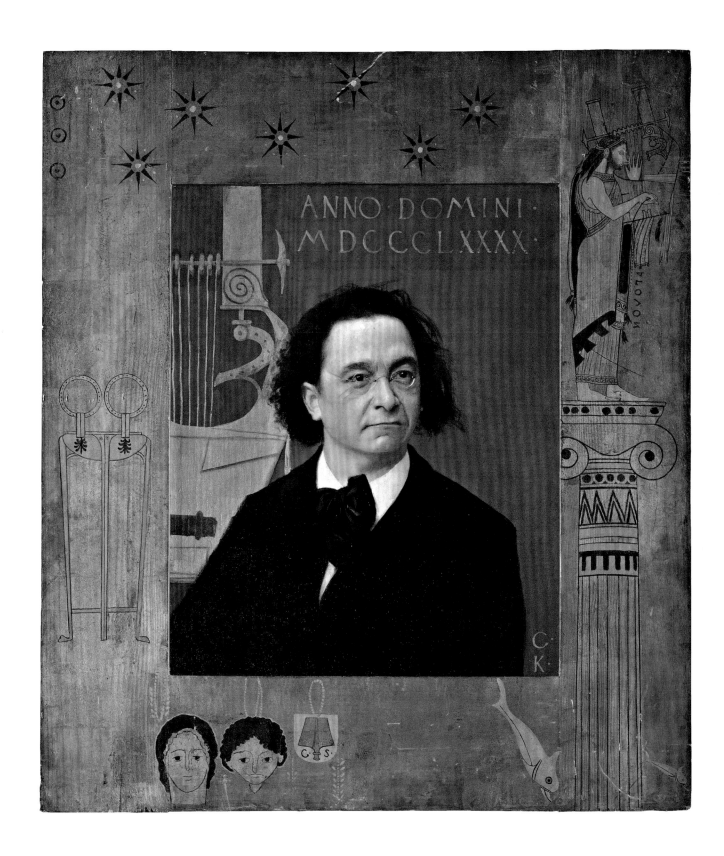

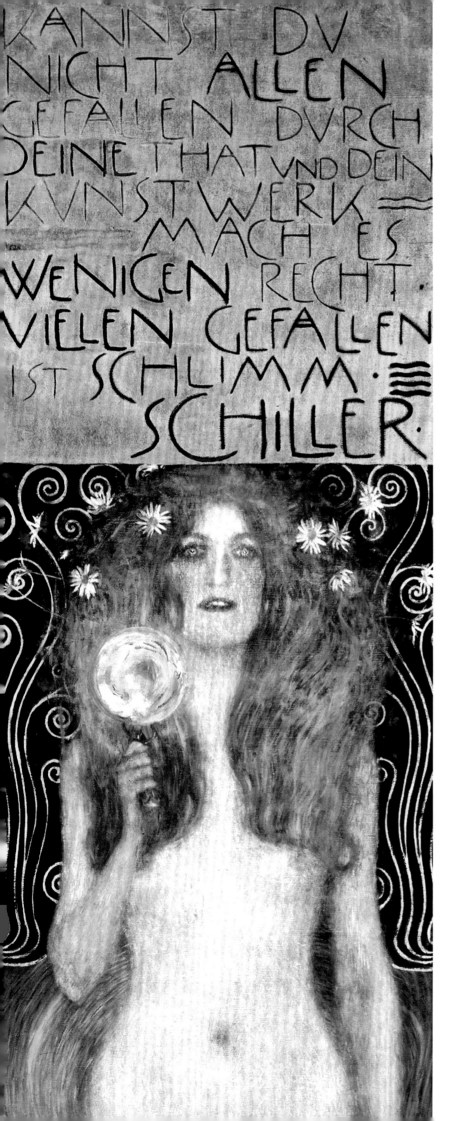

44
Gustav Klimt
Nuda Veritas 1899
Oil on canvas, 252 × 56.2
Österreichisches Theatermuseum,
Vienna, Nachlass Bahr-Mildenburg

With the programmatic and
controversial painting *Nuda Veritas*
(*The Naked Truth*), Klimt holds up
a mirror to his public. Subjected
to jealous attacks, the artist feels
himself committed only to artistic
truth, quoting the German poet
Friedrich von Schiller: 'If thou canst
not please all men by thine actons
and by thine art, then please the
few; it is bad to please the many.'

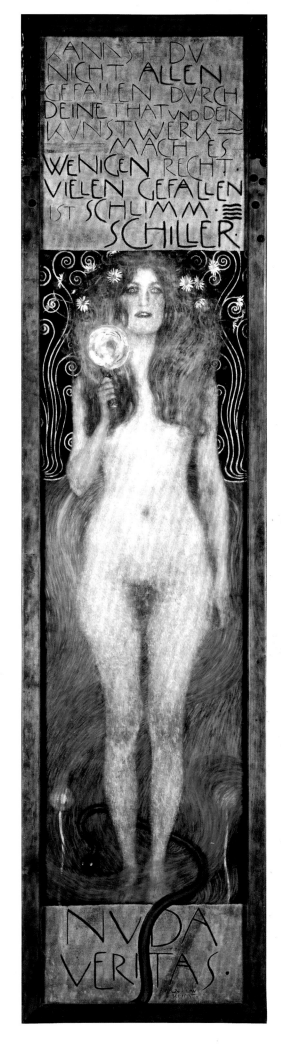

45
Gustav Klimt
Pallas Athene 1898
Oil on canvas, 75 × 75
Wien Museum, Vienna

Pallas Athene, the classical goddess
of War, Wisdom and the Arts, was
the guardian of the Vienna Secession.

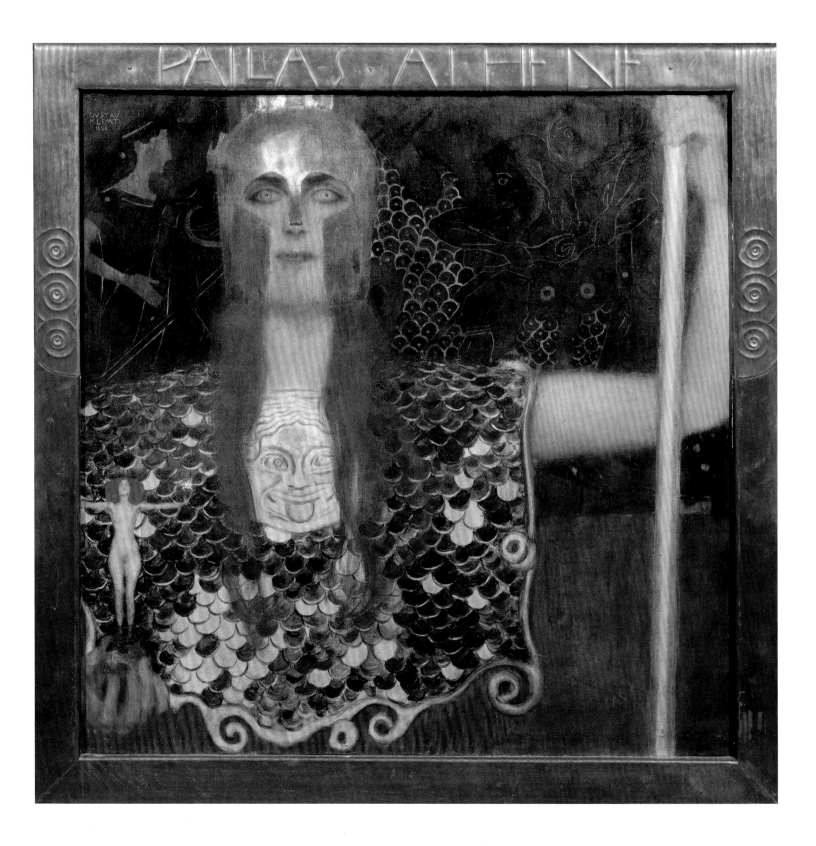

46
Gustav Klimt
*Poster for the First Secession
Exhibition – Uncensored
Version* 1898
Printed by A. Berger, Vienna
Colour lithograph on paper, 97 × 70
Wien Museum, Vienna

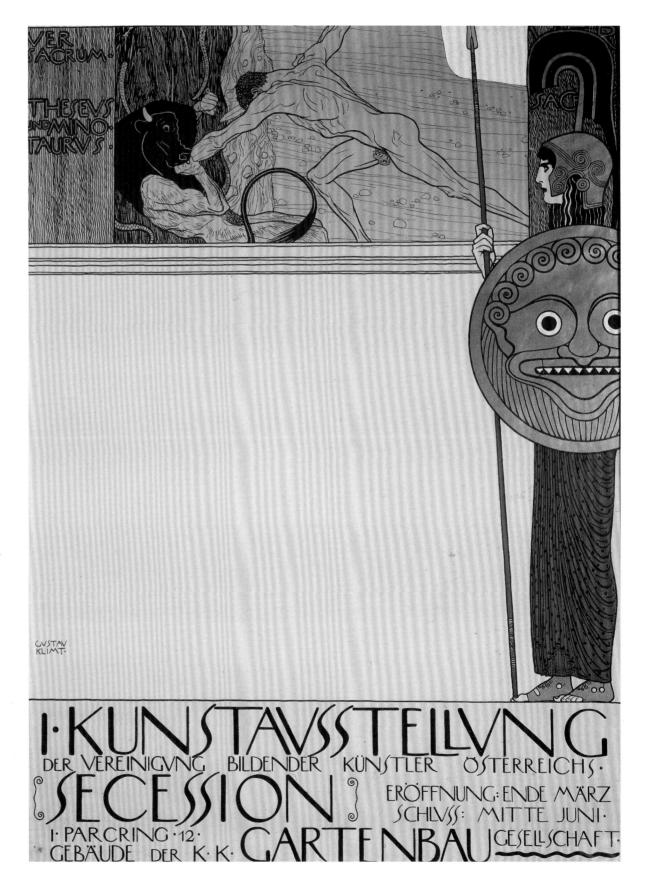

47
Gustav Klimt
*Ex-Libris for the Viennese Secession
with 'Pallas Athene' Logo* c.1900
Red lithograph on paper, 10.2 × 5.2
Private Collection, Vienna

48
Gustav Klimt
*Final Poster Design for the
First Secession Exhibition* 1898
Pencil underdrawing, pen,
ink with corrections in opaque
white on paper, 130 × 80
Wien Museum, Vienna

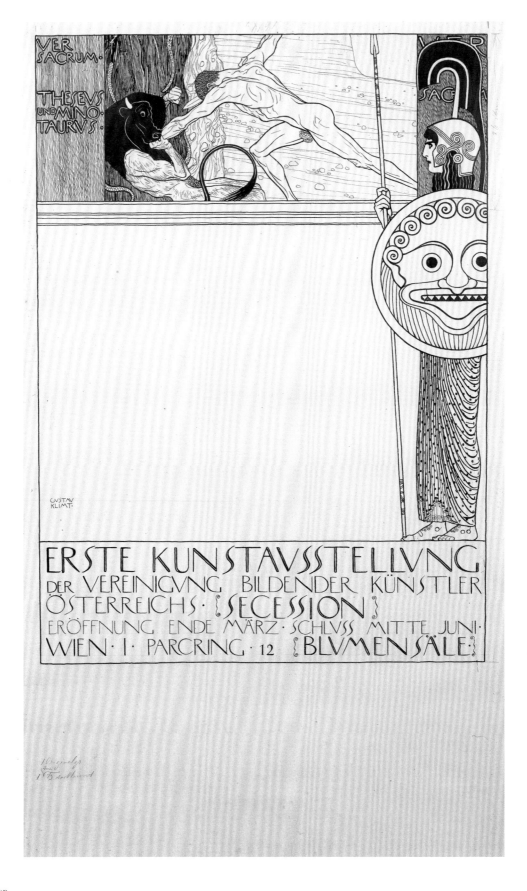

49
Gustav Klimt
*Poster for the First Secession
Exhibition – Censored Version* 1898
Printed by A. Berger, Vienna
Colour lithograph on paper, 97 × 70
Wien Museum, Vienna

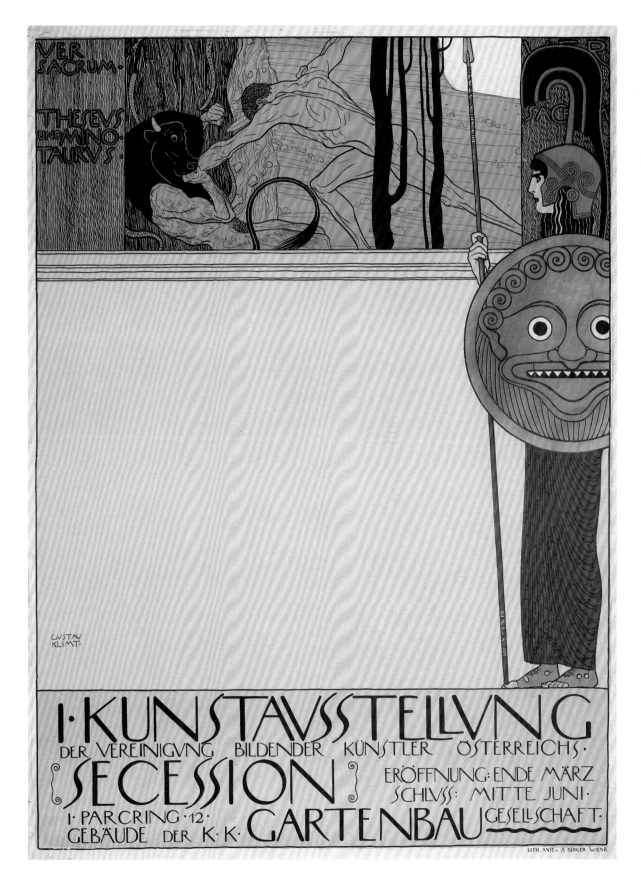

50
Four Postcards with Views
of the Viennese Secession
1898–1901
Each: 9 × 14
Private Collection, Vienna

On the day of the opening of
the Secession building, 12 November
1898, newspapers commented:
'The dome with its gleaming leaf
decoration has already become
a Viennese landmark, and the
Viennese wit accordingly has
christened the whole building
"To The Golden Cabbage".'

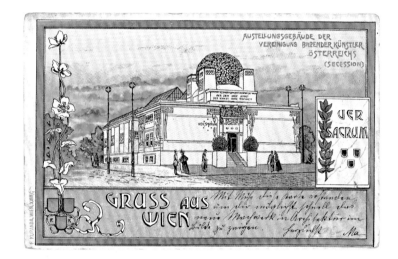

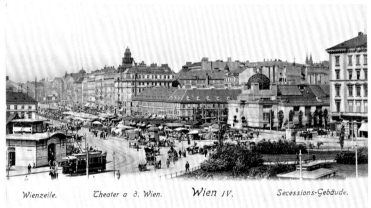

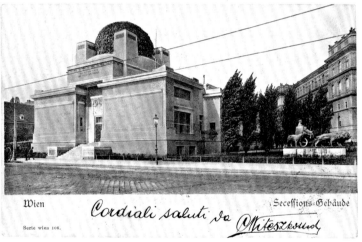

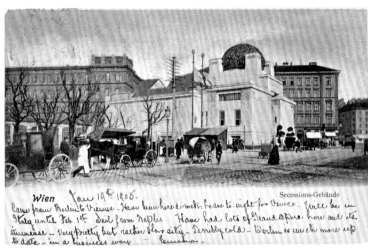

51
*Postcard with a View of the
Secession Exhibition after a
Drawing by Joseph Maria
Olbrich* 1898
Printed by A. Berger, Vienna
Green and gold lithograph, 14 × 9
Private Collection, Vienna

52
*Postcard with a View of the
Secession Exhibition after a
Drawing by Ferdinand
Andri* 1906
Brown, blue and gold
lithograph, 14 × 9
Private Collection, Vienna

76 — 77

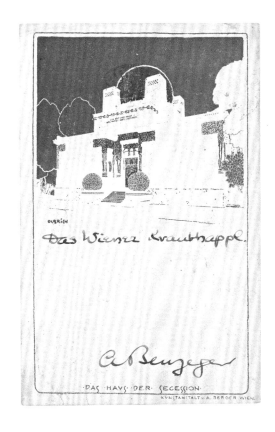

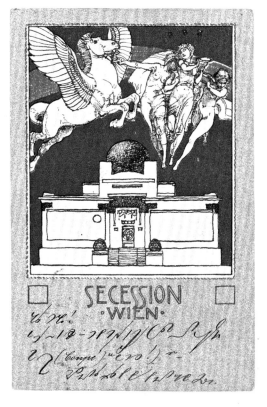

53
Josef Hoffmann
*Chair made for the Fifth
Secession Exhibition* 1899
Green-stained wood with
padded leather seat, 76 × 61 × 44
Collection Hummel, Vienna

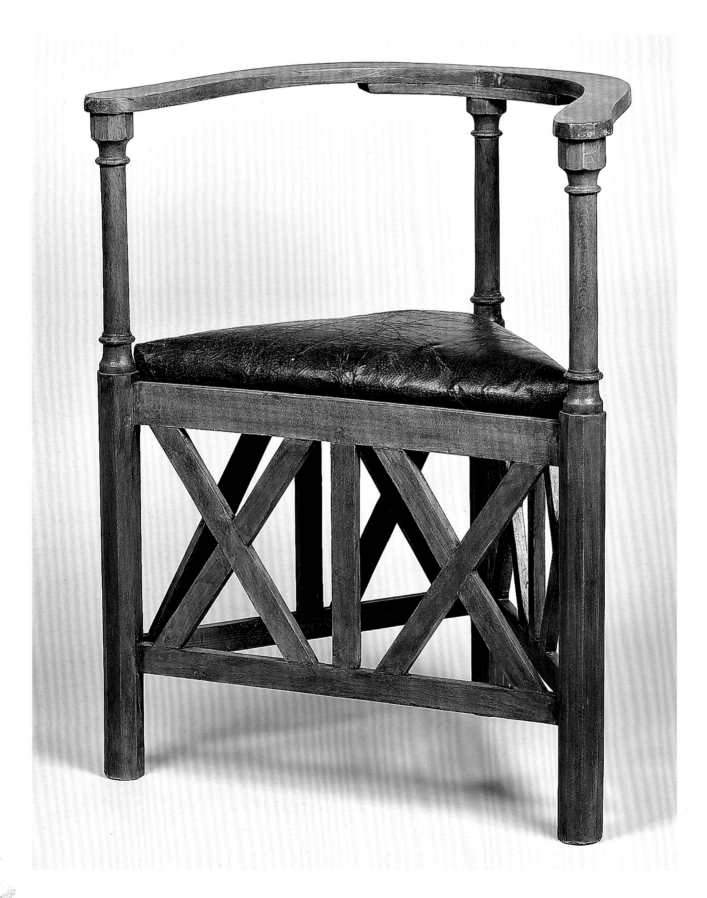

54
Postcards with Views of Secession
Exhibition Installations 1900–1902
Coloured postcards
Orientation varies, each: 9 × 14
Private Collection, Vienna

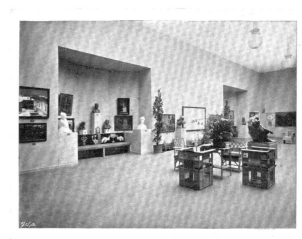

XV. AUSSTEL-
◦ LUNG DER ◦
VEREINIGUNG
BILDENDER
KÜNSTLER
ÖSTERREICHS
SECESSION

VIII. AUSSTELLUNG DER VEREINIGUNG BIL-
DENDER KÜNSTLER ÖSTERREICHS SECESSION

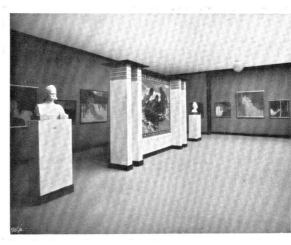

XIII. AUSSTEL-
◦ LUNG DER ◦
VEREINIGUNG
BILDENDER
KÜNSTLER
ÖSTERREICHS
SECESSION

XII. AUSSTELLUNG DER VEREINIGUNG
BILDENDER KÜNSTLER ÖSTERREICHS SECESSION
═══ SAAL DER SCHWEDISCHEN KÜNSTLER ═══

2 The Beethoven Frieze

Gustav Klimt's *Beethoven Frieze* was shown from 15 April to 27 June 1902 in the fourteenth exhibition at the Viennese Secession. The main focus of the exhibition (preparations for which had already begun in summer 1901)[1] was Max Klinger's polychrome Beethoven sculpture. This work crucially paved the way for 'conventional, repeated exhibitions of paintings' to be replaced by 'events of a different kind'. The idea was – as Ernst Stöhr explained in the foreword to the catalogue – that painting and sculpture should be governed by a common spatial concept and serve the same overall purpose. The Secessionists wanted to 'learn' from the experience of creating a 'fully thought-through design for an interior' and develop the 'highest and best that people could ever have devised', namely 'temple art'.[2] The theoretical basis for this exhibition concept was the programmatic text 'Painting and Drawing' (1891) by Max Klinger, parts of which were published in the exhibition catalogue. Taking the Wagnerian concept of the Gesamtkunstwerk as its starting point, Klinger applied the same principle of the unifying of diverse art forms to the visual arts and postulates the coming together of painting,

sculpture and architecture.[3]

An important part of the exhibition was the deliberately edifying catalogue, intended to inform the visitor of the salient features of the Beethoven exhibition as a whole and of individual works in particular. Accordingly, the catalogue begins with an 'orientation map for the wall paintings and sculptures' (fig.57),[4] and a recommendation that visitors should start their tour of the exhibition in the left side-room, which contained Gustav Klimt's *Beethoven Frieze*. The wall paintings, which ran 'like a frieze around the top halves of three walls' and formed 'a coherent sequence',[5] were to be read from left to right. The catalogue also included a sketch of the programme of the frieze.[6] In the first section on the long wall on the left there is a group of female figures, floating just below the upper edge of the frieze and entitled 'longing for happiness'. The 'floating' figure first appears in the studies for the University painting *Medicine* and is repeated here, on into the first third of the long wall on the right; it connects all three scenes in terms of both form and content. The first of these scenes is of a group of figures, described in

55
*Working Sketch for the Left Wall
of the Beethoven Frieze, showing
the group Weak Humanity*
1901/2
Pencil and watercolour, 19 × 64
Private Collection

the catalogue as representatives of 'the sufferings of Weak Humanity: the pleas of the latter – directed towards the Knight in Shining Armour – as external ... driving forces who urge him to take up their struggle for happiness'. Weak Humanity is represented by three naked figures seen pleading with the Knight in Shining Armour. In a working sketch for the left wall, which has only recently come to light, the group of Weak Humanity also includes a kneeling figure bent forwards, its face and head hidden in its hands. This figure does not appear in the finished work, although it expresses the 'sufferings' of humankind much more vividly than the other three figures. There are no records as to why Klimt did not realise this figure. The description of this section, which fits the unrealised figure so well, raises the question as to whether the author possibly wrote his account on the basis of the working sketches.

In the case of the other figures in this group, Klimt did not change his original scheme. Two allegorical female figures, in highly decorative clothing, rise up behind and are partially hidden by the figure of the knight. Their legs do not continue

right to the ground, reinforcing the impression that they are somehow floating upwards. In the catalogue they are named Ambition and Empathy, and described as the 'inner driving forces' that motivate the knight to struggle for happiness on behalf of humankind. Their floating state emphasises their role as expressions of the internal ideals according to which the knight lives his life.

The figures representing 'longing for happiness' reappear in the last third of the left wall and lead the knight to the section on the short, back wall, where we see the Hostile Powers. The knight has to take on Typhon, against whom even the gods struggled in vain: his daughters, the Three Gorgons. Sickness, Madness, Death. Lewdness, Lust, Excess. The knight's path leads him into the realms of Greek mythology. While Klimt presented the first group as a personification of humankind's external demeanour – entreating, naked and suffering – in the second section of the frieze on the back wall he depicted the inner causes of this suffering: the fears and temptations arising from the torments of the soul that human beings have to face. Nowhere are the inner torments

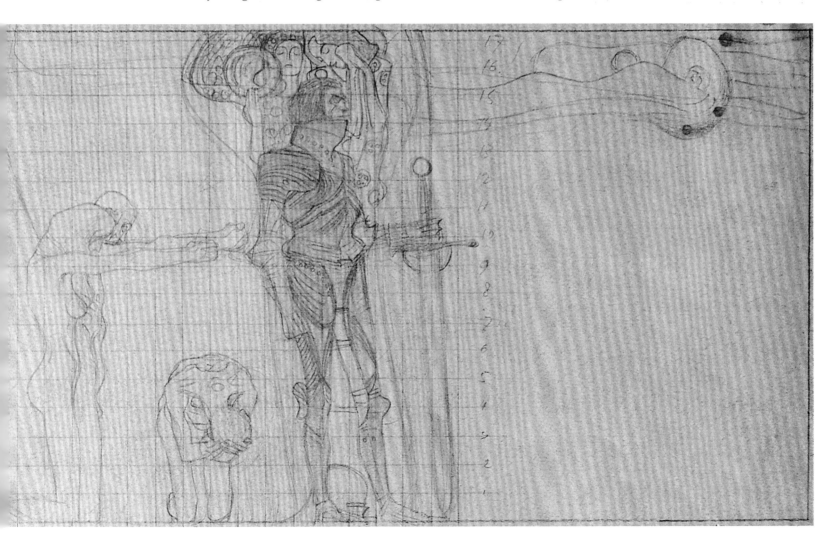

56
Klimt Room of the Fourteenth
Secession Exhibition 1902
Vintage print, 17.9 × 25.5
Österreichische Nationalbibliothek –
Bildarchiv, Vienna

57
Layout and Recommended Route
through the Installation, from the
Catalogue for the Fourteenth
Secession Exhibition 1902

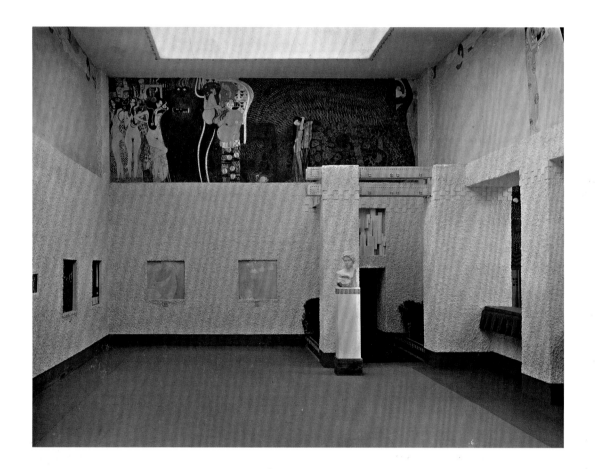

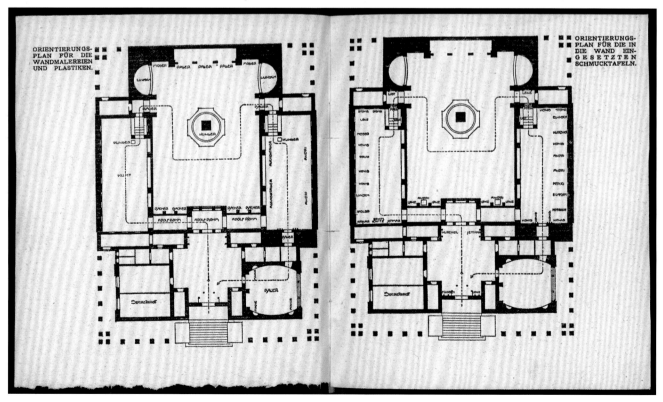

58
Gustav Klimt
Allegory of Music (Standing Woman Playing Lyre)
Published in *Ver Sacrum*, vol.IV, 1901
Colour lithograph, 17.5 × 9
Albertina, Vienna

embodied more incisively than in the skeletal, cowering, female figure personifying Nagging Care. The programme of the frieze – as Marian Bisanz-Prakken has shown [7] – closely matches Richard Wagner's description of Beethoven's *Ninth Symphony*.[8] When it came to his reinterpretation of Beethoven's Ninth in Dresden in 1846, Wagner felt the need to write descriptive programme notes that would help the ordinary listener to cope with the piece. In these notes he described the images that arose from his own experience of hearing the work and used a poem by Goethe as a framework for his analysis of the four movements of the symphony.[9] His interpretation of the main theme of the first movement could certainly have served as a source of inspiration for Klimt's design for the left wall and the back wall. Wagner wrote:

> a struggle on the most magnificent level by the soul striving for joy against the pressure of that hostile force that inserts itself between us and earthly happiness ... Faced with this mighty enemy we recognise in ourselves a noble defiance, a masculine spirit of resistance that ... rises to the point of open combat with his opponent, and it is as though we are witnessing two doughty wrestlers ... Every so often we catch a glimpse of the wistfully sweet smile of the happiness ... that we are battling to grasp hold of and that our enemies slyly prevent us from attaining ... and we sink back into dark brooding, that only spurs us on again to defiant resistance, to grapple again with that daemon come to rob us of joy. [At the close of the first movement] it seems that this sombre, joyless mood, growing to gigantic proportions, embraces the entire universe ... [10]

The 'soul striving for joy' is reflected in the motif of the floating figures ('the longing for happiness') that emerge 'every so often' behind the Hostile Powers. The 'masculine spirit of resistance' is as it were embodied in the figure of the knight, struggling against the demon Typhon who has now taken on 'gigantic proportions'. For Wagner, elements of the second movement can be read as portrayals of earthly lusts, which could be said to match Klimt's personifications of temptation. That these earthly lusts are ultimately unmasked as no more than 'narrowly constrained amuse- ment' such that the human being is driven to resume his search for deeper happiness is Wagner's interpretation,[11] corresponding to Klimt's reprise of the motif of the floating figures at the beginning of the right-hand wall ('human longings and desires fly out over it'). Klimt continues the motif of the floating figures throughout the first third of the right wall until they come up against a golden wall above a female figure playing a cithara, entitled 'the longing for happiness is allayed in poetry' in the catalogue. This is followed by a section of wall, not decorated by Klimt, with an opening that allows the viewer to look through to Max Klinger's sculpture of

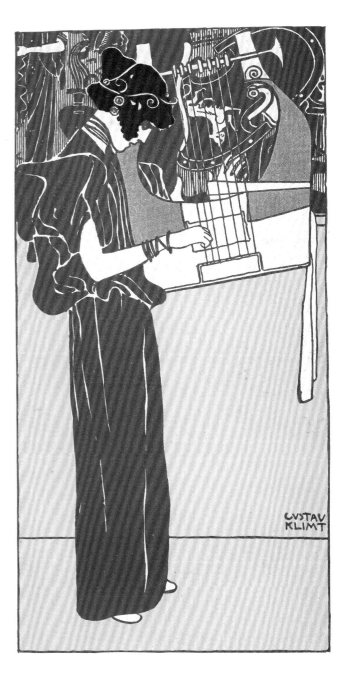

59
Alfred Roller
*Poster for the Fourteenth
Secession Exhibition (The Beethoven
Frieze Exhibition)* 1902
Colour lithograph, 95.5 × 63
Wien Museum, Vienna

Beethoven (fig.62). The last section of the frieze is devoted
to the 'arts' that lead us 'into that ideal realm, the only place
where we can find pure joy, pure happiness, pure love'. Klimt
represented the 'ideal realm' as two lovers, embracing fondly
and surrounded by a 'chorus of angels of paradise'. In the
catalogue Klimt's figures are accompanied by the lines,
'Freude, schöner Götterfunke. Diesen Kuss der ganzen Welt!'
(Joy, beautiful spark of Gods. This kiss for the entire world!)
from Schiller's 'Ode to Joy', set by Beethoven in the fourth
movement of his *Ninth Symphony*. For Wagner the special
quality of this symphony comes from the 'addition of language
and the human voice' in the last movement.[12] Beethoven
combines the music with the human voice and in so doing
reaches new heights in his work. Comparing Wagner's reading
of Beethoven with Klimt's frieze, the figure playing a cithara
personifies the music that the creator, Beethoven – clearly
in view in the central room – combines with the human voice,
which is in turn portrayed in the 'chorus of angels of paradise'
in the last section of the frieze. The interpretation of the
cithara-playing figure as Poetry, allaying human beings' longing
for happiness, is disconcerting. In Wagner's description of the
third movement of the symphony there is no passage that
could be linked to the figure who is given the name of 'Poetry'
in the catalogue. Meanwhile, earlier representations of the
theme of 'music' in Klimt's œuvre bear a close resemblance
to the female figures in the *Beethoven Frieze*. The earliest
example of a woman with a cithara is seen in the sketch of
a soporta (a panel over the door) made in 1895 and entitled
'Music'; Klimt realised the finished version in Nikolaus Dumba's
music salon in the Schloss Immendorf in 1897–8, but the
castle was destroyed by fire in 1945. The same motif appears
again, with the name 'Music', in a print reproduced in 1901
in the Secession journal *Ver Sacrum*, which was then in
its fourth year (fig.58). If one reads the figure playing the
cithara as an allegory of music, then the images in the frieze
work as a self-contained sequence in keeping with Wagner's
description of the symphony.

It may be that the reason for the figure with the cithara
being equated with Poetry lay in the basic concept of the
exhibition and its declared aim to realise a Gesamtkunstwerk.
Architecture, painting, sculpture, music and poetry are
all represented in both the form and the content of the
Beethoven Frieze. The exhibition architecture is not only
a fixed support for Klimt's frieze but also more generally
for the other planimetric works in the Beethoven exhibition.
Klimt worked directly on the dry plaster, so that in a sense
his frieze could be described as an architectural 'temple
ornament'. The technique he employed for this piece did
not only involve painting. He also used drawing utensils, which
took him into the area of graphic art, and applied decorations
and glass to it, as an artist-craftsman would do. The visual
link, allowed by the architecture of the room, through to
Klinger's Beethoven sculpture, created a connection with
the plastic arts. Beethoven himself represents music.

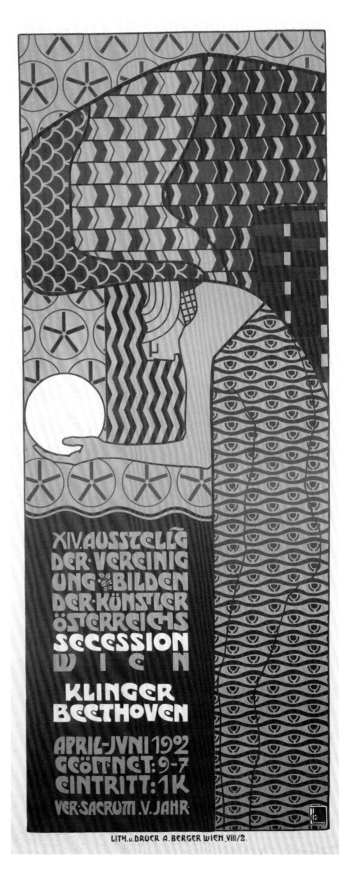

By interpreting the figure with a cithara as Poetry, the author of the catalogue was pointing to the role of the art of writing, and specifically to Schiller's 'Ode to Joy' which is itself at the heart of Beethoven's *Ninth Symphony*. This multifaceted interplay of associations arising from the *Beethoven Frieze* brings together all the main genres of art. If one reconstructs the vista from the Beethoven sculpture in the central room back through to the left side-room, one's gaze meets the Knight in Shining Armour.[13] This visual analogy between Beethoven as an artist and a Knight in Shining Armour rather suggests that the knight can be read as an artist able to lead humankind into the 'ideal realm'. The status enjoyed here by the artist and art has echoes of Nietzsche's 'artists' metaphysics'. The *Gesamtkunstwerk* was rounded off on the evening of the opening with Mahler's arrangement for wind instruments of themes from the fourth movement of Beethoven's *Ninth*. Wagner's writings were highly regarded by the Secessionists. However, so far it has not been possible to identify who was responsible for the consideration given to Wagner's ideas in the context of the fourteenth exhibition. The evidence would suggest it may have been Alfred Roller, who was a key figure in the organisation of the Beethoven exhibition.[14] During the early years of the Secession's exist-ence, Roller played a leading role in the formulation and mediation of its intentions. As the editor of *Ver Sacrum*, he set great store by clarity and lucidity of meaning in any text, and liked to cite the writings of the Hamburg art theorist Alfred Lichtwark as examples of good writing, praising the 'accessibility, urgency and plasticity' of his style and his 'entirely non-philosophical, always concrete language'.[15] At the time of the opening of the Beethoven exhibition in 1902, the Secessionists had already withdrawn from their role as 'public art educators' whose aim was to sensitise the Viennese public to trends in contemporary art.[16]

The distinctly didactic structure of the catalogue, which reflects a desire to communicate the concept of the presenta-tion to the exhibition visitor, attests to the importance of the role played by Roller. The idea of proposing a fixed route through the exhibition so that the visitor could take in its drama and experience it as a whole is indicative of qualities that Roller was to manifest later on in his career. It is known that Roller met Gustav Mahler (Director of the Court Opera at the time) at the Beethoven exhibition. In 1903 Mahler engaged Roller as a set designer.[17] Both Mahler and Roller were interest-ed in Wagner's work. If one looks at the programme of the motifs in the matching frieze in the right-hand side-room, it appears that passages from Wagner's description of the fourth movement of Beethoven's *Ninth Symphony* are even more relevant to this work than they are to the *Beethoven Frieze*.[18] It therefore seems possible that Wagner's text was suggested by Roller as the broad basis of the artistic concept for the exhibition as a whole. In view of the role of Max Klinger – who had been in contact with the Secession ever since its founding – it seems there can be no doubt as to the direct influence of Wagner's interpretation of Beethoven's *Ninth Symphony* on the fourteenth exhibition in general and on the *Beethoven Frieze* in particular.

From the outset, the artists of the Secession[19] were aware that they were creating works that would only exist for the duration of the exhibition. This explains Klimt's use of a pragmatic, cost-effective secco technique[20] that allowed him to transfer his working sketches (fig.55) to the wall without the usual time constraints. However, even while the exhibition was still on, supporters of the Secession spoke out against the imminent destruction of the frieze.[21] Despite the deliberately ephemeral nature of the presentation, the works on show were also offered for sale.[22] It seems, as Erich Lederer recounted,[23] that the frieze was bought in June 1902, before the exhibition closed, by the art patron Carl Reinighaus. Klimt's work remained in the Secession[24] until Klimt's one-man show in November–December 1903, when it was taken down in order to prevent it being damaged; it was divided into sections and placed in storage in a repository in Michelbeuern in the tenth (Währing) district.[25] The reason that the frieze remained in situ until 1903 most probably has to do with storage issues, and we know from a statement by Apard Weixlgärtner[26] that the frieze stayed in Michelbeuren until 1912. In 1915 the frieze was bought by the Lederer Family.[27] When it came to the Klimt memorial exhibition in 1928, the original intention was that the whole *Beethoven Frieze* should be shown. However, Serena Lederer turned down the exhibition organisers' request. It was only when she was approached by Josef Hoffmann and Carl Moll, supported by Erich Lederer, that she agreed to lend at least the panel showing the Hostile Powers. In the run-up to the exhibition, the panel was divided in two by Fritz Wotruba and Franz Ullmann in order to prevent any damage being done to it during the transportation process, only for Serena Lederer to insist – at her 'express wish' – that it be returned to her even before the exhibition opened.[28] In 1936, because of changes to the space and partial damage, the frieze could no longer be shown in its original configuration and was present-ed on four walls instead of on the original three walls.[29] During the war, after the 1943 exhibition,[30] poor storage conditions led to the frieze suffering yet more damage. Following its purchase by the Austrian Republic, the frieze was released for restoration in 1973 and presented in the Künstlerhaus in 1985. Finally, it returned to its first home in Friedrichstrasse[31] in the original exhibition space of the Viennese Secession.

Eva Winkler
Translated from the German by Fiona Elliott

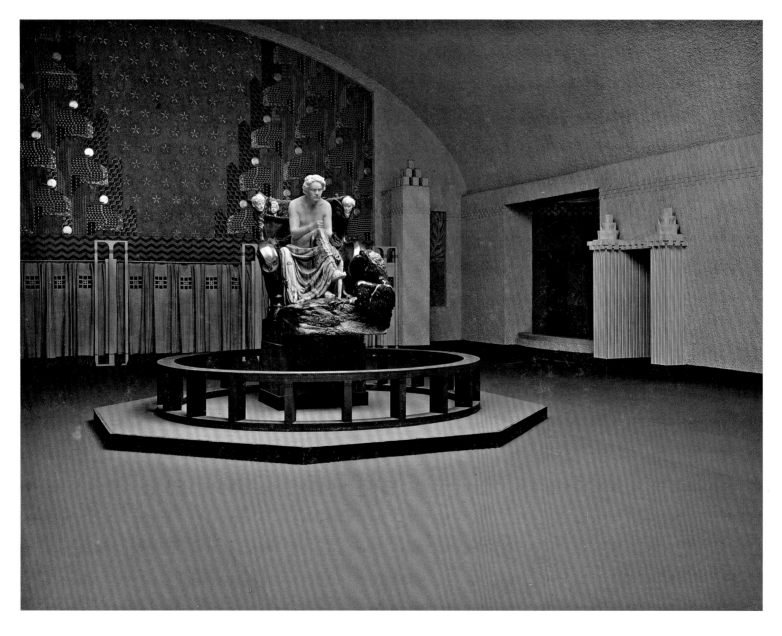

The Beethoven Frieze

60, 61
*The Fourteenth Secession
Exhibition*
1902
Vintage prints
Each: 17.9 × 25.5

Exhibition includes works
by Ferdinand Andri, Josef Maria
Auchentaller, Rudolph Jettmar,
Othmar Schimkowitz, Leopold
Stolba, Richard Luksch, Fritz König,
Emil Orlik, Koloman Moser,
Maximilian Lenz, Ernst Stöhr
and others
Österreichische Nationalbibliothek –
Bildarchiv, Vienna

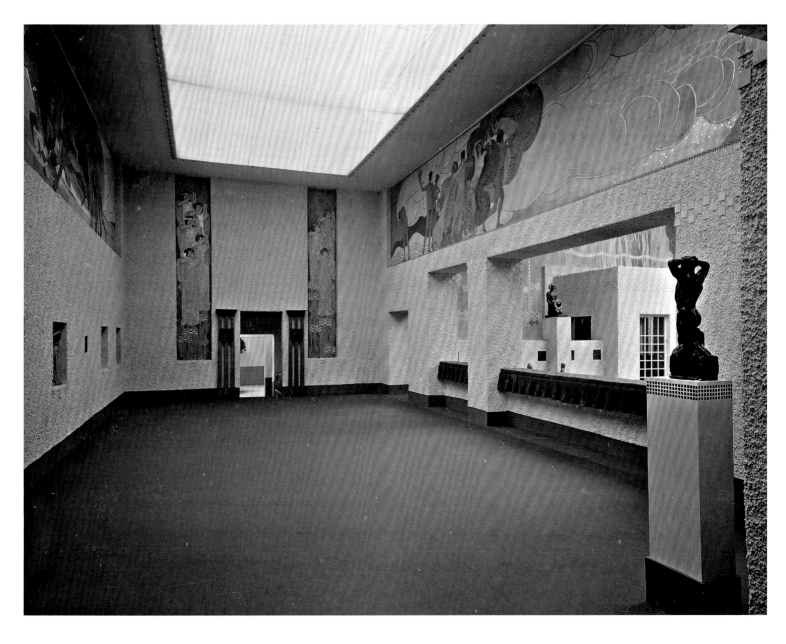

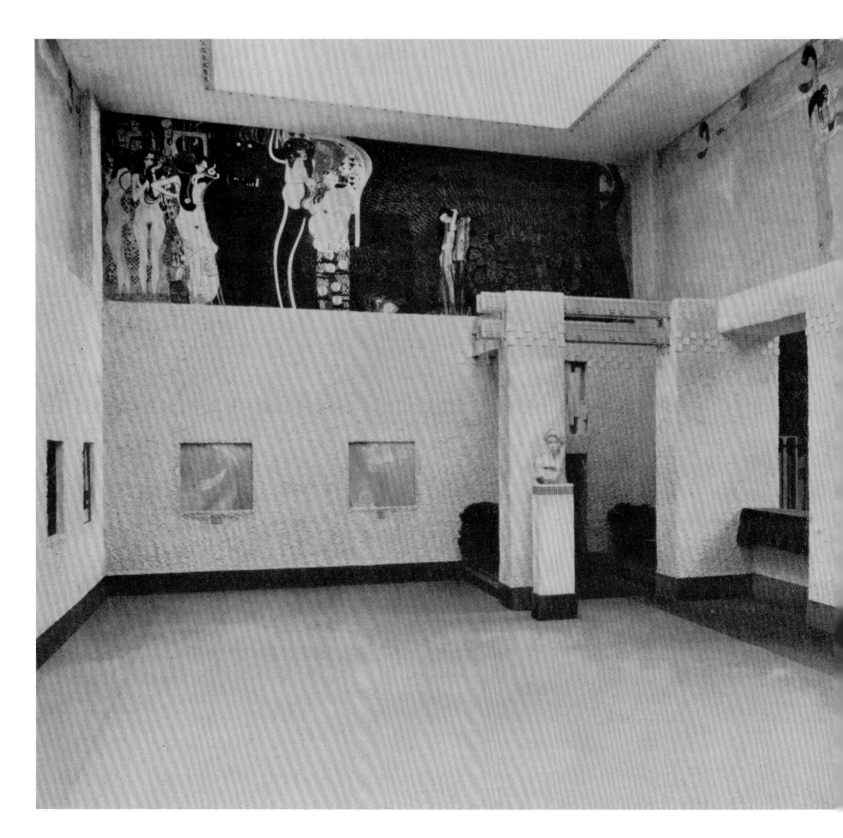

The Beethoven Frieze

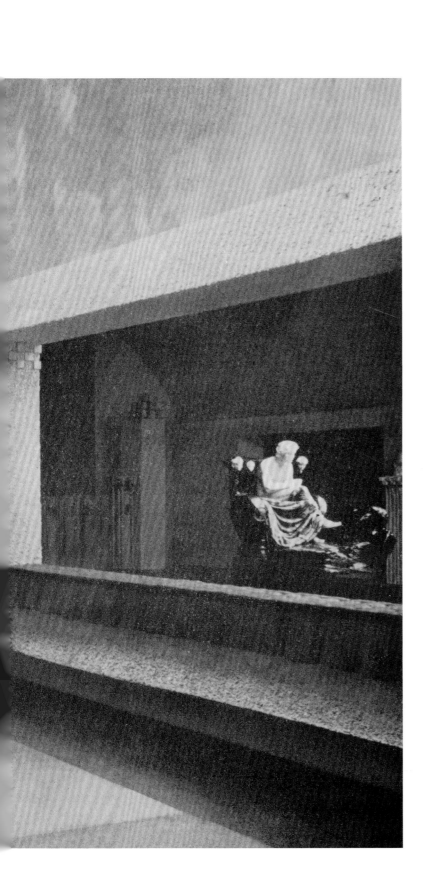

62
Klimt Room of the Fourteenth Secession Exhibition 1902
Vintage print
Belvedere, Vienna

Hostile Powers segment (end wall), figure of Poetry (right wall), and view through the opening to Klinger's *Beethoven* in the central space.

Overleaf: detail of fig.65
The Hostile Powers: (from left to right) two of the Three Gorgons, Typhon, Lewdness, Lust and Excess

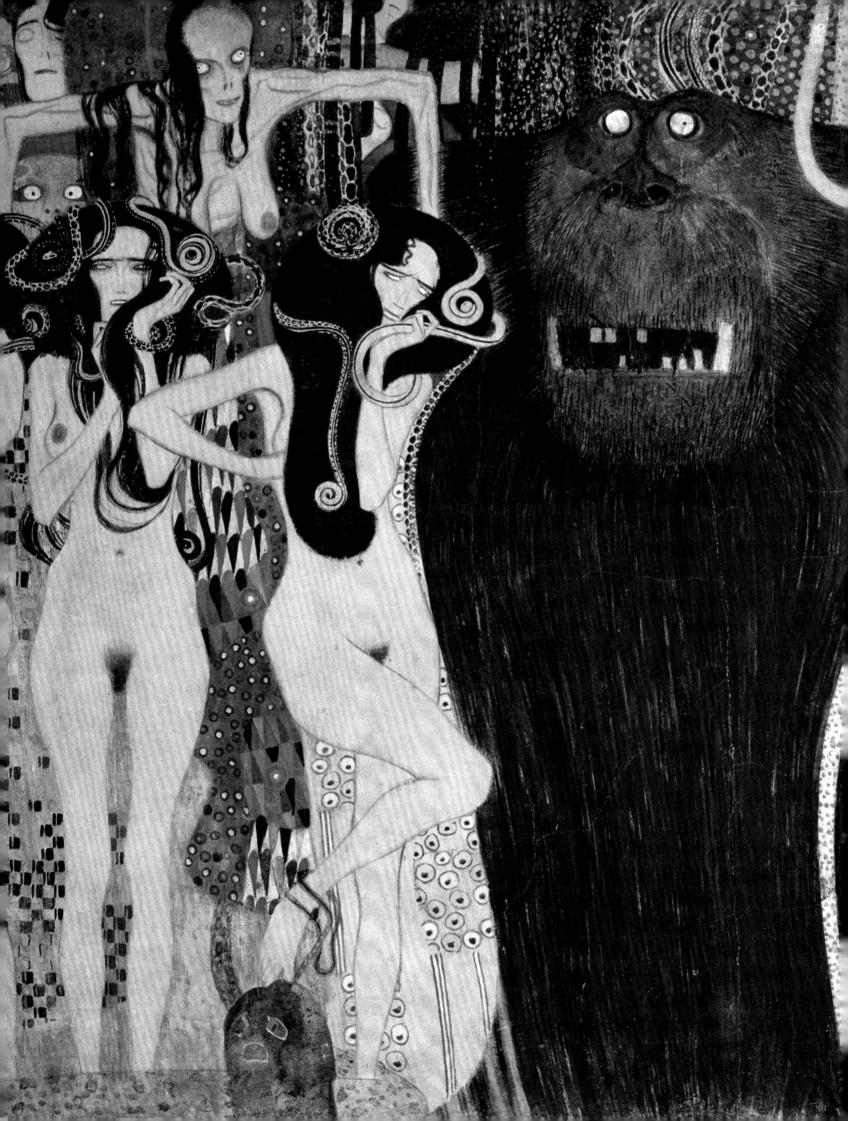

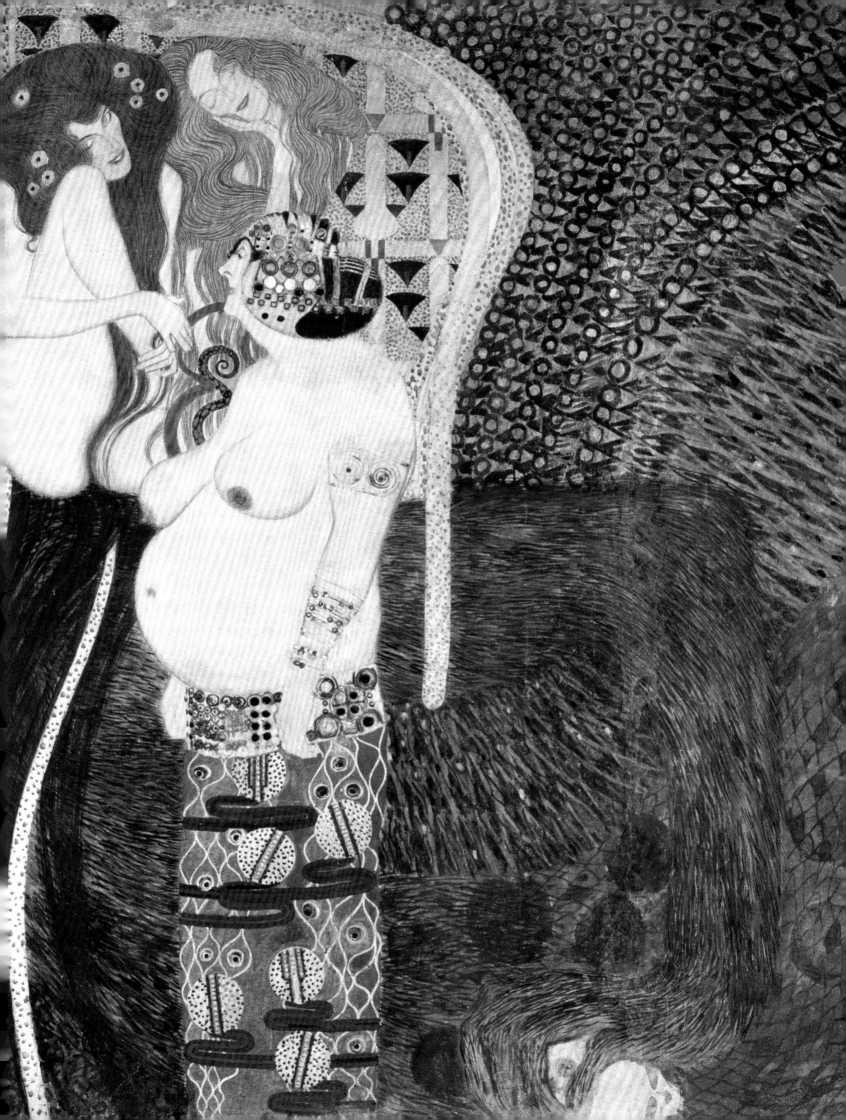

63
Gustav Klimt
Two Sketches for the Three Gorgons
for the Beethoven Frieze 1901–2
Pencil on paper, 29.9 × 39.7
Albertina, Vienna

64
Gustav Klimt
Composition Sketch
with Central Gorgon
and Two Other Heads 1902
Black chalk and wash
on paper, 43.5 × 31
Wien Museum, Vienna

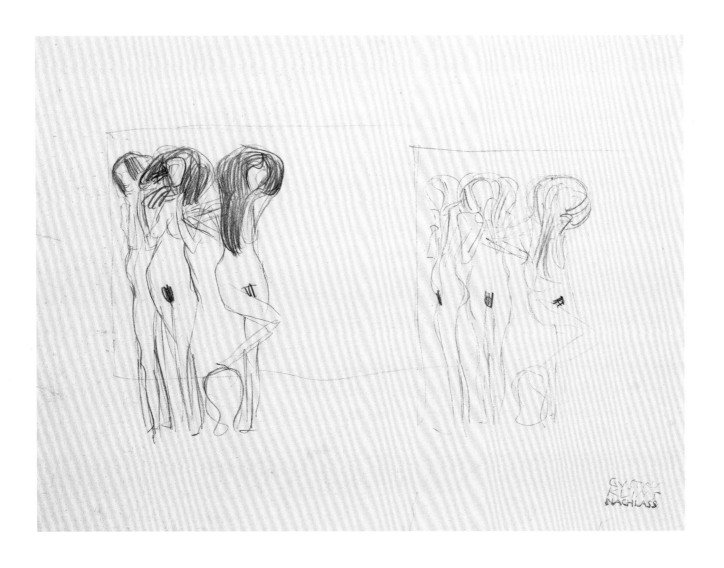

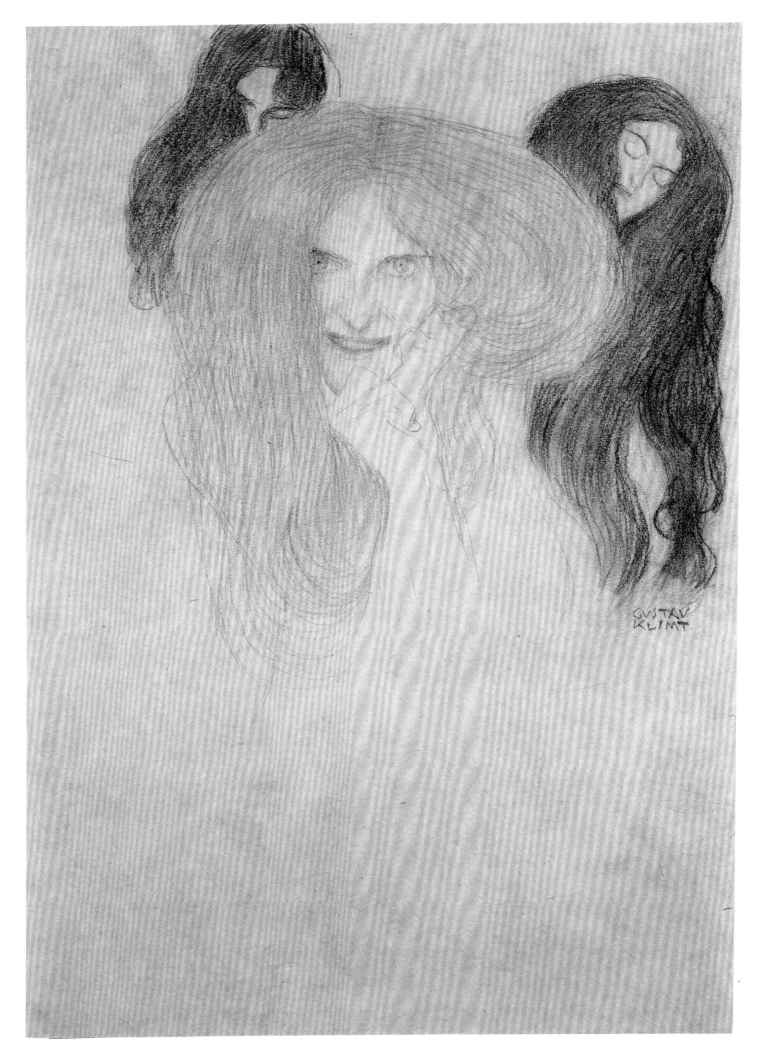

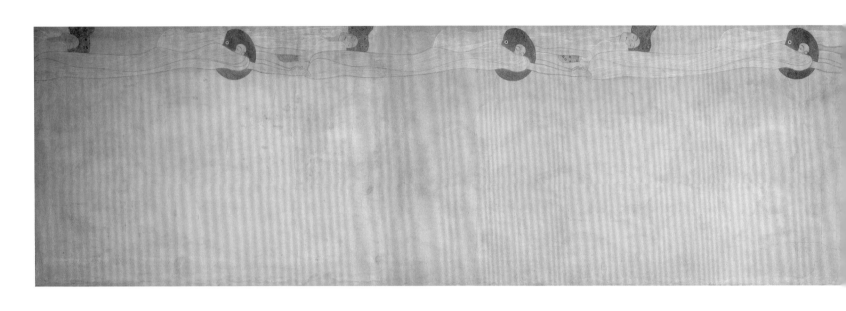

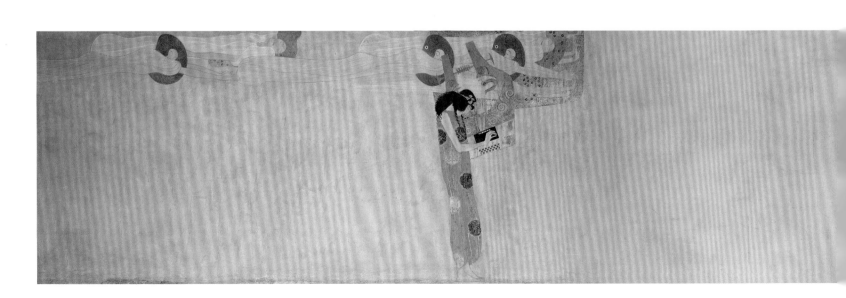

The Beethoven Frieze

65
Gustav Klimt
The Beethoven Frieze 1901–2
Casein, gold foil, chalk, graphite,
plaster with decorative applications
including gilded gypsum, coloured
gem stones, curtain rings and
mother of pearl disks

Overall length 34.14m
(left and right walls 13.92m; front
wall 6.30m; height 2–2.15m)
Belvedere, Vienna

Overleaf: detail of fig.65, the
'Kiss for the Whole World'

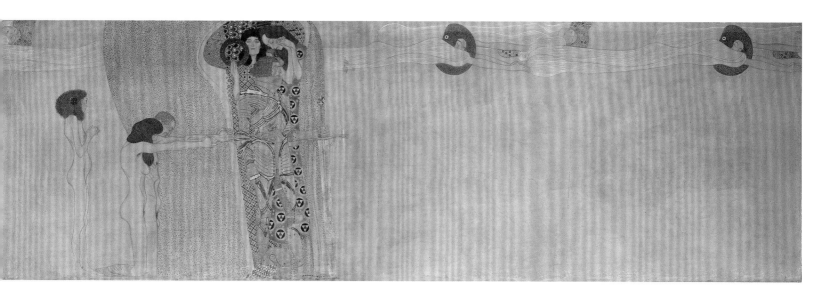

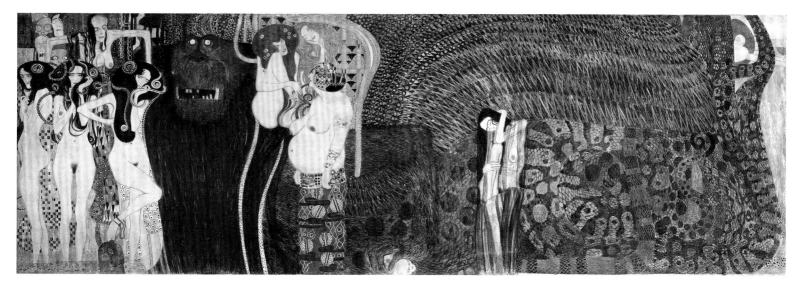

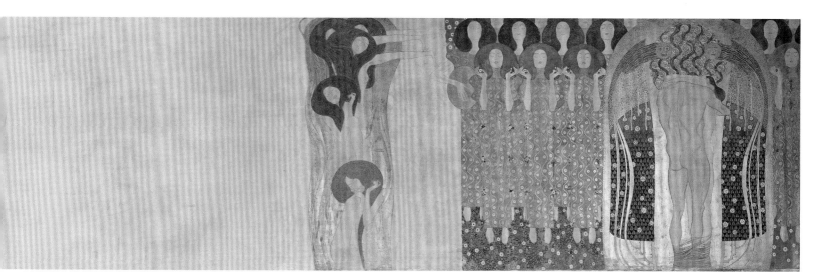

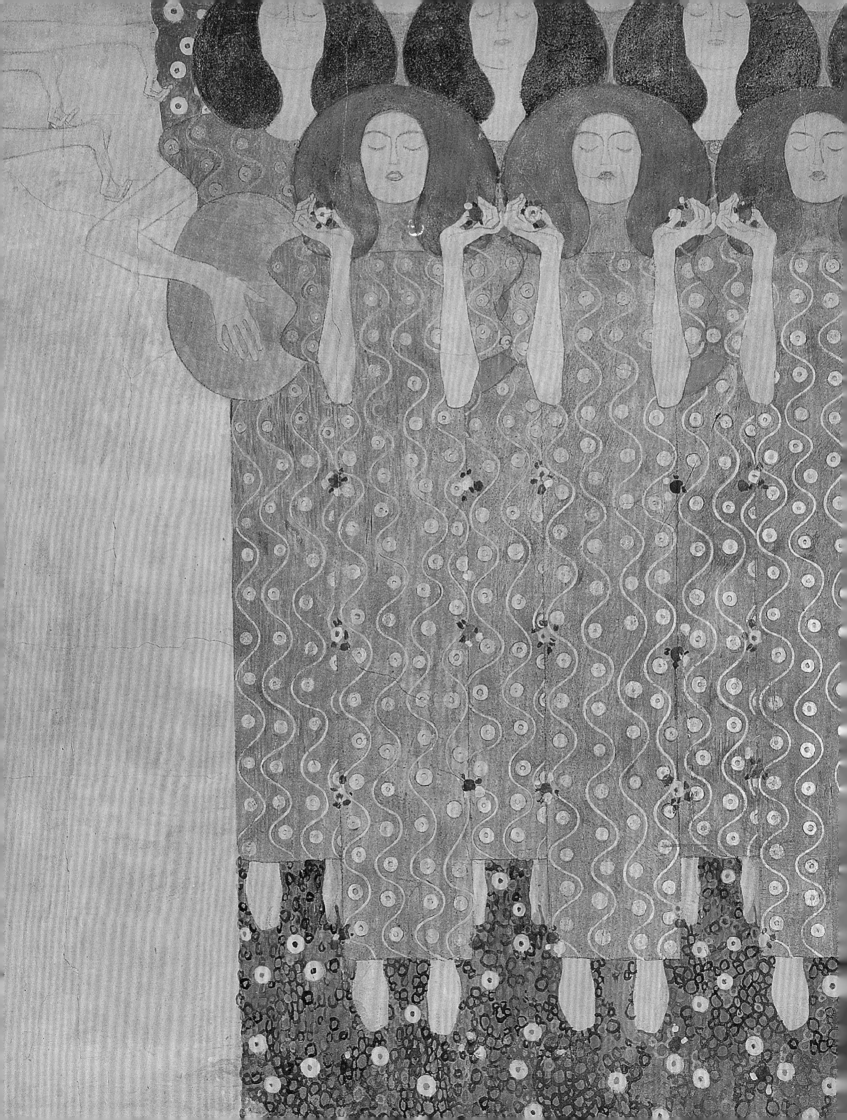

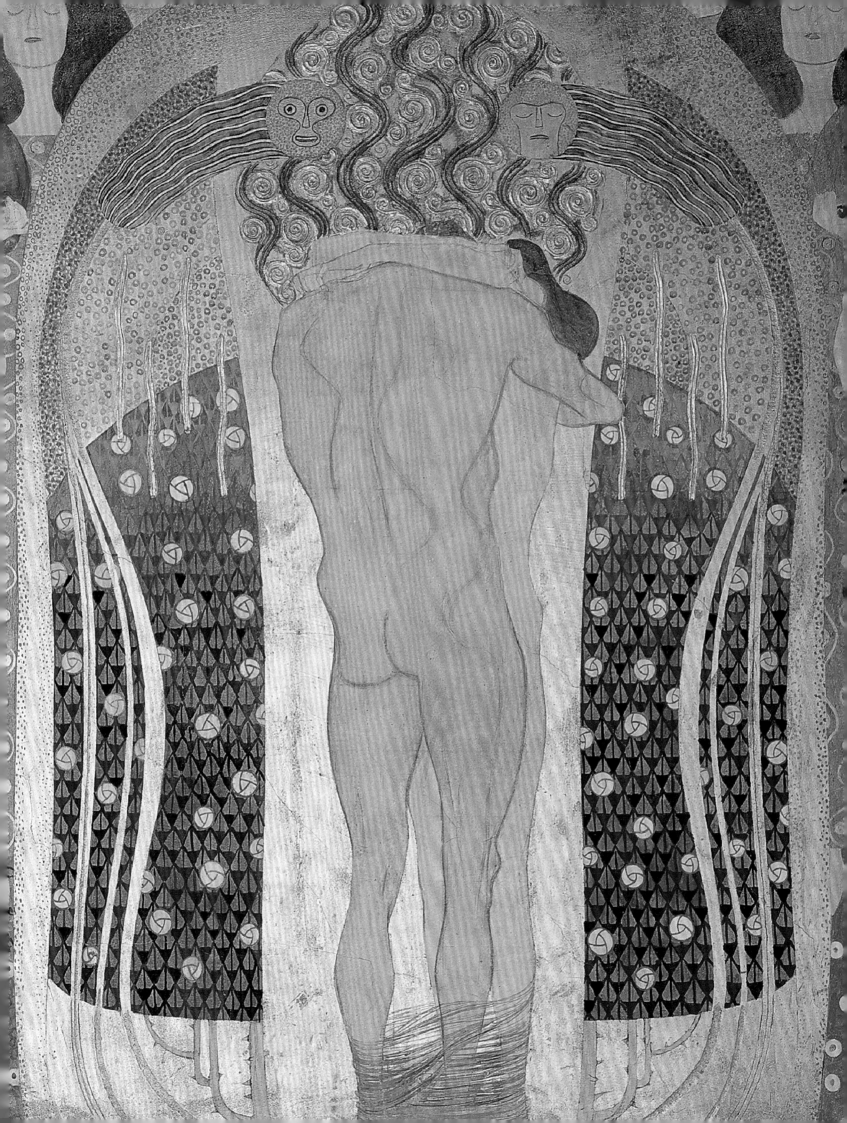

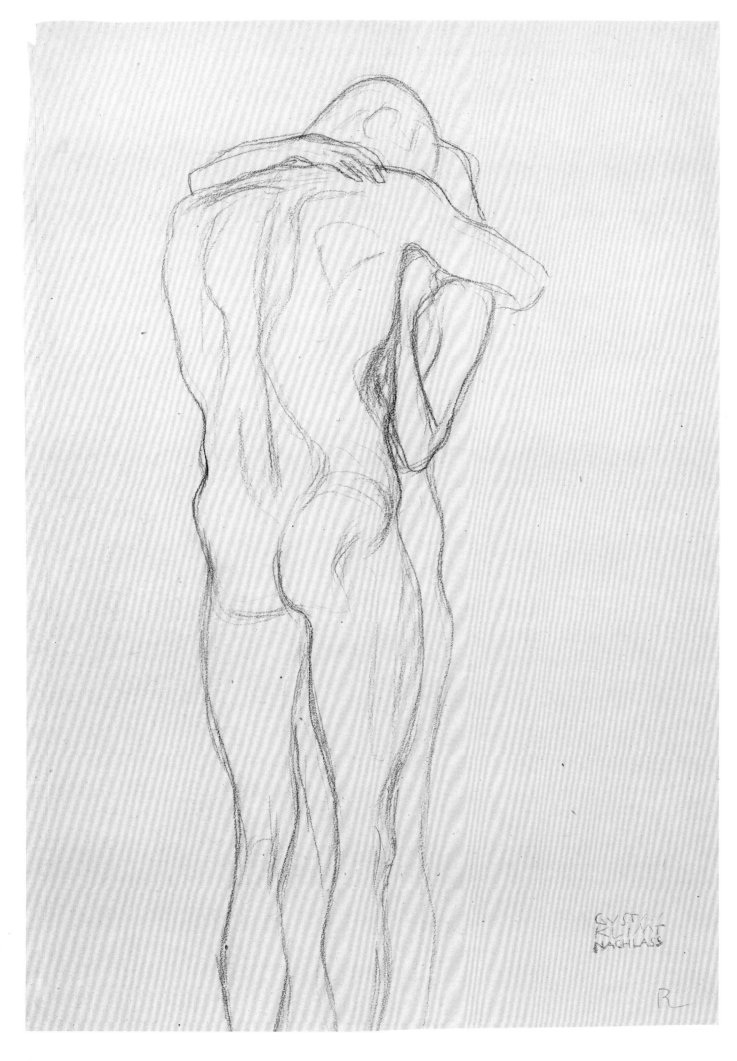

The Beethoven Frieze

66
Gustav Klimt
Embracing Lovers – Beethoven Frieze 1901–2
Black chalk on paper, 45 × 30.8
Albertina, Vienna

67
Gustav Klimt
Study for the Figure Nagging Care – Beethoven Frieze 1901–2
Black chalk and pencil on paper 39.8 × 29.9
Albertina, Vienna

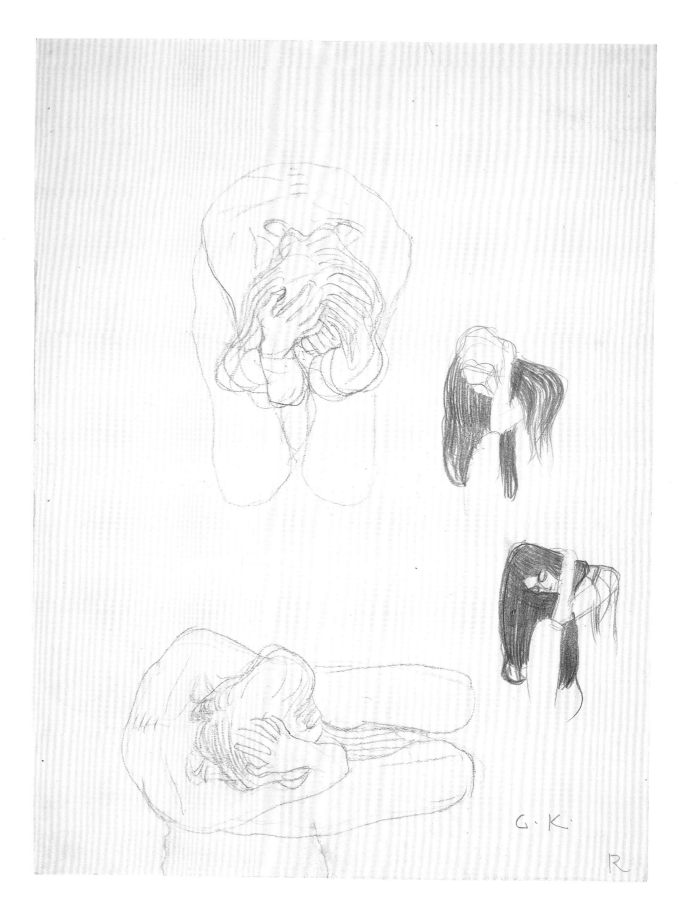

The Wiener Werkstätte

The central purpose of the founding, in 1903, of the Wiener Werkstätte (Viennese Workshop) was, according to the 'programme' recorded two years later, to bring designers, craftsmen and the public closer together through the production of objects whose aesthetic virtue lay in their simplicity and functionality. The 'public' was in this case to prove an exclusive one; the internal structure of the association was to remain hierarchical; organisation and financing were to be much disputed; and simplicity and functionality were not always especially prominent after the very early years. In the final reckoning, however, there could be no doubt that the Wiener Werkstätte had made its mark, be it in Vienna or beyond, even if most of its successes were scored during the first of its three decades (it endured until 1932), before the major re-structuring and re-financing of 1913–14. Of its three founders, the architect-designer Josef Hoffmann, the designer and painter Koloman Moser, and the wealthy textile manufacturer Fritz Waerndorfer (see also pp.118–31), only the first was still associated with the Wiener Werkstätte after 1914.

The Wiener Werkstätte drew its inspiration from many sources, both international and local. Of particular ideological importance was the notion of the 'craft guild', as embodied in Charles Robert Ashbee's British Guild of Handicrafts; and the work of the Glasgow team of Charles Rennie Mackinstosh and Margaret Macdonald Mackintosh provided Hoffmann in particular with an example that encouraged him in the style towards which he was already progressing. Of key importance within Vienna was the founding of the Viennese Secession in 1897 and the publication, from 1898, of its journal *Ver Sacrum* (see pp.60–79), followed by its international exhibition of 1900 surveying new developments in design. Further factors were the advent of a more liberal ethos at the Viennese Kunstgewerbeschule (School of Applied Arts), where Hoffmann and Moser both taught from 1899; Hoffmann's first experiments in creating a domestic architecture truly suited to 'modern life' at his Hohe Warte villas (see pp.132–48); and Moser's early expertise in two-dimensional (graphic and textile) design.

The crucial catalyst was the generous financial backing supplied by Fritz Waerndorfer, whose pre-established deep interest in design, role as a mediator between Vienna and Great Britain, and eagerness to support Hoffmann and Moser brought about the establishment, in June 1903, of a series of workshops (including facilities for metalwork and for book-binding) in Neustiftgasse, west of the city centre. As the workshops grew in number (one for woodwork was added in 1904, and the first textiles were produced in 1905) and contracts were agreed with outside manufacturers (among the first being Prag-Rudniker for furniture and Bakalowits & Söhne for glassware), an ever greater diversity of items could be included in the display galleries incorporated within the Neustiftgasse premises (fig.75), as also in other Wiener Werkstätte exhibitions: in 1904 at a leading Berlin department

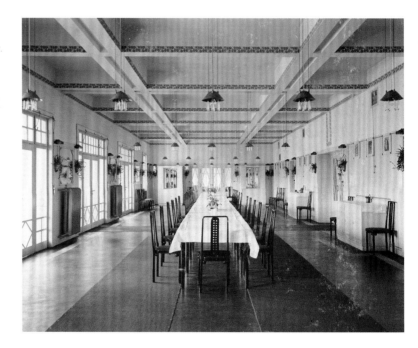

store, and in 1905 at the second, Graben branch of the Galerie Miethke (for which Hoffmann also provided a new interior).

While continuing to produce a wide range of individual objects for sale or on commission (figs.69, 76, 103, 159), Wiener Werkstätte members also contributed, each in his own field, to a series of major collaborative projects, most of these centred on architectural and design commissions received by Hoffmann. Here, their own input and that of their regular manufacturer associates increasingly coexisted with the contribution of those maintaining a looser, temporary working relationship, be it as designers, makers or autonomous workshops. The varied character of the output of the Wiener Werkstätte necessarily reflected this situation. But it was above all a reflection of the evolving stylistic preferences of Josef Hoffmann.

The early, 'purist' style of the Wiener Werkstätte was to be found at the sanatorium at Purkersdorf (1904–5, figs.68, 70, 71, 72), around fifteen kilometres west of Vienna, commissioned by the industrialist Viktor Zuckerkandl. Hoffmann here combined up-to-date construction, using ferro-concrete, with a restrained elegance in design that enabled him to counter an appropriate emphasis on modern hygiene with the traditional reassurance of extreme comfort. With the chief exception of the painted plaster figural reliefs flanking the principal entrance, by Richard Luksch, a strict rectilinearity prevailed, ornament being limited to geometrical pattern and colour being used sparingly and to specific ends. In the emphatically uncluttered dining room (fig.68), flooded by daylight entering through a glazed veranda, a reddish-brown carpet and Hoffmann's partially steam-bent beech-wood chair with red oilskin seat (made by J. & J. Kohn) provided a compensating warmth.

Even before the departure, in early 1907, of Koloman Moser (after disagreements with Waerndorfer), and his effective replacement by Eduard Josef Wimmer-Wisgrill, who was later to head a fashion department, the Wiener Werkstätte entered an 'ornamental' phase (figs.158, 145), further encouraged in this direction by other new associates of Hoffmann, such as the ceramicists Michael Powolny and Bernard Löffler. With time, this became more restrained: colour was still important but was now accompanied by both the glamour of luxurious materials and the rigour of Hoffmann's emerging interest in Neo-Classicism. The peak of this development was reached at the Palais Stoclet (1905–11; figs.26, 82), built on the eastern outskirts of Brussels for Adolf Stoclet, the son of a wealthy Belgian banker. This was to incorporate major works by Gustav Klimt and other autonomous collaborators.

The opulence of the chief interiors of the Palais Stoclet was enhanced through contrast with the daringly 'plain' aspect of the exterior: its cladding, in large slabs of white Norwegian Turili marble, with each façade 'framed' in blackened gilt chased-metal moulding. Meanwhile, the breath-taking pillared and galleried Great Hall and the adjacent dining room housing Klimt's mosaic frieze (fig.81) achieved a seductive accumulation of superbly worked luxurious materials, from the walls faced in honey-coloured Paonazzo marble to the dining table of Macassar ebony polished to a high sheen.

The reorganisation of the Wiener Werkstätte in 1913–14, after the bankruptcy of Fritz Waerndorfer and his replacement, as Commercial Director, by Otto Primavesi (see pp.182–9), heralded a new era in terms of both its activity and its output. Surviving, even expanding and diversifying, during the Great War, from 1919–20 it met with repeated disapproval for its perceived failure to adapt to the greatly changed conditions of post-imperial Austria.

Elizabeth Clegg

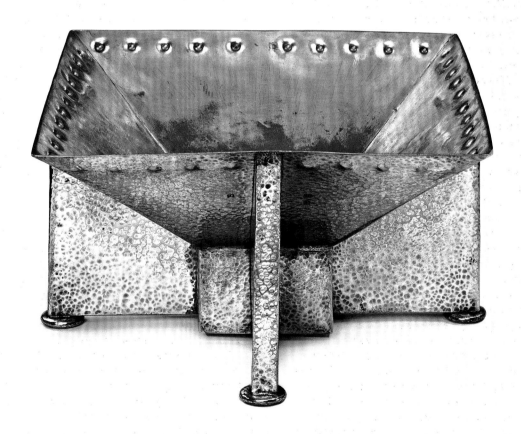

Josef Hoffmann
*Bookcase from the Reading Room at
the Purkersdorf Sanatorium* 1904–5
Made by the Wiener Werkstätte
Oak, silver oak, white painted wood
doors, leaded glass, packfong
171.5 × 39 × 144.3
Ernst Ploil, Vienna

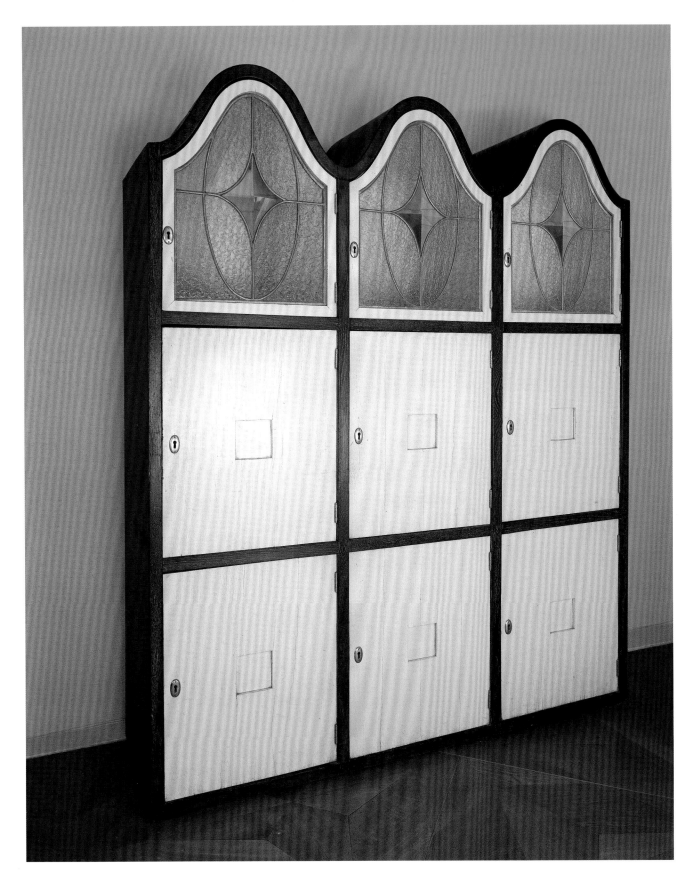

71
Josef Hoffmann
*Sketch for Purkersdorf
Sanatorium* 1903–4
Ink, crayon and pencil
on squared paper, 20.4 × 33.4
Kunsthaus Zug, Stiftung
Sammlung Kamm

72
*Postcard with a view of
Purkersdorf Sanatorium* c.1905
Photo postcard, 9 × 14
Private Collection, Vienna

73
Josef Hoffmann
*Sketch for the 'Kunstschau'
Small Country House* 1908
Ink, coloured pencil and pencil
on squared paper, 33.8 × 20.7
Kunsthaus Zug, Stiftung
Sammlung Kamm

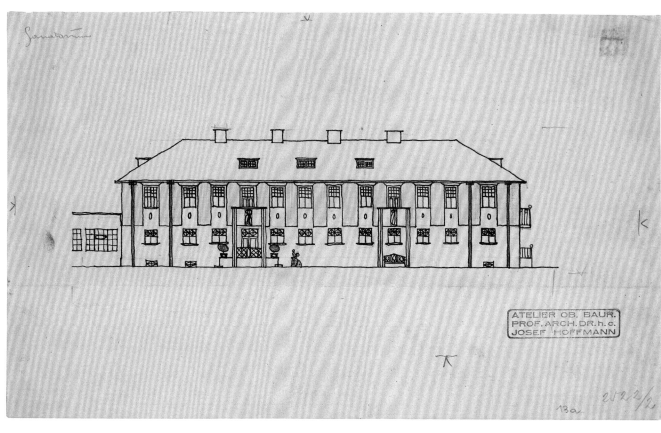

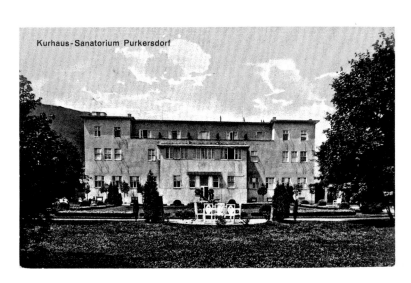

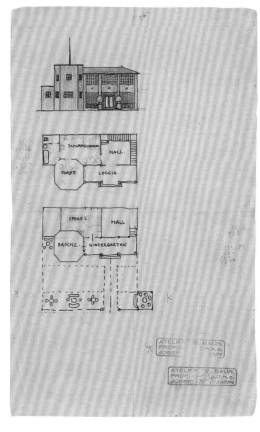

74
Josef Hoffman
Fruit Basket c.1904
Made by the Wiener Werkstätte
Silver, 27 × 23 × 23
Victoria and Albert Museum,
London

75
Reception and Exhibition Room at
the Wiener Werkstätte Headquarters
at 32/34 Neustiftgasse, Vienna 1905
Anonymous photograph
MAK – Austrian Museum of Applied
Arts/Contemporary Art, Vienna

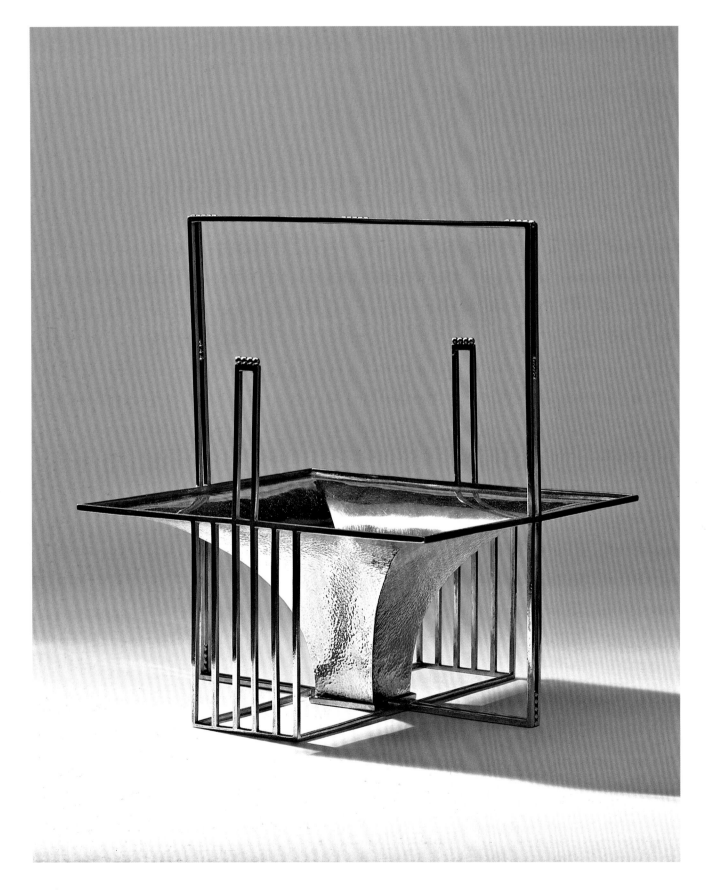

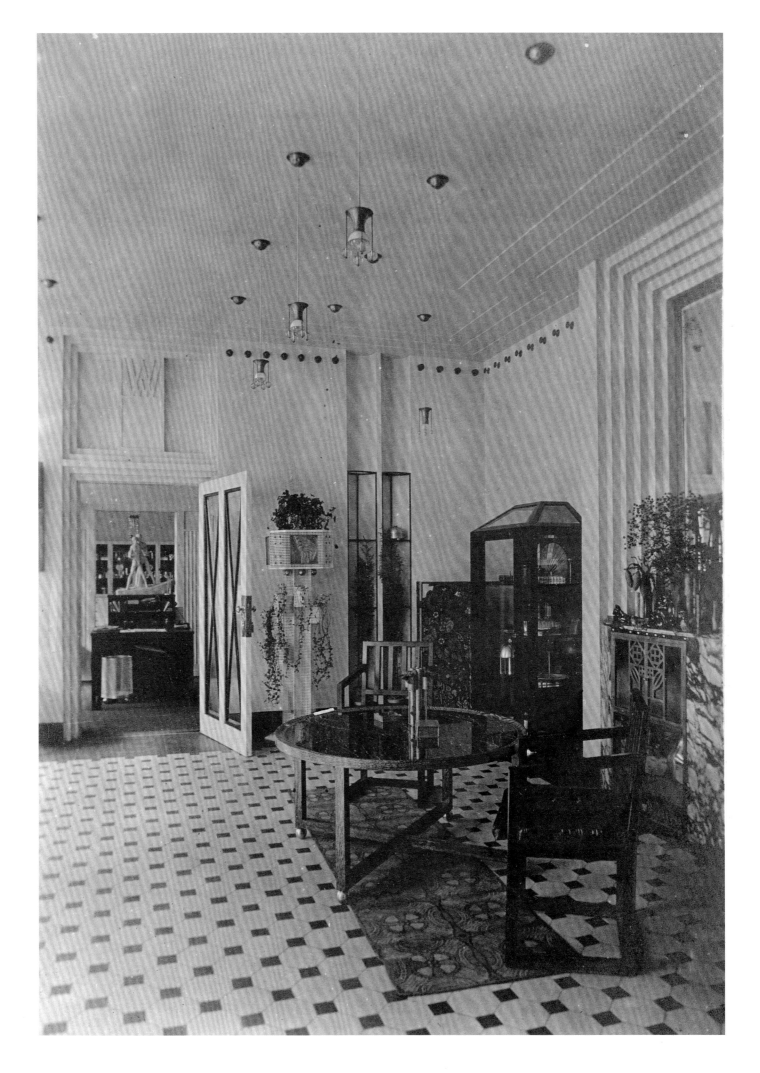

Koloman Moser
*Desk and Integrated Armchair
for Eisler von Terramare* 1903
Made by the Wiener Werkstätte
(Casper Hradzil)
Deal, oak and mahogany, veneers
of thuya wood, inlaid with
satinwood and brass
Desk: 144 × 120 × 60; armchair:
67 × 60 × 60
Victoria and Albert Museum,
London

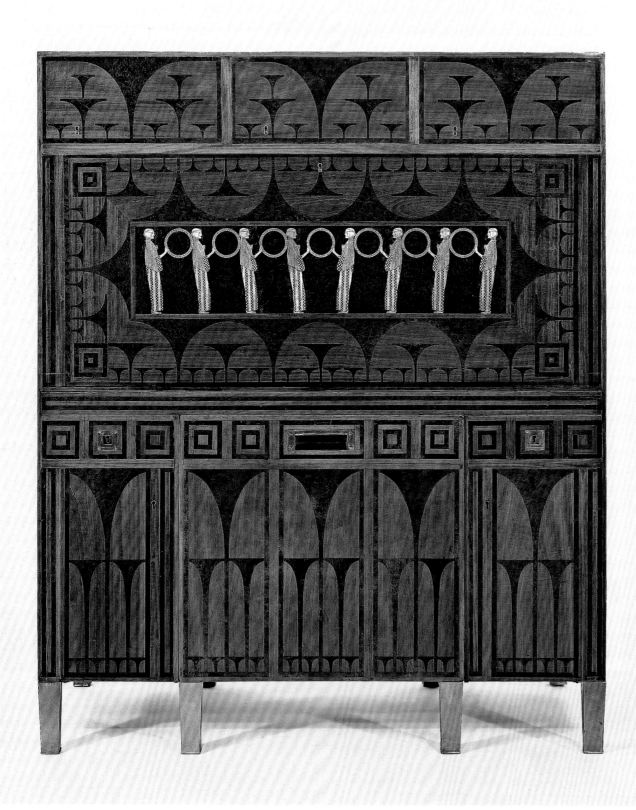

77
Carl Otto Czeschka
Small Box 1906
Made by the Wiener Werkstätte
Wood and leather, 9 × 13 × 13
Ernst Ploil, Vienna

78
Josef Hoffmann
Biscuit Tin made for
Gustav Klimt 1912
Made by the Wiener Werkstätte
(Alfred Mayer)
Silver, gilt and ivory
Height 18.5
From the Estate of Gustav Klimt
Private Collection

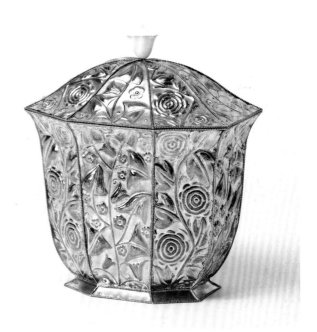

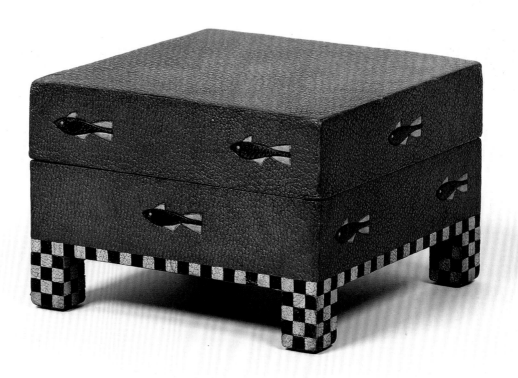

79
Josef Hoffmann
Adjustable Armchair c.1908
Made by J. & J. Kohn, Austria
Steam-bent beechwood frame,
stained mahogany colour,
plywood geometric pattern,
brass pole, 110 × 62 × 83
Victoria and Albert Museum,
London

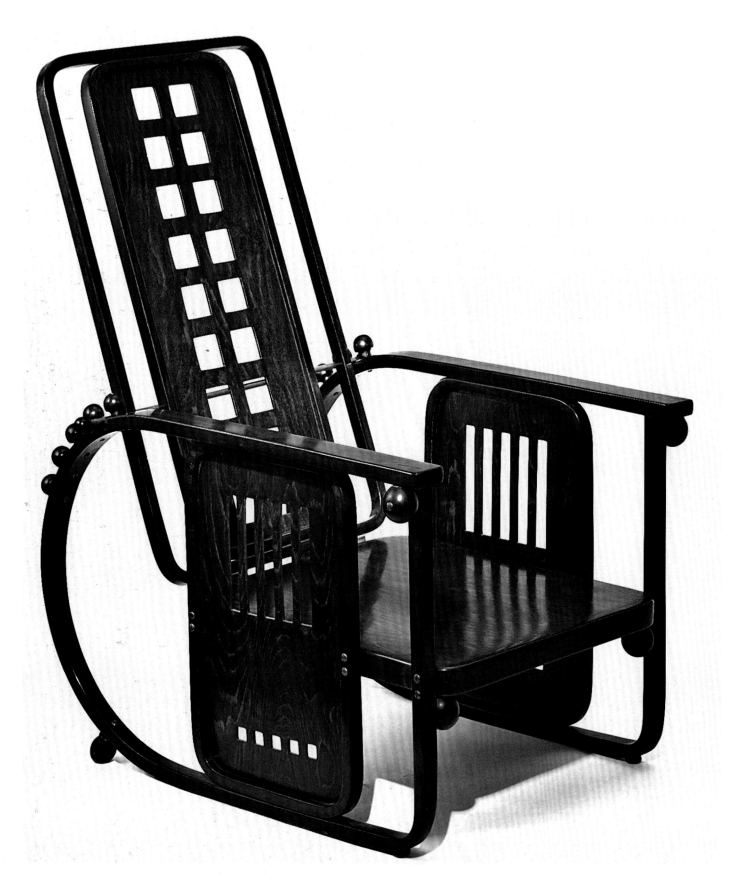

The Wiener Werkstätte

80
Josef Hoffmann
Smoking Table 1910
Made by the Wiener Werkstätte
White enamelled zinc (re-finished)
with a light grey-blue top, 68 × 41
Victoria and Albert Museum,
London

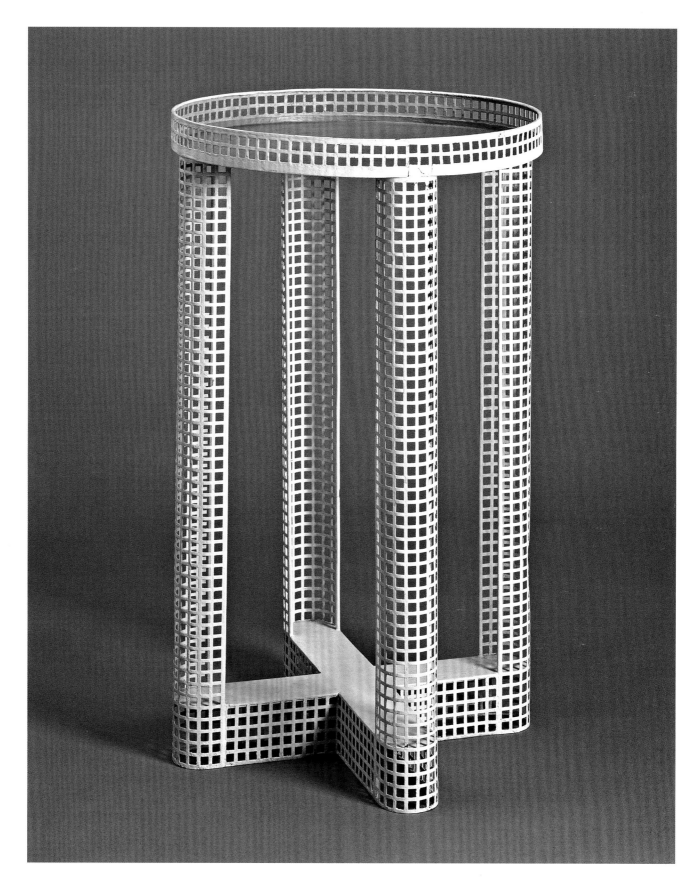

81
Gustav Klimt
Schematic Drawing for the Stoclet
Frieze, Left Wall 1905–11]
Blueprint squared for enlargement
Indian ink on paper, 21.9 × 75.3
Wien Museum, Vienna

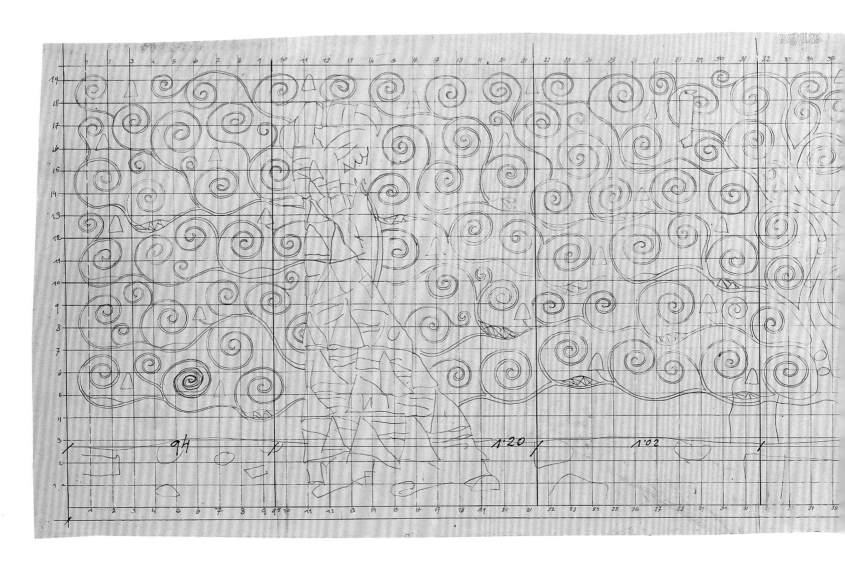

82
Josef Hoffmann
*Sketch for the Ground Floor
of the Palais Stoclet* c.1906
Pen and ink on paper, 20.5 × 31
Kunsthaus Zug / Sammlung
Kamm

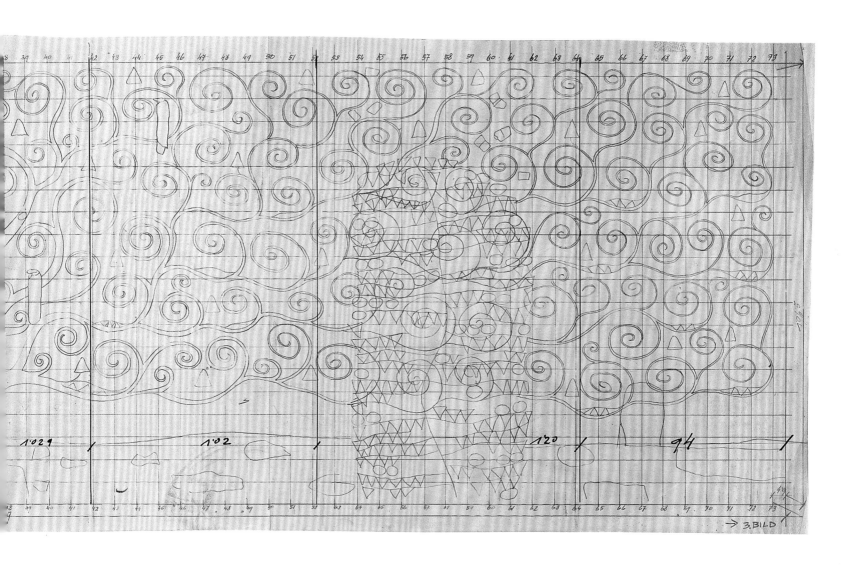

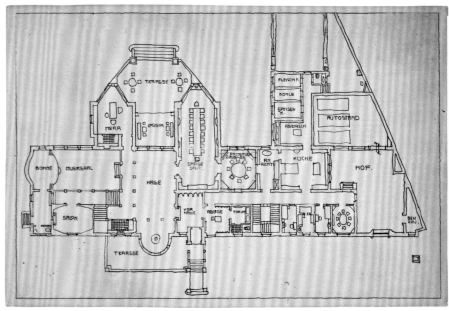

83
Josef Hoffmann
Writing Desk Set 1910
Made by the Wiener Werkstätte
Mother-of-pearl with ebony fillets
Ink stand 7 × 25 × 12.5; Candlestick
10.5 × 4; Pen holder, length 10.5; Seal
10.5 × 4; Card holder 4.5 × 7.5 × 13.5
Victoria and Albert Museum,
London

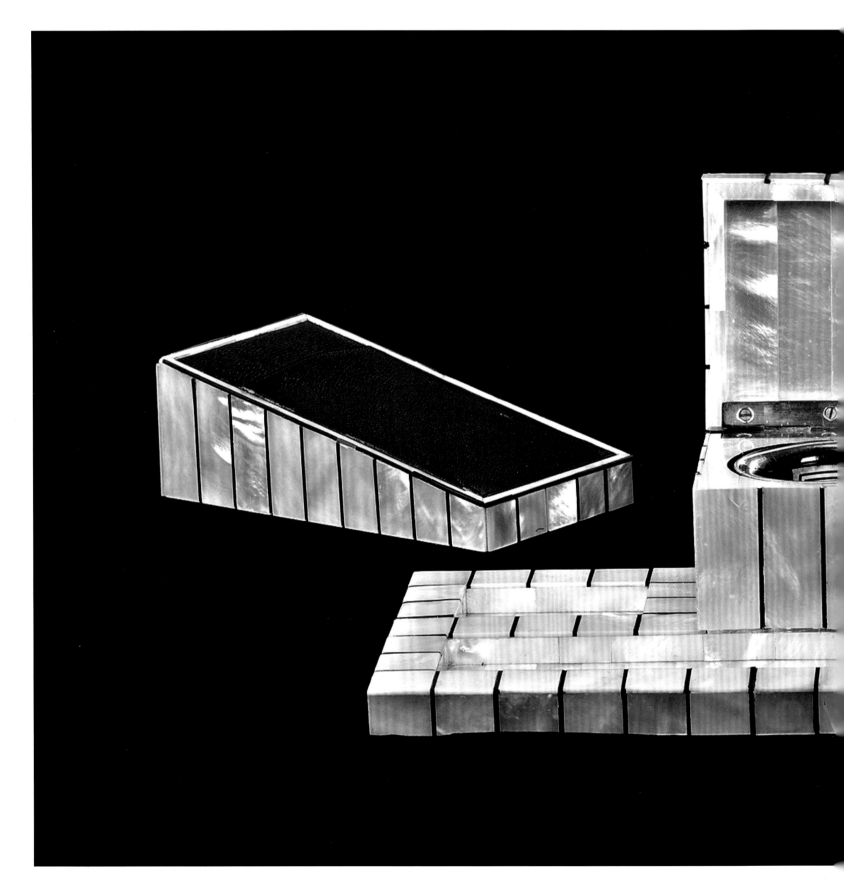

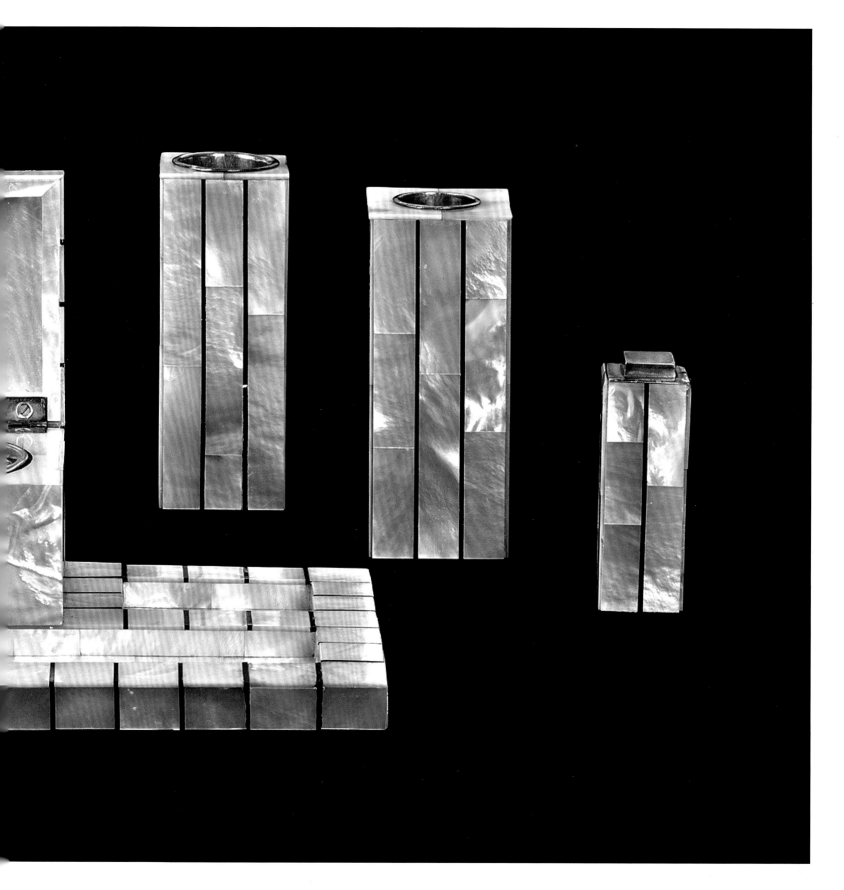

The Wiener Werkstätte

84
Josef Hoffmann
Cabinet from the Flöge Sisters'
Fashion Salon 1904
Made by the Wiener Werkstätte
Ebonised and white-painted
wood, 234 × 145 × 39
Courtesy Galerie Yves
Macaux, Brussels

85
Moritz Nähr
Emilie Flöge and Gustav Klimt c.1905
Gravure print, 28.6 × 24.2
Lentos, Kunstmuseum Linz

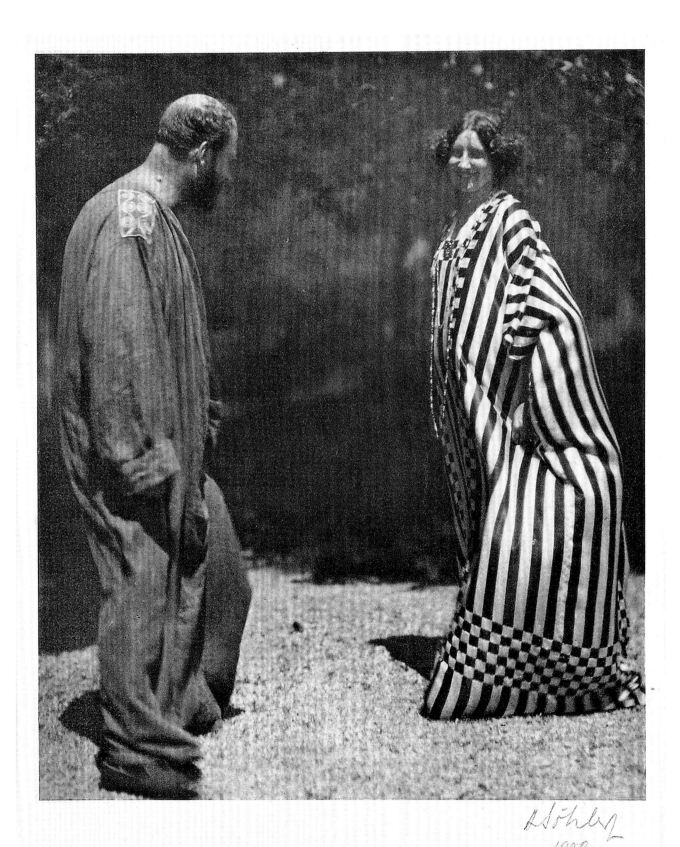

86
Black Suit from the Flöge Sisters'
Fashion Salon c.1914
Silk, partially quilted velvet
Jacket length 83, shoulder 33,
skirt length 91, waist 92
Wien Museum, Vienna

87
Josef Hoffmann
Belt Buckle 1910
Made by the Wiener Werkstätte
Silver, Diameter 6
Ernst Ploil, Vienna

88
Josef Hoffmann
Belt Buckle 1909
Made by the Wiener Werkstätte
Silver, gilt, mother-of-pearl, 5.5 × 6.5
Kunsthaus Zug, Stiftung Sammlung
Kamm

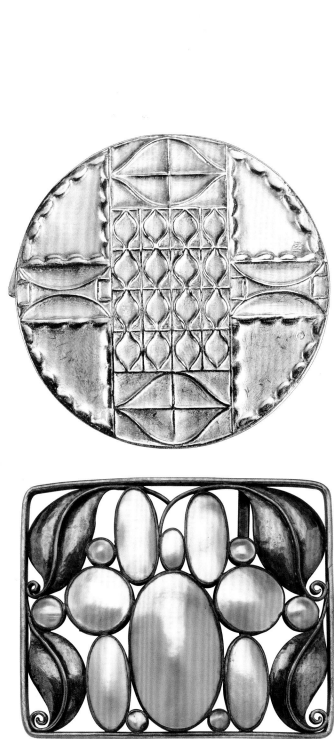

89
*Emilie Flöge Modelling
a Reform Dress*
Published in *Deutsche Kunst
und Dekoration*, volume XIX,
October 1906 – March 1907
Österreichische Nationalbibliothek –
Bildarchiv, Vienna

90
*Emilie Flöge Wearing a Reform
Dress with Muff in the Flöge
Sisters' Fashion Salon*
Autumn 1910
Silver gelatin print, 19 × 8.5
Imagno/Collection Christian
Brandstätter, Vienna

91
*Emilie Flöge Wearing a Reform
Dress in the Flöge Sisters' Fashion
Salon* Autumn 1910
Silver gelatin print, 20.6 × 8.2
Imagno/Collection Christian
Brandstätter, Vienna

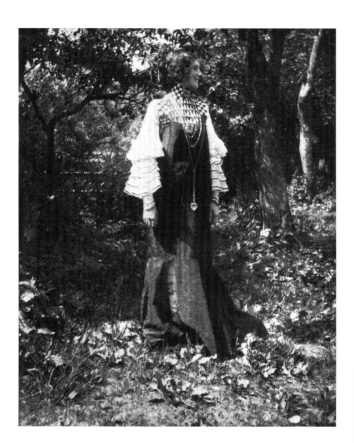

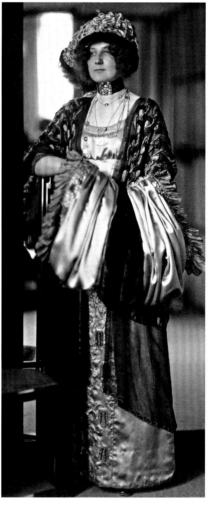

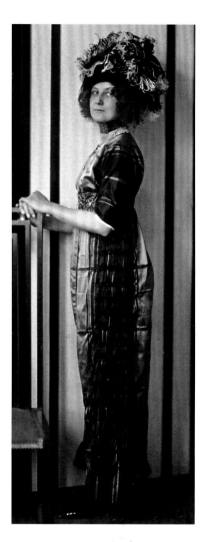

4 Fritz and Lili Waerndorfer

Among Gustav Klimt's early patrons, Fritz and Lili Waerndorfer were notable for the novel, controversial or openly provocative character of several of the works they acquired (figs.99, 93). They were also to be among the first key patrons of Josef Hoffmann, whose interiors for their house in the pleasant eighteenth (Währing) district of Vienna were among the most radical of his first, 'purist' phase (figs.98, 97). Fritz Waerndorfer's overriding interest in the applied arts was above all reflected in his role as co-founder, with Hoffmann and Koloman Moser (in 1903), and chief financial backer (for around a decade) of the Wiener Werkstätte (see pp.100–17). In addition, the Waerndorfers were responsible for an outstanding British contribution to Modernist design in early-twentieth-century Vienna: the music room they commissioned in 1902 from the Glasgow partnership of Charles Rennie Mackintosh and Margaret Macdonald Mackintosh (fig.96). While the Villa Waerndorder, as a remarkable instance of the harmonious fusion of the fine and applied arts, was not to outlive the bankruptcy of its owner, in 1914, and the subsequent upheavals of the Great War, the elements that do survive and both the photographic record and published recollections of its interiors confirm its erstwhile status as a testament to committed, generous and adventurous patronage.

Born in Vienna in 1868, Fritz Waerndorfer (originally Friedrich Wärndorfer) was the second son of the wealthy Jewish co-owner of what had by 1900 become the Österreichisches Textilwerk, one of the largest textile manufacturing concerns in Austria-Hungary. Sent in the late 1880s on an extended tour of Great Britain in order to study the textile industry at its most developed, the young man preferred to devote his time to the London art world, notably including the applied arts collections of the South Kensington (later Victoria and Albert) Museum. He thereby acquired a lasting passion for innovation in design. A few years after his return to Vienna, in the mid-1890s (when he married Lili Hellmann and bought a house in Karl-Ludwig-Strasse), the combination of his knowledge of contemporary British design and his international business connections was to provide the starting point for a long friendship with Josef Hoffmann, whom Waerndorfer was first able to assist with preparations for the eighth Secession exhibition, scheduled for late 1900 and intended as an international survey of new developments in design for the applied arts. Waerndorfer's chief contribution – as a mediator between Vienna and Glasgow (both Mackintosh and Macdonald having been invited to exhibit, fig.102) – proved crucial to the planned show but was also to be of longer-term significance.

It is probable that Waerndorfer had, by this point, already started to acquire paintings by Klimt, his first purchases including items that represented the artist as both a figure-head of the 'Secession militant' and as a sensitive and formally innovative landscape painter. *Pallas Athene* (fig.45) had featured at the second Secession exhibition, in the winter

of 1898. *Calm Pond* (fig.99), believed to be the first landscape to which Klimt gave the distinctive square format he thereafter favoured for this genre, was shown at the seventh exhibition, in the spring of 1900, along with two other works that Waerndorfer acquired: a second Klimt landscape, *Orchard in the Evening* and a *Kneeling Youth* by the Belgian sculptor George Minne. All three items were subsequently installed within Hoffmann's adaptation of the smoking room at Karl-Ludwig-Strasse (fig.98), carried out by early 1902 in advance of a much larger scheme completed by the end of that year. Hoffmann's design for a ground-floor dining room (fig.97) was to be executed more or less in parallel with the creation of an adjacent music room, commissioned from Mackintosh and Macdonald (fig.96).

Separated only by a heavy, embroidered curtain, the two rooms could hardly have been less alike. Hoffmann's dining room was exceptionally bright (a high window ran along most of its northern side and the walls were faced largely in white marble, with their upper sections and the ceiling reportedly rendered in 'silver-tinted' plaster), and emphatically uncluttered (a long buffet and several cabinets were all inbuilt). The severe and 'masculine' air of its black and white marble floor was relieved by the presence of two delicate figures by Minne placed, at its western end, on marble-topped pylons and (as in the smoking room) backed by wall-mounted mirrors. The music room, by contrast, a space chiefly reserved for the evening and seen to best advantage in delicately tinted artificial illumination, was insistently 'furnished' (from the low-seated, high-backed Mackintosh armchairs to the Anglophile's obligatory inglenook), while Hoffmann's assertive monochrome was here countered by the grey and lilac tones that gave the space an essentially 'feminine' charm. When installed, several years later, Macdonald Mackintosh's gesso frieze, inspired by scenes from Maurice Maeterlinck's Symbolist drama of 1893, *Les Sept Princesses*, would clearly have complemented this scheme in every respect.

A further experiment in the incorporation of fine art within a domestic interior was to be made with what was perhaps Waerndorfer's last, and certainly his most daring, acquisition of a work by Klimt: *Hope I* 1903 (fig.93). This was destined for the relative seclusion of the long, narrow gallery that Waerndorfer had installed at the rear of his house and was further sheltered from the accidental or untutored gaze by being housed within a cabinet specially designed for this purpose by Koloman Moser. It is reported that this 'shrine' would be opened and the painting revealed in a 'ceremony' performed by Lili Waerndorfer for the benefit of guests deemed capable of grasping the essentially 'sacred' character of the image. One is, however, prompted by the surviving photographic evidence (fig.92) to question how far this arrangement functioned, rather, as a sort of off-colour 'tease'. It seems that the young woman's coyly beckoning gaze, not a feature of Klimt's preparatory drawings or of his later reworking of the theme (background, fig.177) was

92
The Picture Gallery at the Villa Waerndorfer, in the Eighteenth (Während) District of Vienna, as adapted by Koloman Moser in 1904–5
Anonymous photograph of c.1905
MAK – Austrian Museum for Applied Arts/Contemporary Art, Vienna

At the far end the cabinet designed to house Gustav Klimt's *Hope I* 1903, part of which is visible through the less densely leaded glass at the upper right.

93
Gustav Klimt
Hope I 1903
Oil on canvas, 189.2 × 67
National Gallery of Canada, Ottawa.
Purchased 1970

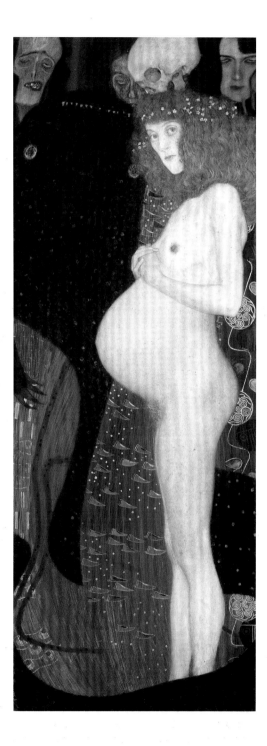

already visible through an area of less densely leaded glass. The sudden uncovering of her distended torso may thus have served primarily to enhance the shock of a not unnatural, and yet here effectively grotesque, combination.

As co-founder of the Wiener Werkstätte, Waerndorfer was happy to furnish his house with its products, especially in the early years, endeavouring to reconcile designs by Hoffmann (figs.103, 104) and by Moser (fig.106) with items acquired during the height of his enthusiasm for Mackintosh. With his enduring penchant for novelty, Waerndorfer was also to encourage both rapid stylistic evolution and related diversification at the Wiener Werkstätte, most obtrusively in 1907, after the departure of Moser, in commissioning Hoffmann and his new, 'ornamentalist' associates, the ceramicists Michael Powolny and Bernard Löffler, to design, decorate and furnish a new, centrally located Viennese night-spot that he was financing: the Cabaret Fledermaus (figs.108, 109). Compelling evidence of Waerndorfer's unfailing sense for all that was most intriguingly novel, the new venture was also a measure of his interest in the visual arts itself shifting towards the work of a new generation: initially that of Oskar Kokoschka and in due course of Egon Schiele.

Elizabeth Clegg

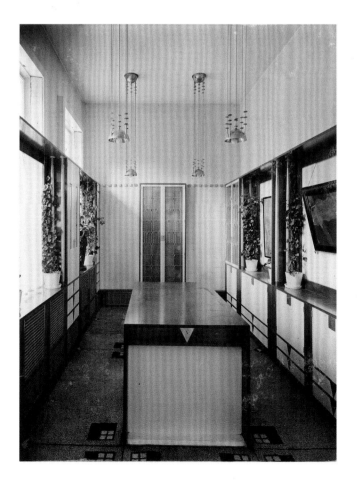

94
Fritz and Lili Waerndorfer
with their Children
Anonymous photograph, c.1900
MAK – Austrian Museum of Applied
Arts/Contemporary Art, Vienna

95
Letter from Fritz Waerndorfer to
Josef Hoffmann 23 December 1902
20.3 × 25.4
Collections of the University
of Applied Arts, Vienna

96
The Music Room at the Villa
Waerndorfer, designed by Charles
Rennie Mackintosh and Margaret
Macdonald Mackintosh in 1902
Anonymous photograph, 1903–4
MAK – Austrian Museum of Applied
Arts/Contemporary Art, Vienna

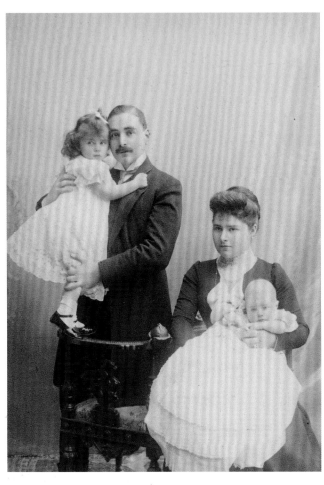

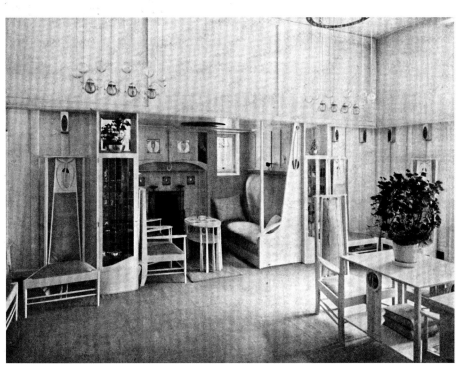

Fritz and Lili Waerndorfer

97
The Dining Room at the
Villa Waerndorfer, designed
by Josef Hoffmann
Anonymous photograph, 1903–4
MAK – Austrian Museum of Applied
Art/Contemporary Art, Vienna

The two small figures on pedestals
at the far end are by George Minne.

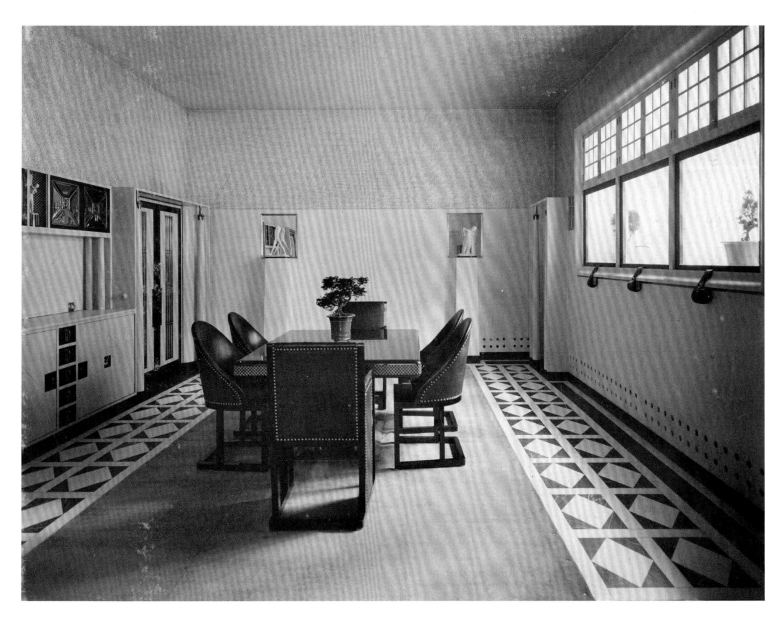

98
Josef Hoffmann
The Smoking Room at
Villa Waerndorfer
Anonymous photograph c.1902
MAK – Austrian Museum of Applied
Arts/Contemporary Art, Vienna

From left to right: Klimt's *Calm*
Pond 1899, George Minne's *Kneeling*
Youth 1898, and Klimt's *Orchard*
in the Evening 1899

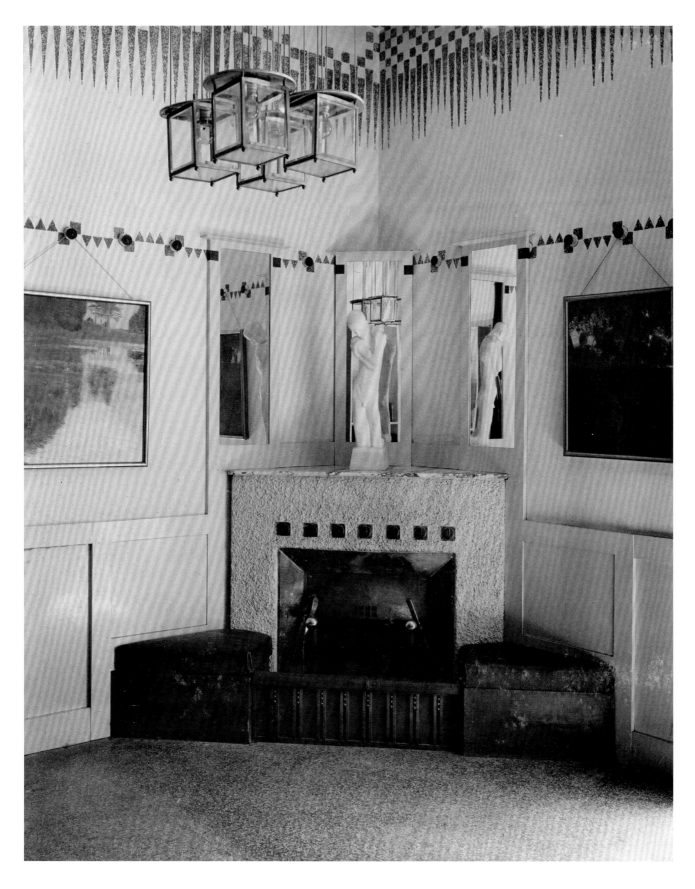

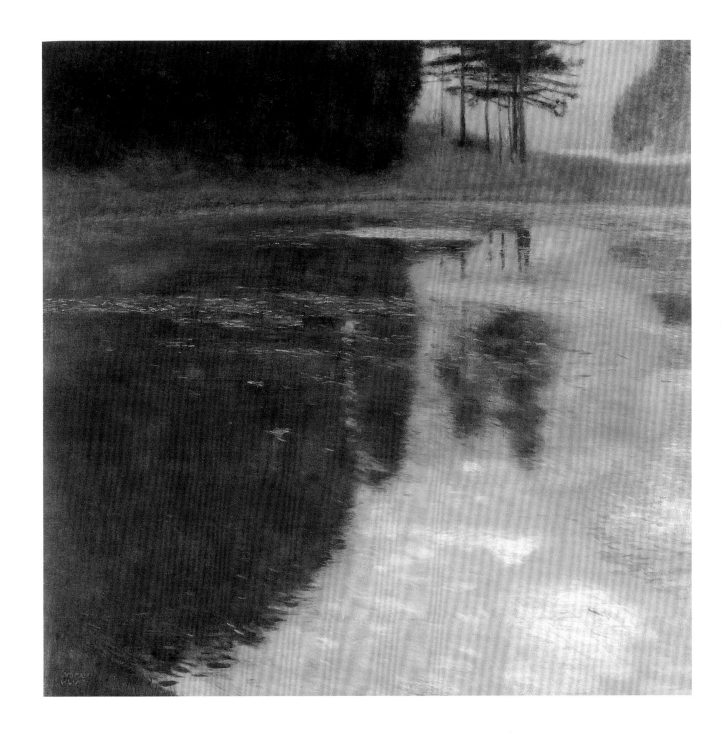

100
Charles Rennie Mackintosh
Design for a Smoker's Cabinet
owned by Hugo Henneberg 1899
Pencil and watercolour on laid
paper, 32.2 × 35
Hunterian Museum and Art
Gallery, University of Glasgow

101
Charles Rennie Mackintosh
Design for a Writing Cabinet
owned by Lili Waerndorfer 1902
Pencil and watercolour on
paper, 15.3 × 28.5
Hunterian Museum and Art
Gallery, University of Glasgow

Fritz and Lili Waerndorfer

102
*Photograph of the Eighth Secession
Exhibition, featuring the work of
Charles Rennie Mackintosh,
Margaret Macdonald Mackintosh
and James Herbert McNair* 1900
Vintage photograph mounted
on card, 18.8 × 15.6
Hunterian Museum and Art Gallery,
University of Glasgow

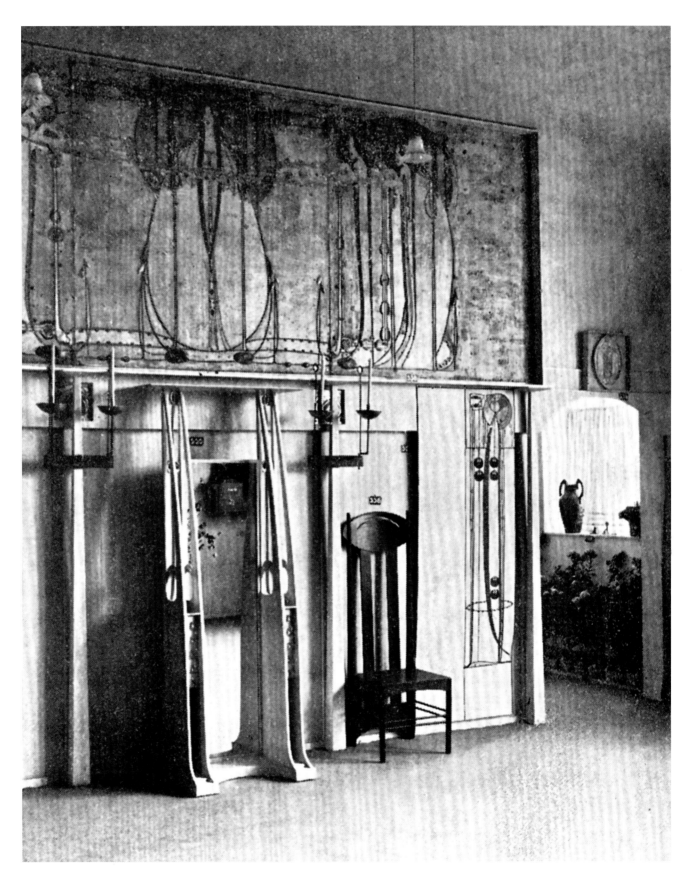

103
Josef Hoffmann
*Pot with Lid owned by Fritz
and Lili Waerndorfer* 1906
Made by the Wiener Werkstätte
Silver with turquoise
stones, 14 × 20.4 × 13.8
Kunsthaus Zug, Stiftung
Sammlung Kamm

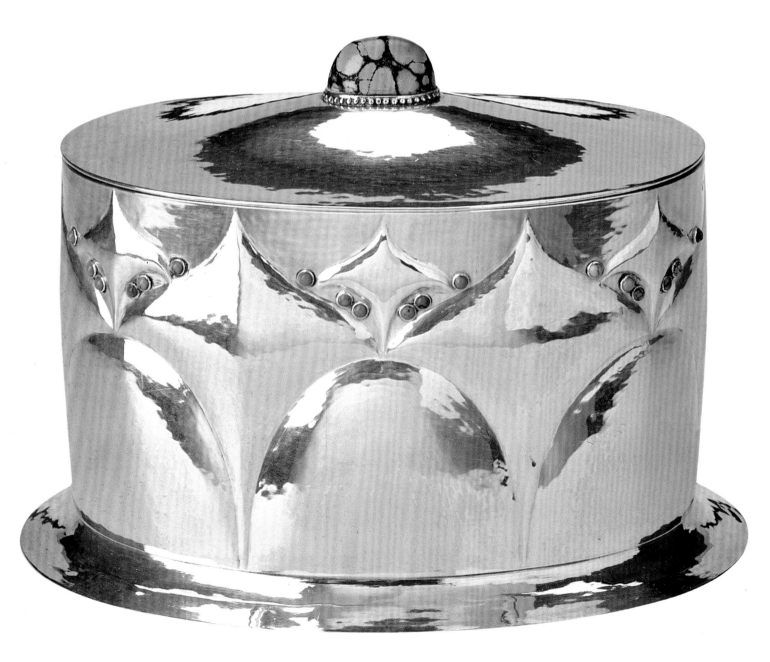

Fritz and Lili Waerndorfer

104
Josef Hoffmann
Selection from 106-piece Cutlery Set for Twelve with the Monogram of Lili and Fritz Waerndorfer 1904–8
Silver and steel
MAK – Austrian Museum of Applied Arts/Contemporary Art, Vienna

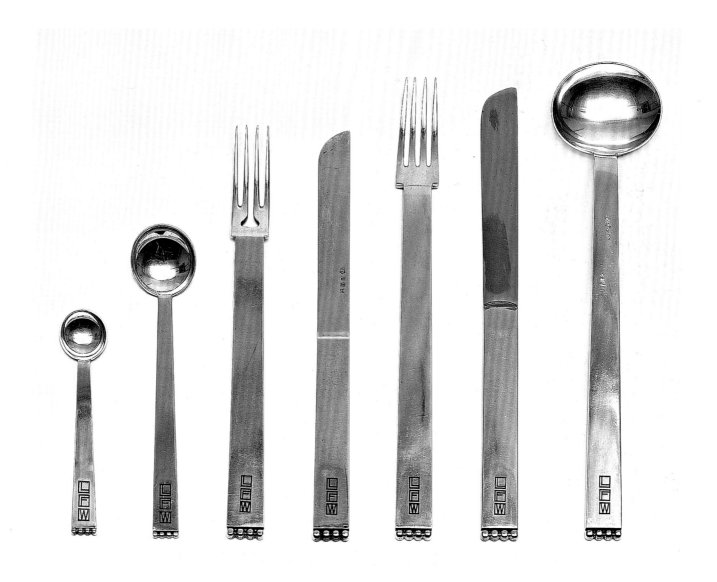

105
Josef Hoffmann
Table Centrepiece owned by
Fritz and Lili Waerndorfer 1905
Made by the Wiener Werkstätte
Silver with lapis lazuli cabochon
Height 13.5
Kunsthaus Zug, Stiftung
Sammlung Kamm

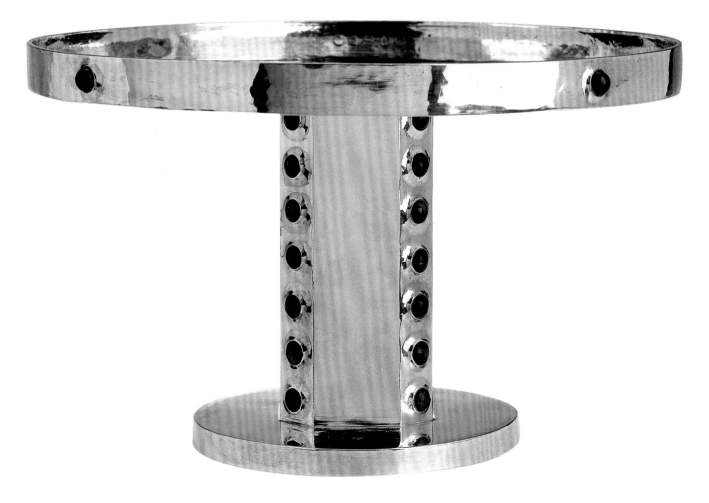

Fritz and Lili Waerndorfer

106
Koloman Moser
*Photograph Album for Lili
Waerndorfer* 1906
Made by the Wiener Werkstätte
Leather, gold embossed, 13 × 14.3
Ernst Ploil, Vienna

107
Josef Hoffmann
*Toilet Paper Holder for the
Villa Waerndorfer* c.1902
Zinc, silver and iron
25.5 × 21 × 7
Ernst Ploil, Vienna

108
*Wiener Werkstätte Postcards, nos. 74
and 75 (Bar and Wardrobe Areas
of the 'Cabaret Fledermaus') 1907*
Colour postcards after a design
attributed to Josef Divéky, 14 × 9
Collection R.H.

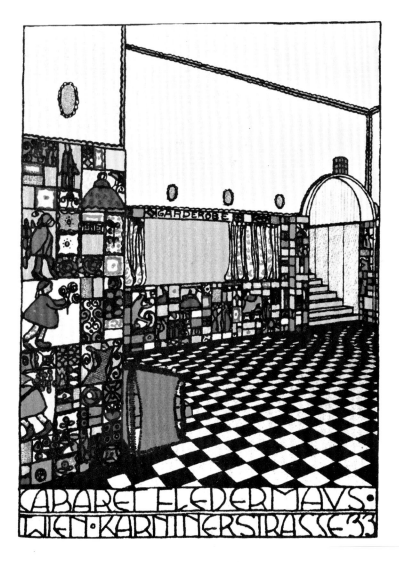

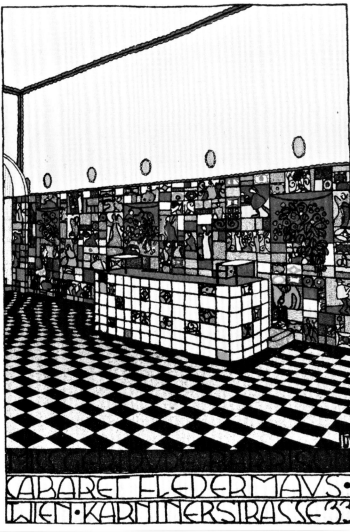

Fritz and Lili Waerndorfer

109
Josef Hoffmann
Chair for the 'Cabaret Fledermaus' c.1907
Black- and white-painted beechwood with leather upholstery, 73.5 × 55 × 44
Victoria and Albert Museum, London

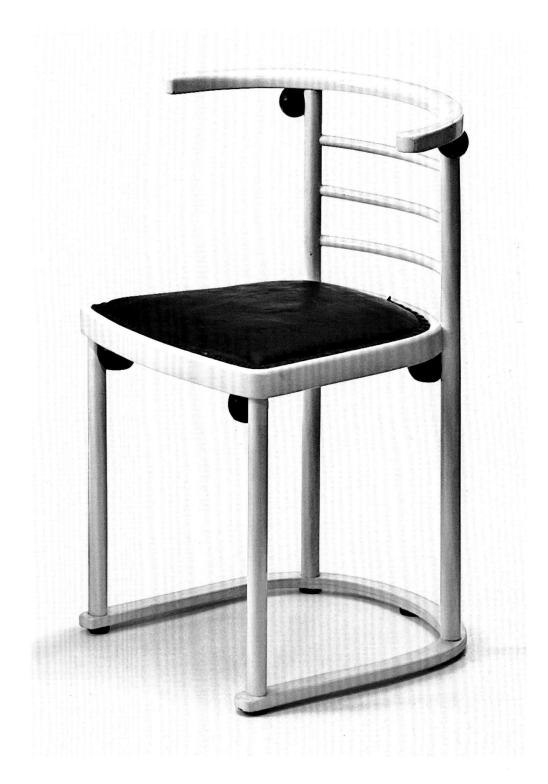

The earliest instance of co-operation between Josef Hoffmann and Gustav Klimt in the creation of a domestic setting is to be found in the large hall, and principal interior, of the villa built for the photographer Hugo Henneberg (figs.110, 111). One of the group of houses initiating a residential development for artists on the Hohe Warte, a semi-rural plateau forming part of the nineteenth (Döbling) district of Vienna, its construction was already underway in 1900, before Klimt embarked on the commissioned portrait of Henneberg's wife, Marie (fig.112). The portrait was still classified as 'unfinished' when it was included in the thirteenth exhibition at the Viennese Secession in early 1902 (fig.54, lower right), by which date the villa had reached completion.

It is, nonetheless, apparent that the hall at the Villa Henneberg, in both its arrangement and its colouring, was designed to accommodate the portrait (fig.111), even though an equally important purpose of this space was, literally, to showcase Henneberg's output as a successful Pictorialist photographer, above all the large, dreamily atmospheric gum prints of landscape subjects for which he was best known (fig.110). It would also seem that the intended setting for Klimt's portrait, assuming this was stipulated in the commission, was not without its influence on two unusual aspects of the painting: its square format (seldom used by Klimt for subjects other than landscape) and the perhaps not unrelated presence (rare in Klimt's work at this time) of real flowers, in this case a centrally positioned posy of violets.

Hugo and Marie Henneberg, a well-known couple in both local and international artistic circles, had married in 1888. By that date Hugo, born in into a Protestant Viennese Austro-German family in 1863, had pursued scientific studies, received a doctorate in physics, become independently wealthy upon the death of both of his parents in 1887 and, in the same year, had taken up 'artistic photography', doubtless encouraged by the founding of the Viennese Club der Amateur-Photographen, or Camera-Club. Marie, born Hinterhuber into a Catholic Salzburg Austro-German family in 1851, and so twelve years older than her future husband, had at one point been employed as a teacher.

Encouraged by the internationalism of the emerging Pictorialist movement in photography, Henneberg soon established a reputation far beyond Vienna, joining the London-based Linked Ring in 1894, exhibiting with the Photo-Club de Paris from the mid-1890s, as well as showing his work at the exhibitions mounted, from 1891, by the Viennese Camera-Club. Here, he met and befriended fellow enthusiasts Heinrich Kühn and Hans Watzek, and from 1896 the three exhibited together, on occasion at the Secession. Excited by recent experiments with bichromate gum prints, Henneberg and Kühn soon made this technique their own, Kühn in his psychologically probing portraits, Henneberg in his poetic landscapes. Sensitively observed, then deftly manipulated for 'pictorial' effect, and tellingly cropped, these have much in common with the 'atmospheric' landscapes that Klimt

painted between 1898 and around 1903 (figs.181, 184, 182).

One of Hoffmann's earliest professional commissions as architect as well as designer, the first four Hohe Warte villas – built for Carl Moll, Koloman Moser, Henneberg himself and another photographer, Friedrich Viktor Spitzer – had many features in common: with brick wall construction and white roughcast facing, each comprised a basement, a raised ground floor, an upper storey and a top-floor studio with splendid views north to the Vienna Woods. (Introducing the 'Hohe Warte Colony' to an international Anglophone reader-ship in 1904 in the pages of The Studio, A.S. Levetus enthused on its 'idyllic' setting.) Their interiors, however, were more diverse, being suited in each case to the requirements of the client.

It is to Carl Moll, chief advocate of a move to the Hohe Warte, that we owe our most vivid notion of the visual aspect of domestic life there. The painted record of his own villa (the larger half of a 'double house' at 8 Steinfeldgasse, shared with Koloman Moser) reveals in particular the striking use of colour, both as an accent and to establish continuity, and the careful muting and distribution of light (figs.116, 119), as well as the extension of living space onto terraces and into gardens (figs.117, 122).

At the Villa Henneberg, at 8 Wollergasse (fig.114), a sloping site spurred Hoffmann to novel solutions and a consequent element of surprise. Here, one entered the multi-purpose, double-storey hall from a much smaller vestibule at its north-eastern corner and so initially glimpsed, across a floor of grey and black chequered marble, its partially lower ceilinged western section (fig.110), where a sofa and side chairs, upholstered in grey goatskin, were grouped below one of Henneberg's segmented landscape panoramas (sunlit meadows, artfully scattered birches, meandering stream), framed as an extension of the greenish-black-stained wainscoting. Only upon advancing, then turning to inspect the rest of the hall, did one finally take in its full height (fig.111), the coarsely plastered upper portion of its eastern wall, the marble, iron and gilt-brass fireplace (for show, rather than use, as each villa was supplied with a form of central heating) and, as the ultimate focal point, Klimt's *Portrait of Marie Henneberg* (fig.112).

Painted in 1901–2, this was the first major female portrait Klimt had produced since those of the late 1890s. His output in the interim (aside from work on commissioned allegorical compositions) had been dominated by landscape, largely using the square format he then first adopted for this genre. This aspect of his recent practice was, indeed, reflected in his contribution to the thirteenth exhibition at the Secession where, of the eight works he presented, including the Henneberg portrait, no fewer than five were square-format landscapes. The critic Ludwig Hevesi's description of the portrait, encountered at the exhibition, seems to take its cue from the 'lyrical' quality he finds in Klimt's evocations of a segment of pine forest or the gleaming

110
*View of Part of the Western Side
of the Hall in the Villa Henneberg
on the Hohe Warte, Vienna, designed
by Josef Hoffmann in 1900–1*
Anonymous photograph published
in *The Studio* in July 1904

A segmented gum print landscape
panorama by Hugo Henneberg is
installed above the wainscoting.

surface of a lake. Entranced by the energised delicacy of
the brushwork in the portrait, he embarks on a synaesthesic
account of how 'one listens with ones eyes' to the 'gentle
rippling of these pinks and greys', at length resolved into
the 'melodious *pianissimo*' of 'rosy flesh tones and a posy
of violets'. Frau Henneberg's ostensibly seated pose seems
to him, rather, a weightless 'hovering', but her pearl- and
silver-grey ensemble, above all the serried flounces of her
bal-entrée (see also fig.125), takes on a 'fantastical' life
of its own as it cascades, 'seething' and glinting, out of the
composition.

Installed in the hall of the Villa Henneberg (fig.111) and
there thrice 'contained' – within its own frame, and that of
the fireplace, and that of the strict rectangular forms of the
house as a whole – the finished portrait, like Henneberg's gum
print landscape on the opposite wall, signalled the tentative
admission into the well-ordered domestic sphere of all
that was ephemeral, impalpable and uncannily delightful in
unfettered nature. It thereby also offered an inverse meta-
phor of the social and cultural ideal being pursued under
its auspices: that of a well-ordered creative life transplanted
beyond the routine, rigidity and tedium of the metropolis.

Elizabeth Clegg

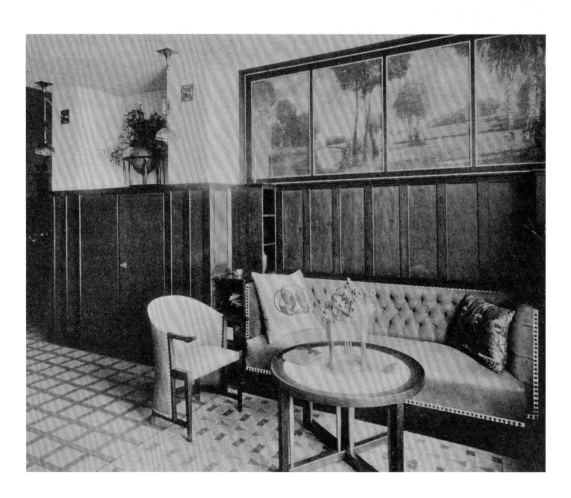

*View of the Eastern Side of the
Hall in the Villa Henneberg on
the Hohe Warte, Vienna, designed
by Josef Hoffmann in 1900–1*
MAK – Austrian Museum of Applied
Arts/Contemporary Art, Vienna

Gustav Klimt's portrait of Marie
Henneberg is above the fireplace.

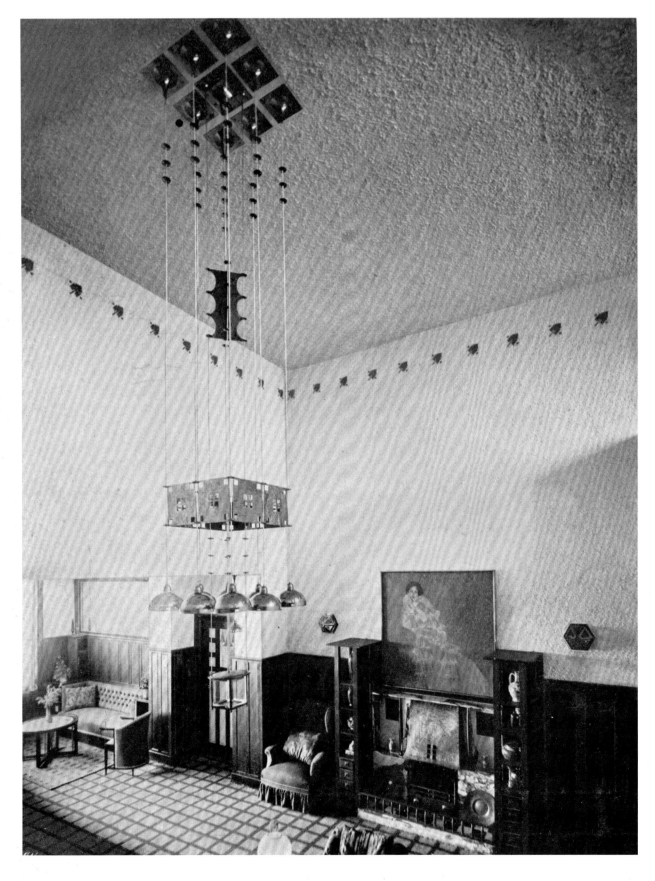

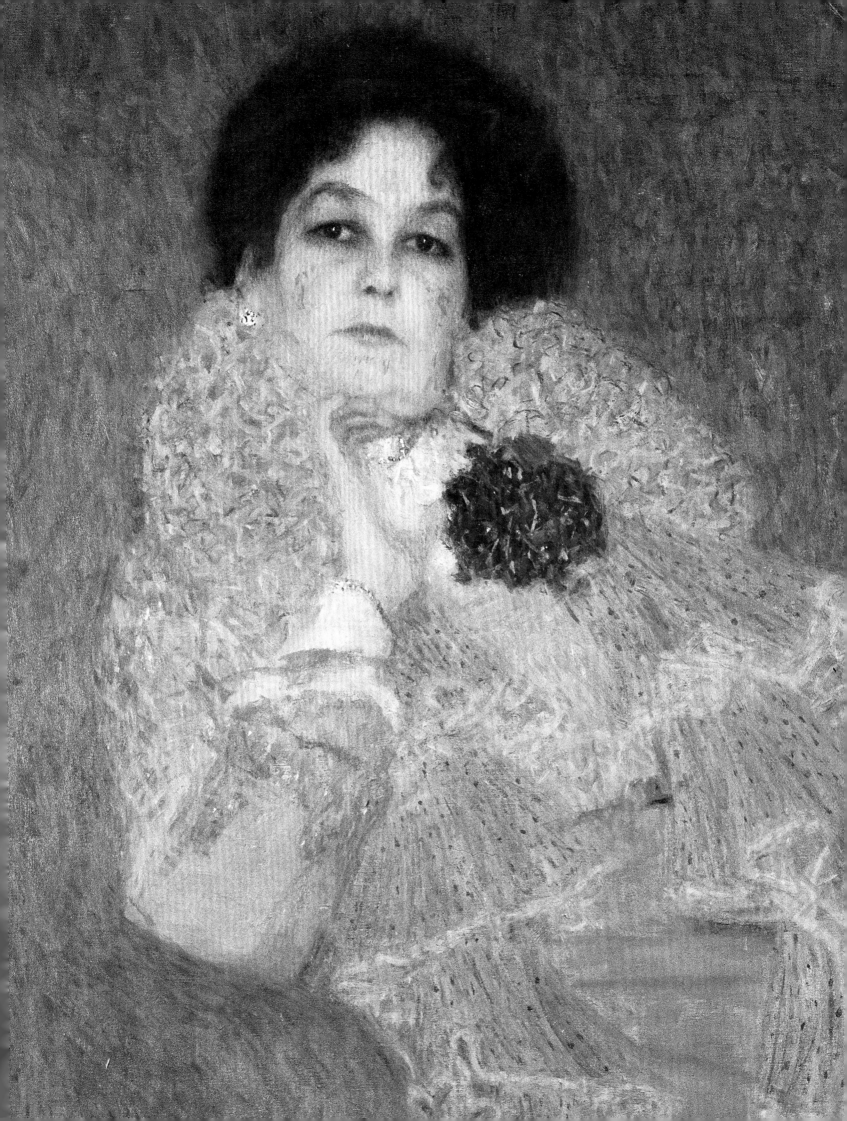

112
Gustav Klimt
Portrait of Marie Henneberg 1901–2
Oil on canvas, 140 × 140
Stiftung Moritzburg, Kunstmuseum
des Landes Sachsen-Anhalt, Halle

113
Gustav Klimt
*Portrait of Rose von Rosthorn-
Friedmann* 1900–1
Oil on canvas, 140 × 80
Private Collection

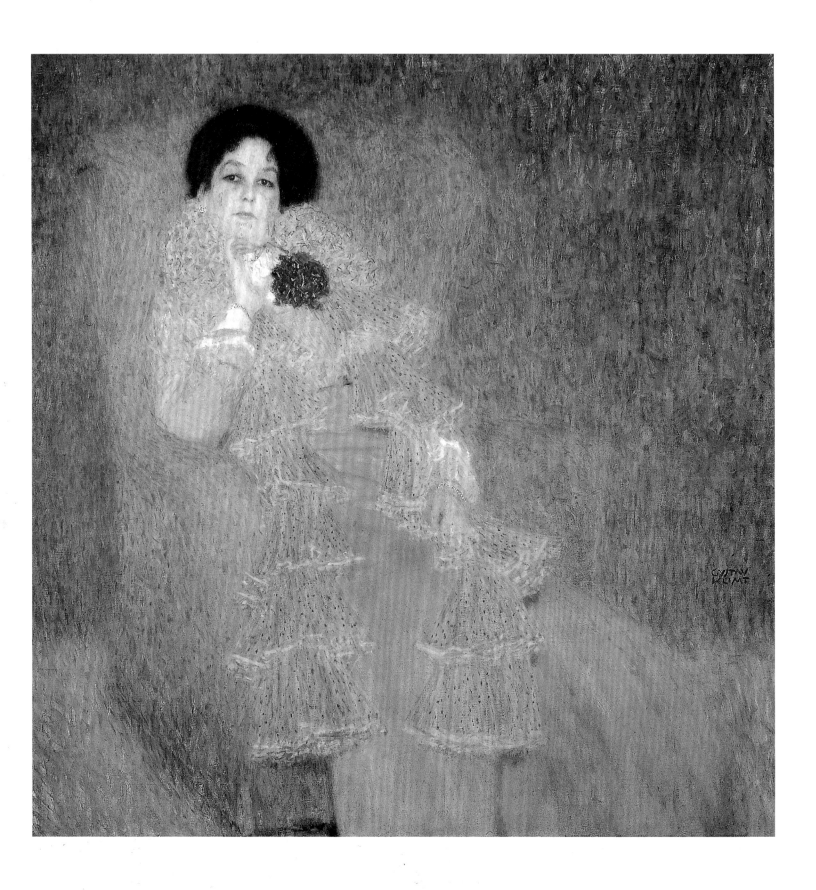

The Villa Henneberg

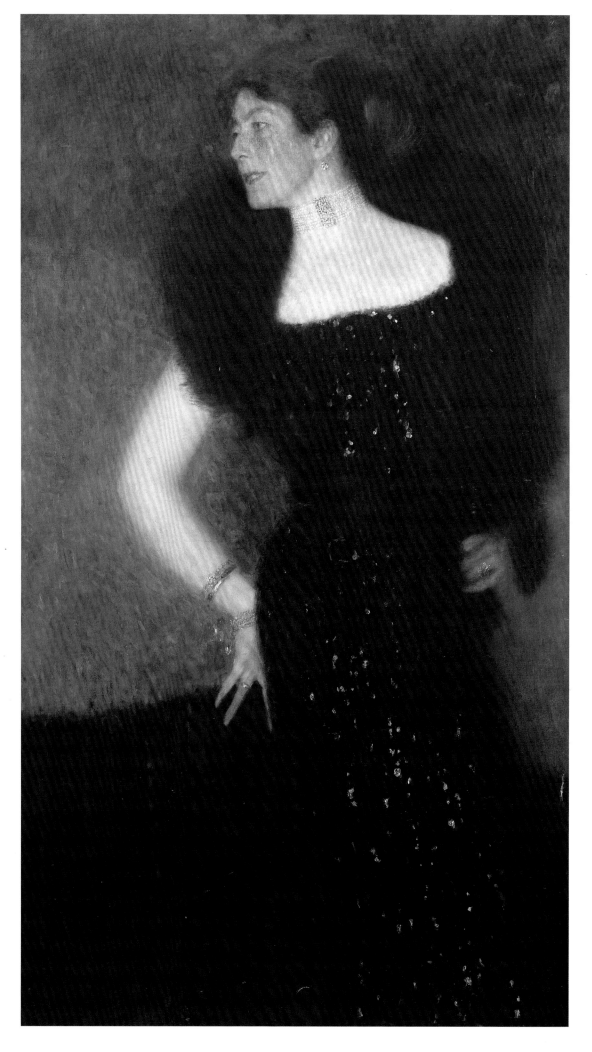

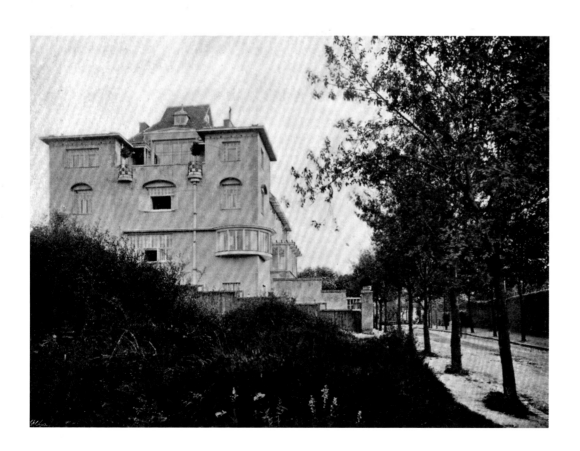

The Villa Henneberg

115
Koloman Moser
*Cabinet from the Salon
of Marie Henneberg* 1902
Made by J. W. Mueller
or Wenzel Hollmann
Cherry wood, brass fittings,
lead-glass windows, polished glass,
glass columns, ruby decoration
221 × 90 × 61.5
Bel Etage Kunsthandel GmbH,
Vienna

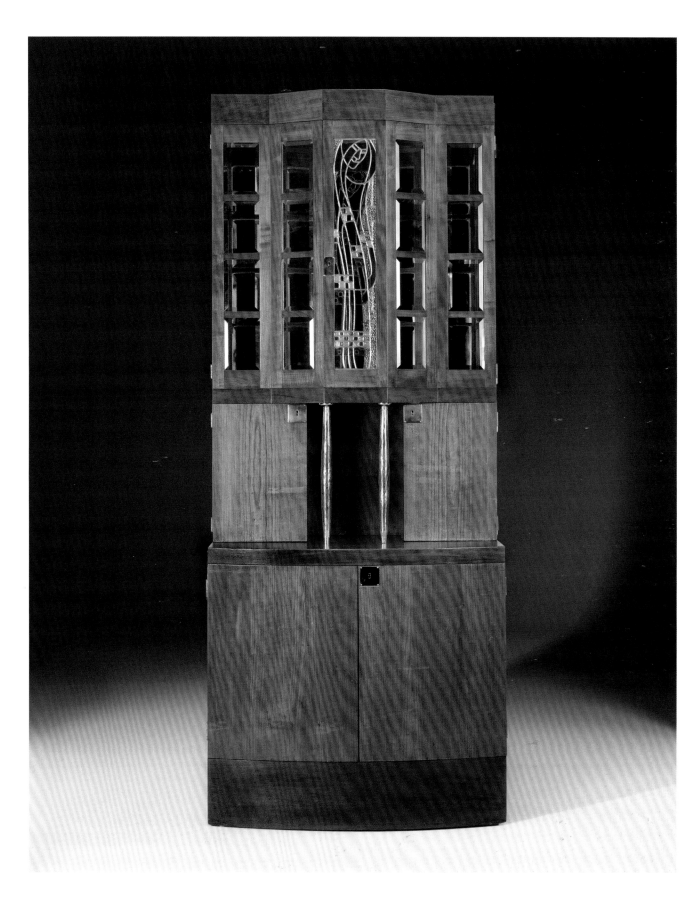

116
Carl Moll
Self Portrait (In My Studio) c.1906
Oil on canvas, 100 × 100
Gemäldegalerie der Akademie
der bildenden Künste, Vienna

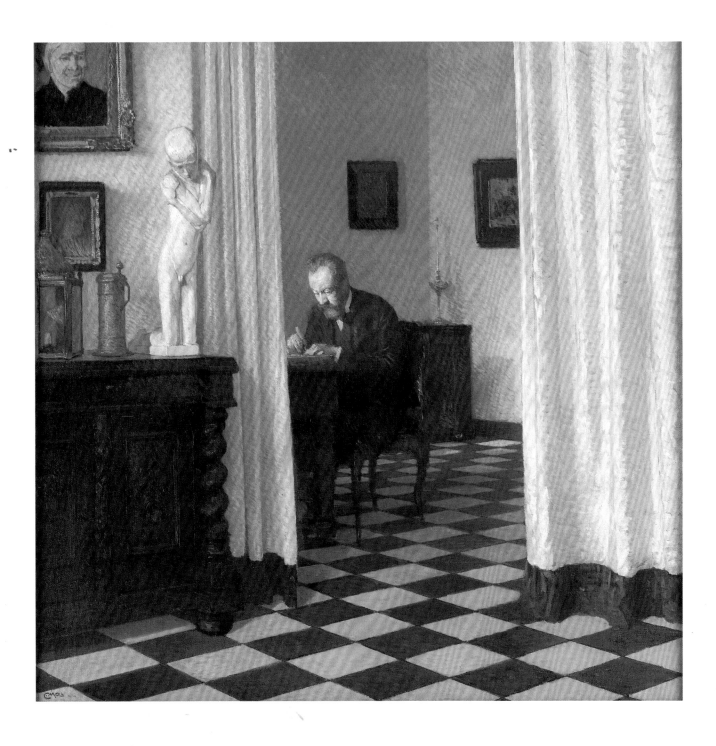

The Villa Henneberg

117
Carl Moll
Terrace of the Villa Moll c.1903
Oil on canvas, 100 × 100
Wien Museum, Vienna

118
*The Dining Room at the
Villa Henneberg*
Anonymous photograph
MAK – Austrian Museum of Applied
Arts/Contemporary Art, Vienna

119
Carl Moll
*My Living Room (Anna Moll
at the Desk)* 1903
Oil on canvas, 100 × 100
Wien Museum, Vienna

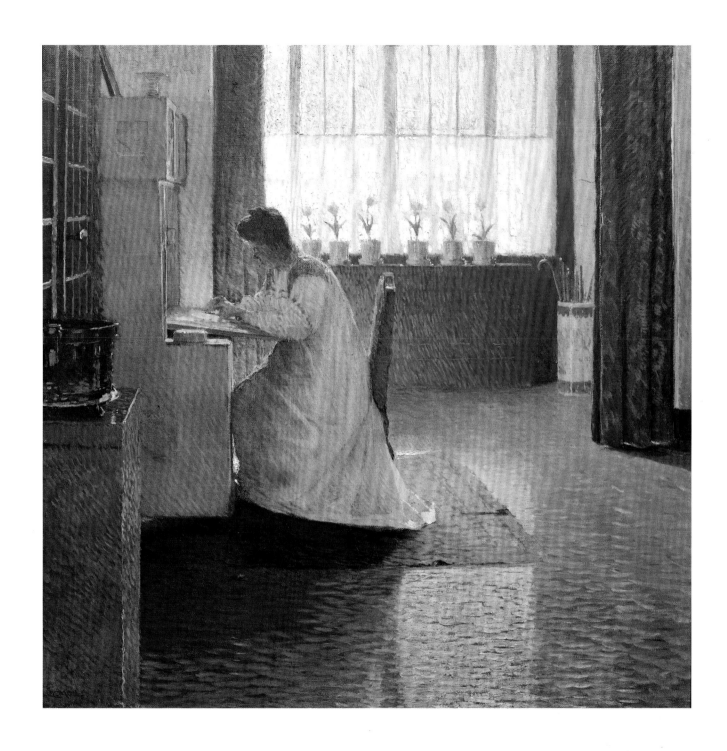

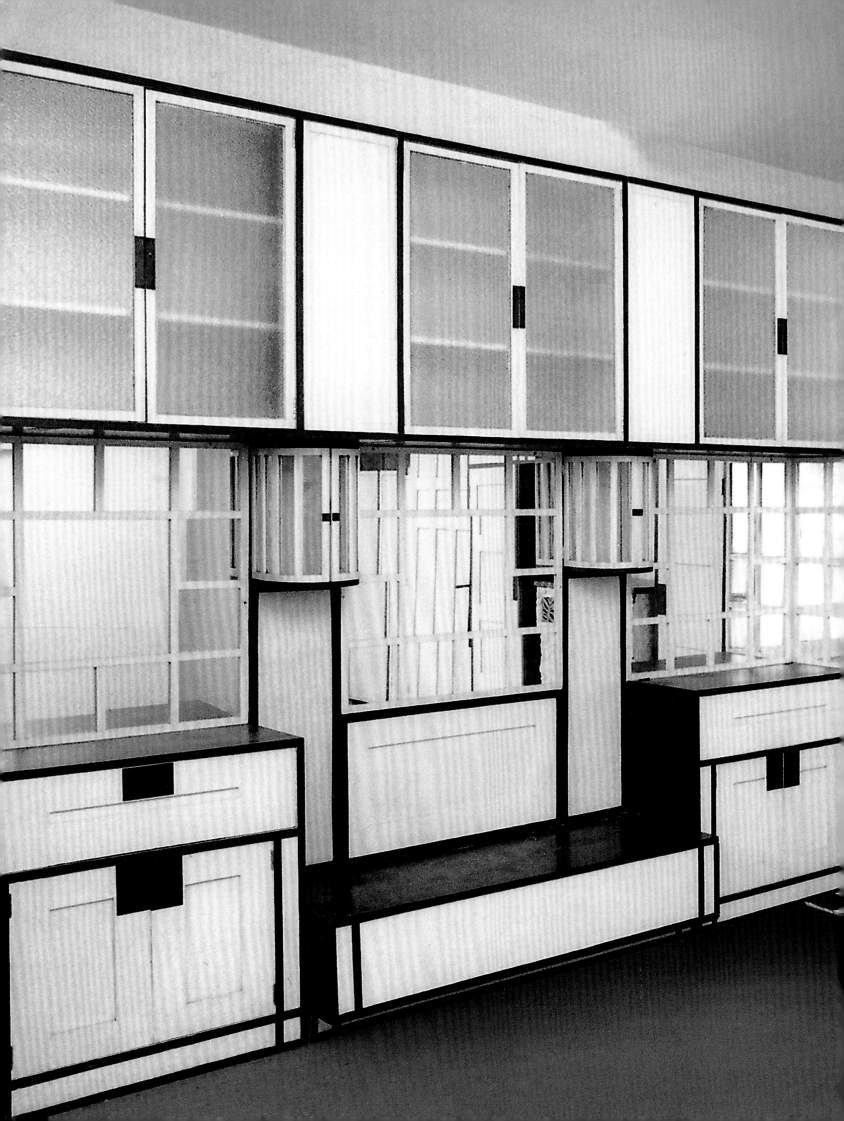

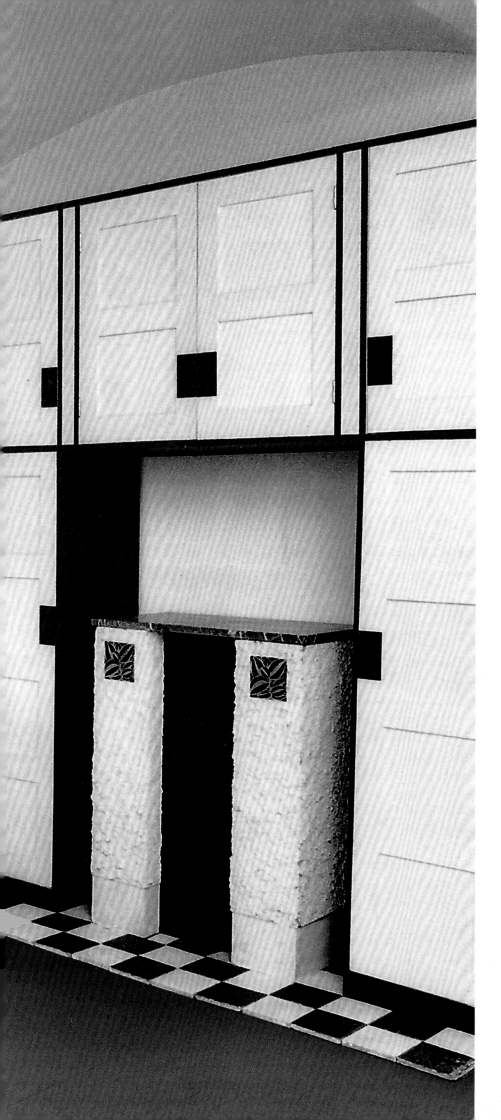

120
Koloman Moser
*The Guest Room of the Moser
House on the Hohe Warte* 1901
Wood, black and white paint,
glass, mirror and ceramic tiles
Height 180, long wall width 393,
short wall width 273
Private Collection

121
Joseph Maria Olbrich
*Armchair for the Music Room
of the Villa Spitzer* c.1898–9
Stained maple, with upholstery
and brass feet, 79 × 54 × 49.5
Victoria and Albert Museum,
London

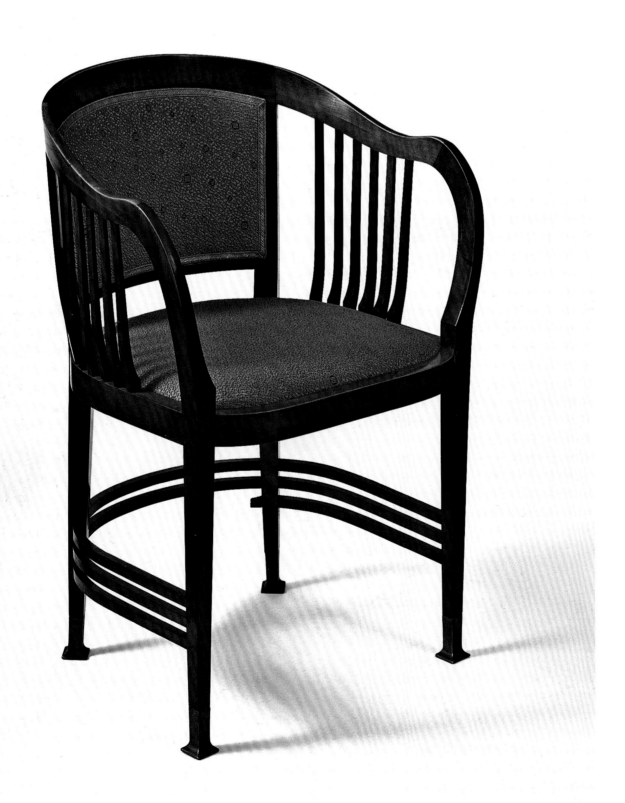

The Villa Henneberg

122
Carl Moll
*The Artist's House on
the Hohe Warte* 1905
Oil on canvas, 81.5 × 80
Essl Museum, Klosterneuburg/
Vienna

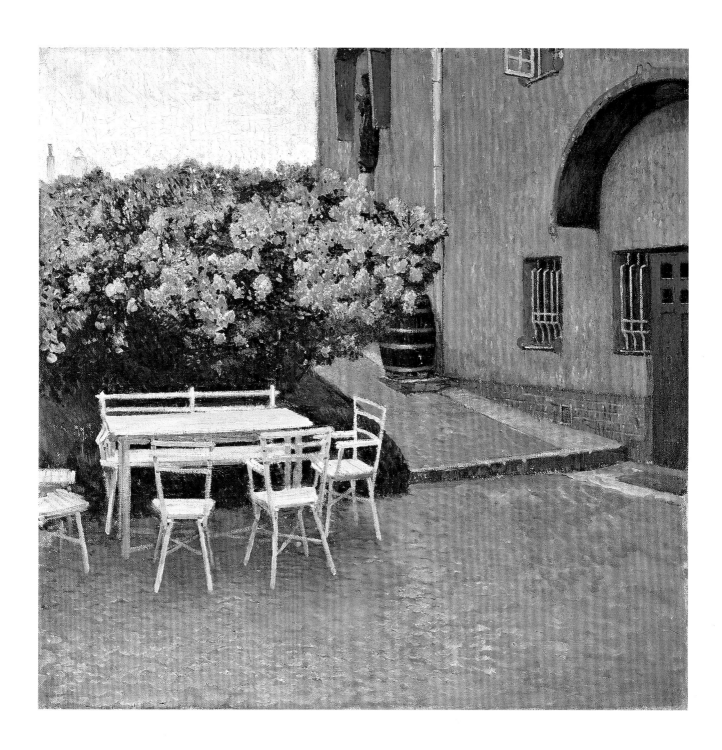

Two of the five elegant rooms designed by Josef Hoffmann in 1913 for Moriz and Hermine Gallia within their large apartment at 4 Wohllebengasse, in the fashionable fourth (Wieden) district of Vienna, embody a form of delayed, indirect 'collaboration' between Hoffmann and Gustav Klimt that spanned a decade of their clients' growing prosperity, continued assimilation into Viennese society and increasing confidence as collectors of both fine and applied art. The portrait of Hermine Gallia (fig.125), commissioned by her husband and first publicly exhibited, still unfinished, at the Klimt retrospective of November–December 1903, was to adorn the walls of the boudoir (fig.127), while a Klimt land-scape of the same period, *Beech Forest II* (similar to fig.182), would grace the salon/music room (fig.123). The Gallias also became early and enthusiastic patrons of the Wiener Werkstätte (and, after 1914, shareholders in this concern), acquiring superb pieces by its co-founders, Hoffmann (figs.133, 135–8) and Koloman Moser (fig.134). To these were added, in 1913, the furniture, wall fabrics and carpets designed by Hoffmann as integral to his five interiors: the boudoir (figs.129–32) and salon/music room, a smoking room/family living room, a formal dining room and a hall (figs.128, 126, 139).

The Gallias' social and cultural journey – from their beginnings as 'respectable', but distinctly provincial, German-speaking Jews from Moravia (Moriz hailed from Bisenz, now Bzenec, Czech Republic) and western Silesia (Hermine was born Hamburger in Freudenthal, now Bruntál, Czech Republic) – to a position as members of the Viennese *arriviste* 'establish-ment' (they also formally converted to Catholicism in 1912) was by no means atypical for such circles in Vienna at this period. Born in 1858 and 1870, respectively, and already related, as uncle and niece, Moriz and Hermine were assured, by the time of their marriage in 1893, of a modicum of financial security through Moriz's position as manager of the Viennese branch of Baron von Auer's Gaslight Factory; and their first shared Viennese home was itself in the fourth district, at Schleifmühlgasse.

In the earlier years of their marriage music was their principal cultural interest – its continued importance is revealed by the size and position of the salon/music room within Hoffmann's later scheme. Moriz Gallia went on to demonstrate his support for the fine arts in Vienna as one of several collectors who followed the urging and example of the Secession by acquiring works of art it had exhibited for donation to the planned, state-funded Viennese Moderne Galerie (which would open to the public in May 1903).

Klimt's record of Hermine Gallia (fig.125) was one of the group of early female portraits in which he found his form in this genre. In the first Klimt monograph (1920) Max Eisler was to characterise this as Klimt's 'white' and 'Whistlerian' period as a portraitist, notable for subjects who seemed to 'hover' rather than stand or sit (another example being Marie Henneberg, fig.112), and for the pale, shimmering

and diaphanous fabrics of their costumes, captured in 'vibrating' brushwork. Hermine, who in a photograph roughly contemporary with the painting (fig.124, back row, extreme left) appears a far more homely and less glamorous figure than that evoked by Klimt, is here shown in a loose-fitting gown of translucent white fabric. But the chief elements in her attire are those that create the swaying sinuosity of the figure, a heightening of the softly curved forms of Klimt's beech trees, and perhaps alluding to an affinity with music: the white boa around the shoulders, the fabulously delicate *bal-entrée* fluttering down over bodice and skirt, the swell of the ribbed, gauzy sleeves, the sweep of the gathered, gleaming train. This last feature also draws attention to the geometric patterning of the carpet (suggestive of Klimt's new interest in mosaic), its rosy reds and cool greens echoed in the sketchier rendering of background wall, and its violet tones reiterated in the square cartouche at the upper right bearing signature and date.

The apartment into which the Gallias moved just under a decade after acquiring the portrait was on the first floor of a recently erected five-storey block designed by the architectural partnership of Franz von Krauss and Josef Tölk. This stood on the site of an older house acquired by Moriz Gallia in 1910 and subsequently demolished. Here, Hoffmann was to devise a setting that would not only suit his clients' evolving aspirations for an elegantly hospitable lifestyle, but would also serve as a showcase for their collection, by this date further enriched through the addition of outstanding products of the Wiener Werkstätte: Hoffmann's onyx-inlaid silver cigarette case (fig.135) and Moser's exquisite, planished silver and lapis lazuli sweet basket (fig.134).

By 1913 Hoffmann's style, as both architect and designer, had progressed from a functionally motivated purism, through a sometimes overtly 'deluxe' ornamentalism, to an often severe Neo-Classicism enriched through daring use of colour. He had, moreover, repeatedly demonstrated his capacity for assimilation and adaptation; and these qualities were to be much in evidence in his work for the Gallias, not least in attuning the design of both boudoir and salon/music room to the chromatic leitmotif provided in each case by Klimt's work.

The architects' floor plan already allowed for a good deal of intercommunication between Hoffmann's five rooms, and he maximised this advantage in the three street-side interiors by grouping furniture towards the walls and keeping the central space free, thereby also permitting the carpets to be seen to advantage (figs.123, 127) and the significance of their respective designs to emerge. The smoking room/family living room, dominated by a massive ebonised wood bookcase, was enlivened through the vibrant green wool of the fabric (supplied by Leopold Löwy) used for its curtains and for the upholstery of a sofa, armchairs and side chairs, made to Hoffmann's design by Wenzel Hollmann. The salon/music room (fig.123), predominantly yellow and white in

123
*Salon/Music Room, designed
by Josef Hoffmann in 1913, in the
Viennese Apartment of Moriz and
Hermine Gallia at 4 Wohllebengasse
in the Fourth (Wieden) District*
Anonymous photograph published
in *Deutsche Kunst und Dekoration*
in February 1916

Gustav Klimt's Beech Forest II
*c.1903 is visible on the wall
to the left.*

colouring, also pointed up both the mottled tree-trunks
of Klimt's landscape and the presence of a large Steinway
grand through the black and white upholstery of the low
seating groups, which in turn set off the hand-knotted
carpet (made to Hoffmann's design by Johann Backhausen
und Söhne), featuring a stylised red and pink floral spray
on a deep green ground.

The predominance of white in Klimt's portrait of Hermine
(fig.125) was echoed in the ceiling, stucco decoration and
fluted pilasters of her boudoir (fig.127) and in its furniture
(made to Hoffmann's design by Johann Soulek) in white
enamelled wood with gilt decorative mounts (figs.129–131).
But the notion of 'continuity' was underlined in the loose
approximation to the portrait's setting achieved through
the combination of red ottoman silk upholstery, wall fabric
of Wedgwood blue silk woven with a stylised rose spray,
and its recurrence in adapted form in the carpet, again
made to Hoffmann's design by Backhausen (fig.132).

Elizabeth Clegg

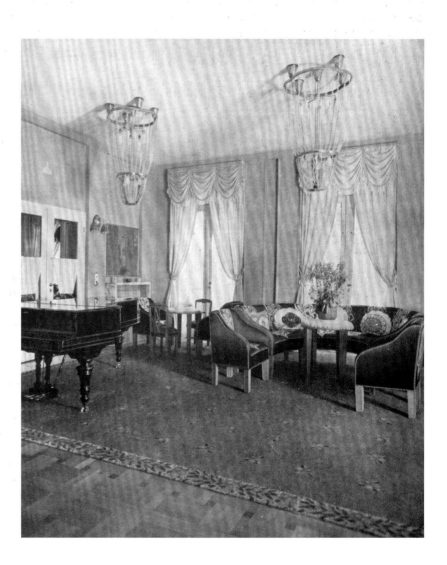

124
Bruno Reiffenstein
The Gallia Family c.1903
Vintage print
19.5 × 25.2
Private Collection

Back row, left to right: Hermine
Gallia, Moriz Gallia, Henrietta
(Henny) Hamburger, Otto
Hamburger, Guido Hamburger.
Middle row: Ernst Gallia, Josephine
Hamburger, Robert Hamburger,
Nathan Hamburger, Margarete
Gallia. Front row: Lene and
Käthe Gallia

125
Gustav Klimt
Portrait of Hermine Gallia 1903–4
Oil on canvas, 170 × 96
The National Gallery, London

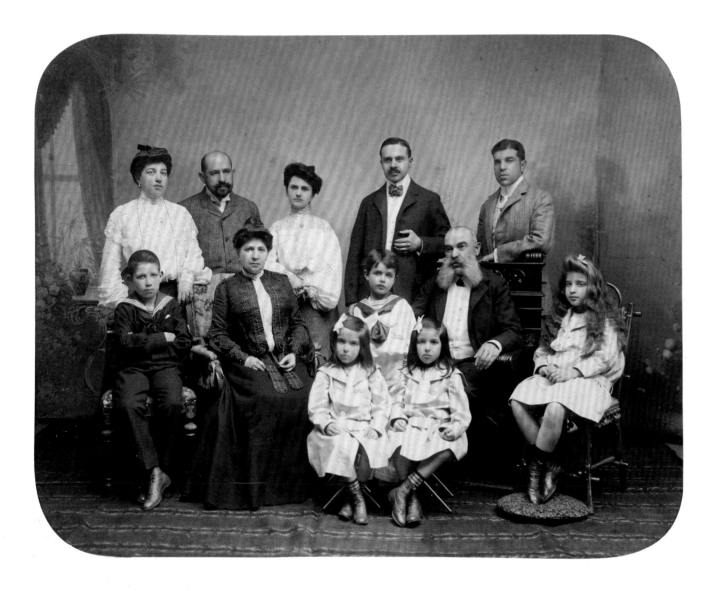

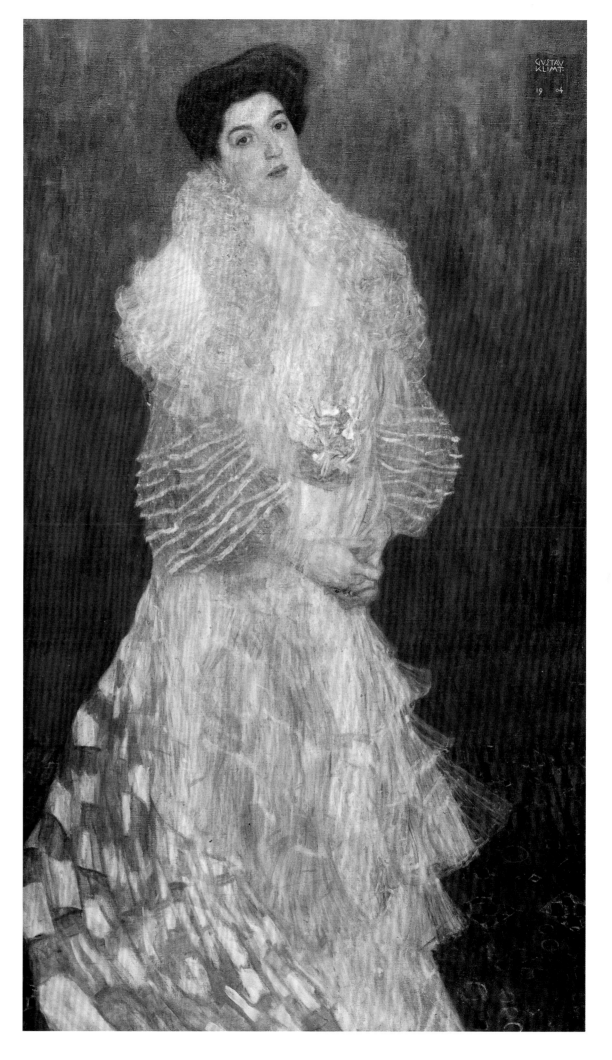

126
Bruno Reiffenstein
*The Hall of the Gallia
Apartment* c.1916
Vintage print, 25.2 × 19.5
Private Collection

127
Bruno Reiffenstein
*The Boudoir of the Gallia Apartment,
with Klimt's* Portrait of Hermine
Gallia *partially visible on the wall
to the left)* c.1916
Vintage print, 25.2 × 19.5
Private Collection

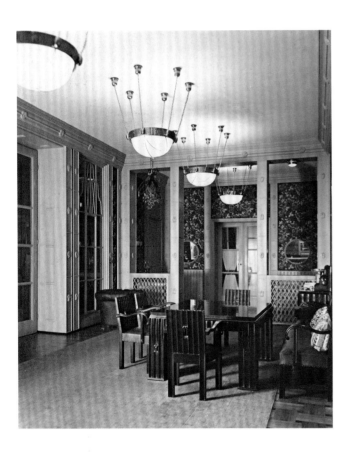

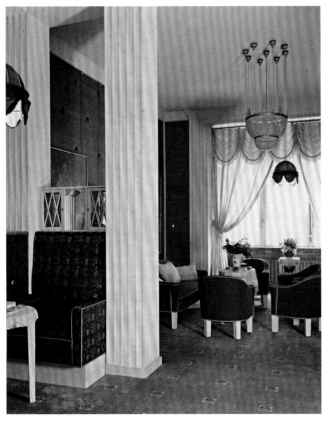

The Gallia Apartment

128
Bruno Reiffenstein
*The Dining Room of the Gallia
Apartment* c.1916
Vintage print, 19.5 × 25.2
Private Collection

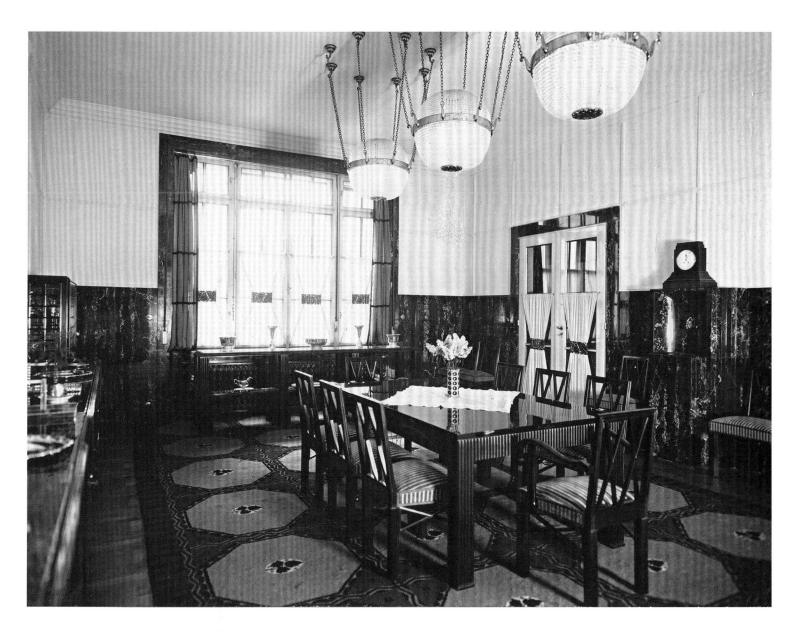

129
Josef Hoffmann
*Bureau from the Boudoir
of the Gallia Apartment* 1913
Made by Johann Soulek
White-enamelled wood, glass,
silk, 179.5 × 111 × 64.6
National Gallery of Victoria,
Melbourne. Samuel
E. Wills Bequest, 1976

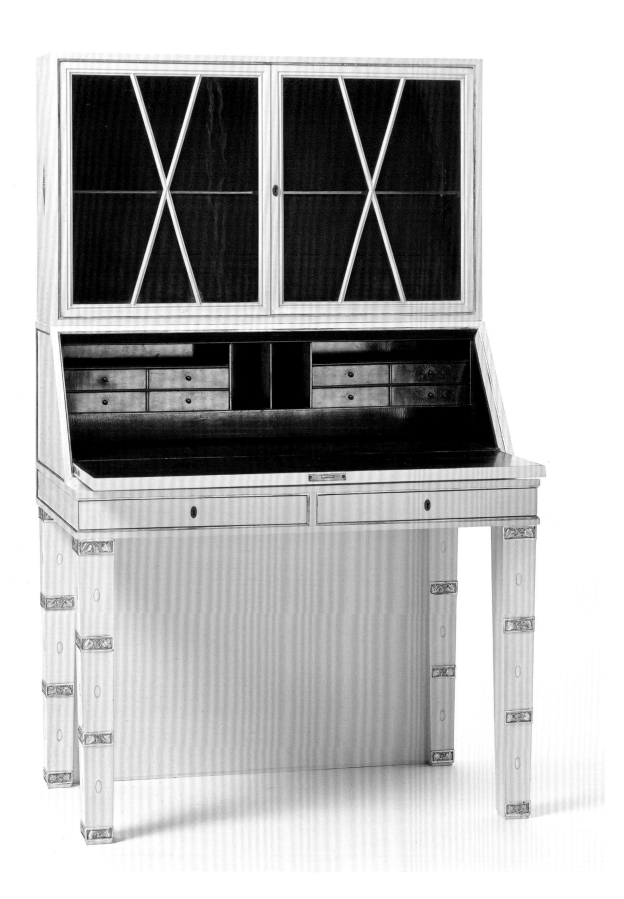

130
Josef Hoffmann
*Occasional Table from the Boudoir
of the Gallia Apartment* 1913
Made by Johann Soulek
Painted wood, gilt, marble
75.6 × 90 × 50
National Gallery of Victoria,
Melbourne. Samuel
E. Wills Bequest, 1976

131
Josef Hoffmann
*Chair from the Boudoir
of the Gallia Apartment* c.1912
Made by Johann Soulek
Painted wood, gilt, other
materials, 91.1 × 48.3 × 49.5
National Gallery of Victoria,
Melbourne. Samuel E. Wills
Bequest, 1976

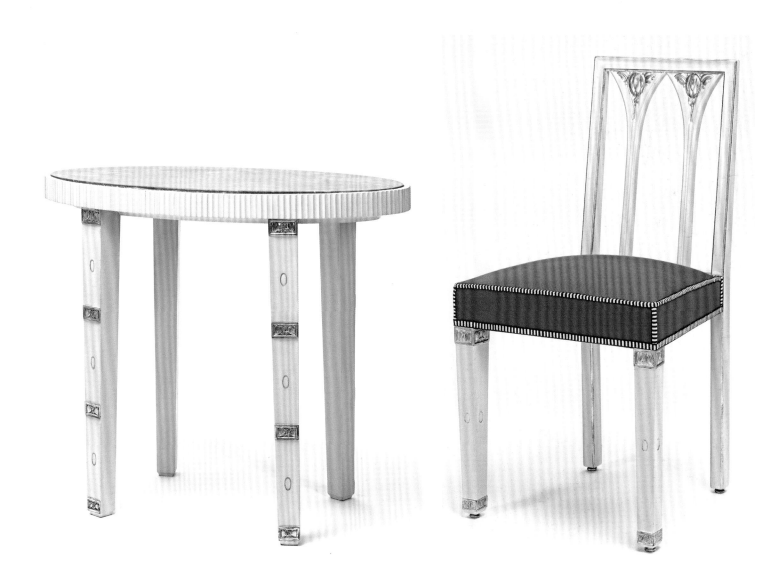

132
Josef Hoffmann
*Design for Boudoir Carpet
of the Gallia Apartment* 1913
Pencil, gouache and crayon
on tracing paper, 86.5 × 129
Backhausen Archive, Vienna

133
Josef Hoffmann
*Fruit Basket from the Gallia
Apartment* c.1905
Made by the Wiener Werkstätte
Silver, ivory, 16.1 × 19.5 × 15.3
National Gallery of Victoria,
Melbourne. Samuel E. Wills
Bequest, 1976

134
Koloman Moser
*Sweet Basket with Monogram
HG (Hermine Gallia)* c.1905
Made by the Wiener Werkstätte
(Josef Holl)
Silver, shell, lapis lazuli
14.8 × 19.4 × 8.6
National Gallery of Victoria,
Melbourne. Samuel E. Wills
Bequest, 1976

135
Josef Hoffmann
*Cigarette Box from the Gallia
Apartment* c.1904–5
Made by the Wiener Werkstätte
(Augustin Grötzbach)
Electroplated silver and onyx
8.5 × 15.1 × 12
National Gallery of Victoria,
Melbourne. Samuel E. Wills
Bequest, 1976

136
Josef Hoffmann
Vase from the Gallia Apartment
c.1913
Made by the Wiener Werkstätte
(Alfred Mayer)
Silver, 12.7 × 29.3 × 25.2
Private Collection, Melbourne

137
Josef Hoffmann
*Vase from the Gallia
Apartment* c.1906
Made by the Wiener
Werkstätte (Josef Holi)
Silver and glass, 10.9 × 22.1 × 10.2
National Gallery of Victoria,
Melbourne. Samuel E. Wills
Bequest, 1976

138
Josef Hoffmann
*Fruit Basket from the Gallia
Apartment* c.1908
Made by the Wiener Werkstätte
Electroplated silver
16.6 × 14.5 × 14.3
National Gallery of Victoria,
Melbourne. Samuel E. Wills
Bequest, 1976

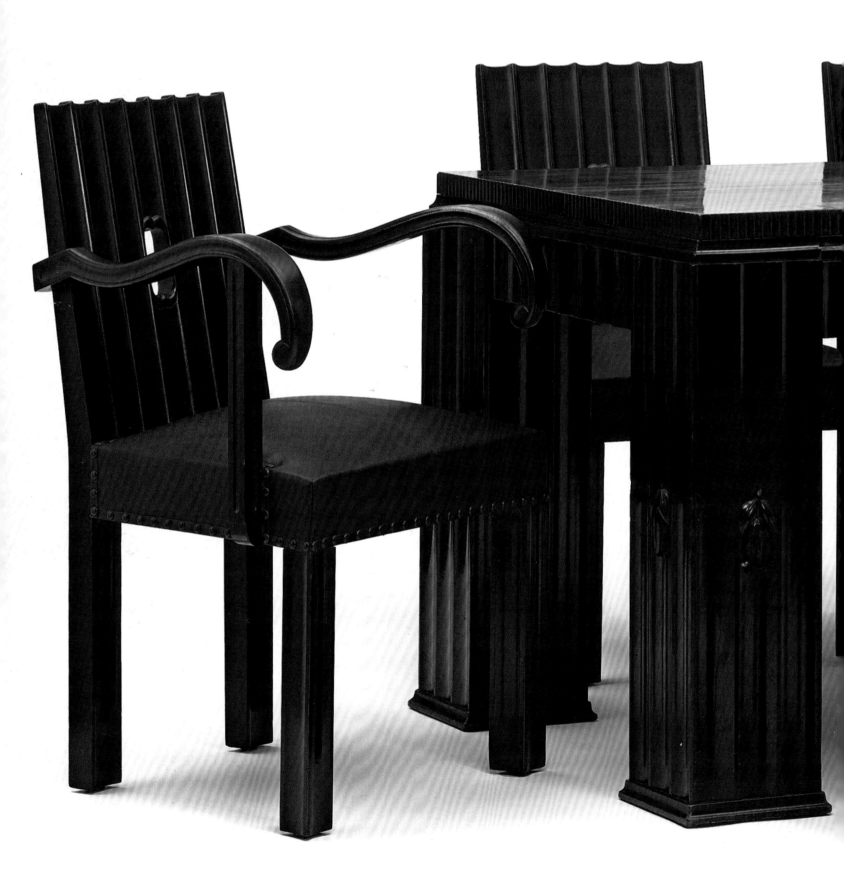

139
Josef Hoffmann
*Dining Table and Chairs from
the Hall of the Gallia Apartment* 1913
Made by Johann Soulek
Ebonized wood, 78 × 127 × 92.5
National Gallery of Victoria,
Melbourne. Samuel
E. Wills Bequest, 1976

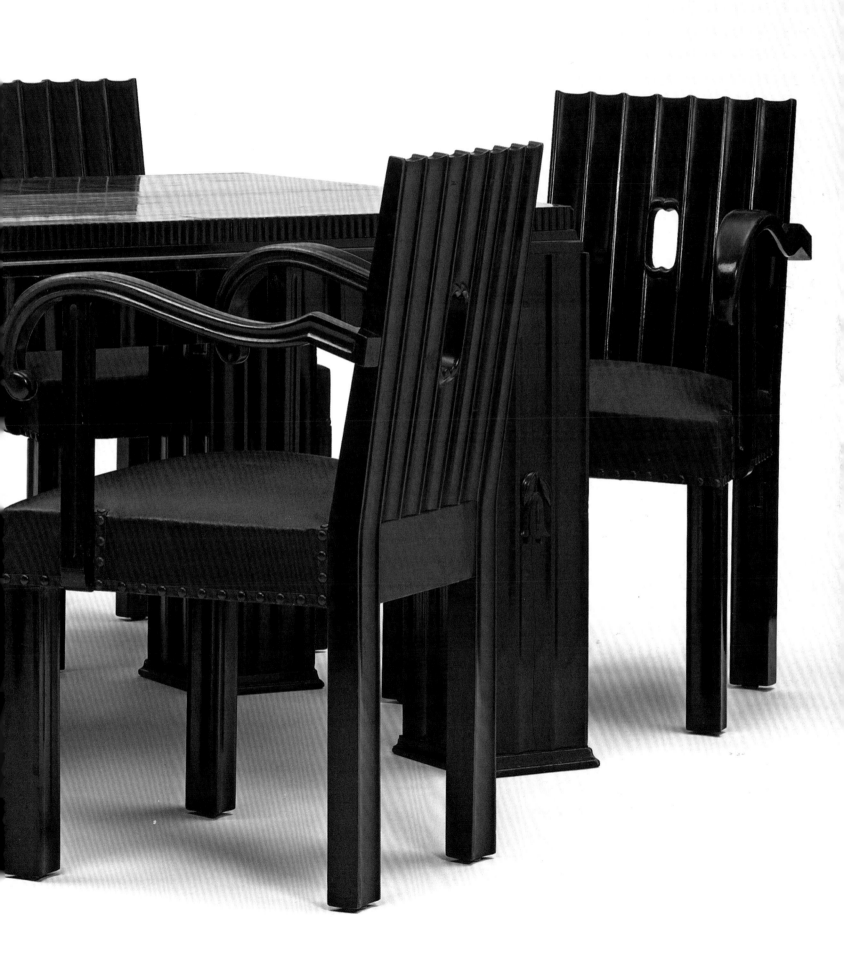

Karl Wittgenstein and the Wittgenstein Family

The patronage of the industrialist Karl Wittgenstein and of members of the wider Wittgenstein family – notably, his elder brother, Paul, the latter's son, Hermann, and Karl's youngest daughter, Margarathe (later Margarethe) – was to be of fundamental importance to the careers of Gustav Klimt and Josef Hoffmann, and to the early endeavours of both the Viennese Secession (see pp.60–79) and the Wiener Werkstätte (see pp.100–17). Their support provided crucial funding for novel enterprises (most notably, an exhibition pavilion for the Secession, figs.50–2), commissions for furniture and interiors (figs.155, 159), and for the construction/adaptation of residential, ecclesiastical and recreational buildings (fig.146), in addition to the acquisition or commissioning of work by a number of outstanding artists. Work acquired or commissioned by the Wittgensteins embraced Klimt's output as portraitist, allegorist and landscapist (figs.140–1, 144), and encouraged the evolution of Hoffmann's architectural and design styles, from his early interest in the English Arts and Crafts Movement, through his use of simplified geometrical forms and black/white contrast, to the refined combination of opulent colour and luxurious materials.

Karl Wittgenstein was the sixth of the eleven children of the wealthy wool merchant Hermann Christian Wittgenstein and his wife Fanny, née Figdor, both of Jewish extraction but converting early to Protestantism. Born near Leipzig in 1847, he moved to Vienna with the rest of the family in 1859. After a rebellious and adventurous youth (including two years spent earning a precarious living in the United States), he briefly attended the Viennese Technische Hochschule and in 1872 embarked on a career in the iron industry, initially in Teplitz, northern Bohemia (now Teplice, Czech Republic), at the iron rolling mill then under the direction of a relative, Paul Kupelwieser, whose post Karl took over in 1877. Married three years earlier to Leopoldine Kalmus (herself Viennese, of Jewish extraction, though raised as a Catholic), with whom he was to have eight children (their youngest son being the future philosopher Ludwig), Wittgenstein soon hit his entrepreneurial stride, proving tireless and innovative in acquiring and amalgamating iron-related enterprises. By 1898, the year of his decision to retire from further direct involvement in this field, he was the driving force behind no fewer than fourteen key mines, processing plants and factories, and was later to be hailed by the London *Times* as the 'Carnegie of Austria'. His dominating personality, formidable intellect, readiness to take risks and exploit technological innovation, and his endeavour to introduce foreign (in particular, American) business practices into economically and industrially backward Central Europe earned him numerous enemies and eventually the widespread hostility and opposition that prompted his decision to redirect his energies. He now turned to his chief recreations (in particular, music and hunting), to private philanthropy, and to the patronage of the fine and applied arts (advised and encouraged in this last venture by his eldest daughter, Hermine).

As a patron, Karl Wittgenstein proved daring and imaginative, and was especially drawn to highly talented individuals engaged in a conscious struggle with social and aesthetic conventions. His collection of fine art, largely amassed at his palatial chief Viennese residence, in Alleegasse, soon contained sculpture by Auguste Rodin, Max Klinger and Ivan Meštrović, and paintings by Giovanni Segantini and, above all, Gustav Klimt. It was fortunate that the start of this final stage in his life (he died in 1913) should coincide with the founding of the Viennese Secession. Wittgenstein readily came to its rescue in 1898 by supplying most of the deposit that the association was required to pay in order to secure a ten-year lease on the site it had been offered by the City of Vienna for the construction of its highly unconventional exhibition pavilion. His subsequent support for the Secession, both before and after the schism of 1905, was later acknowledged in a memorial plaque.

In 1899 Paul Wittgenstein became a patron of Josef Hoffmann (a role in which his brother Karl was soon to follow), commissioning him to adapt and extend the Bergerhöhe, his country house near Hohenberg, Lower Austria, and three years later to build a small church in nearby St. Aegyd. Both projects, as executed, reflect Hoffmann's interest at this time in the English Arts and Crafts Movement and its high regard for the updated vernacular. After Hoffmann had collaborated with Koloman Moser in 1904 on the interior, furnishings and fittings for the Berlin apartment of Margaret Stonborough-Wittgenstein, Karl's daughter (figs.148, 150, 159), he did so again in 1906 for the Viennese apartment of Paul's son, the physician Hermann Wittgenstein, the result making striking use of black and white and incorporating both inbuilt and free-standing furniture (fig.155).

By now Karl Wittgenstein had become a keen supporter of Gustav Klimt, in 1904–5 commissioning a portrait of Margaret to mark her marriage to the American chemist Jerome Stonborough (fig.140). This is particularly intriguing for its incorporation of simplified architectural forms in the background, evocative of Hoffmann's contemporary work. At approximately the same time he acquired a picture first exhibited at Klimt's one-man show of 1903, the allegorical composition *Life is a Struggle (The Golden Knight)* (fig.144). Between 1908 and 1911 Wittgenstein added three further Klimt paintings to his collection: *Water Serpents I* (figs.141, 142), the quintessence of this artist's incomparable blend of vividly realised fantasy and exquisitely crafted ornament, in addition to *The Sunflower* 1906/7 and a 1910 view of Schloss Kammer on the Attersee. Hermine, meanwhile, acquired a further landscape: the vibrantly coloured *Farmhouse Garden with Sunflowers* 1908.

While Hoffmann and his associates created only two interiors for Karl Wittgenstein's hunting lodge at Hochreith, near Hohenberg, Lower Austria, these were expressly opposed in terms of colouring, materials and decoration. A white vestibule, entered by way of a veranda, established

140
Gustav Klimt
*Portrait of Margaret
Stonborough-Wittgenstein* 1905
Oil on canvas, 180 × 90
Neue Pinakothek, Munich

a 'joyful' mood with its brightly coloured decorative
elements: glazed door panels by Koloman Moser and Carl
Otto Czeschka's inset square lacquer paintings of birds and
baskets of flowers. The larger, multi-purpose main room
(fig.146), intended to convey a sense of luxury, intimacy and
warmth, employed tones carefully co-ordinated with the
highly polished reddish-brown Maracaibo wood used for the
ceiling beams, wall panels and doors, with only a few con-
trasting elements: the white of a tile stove with a decorative
ceramic figure of Diana by Richard Luksch, or the yellow of
an embroidered curtain used as a room divider. A strong sense
of deliberation in design was maintained through the uniform
grid of the gilt-framed wall panels and its reflection in the
assertively rectangular forms of much of the furniture: a
space-saving inbuilt desk unit, or a dining table and a small
card table (fig.145). The essentially 'urban' sophistication
of this room, a defiant anomaly in its rural setting, soon found
discerning admirers, one of the first to praise Hoffmann's
achievement being his associate and patron Fritz Waerndorfer
(see also pp.118–31), who wrote: '[the room] is inordinately
beautiful, but not in the least ostentatious, one is not
especially struck by the gilt framing (I could easily imagine
someone who had much admired the room being then asked
what he thought of the gilt framing, and replying that he
had not noticed it at all), the carpet is splendidly warm in
tone, and the whole thing is just as I would have imagined
the most intimate of interiors created for a Fugger [a member
of the illustrious banking family] in the Middle Ages.'

Elizabeth Clegg

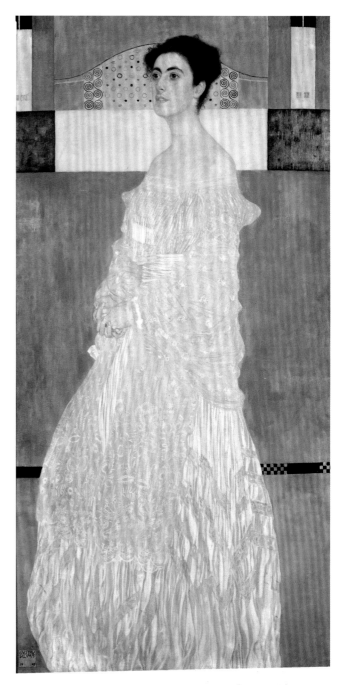

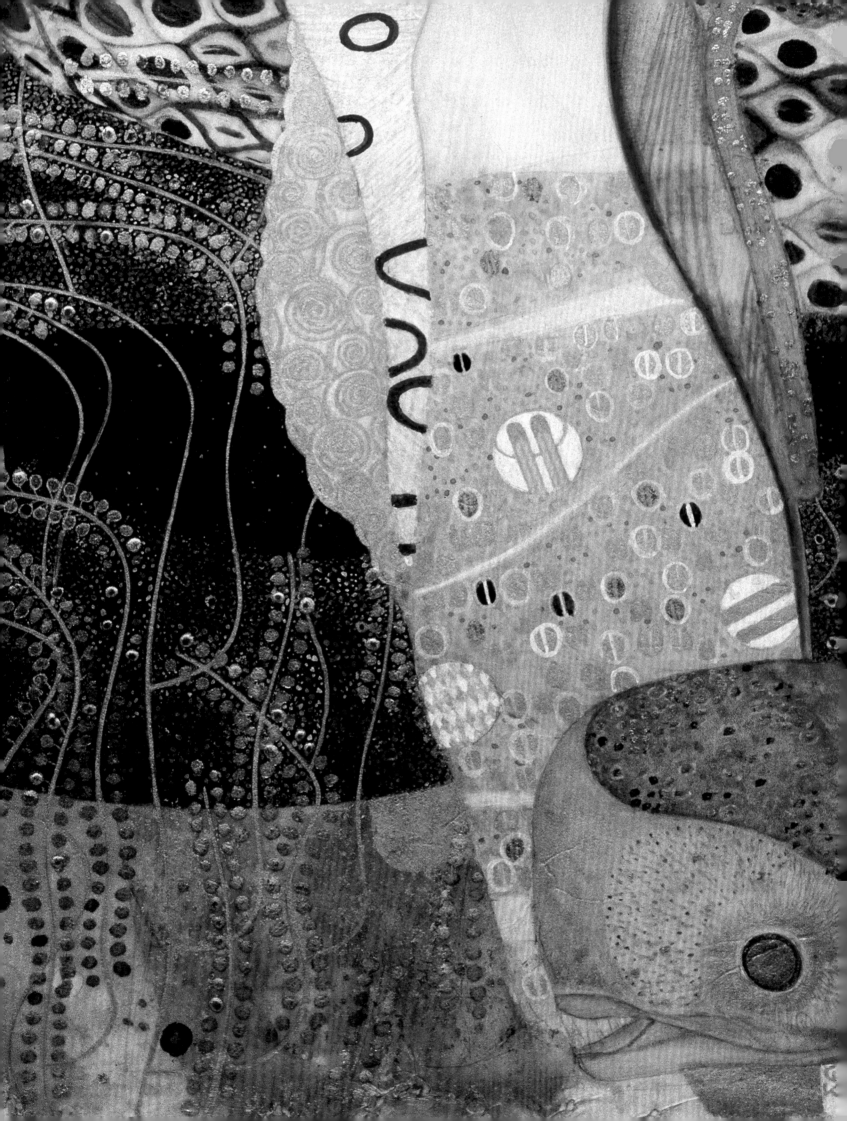

141
Gustav Klimt
Water Serpents I 1904–7
Mixed media on
parchment, 50 × 20
Belvedere, Vienna

The painting was acquired
in 1908 by Karl Wittgenstein.

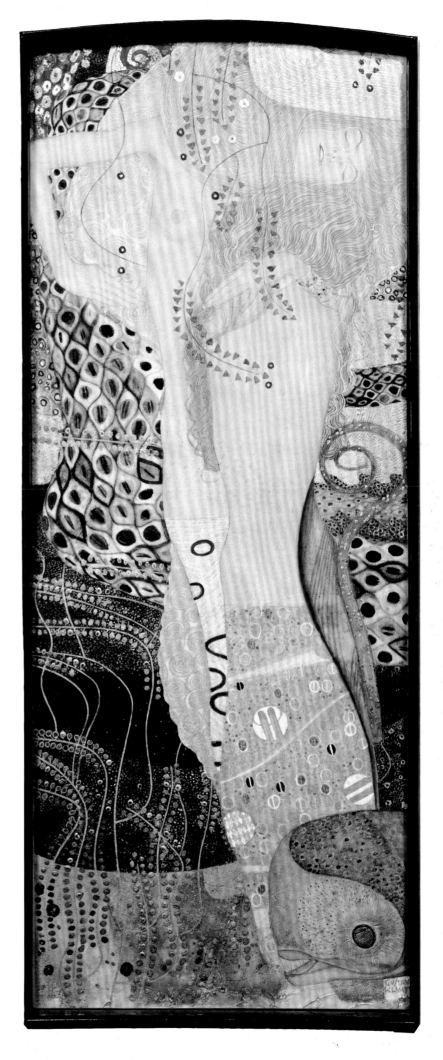

142
Detail of the Wiener Werkstätte
frame for *Water Serpents I*

143
*Gold Laurel Leaves presented
to Rudolf von Alt on the Occasion
of the Foundation of the Viennese
Secession* c.1898
Gold and wood, 26 × 17.5 × 3
Private Collection

The laurel wreath was awarded by
the Vienna Secession to its founding
member and honorary president,
Rudolf von Alt. After his death,
Alt's daughter presented the wreath
to the Wittgenstein family.

144
Gustav Klimt
*Life Is a Struggle
(The Golden Knight)* 1903
Oil, tempera, and gold on
canvas, 103.5 × 103.7
Aichi Prefectural Museum
of Art, Nagoya

Owned by Karl Wittgenstein, the
painting was originally installed
in the staircase of his Vienna house.

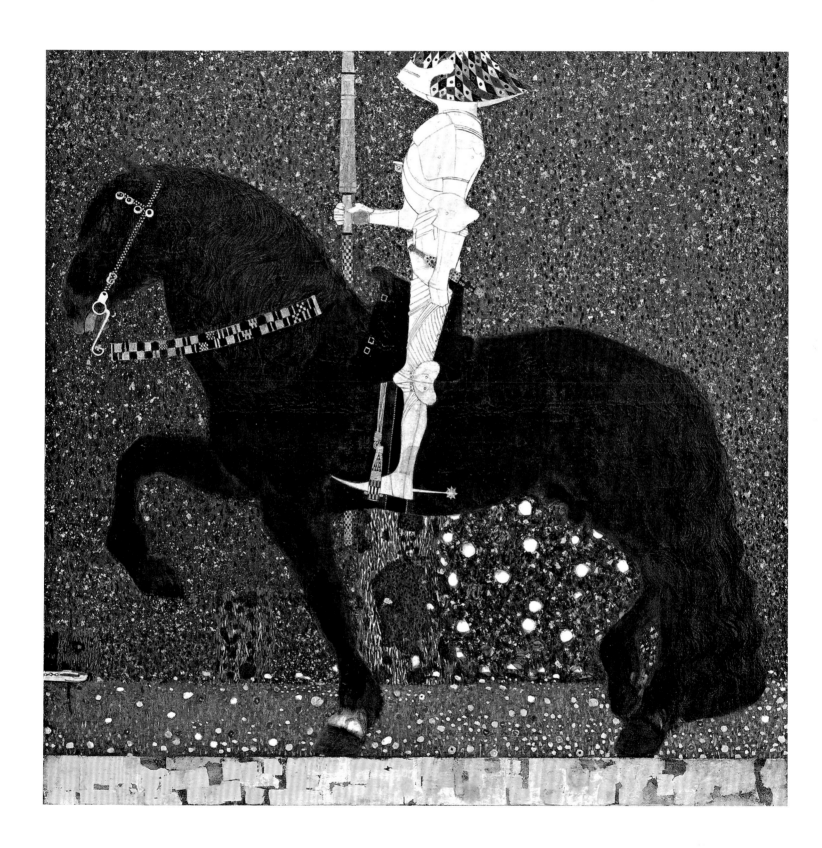

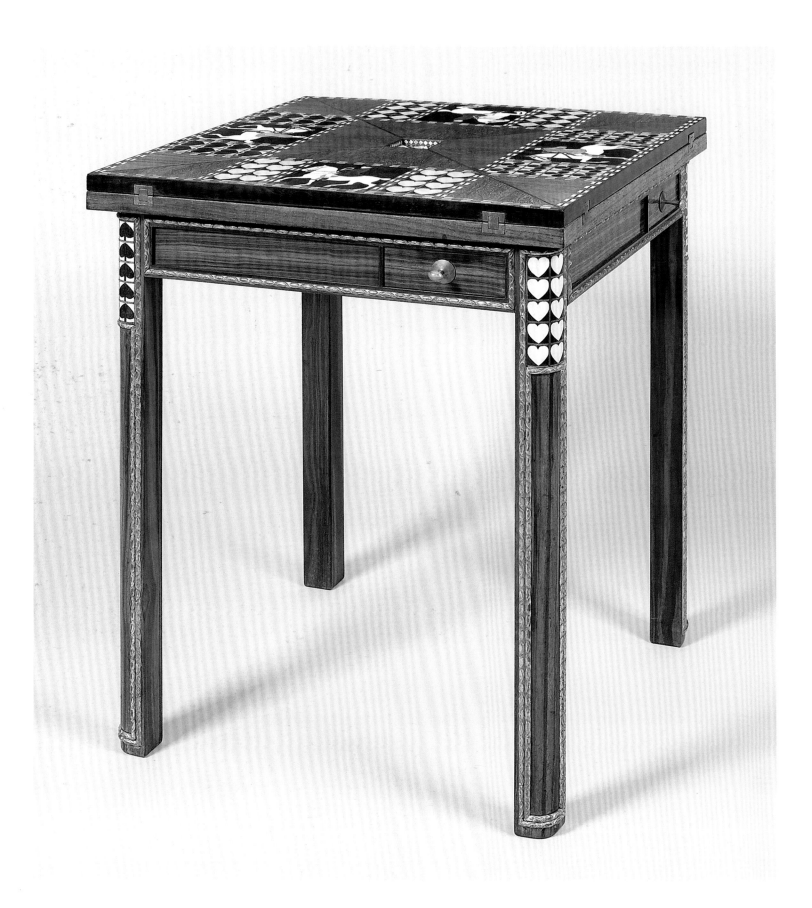

145
Josef Hoffmann and
Carl Otto Czeschka
*Card Table for Karl
Wittgenstein* 1907
Various exotic woods, ivory
and mother of pearl, 75 × 59 × 59
Asenbaum Collection

146
*The Main Room of the Hunting
Lodge at Hochreith, designed
for Karl Wittgenstein by
Josef Hoffmann* 1906
Anonymous photograph
MAK – Austrian Museum
of Applied Arts/Contemporary
Art, Vienna

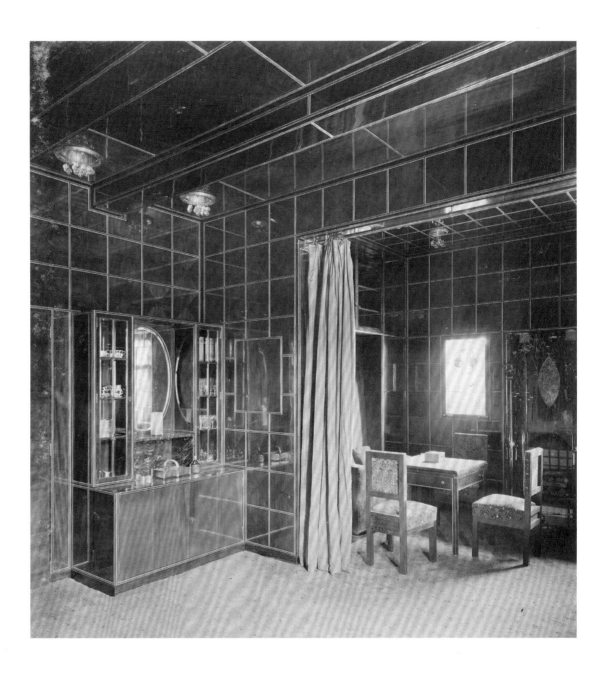

The Tea and Coffee Service Owned by Margaret Stonborough-Wittgenstein[1]

147
Original Wiener Werkstätte
photograph of a Tea Service
designed by Josef Hoffmann
for the Stoclet family 1903
MAK – Austrian Museum of Applied
Arts/Contemporary Art, Vienna

Objects bear silent witness to their own age; they often survive those who made or owned them. But even if they escape destruction, they are generally forcibly removed from their original context and sink into oblivion. If only objects had the power of speech and could tell us their stories ... and a very particular story springs to mind at the sight of the tea and coffee set (fig.148) owned by Margaret (also known as Margarethe or Gretl) Stonborough-Wittgenstein (1882–1958). This is not only one of the few surviving tea and coffee sets designed for his many distinguished clients by Josef Hoffmann in the early days of the Wiener Werkstätte, it also very much reflects the lifestyle and fate of the families that championed the art of Gustav Klimt.

The extensive Wittgenstein family included many staunch supporters of the Viennese Secessionists. They were active participants in the artistic and cultural life of turn-of-the-century Vienna and generous clients, employing members of the Wiener Werkstätte (founded in 1903) under the leadership of Josef Hoffmann and Koloman Moser[2] to work on and decorate a whole series of town houses, apartments, villas and country residences. Margaret's father, Karl Wittgenstein (1847–1913), was one of the most successful entrepreneurs in the then Austro-Hungarian Empire. He was the epitome of a self-made man. Born into a wealthy family that had converted from Judaism to Protestantism, he always followed his own instincts. Within just thirty years he created an empire in the iron and steel industry, the like of which has never been seen again. After the age of fifty, he began to step back from the day-to-day running of the business and further

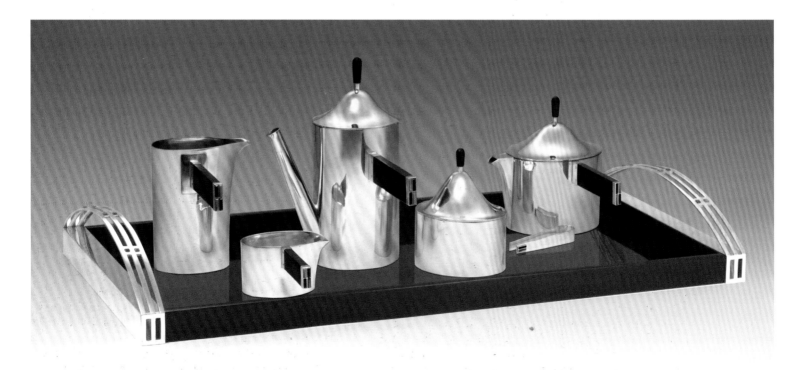

148
Josef Hoffmann
Tea and Coffee Service for Margaret Stonborough-Wittgenstein 1904
Made by the Wiener Werkstätte (Adolf Erbrich, Josef Holi, Josef Hoßfeld and Josef Wagner)
Silver, coral and onyx, ebony
Asenbaum Collection

Model nos. S 314 (tray), 386 (coffee pot), 388 (milk jug), 389 (tea pot), 390 (cream jug), 391 (sugar box). Marked: WW rosemark, JH (Josef Hoffmann), JH (Jose Holi), AE (Adolf Erbrich), JW (Josef Wagner), Vienna hallmark (except the sugar tongs)

149
Josef Hoffmann
Design sketches for the Tea Pot and Cream Jug
Pencil on squared paper
MAK – Austrian Museum of Applied Arts/Contemporary Art, Vienna

increased his fortune by dint of industrial mergers and astute speculation in stocks and shares. Karl Kraus, ever critical of Karl Wittgenstein's financial machinations, wrote in 1899, 'The Viennese stock exchange fears nothing in the world apart from God, Taussig[3] and Wittgenstein ...'.[4] With his future income secure, in 1901 Karl Wittgenstein retired completely from business and devoted all his energies to travelling, hunting and – most important of all – the arts.[5]

Having moved from Teplitz to Vienna in 1875, Karl Wittgenstein's ever-growing family enjoyed a luxurious lifestyle in Vienna, both in the Stadtpalais and in their villa in Neuwaldegg. 'The Wittgenstein's salon soon became a favourite venue for Viennese intellectuals.'[6] His wife Leopoldine (Poldy), neé Kallmus (1850–1926), was above all a music-lover; artists such as Johannes Brahms, Gustav Mahler and Pablo Casals came and went in the Wittgenstein household and there were regular house concerts.

The eight children,[7] who were taught privately at home, grew up surrounded by art and culture. It was through his friendly connections with Rudolf von Alt that Karl Wittgenstein came to be one of the first supporters of the Viennese Secessionists. Amongst other things, his donation of 50,000 Gulden (100,000 crowns) funded a considerable proportion of the construction of the Secession building (finished in 1898); he also purchased important works at their exhibitions. With the assistance and advice of his eldest daughter Hermine, he built up an extensive art collection, including numerous drawings and at least five oil paintings by Gustav Klimt.[8] One of these paintings was a portrait of Margaret[9] commissioned by her mother Leopoldine in early 1904 (fig.140); Klimt was already a family friend by this point. The frame was made by Josef Hoffmann. The portrait was intended for the Wittgenstein family home since Margaret, who had just become engaged, was to move from Vienna to Berlin with her future husband Jerome Stonborough (1873–1938), a medical student from the United States. In 1904 Karl Wittgenstein commissioned the Wiener Werkstätte to design and produce a large number of items for his daughter's new home in Berlin.

The records for that same year in the model books compiled by the Wiener Werkstätte (now in the Museum für Angewandte Kunst, the Austrian Museum of Applied Arts, Vienna) refer to the silver tea and coffee service shown here. The entries in the model books – generally dated and with the name of the designer – also provide an insight into the company's own costs. Besides listing the materials used and the time taken to make a piece, they also include the sale price and, where it was applicable, the name of the client or purchaser. It is thus possible to trace the full history of the making of this service. In addition to this, Josef Hoffman's design sketches for four of the pieces[10] still survive in the Archives of the Wiener Werkstätte. The first entry, made on 27 September 1904, concerns the large ebony wood tray (S 314) with silver handles set with cabochon-cut coral and onyx. The entry for the client or purchaser reads 'Flesch retour / M(argaret) Wittgenstein'. It seems that a certain Herr 'Flesch', a member of the imperial council, returned this tray having had it on approval.

In this design we see Josef Hoffmann producing a variation on a type of tray that he had already developed in 1902 (before the founding of the Wiener Werkstätte) for a service[11] made by the firm of Alexander Sturm for Karl Wittgenstein's sister, Milly Brücke. In 1903 Hoffmann used the same shape of tray for the service designed for the Stoclet Family (fig.147). Another of the sketches by Hoffmann relates to a tea pot, model number S 378, which is dated 16 November 1904, albeit without a client or purchaser being named. Executed on graph paper in coloured pencils and graphite pencil, the drawing (fig.149) shows various views of a tea pot, a cream jug and details of possible handles. It was in these sketches that Hoffmann first established the vocabulary of forms for Margaret's tea and coffee service.

These pieces are characterised by an oval base, undecorated smooth sides and a horizontal ebony handle. The flat silver end to the handle is divided into four quarters which – like the silver handles of the ebony wood tray – are decorated with coral and onyx. This black-and-red, geometric ornament was to become the exclusive hallmark of Margaret Stonborough-Wittgenstein's tea and coffee service.[12] More pieces from the same set are recorded in the model book, dated 2 December 1904 and marked with the names 'Gretl Wittgenstein/ Kupelwieser'. These items can be seen on the tray already mentioned here in an in-house photograph made for the Wiener Werkstätte (fig.152) and published in 1905 in Deutsche Kunst und Dekoration.[13] The records for 1905 contain another seven entries referring either to a '2nd set' or to additional items made to complement the main set.[14]

It seems very likely that during Margaret's consultations with Josef Hoffmann and Koloman Moser regarding items

Original Wiener Werkstätte
Photograph of the Dining Room
in Margaret Stonborough-
Wittgenstein's Apartment in Berlin
MAK – Austrian Museum of Applied
Arts/Contemporary Art, Vienna

needed for her future home in Berlin she saw the large ebony wood tray in the premises of the Wiener Werkstätte in Neustiftgasse and that she then purchased it for herself in September 1904. In view of her approaching wedding, she ordered a tea and coffee service to go with the tray. The surviving sketches tell us that the tea pot – bought by Margaret in November of the same year – was the first item to be made. This was not to become part of the first service since it was decided to make the knobs on the lids out of ebony, to match the tray. With the exception of the sugar bowl, all the other parts of the final service were finished by the end of 1904, in time for the wedding on 7 January 1905.[15] The designation 'Gretl Wittgenstein/Kupelwieser' refers to the fact that these items were given to Margaret as a wedding present by the Kupelwieser Family.[16]

In March 1905 the '2nd service' – a tea service – was completed. That same month, the craftsmen from the Wiener Werkstätte finished work on the Berlin apartment and installed the remaining lighting. A letter from Margaret to her mother records the fact that Koloman Moser even travelled to Berlin in April in order to spend 'three whole days' shifting furniture and hanging pictures.[17] The small tea pot and the samovar, that are listed last in the model book and complete the main service, were given to Margaret by Poldy Wittgenstein as a Christmas present in 1905.

The total cost of all the individual items displayed here amounted to 1,285 crowns, around two-and-a-half times the annual pay for a skilled worker. That same year Gustav Klimt put a price of 10,000 crowns – a small fortune – on his portrait of Margaret. However, it seems that it was not that unusual to have such costly tea and coffee services made as wedding presents. By way of comparison, the one made in 1904 (fig.151) for Ladislaus and Margarethe[18] von Rémy-Berzenkovich cost 1,030 crowns and the set ordered a year later for Hermann Wittgenstein cost 1,780 crowns.

The tea and coffee service was prominently displayed In the new Berlin apartment of the young Stonboroughs. Along with a number of other silver items from the Wiener Werkstätte, it resided on the sideboard in the dining room designed by Josef Hoffmann (fig.150). After only two years, however, the young couple left this luxuriously appointed apartment and settled in Zurich, following a lengthy stay in New York with Jerome's relatives, the Guggenheims. The tea and coffee service remained a key item in Margaret's household and her constant companion, so to speak. A photograph taken in the 1930s shows Margaret enjoying afternoon coffee with friends and relatives in the salon of the house at 19 Kundmanngasse in Vienna designed for her by her youngest brother Ludwig and Paul Engelmann, a student of Adolf Loos; clearly in view on the table in front of Margaret are pieces from her much loved silver tea and coffee service (fig.153). Margaret even managed to prevent the service from being confiscated by the Nazis[19] and to take this memory of Viennese life and culture with her into exile.

Paul Asenbaum

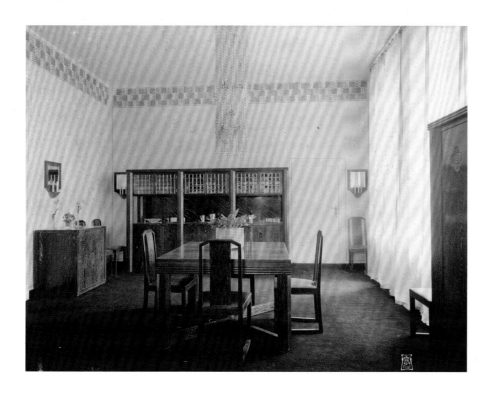

151
Josef Hoffmann
Tea and Coffee Service for
Ladislaus and Margarethe
Rémy-Berzenkovich 1904
Silver, ebony, natural fibre
Asenbaum Collection

152
Original Wiener Werkstätte
Photograph of the Tea and
Coffee Service for Margaret
Stonborough-Wittgenstein
MAK – Austrian Museum of Applied
Arts/Contemporary Art, Vienna

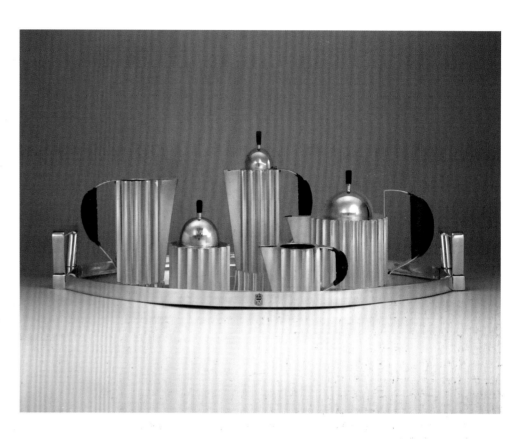

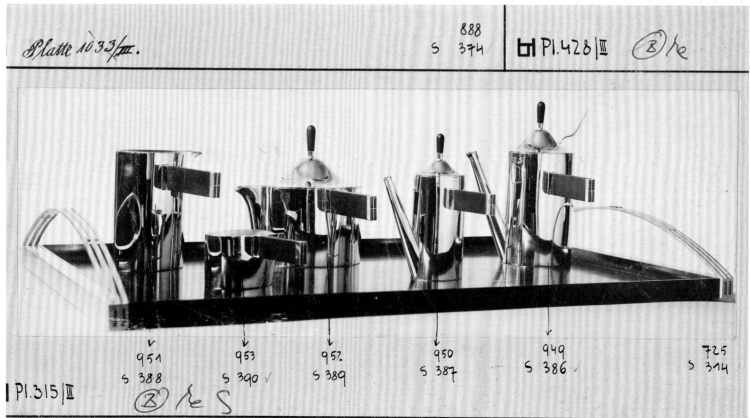

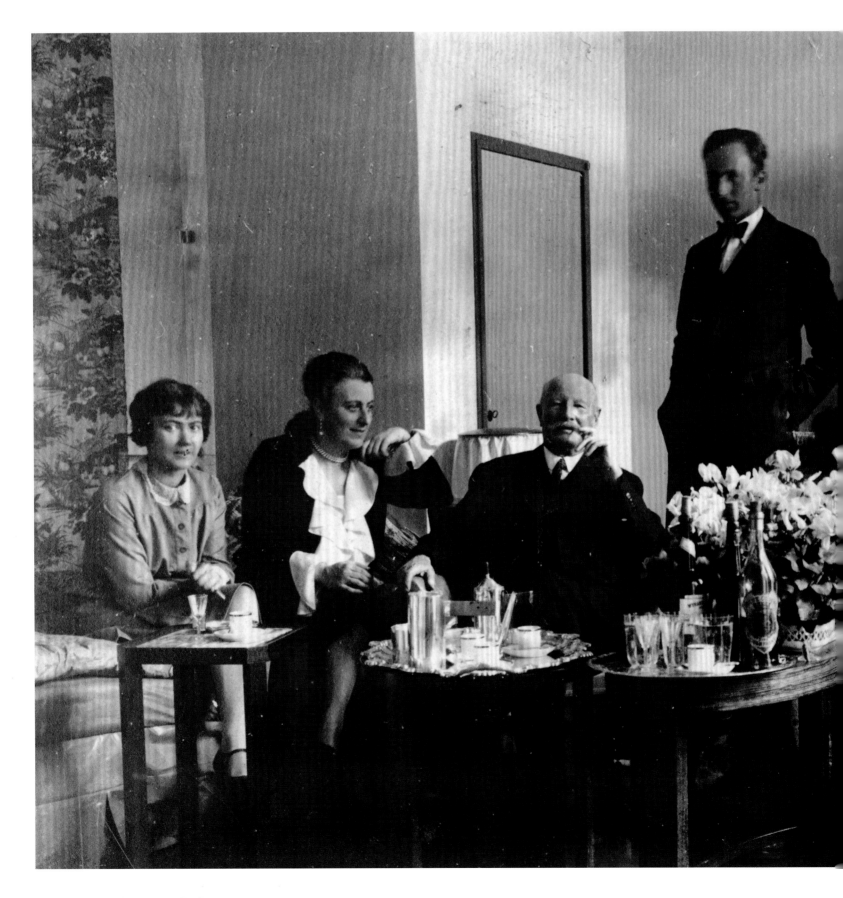

Karl Wittgenstein and the Wittgenstein Family

153
Moritz Nähr
Margaret Stonborough-Wittgenstein with Friends and Relatives in her Residence at Kundmanngasse 19, Vienna c.1931
Vintage print c.1930
Pierre and Françoise Stonborough, Vienna

Left to right: Marguerite Respinger, Margaret Stonborough-Wittgenstein, Primarius Foltanek, Carl 'Talla' Sjögren, Ludwig Wittgenstein, Count Georg Schönborn-Buchheim, Arvid Sjögren).
Note the Josef Hoffmann silver tea and coffee service, on the Josef Hoffmann coffee table.

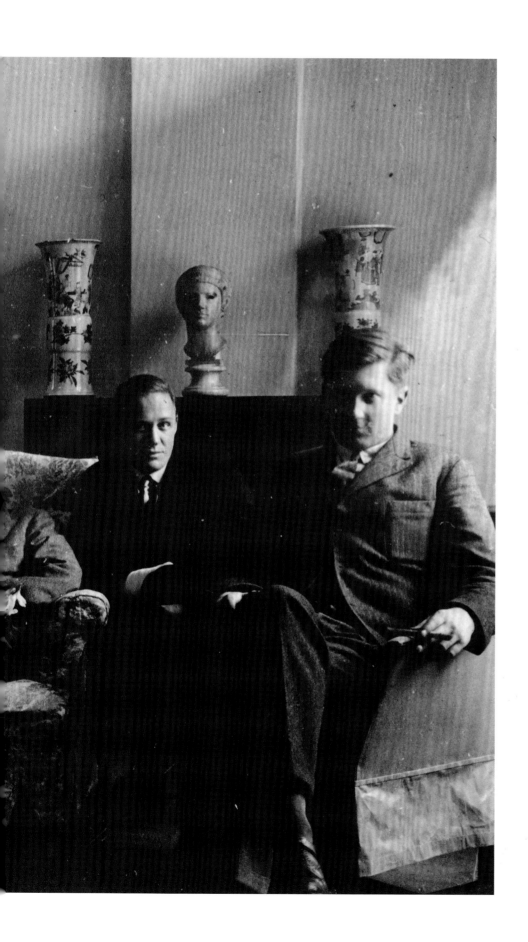

154
Gustav Klimt
*Study for Portrait of Margaret
Stonborough-Wittgenstein* 1905
Pencil on paper, 54.5 × 35
Private Collection

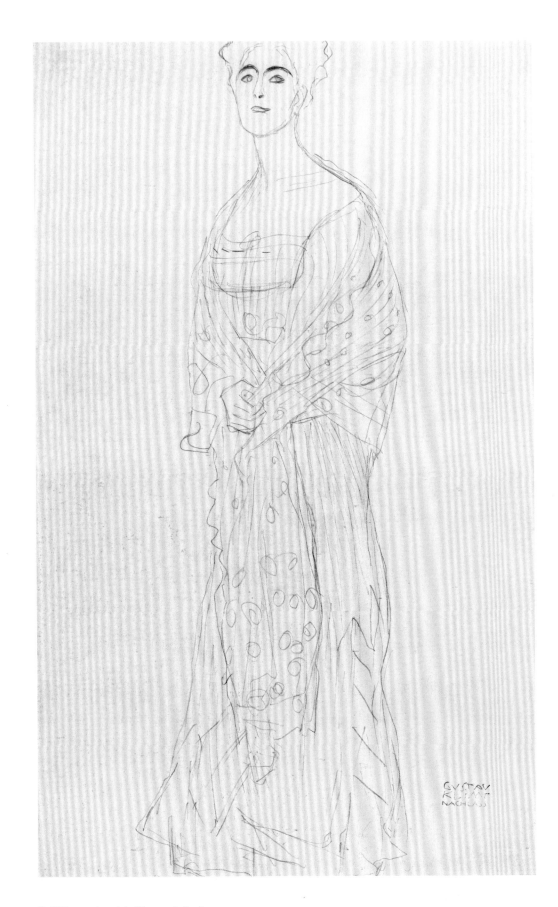

155
Koloman Moser
Bed from the Guest Room
of the Apartment of
Dr Hermann Wittgenstein,
Salesianergasse, Vienna 1906
Grey and white painted soft
wood with brass fittings
Bed 100 × 207 × 90,
bedside table 74 × 40 × 37
Collection Hummel, Vienna

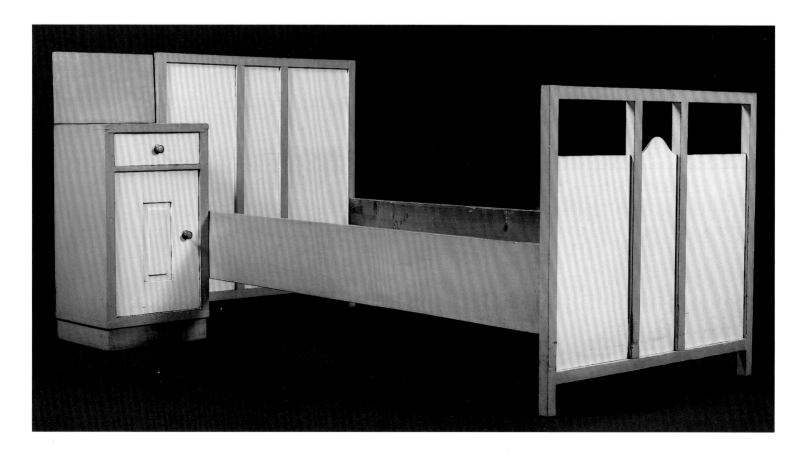

156
Koloman Moser
Sugar Bowl with Spoon for Margaret
Stonborough-Wittgenstein c.1905
Made by the Wiener Werkstätte
Silver, bowl height 12.5, diameter
11; spoon, length 14.5, width 2.5
Private Collection

157
Josef Hoffmann
Three Albums containing
Photographs of Karl Wittgenstein
and his Family c.1905
Made by the Wiener Werkstätte
Bound in gold-tooled leather
Each 21 × 25 × 6.3
Private Collection

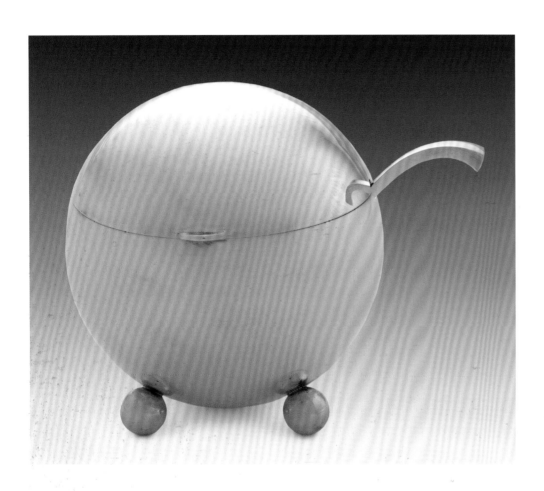

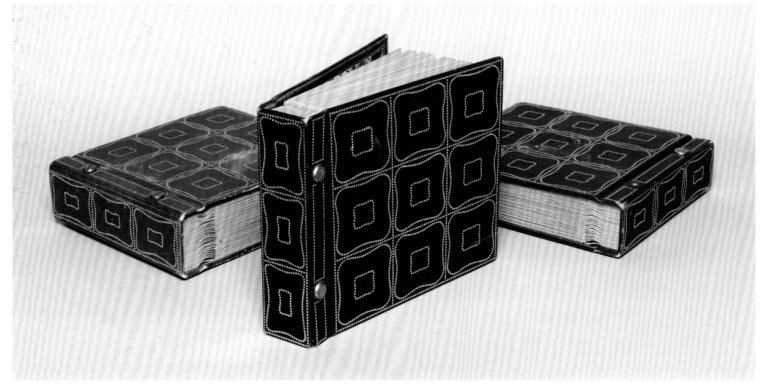

Karl Wittgenstein and the Wittgenstein Family

158
Carl Otto Czeschka
Niccolò Bonbon Box for Margaret
Stonborough-Wittgenstein 1906
Made by the Wiener Werkstätte
Silver, Height 9.4, diameter 10.7
Private Collection

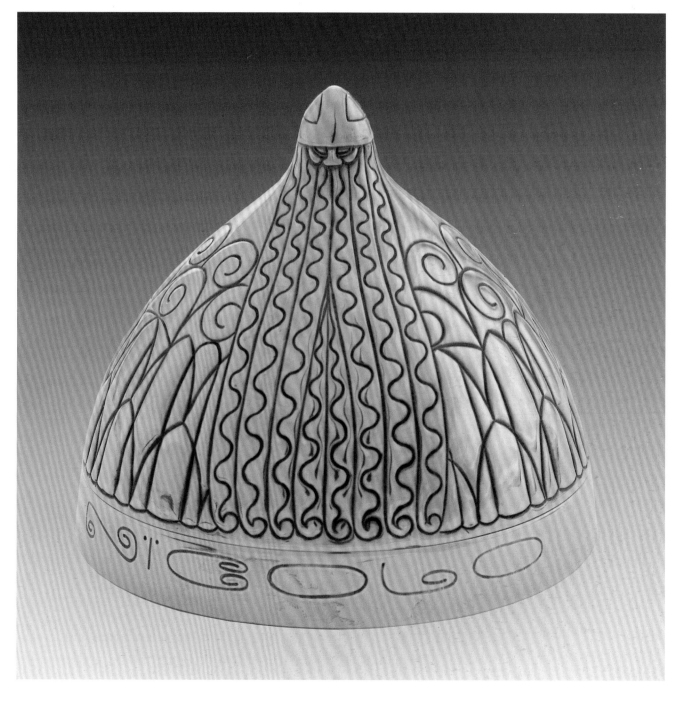

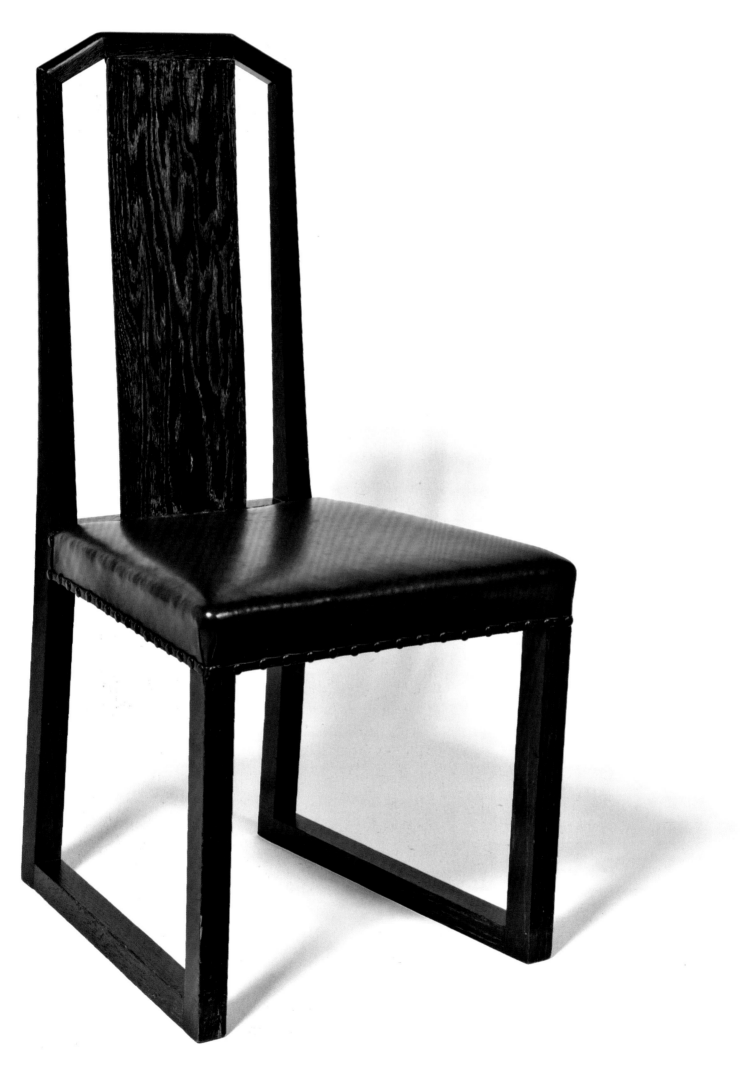

Karl Wittgenstein and the Wittgenstein Family

159
Josef Hoffmann
Chair from the Dining Room of
Margaret and Jerome Stonborough's
Berlin Residence 1905
Made by the Wiener Werkstätte
Silver oak and black-stained oak
98.5 × 47 × 47
Ernst Ploil, Vienna

160
Josef Hoffmann
Coal Scuttle owned by
Paul Wittgenstein 1905
Made for the Wiener Werkstätte
(Thomann Co.)
Wrought iron, nickel handle
with oxidised copper shovel
Scuttle height 53.6; shovel
Length 45
Ernst Ploil, Vienna

Eugenia and Otto Primavesi

Eugenia and Otto Primavesi were the most significant new patrons of Klimt's last years, and second only to August and Serena Lederer (who made acquisitions over a much longer period) as his most important patrons overall, as much for the range as for the number of the works they owned (figs.164, background of 177, 189). They were also to make key purchases from the Klimt estate (figs.171). In the same period they figured prominently in the career of Josef Hoffmann, in 1913 commissioning him to design and decorate a substantial country house in a hybrid 'rustic Neo-Classical' style at Winkelsdorf, near Mährisch-Schönberg, northern Moravia (now Kouty, near Šumperk, Czech Republic) (fig.161), and to make adaptations to their pre-existing house in the north-central Moravian city of Olmütz (now Olomouc, Czech Republic). They took a longer-term, indirect interest in Hoffmann as co-founder of the Wiener Werkstätte, of which they were keen supporters (figs.167, 168, 165) and, upon its restructuring after bankruptcy in 1914, key financial backers, Otto also serving from 1915 as its Commercial Director. The Wiener Werkstätte, in particular its textiles, was to be a dominant presence in the interiors at Winkelsdorf (fig.162).

The Primavesis had married in 1895. Owner and Executive Director of the Primavesi Bank, based in Olmütz, Otto had been born in 1868 into a Catholic family that had moved there from Lombardy in the late eighteenth century and had long occupied a leading position in the financial, economic and political life of the city and the region. Eugenia, born Butschek into the Catholic family of a railway official near Vienna in 1874, had trained as an actress (taking the stage name 'Mäda'), and had met her future husband in Olmütz during one of her first professional engagements. Soon abandoning her acting career, she nonetheless long maintained a theatrical flair in the running of her various households, in all of which there prevailed a fervent 'cult of the child' – the Primavesis were to have four: Otto, Lola, Mäda and Melitta, born in 1898, 1900, 1903 and 1908 – and an equally important 'cult of the mother', Eugenia herself.

It was through the German-Moravian sculptor Anton Hanak, a close friend since 1904, that the Primavesis were introduced, in 1911, to Hoffmann and, probably early the following year, to Klimt; and they lost little time in extending important commissions to both. While discussions were underway with Hoffmann concerning plans for a new house in the country, Klimt was asked to paint a portrait of Mäda and then one of her mother, the subjects making several visits to his Viennese studio(s) for this purpose. The resulting images, of 1912 and 1913–14 (figs.166, 164), are among the first to signal the advent of Klimt's new, late portrait style, be it in their colouring (pinkish lilac, icy blue, emerald green, lemon yellow), their generally looser brushwork, or their greater emphasis on attractive ornamental details of indeterminate import. Intriguingly, both portraits do nonetheless seem to anticipate aspects of the interior of the house at Winkelsdorf (which would, at the least,

have then been under discussion). Mäda's room was to be decorated in a pale and dark blue version of the Wiener Werkstätte zigzag textile pattern *Wallflower*, which is possibly prefigured in the foreground of her picture. And the arched green form behind the head and shoulders of Eugenia is close in colour and shape to decorative elements found in the parents' sitting room and in the hall (fig.162).

Hoffmann's country house for the Primavesis, which was completed and habitable, if not yet fully decorated, by the summer of 1914, was remarkable as much for its superb site (around seventy kilometres north of Olmütz) as for its novel appearance. Positioned towards the top of a south-east-facing slope in the densely wooded foothills of the Altvater Mountains (Jeseníky) overlooking the Tess (Desná)

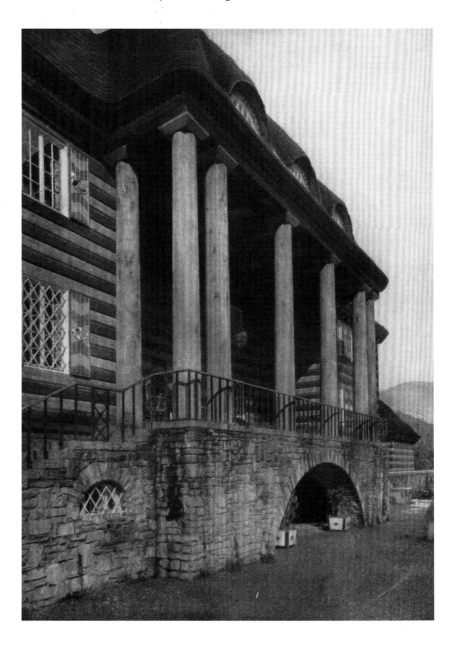

161
*The Main Façade of the House
at Winkelsdorf, near Mährisch-
Schönberg, northern Moravia
(1913–14), designed by Josef
Hoffmann for Otto and Eugenia
Primavesi*
Anonymous photograph published
in *Deutsche Kunst and Dekoration*
in June 1916

162
*The Eastern End of the Hall on
the raised Ground Floor of the
Villa Primavesi at Winkelsdorf*
Anonymous photograph published
in *Deutsche Kunst and Dekoration*
in June 1916

The hall was primarily white, green
and black in colouring, incorporating
upholstery and hangings in the
Wiener Werkstätte textile 'Rose
Garden' by Dagobert Peche, and
a richly decorated tiled stove made
by the sculptor Anton Hanak.

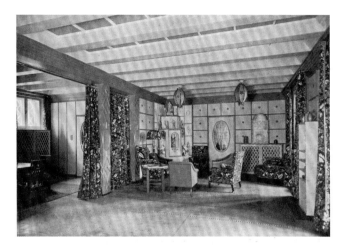

Valley, it had a frontage of nearly thirty metres resting on a high, random ashlar base (with a large arched opening to the basement), raised ground and first floor walls in alternating courses of natural (ash grey) and stained (dark brown) wooden beams, enlivened with shutters gaily painted in green and white, a loggia with eight round oak pillars, and a roof (with semi-circular dormer windows) thickly thatched in gradually darkening straw (fig.161). Here, Hoffmann effectively succeeded in accommodating the desire of Eugenia, much encouraged by Hanak, for a house deeply rooted in the northern Moravian vernacular, in terms of building materials and traditions (and, indeed, most of the workforce), while subordinating the result to the discipline of the Neo-Classicism of his own recent practice.

The house was at its most convincing as a modern reworking of the vernacular in the treatment of wood in its interiors, where the panelling of walls and the relief carving of pillars and beams (again, with much help from local craftsmen) was picked out in bright greens, pinks and blues, invariably used in combination with white. The desired effect was thereafter extended through the addition, in 1914–15, of a non-vernacular element: textiles from the Wiener Werkstätte (now chiefly supported by the Primavesis). Delicious ensembles were thereby devised: the hall (fig.162) combined panelling in white, green and black, white painted pillars carved in angular lozenges of low relief, and hangings, upholstery and a lampshade in Dagobert Peche's *Rose Garden* fabric.

The Winkelsdorf residence was soon established as a rural version of the idealised 'hearth and home' created at the house in Olmütz, which the Primavesis continued to use. Both Klimt and Hanak were happy to acknowledge 'Eugenia as mother' at the heart of the new house, Klimt agreeing to part with his much exhibited but still unsold composition of 1907–8, *Hope II* (in the background of fig.177), which arrived at Winkelsdorf in December 1914, in time for the first Christmas to be celebrated there (though it was later moved to Olmütz), and Hanak, two years later, presenting her with a quasi-oriental branching figurine in gem-studded, gilt embossed brass that honoured the *Mother with Four Children*, its back inscribed with their names and dates of birth. Meanwhile, Hanak enlisted Hoffmann's assistance in his struggle with the material and labour shortages of wartime to give the house at Winkelsdorf a literal 'focal point' by supplying its chief interior, the hall, with a splendid, 'supra-vernacular', polygonal tiled stove (visible in fig.162) decorated with colourfully glazed ceramic figures.

The Primavesis' final acquisitions of work by Klimt were made in 1919–20, as the idyll they had nurtured in Olmütz and in Winkelsdorf was beginning, along with the rest of 'old Austria', to unravel. After the artist's death and their own move to Vienna, they seem to have been spurred, as purchasers, by a characteristic combination of nostalgia and a defiant faith in the future. *Baby (Cradle)* (fig.171), painted rapidly in August 1917 as an extra, last-minute contribution to the *Austrian Art Exhibition* then being prepared for Stockholm, would have had an immediate appeal on account of its intoxicating jumble of brightly coloured textiles (including some, perhaps, from Moravia); but the infant's urgent gesture and transfixing gaze from atop a tumultuous forward thrusting triangle made it an addition to the 'cult of the child' that pointed far into the future. In going on to purchase the nine cartoons of 1905–9 for the Palais Stoclet mosaics, Otto and Eugenia were securing a sumptuous souvenir of their visit to the installed mosaic frieze, in the company of Klimt in the spring of 1914, but also a supreme, and now sorely needed, example of ornament as talisman.

In 1922 the house at Winkelsdorf was destroyed by fire; and in 1926 Otto's death was rapidly followed by the failure of the Primavesi Bank. In 1928, when Eugenia loaned pictures to the Klimt memorial exhibition mounted by the Viennese Secession, several of these (figs.166, 171) were listed in the catalogue as up for sale.

Elizabeth Clegg

163
Gustav Klimt
*Study for Portrait of Eugenia
Primavesi* 1912–13
Pencil on paper, 56.6 × 37
Albertina, Vienna

164
Gustav Klimt
Portrait of Eugenia Primavesi
1913–14
Oil on canvas, 140 × 85
Toyota Municipal Museum of Art

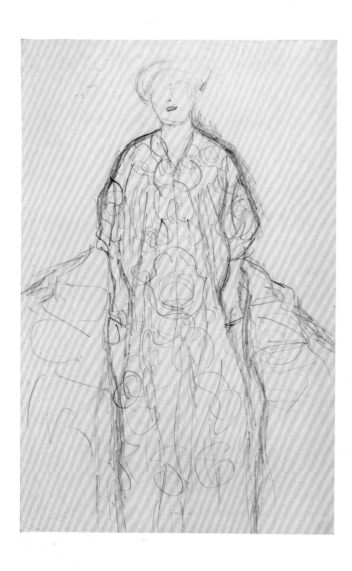

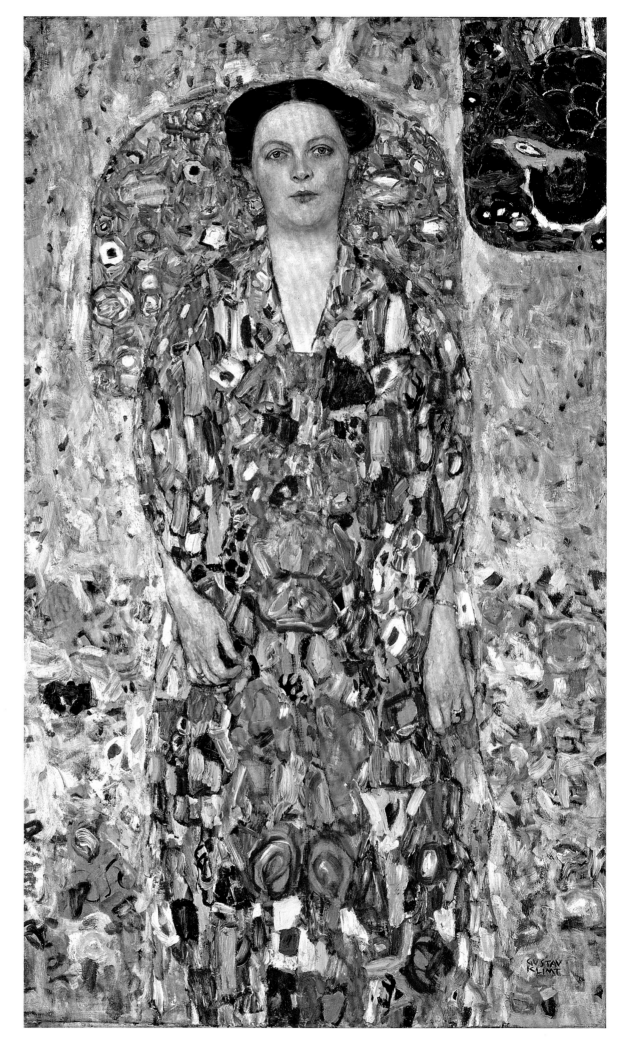

165
Scarf for Mäda (Eugenia)
Primavesi c.1914–16
Made by the Wiener Werkstätte
Black silk with silk embroidery
230 × 45
Primavesi Family Collection

166
Gustav Klimt
Portrait of Mäda Primavesi c.1912
Oil on canvas, 149.9 × 110.5
The Metropolitan Museum of Art,
New York. Gift of Andre and Clara
Mertens, in memory of her mother,
Jenny Pulitzer Steiner, 1964

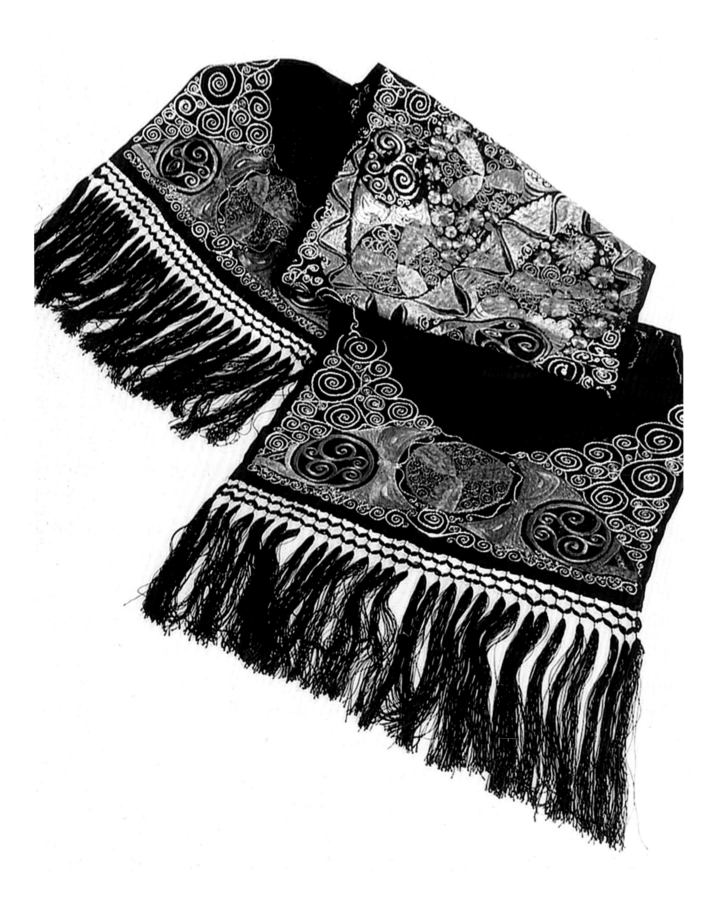

Eugenia and Otto Primavesi

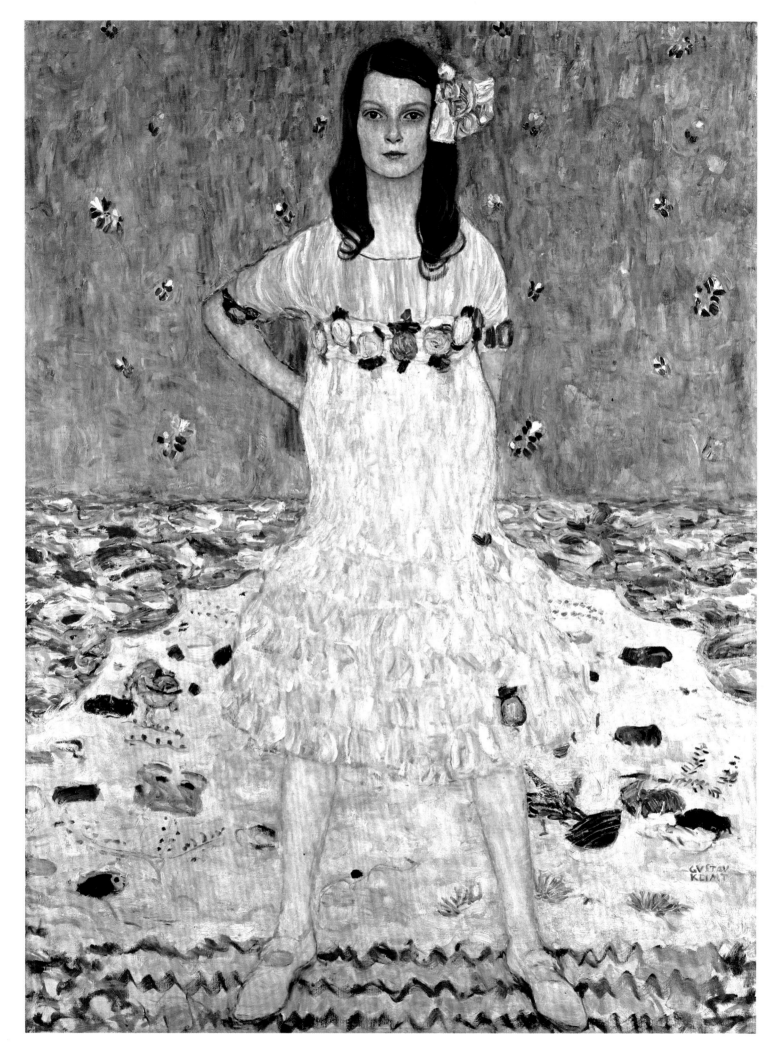

167
Koloman Moser
Ink Pot owned by the
Primavesi Family 1903
Made by the Wiener Werkstätte
Copper and silver
Height 10.5 cm, diameter 17.5
Primavesi Family Collection

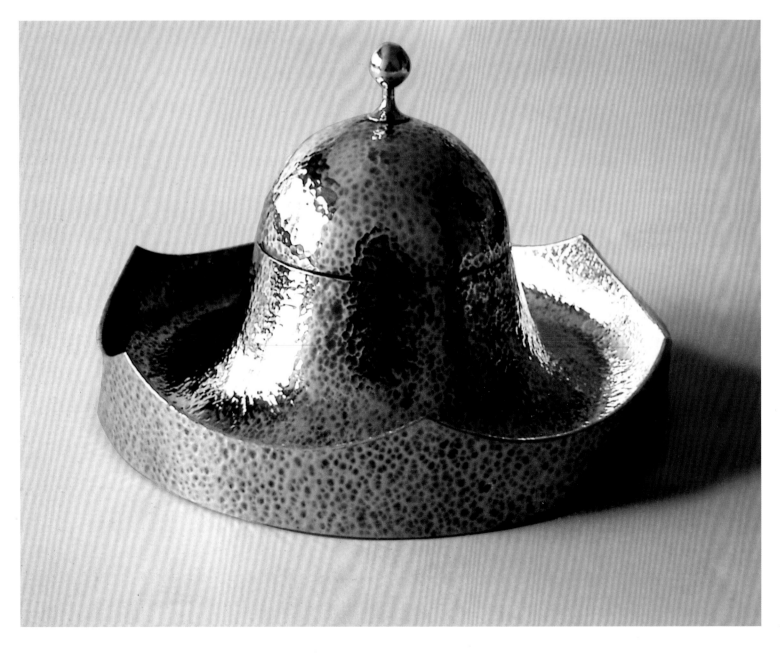

168
Koloman Moser
*Pen Wiper owned by the
Primavesi Family* 1903
Made by the Wiener Werkstätte
(Johann Blaschek)
Copper and silver
Height 5, diameter 13
Primavesi Family Collection

169
Gustav Klimt
Portrait of a Child, owned by the
Primavesi Family 1898
Pencil on paper in a silver frame
designed by Josef Hoffmann
Frame 46.3 × 36.3
Primavesi Family Collection

170
Gustav Klimt
Stone Head owned by the
Primavesi Family 1912–13
20.5 × 33 × 18
Primavesi Family Collection

Eugenia and Otto Primavesi

171
Gustav Klimt
Baby (Cradle) 1917
Oil on canvas, 110 × 110
National Gallery of Art, Washington,
D.C., Gift of Otto and Franciska
Kallir with the help of the Carol and
Edwin Gaines Fullinwider Fund

The painting was acquired by the
Primavesi family from the Klimt
estate auction in 1919.

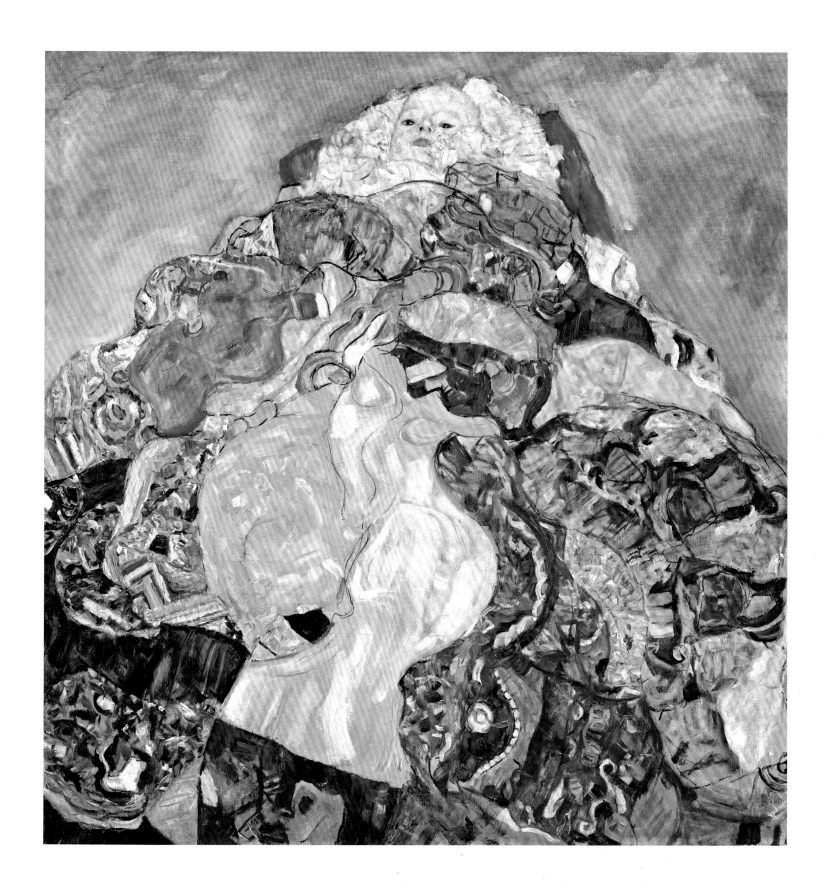

The Artist's Studio

Gustav Klimt and Egon Schiele

During the greater part of his career, Gustav Klimt used two principal studios. One of these was located on the top floor of a building in Josefstädterstrasse in the relatively central eighth (Josefstadt) district. This was Klimt's initially shared workplace from 1892 to 1912 (when the building was demolished). The other was in Feldmühlgasse in the remote, western, thirteenth (Hietzing) district, where he worked from 1912 to 1918. Each comprised a studio proper, with easels and other essential equipment, one or more anterooms (figs.177, 172) where Klimt might entertain patrons and other guests, and access to a 'wild' garden.

Neither of these studios was comparable to the almost theatrically 'public' spaces in which some painters of the previous generation had gloried (most prominently the Austrian artist frequently compared with Klimt at the start of his career, Hans Makart). And this was above all true in as far as Klimt protectively encouraged the notion of his studio as a space apart, reserved for himself and his models (see pp.214–31). Both locations did, nonetheless, have a significant 'public' dimension in three respects. Given Klimt's frequent contribution to the interiors designed by Josef Hoffmann for their mutual patrons, it is understandable that these clients should take an interest in his studio as an expression of his own character, and even (as in the case of Fritz Waerndorfer) propose to contribute to its embellishment. Both studios achieved a further, if less immediate, 'public' dimension in as far as motifs inspired by items in the collection that Klimt stored or displayed there were incorporated into some of the portraits he produced in his later years. Thirdly, Klimt's last studio was to assume an 'afterlife' in the popular imagination that has not entirely lost its resonance nearly a century later.

The suite of furniture in black-stained oak that Fritz Waerndorfer commissioned for Klimt from Josef Hoffmann and the Wiener Werkstätte in 1903–4, initially without the artist's knowledge and then apparently with his somewhat grudging acquiescence, can be found in the photographic record of both the Josefstädterstrasse and the Feldmühl-gasse studios. Visible in the anteroom of the former (fig.177), in addition to Klimt's picture of 1907–8, *Hope II*, are the centre and right sections of a tall three-part wall unit, which Klimt used chiefly to store and display items in his collection, and a small cabinet on casters, intended for the storage of painting utensils. In the photograph taken in Feldmühlgasse (fig.172) we see the wall unit in its entirety (it comprised left and right sections each with cupboards below glazed bookshelves, and a central section with five large drawers below a glazed display cabinet), in addition to a pair of high-backed armchairs, a table (fig.176) and a small box.

The anteroom at Feldmühlgasse is also notable for its carpet, with a geometrical pattern apparently identical to the one used in around 1912 in Hoffmann's decorative scheme for his villa for the Viennese architect Eduard Ast (one of a second wave of additions to the Hohe Warte). The careful alignment of the framed Japanese woodcut prints and other images in relation to the height and positioning of the wall unit suggests that Hoffmann may also have had a hand in arranging the room in the process of overseeing the re-installation of the furniture. The prominence of the wall unit within both anterooms underlines the importance to Klimt of the material displayed and stored within it, in particular the costly Chinese and Indian silks and silk garments that were kept in its cupboards. Elsewhere in the studio Klimt is said to have displayed, among other items, a small Romanesque Madonna, several pieces of African carved wood sculpture (fig.180), a Japanese *netsuke* mask, and a red and black suit of Japanese armour.

It was apparently among the oriental pieces in his collection that Klimt found inspiration for the invented figural backdrops that are one of the most distinctive features of his late female portraits. He seems to have first used this device towards the end of his time at the studio in Josefstädterstrasse: in his second portrait of Adele Bloch-Bauer, painted in 1912. After the move to Feldmühlgasse, he employed it frequently, as revealed in the portraits of Elisabeth Lederer c.1914 and Friederike Maria Beer 1916, among other examples.

Klimt's last studio, on account of its relative remoteness from the city centre and the artist's growing reputation as a 'recluse', both ascetic and voluptuary, had already begun to intrigue commentators during his lifetime. Following his death a number of published accounts helped maintain popular interest in the house and garden at Feldmühlgasse. The critic Arthur Roessler saw these as a relic of an older, semi-rural Vienna, while Klimt himself, a tanned and robust figure, seemed 'patriarchal', even 'timeless'. Among the most vivid and least sentimental accounts is that of Egon Schiele (figs.173, 174), as reported by Roessler, which concludes by urging Klimt's friends to purchase the Feldmühlgasse studio and to preserve it exactly as Klimt had left it, for it was in itself 'a work of art'. (Nearly ninety years later, in the autumn of 2007, plans for its restoration were announced.)

The strongest influence on our current mental image of Klimt's last studio is the impression derived from the photographic record of his work room shortly after his death, with unfinished compositions – *Lady with a Fan* and *The Bride* – still on his easels. We do not, however, know to what extent the interior (as seems rather probable) was first carefully 'arranged'. This haunting evocation of presence in absence thus proves no less inscrutable than any of the equally familiar photographic images of Klimt in his last decade – from the formally suited Viennese gentleman posing in 1908–9 for Dora Kallmus to the idiosyncratic 'genius' in one of his embroidered artist's smocks (figs.178, 212) seen in the series of c.1912 and 1914 by Moritz Nähr (frontispiece), and Anton Josef Trčka.

Elizabeth Clegg

172
*Anteroom of Klimt's Studio
at Feldmühlgasse in the Thirteenth
(Hietzing) District, which he
used between 1912 and 1918*
Photograph c.1914 by Moritz Nähr
Österreichische Nationalbibliothek –
Bildarchiv, Vienna

To the left, the wall unit seen also
in fig.177. Of furniture in the same
suite, this view shows the two
high-backed armchairs, a table
and a box. Also visible are some
of Klimt's collection of framed
Japanese woodcut prints.

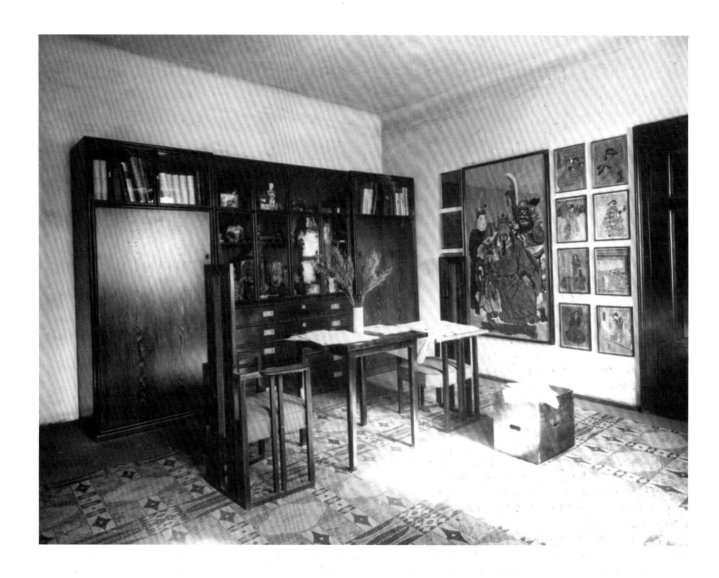

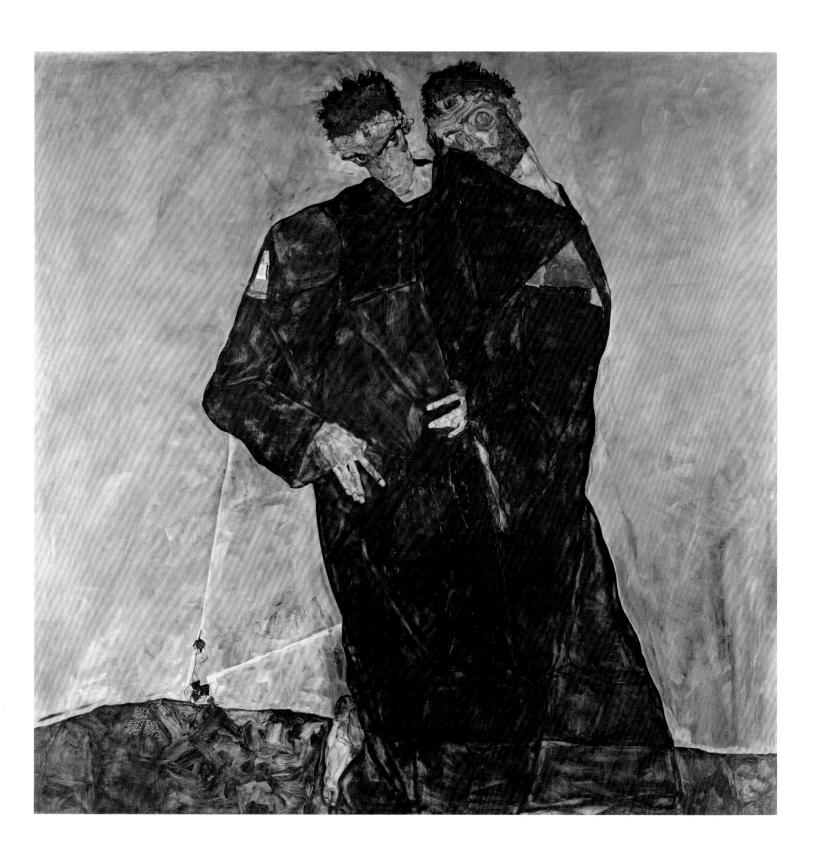

174
Johannes Fischer
Egon Schiele in his Studio 1914
Photograph
Egon Schiele Archive. Albertina,
Vienna

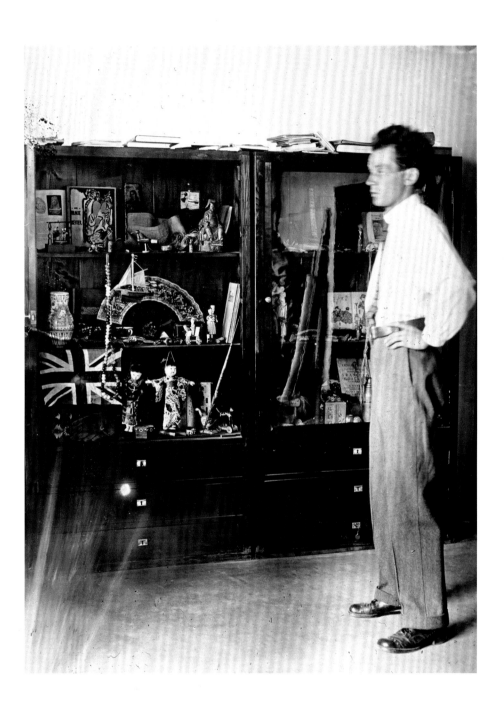

175
Portfolio owned by Gustav Klimt
date unknown
Made by the Wiener Werkstätte
Card covered with linen, gold lined
interior, exterior embossed with
gilt 'GK' monogram, 42 × 62 × 4
From the Estate of Gustav Klimt
Private Collection

176
Josef Hoffmann
*Table from Gustav Klimt's
Studio* 1903–4
Oak, 69.5 × 70 × 75.3
Ernst Ploil, Vienna

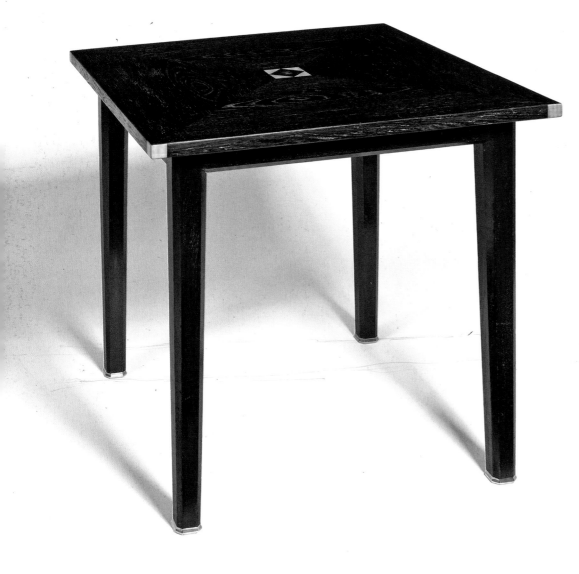

177
Anteroom of Klimt's Studio at
Josefstädterstrasse in the Eighth
(Josefstadt) District, which he used
between 1892 and 1912
Anonymous photograph c.1905
Österreichische Nationalbibliothek –
Bildarchiv, Vienna

In the background *Hope II* 1907–8;
to the left, part of the wall unit
in black-stained oak designed by
Josef Hoffmann in 1903–4; in the
foreground a cabinet forming part
of the same suite of furniture.

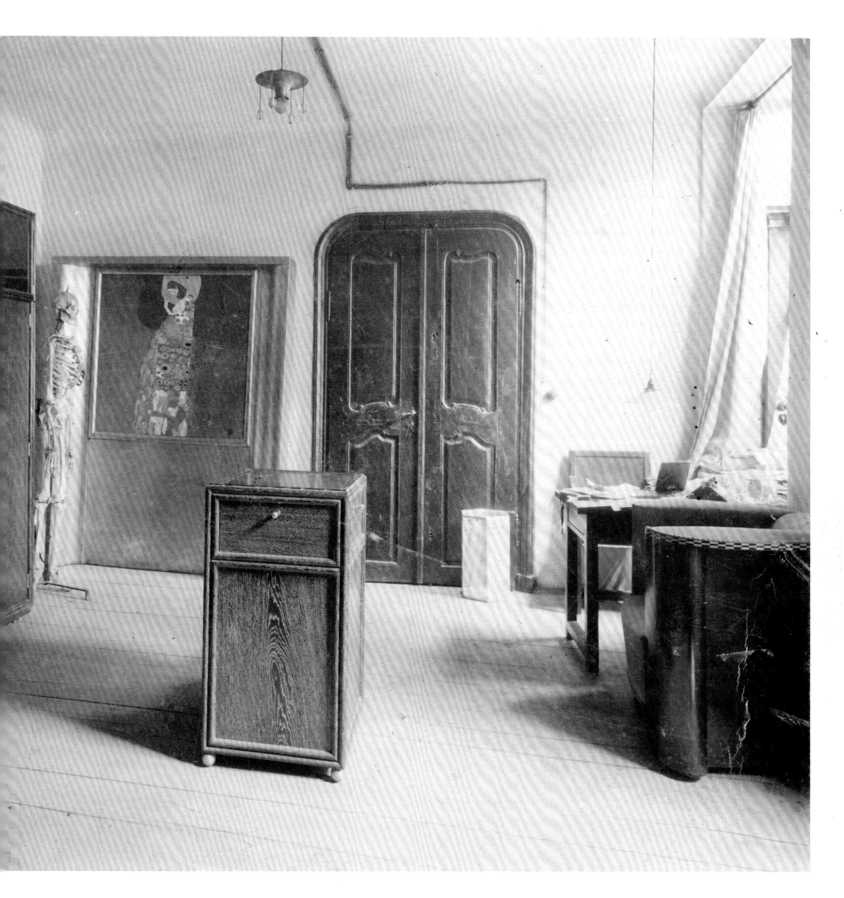

Smock Owned by Gustav Klimt c.1903
Indigo blue linen, white embroidery
at shoulders, Length 143
Wien Museum, Vienna

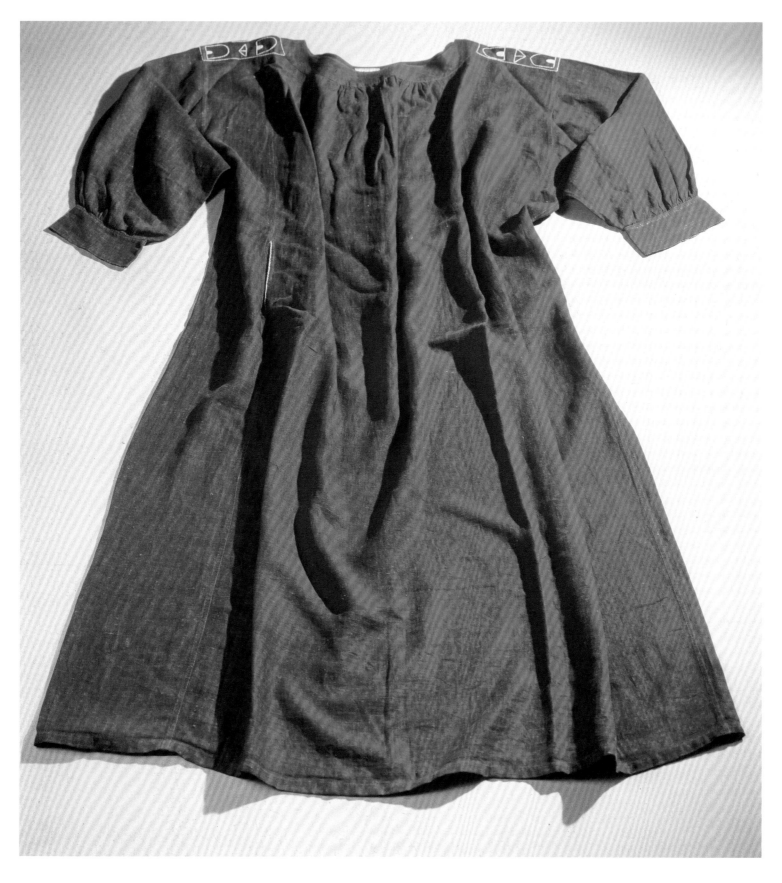

179
*Soapstone Stamp with Animal
Motifs* date unknown
Light soapstone, 20.5 × 6.6
From the Estate of Gustav Klimt
Private Collection

180
African Figures late 19th century
Probably Bari/South Sudan
Wood, animal teeth and leather
Left: Female Figure, height 41.5
Right: Male Figure, height 37
From the Estate of Gustav Klimt
Private Collection

Gustav Klimt and Landscape

While Klimt's first surviving landscape paintings date from the early 1880s, it was not until the late 1890s, when he was well established as both allegorist and portraitist and already allying himself with emergent Modernist tendencies, that he began to turn consistently to landscape subjects. He did so, almost invariably, during the summer vacations he spent in the picturesque Salzkammergut, to the east and south of Salzburg, with members of the Flöge family (including his companion, Emilie). For Klimt, this was a type of painting in which he was always able to experiment, free of the pressures associated with a commission or the continual distractions of the metropolis.

Klimt appears to have first exhibited landscape paintings in 1898, at the inaugural and the second shows mounted by the Viennese Secession. After the early 1900s, as he eschewed large public commissions and became all the more dependent upon selling his work, a ready supply of new landscapes was to prove useful. A century later Klimt's landscape paintings have become a widely recognised and admired aspect of his oeuvre.

One of the most immediately distinctive features of Klimt's landscapes is their square format. This he adopted early: having begun to paint square-format portraits and allegories in 1897/98, the following year he exchanged the artfully cropped, elongated canvas of *After the Rain* (fig.181) for the regular quadrilateral of *Calm Pond* (fig.99). It is, indeed, the uniformity of Klimt's painted landscapes in this one respect that points up their diversity and rapid evolution in so many others: pictorial composition, brushwork, colouring or the range of motifs, even allowing for the recurrence of certain types of subject. Klimt returned tirelessly and affectionately to lakes and lakeside villages (*Schloss Kammer on the Attersee I* 1908, fig.191; *Litzlberg on the Attersee* 1915, fig.190); to trees, both as settings and as individual motifs (*Pine Forest I* 1901, fig.184; *Apple Tree I* c.1912, fig.188); and to gardens, parks, meadows and wooded slopes (The *Orchard* 1905/6, fig.183; *The Park* 1909, fig.185; *Garden Landscape with Hilltop* 1916, fig.189)

Klimt's stylistic evolution as a painter of landscapes may be linked to the sequence of his Salzkammergut vacation sites over two decades, even if stylistic shifts cannot be explained solely in terms of response to motifs encountered in each: St. Agatha in 1898 (fig.181), Golling in 1899 (fig.99), and then three villages on the Attersee: Litzlberg between 1900 and 1907 (figs.184, 183), Kammerl between 1908 and 1912 (figs.191, 185), and Weissenbach in 1914–15 (fig.190). Throughout, moreover, one can point to corresponding shifts in Klimt's approach to the portraits and allegories on which he largely worked while in Vienna.

The 'poetic' sensuality of the landscapes of 1898–9 (figs.181, 99) has a counterpart in the treatment of portraits such as that of Sonja Knips (1898), and in the first oil sketches (of 1897–8) for his three University Faculty Paintings, *Philosophy*, *Medicine* and *Jurisprudence*.

The varieties of stylisation emerging in the landscape paintings of 1900–7, made at Litzlberg, likewise have parallels in other genres. The quasi-pointillist brushstrokes employed to render the ruffled surface of the Attersee or the wind-tossed foliage of tall poplars recur in the treatment of costume in the portraits of Marie Henneberg (fig.112) and Hermine Gallia (fig.125).

The sequence of views of Schloss Kammer on the Attersee, charting Klimt's development as a landscapist over the years 1908–12, opens with the motif observed across the lake, somewhat tentatively and perhaps with the aid of a telescope (fig.191), but ends with the incisively plotted, tree-lined approach to the building from the landward side. A similar achievement of much greater formal assertiveness is to be found in the brazen modernity of *Judith II (Salome)* 1909 (fig.194), or in the compositional and thematic enigma of the later re-worked allegory of 1910/11, *Death and Life*. The landscapes of the late, Weissenbach period are notable for their range in both style and emotion: from serene 'vistas' of a more conventional type (fig.190) to instances of a wilful 'artlessness', as found in *Apple Tree II* 1916 (fig.187), which recalls the contemporary work of a much younger colleague, Egon Schiele.

Klimt's landscapes were acquired by a wide range of his patrons. Some of these proved to be especially enthusiastic supporters of this aspect of his work. It is telling that two of the three Klimt landscapes owned by Karl Wittgenstein (his daughter Hermine owned a fourth) were allegorical in character: both *Life is a Struggle* 1903 (fig.144) and *The Sunflower* 1906 clearly appealed to his

181
Gustav Klimt
After the Rain 1898
Oil on canvas, 80 × 40
Belvedere, Vienna

182
Gustav Klimt
Beech in the Forest c. 1903
Oil on cardboard, 22.5 × 24.5
Private Collection, Courtesy Museum
der Moderne Salzburg

lifelong belief in the 'survival of the fittest' striving, self-reliant individual. Apart from the two portraits of Adele Bloch-Bauer commissioned by her husband, Ferdinand, the Klimt pictures acquired by this couple were landscapes, ranging in date, style and mood from the subtly toned and carefully delineated *Birch Forest* 1903, by way of the joyfully effervescent *Apple Tree I* c.1912 (fig.188) to the coolly diagrammatic *Houses at Unterach on the Attersee* 1915/16. While August and Serena Lederer bought Klimt paintings of all types, their extensive collection (much of it tragically lost to fire in 1945) embraced many landscapes, among them the overtly ornamental *Golden Apple Tree* 1903 and an outstanding example of Klimt's late, graphic treatment of ostensibly 'inconsequential' motifs, *Garden Path with Chickens* 1916.

By far the most important patron of Klimt as a landscape painter was the industrialist Viktor Zuckerkandl, brother of the Viennese physicians Emil and Otto, and brother-in-law of one of the artist's most committed champions, the journalist and critic Berta Zuckerkandl, Emil's wife. Equally

significant as an early patron of Josef Hoffmann, from whom he commissioned a thoroughly modern and superbly appointed sanatorium at Purkersdorf, on the western outskirts of Vienna (figs.71, 72), Zuckerkandl assembled, in a nearby villa, some of the most exquisite landscapes to be produced by Klimt, among them *Roses under Trees* 1904/05, *Field of Poppies* 1907 and *Litzlberg on the Attersee* 1915 (fig.190). After his move to Berlin, in 1916, his nephew (Otto's son), the future musicologist Viktor Zuckerkandl, Jnr., reflecting the taste of a younger generation, bought *Apple Tree II* (fig.187) directly from Klimt, subsequently presenting it to his sister Nora.

Elizabeth Clegg

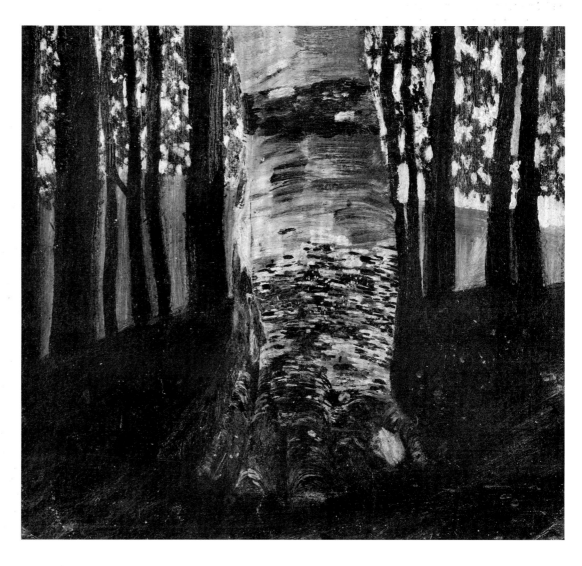

183
Gustav Klimt
The Orchard c.1905
Oil on canvas, 98.7 × 99.4
Carnegie Museum of Art,
Pittsburgh, Patrons Art Fund

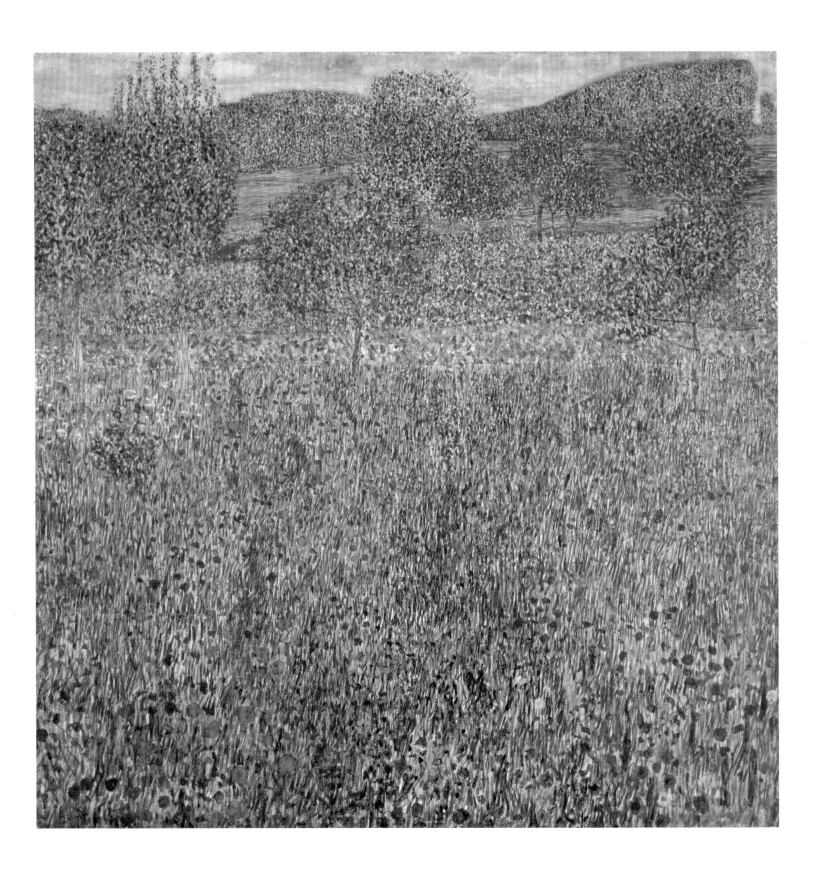

184
Gustav Klimt
Pine Forest I 1901
Oil on canvas, 90 × 90
Kunsthaus Zug, Stiftung
Sammlung Kamm

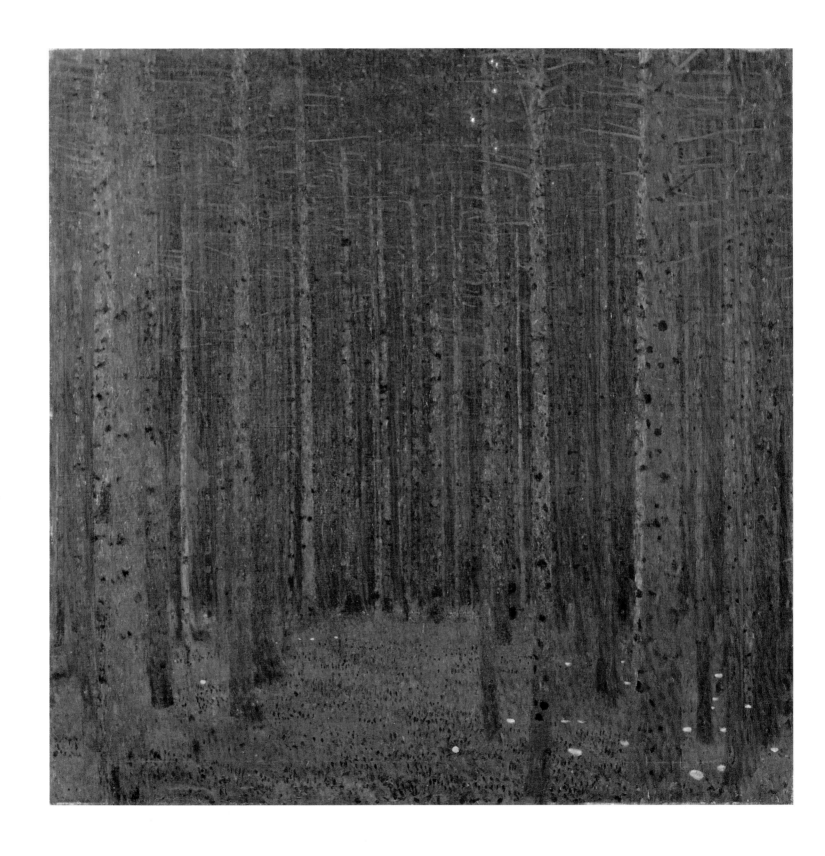

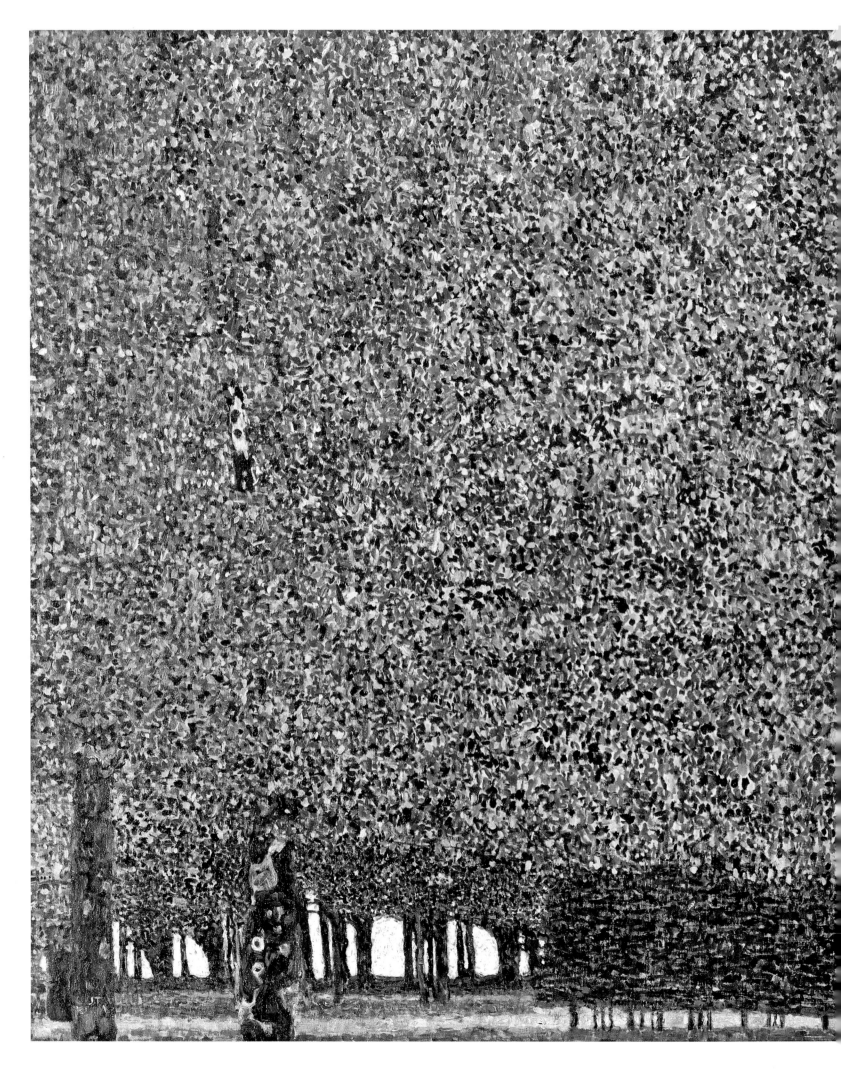

185
Gustav Klimt
The Park 1909–10
Oil on canvas, 110.4 × 110.4
The Museum of Modern Art,
New York, Gertrud A. Mellon
Fund, 1957

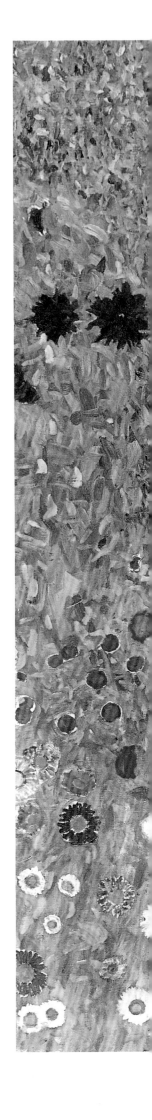

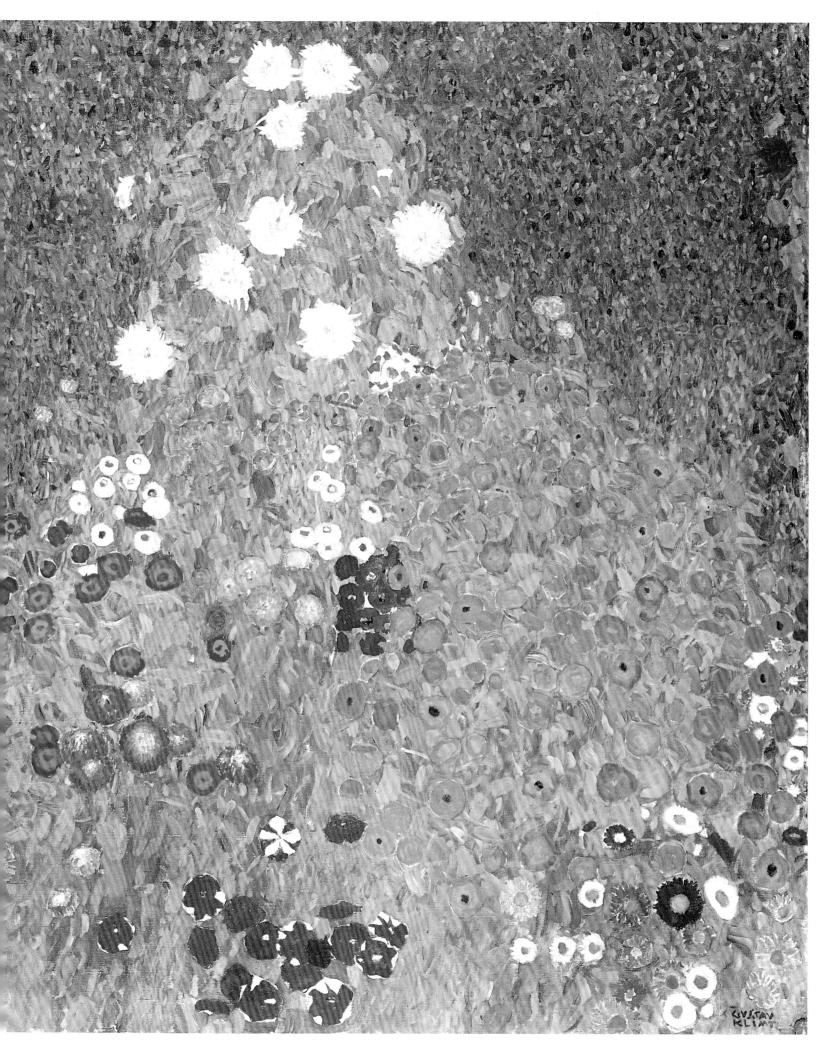

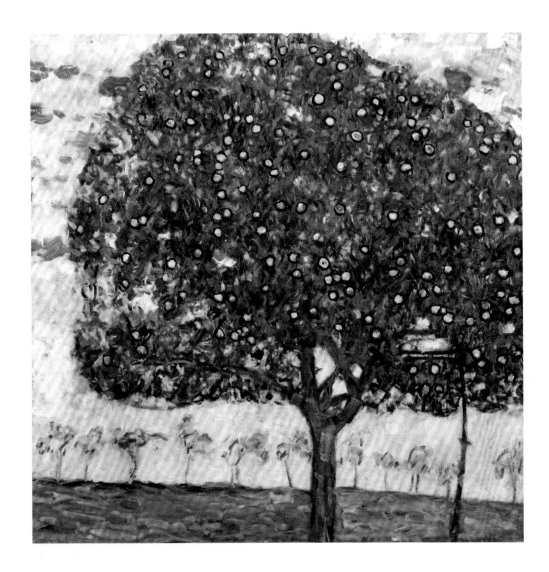

188
Gustav Klimt
Apple Tree I c.1912
Oil on canvas, 109 × 110
Private Collection

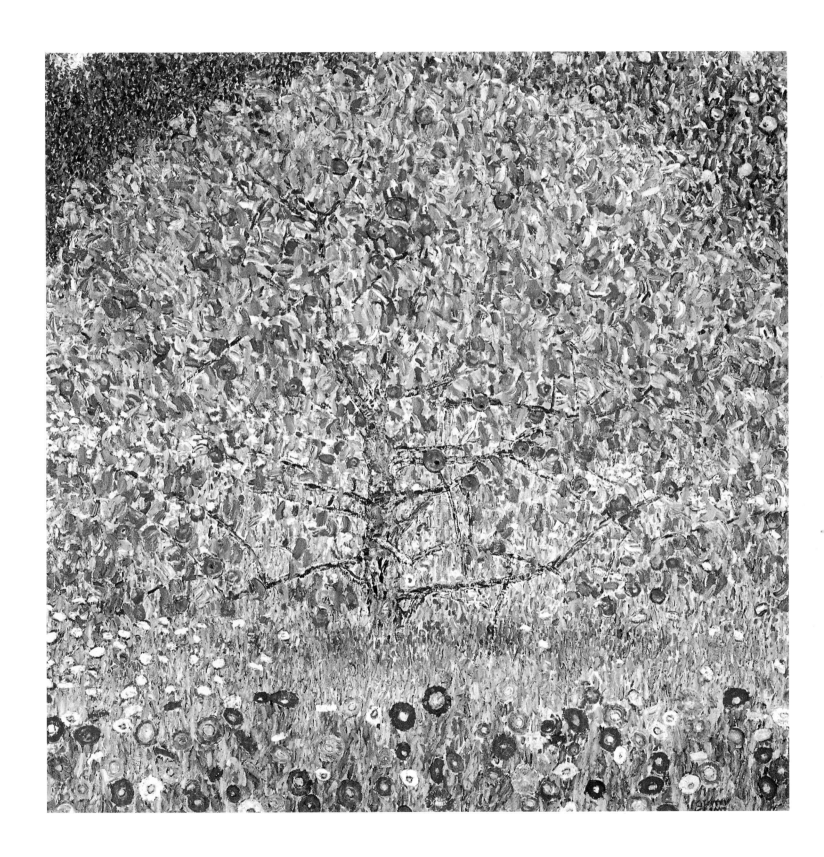

189
Gustav Klimt
*Garden Landscape with
Hilltop* 1916
Oil on canvas, 110 × 110
Kunsthaus Zug, Stiftung
Sammlung Kamm

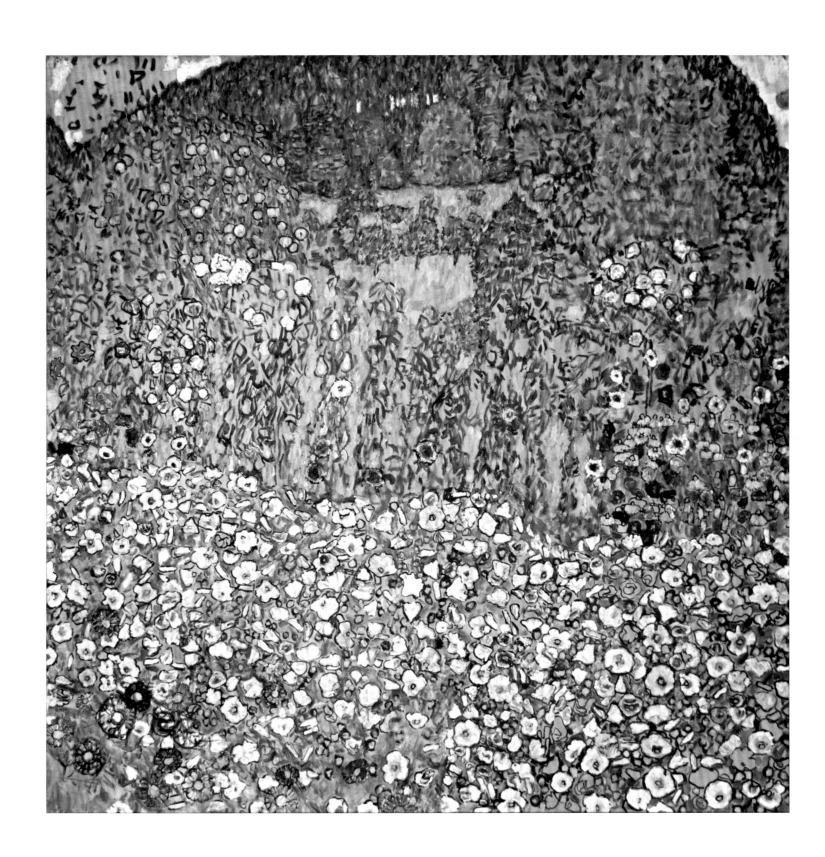

190
Gustav Klimt
Litzlberg on the Attersee 1915
Oil on canvas, 110 × 110
Museum der Moderne,
Salzburg

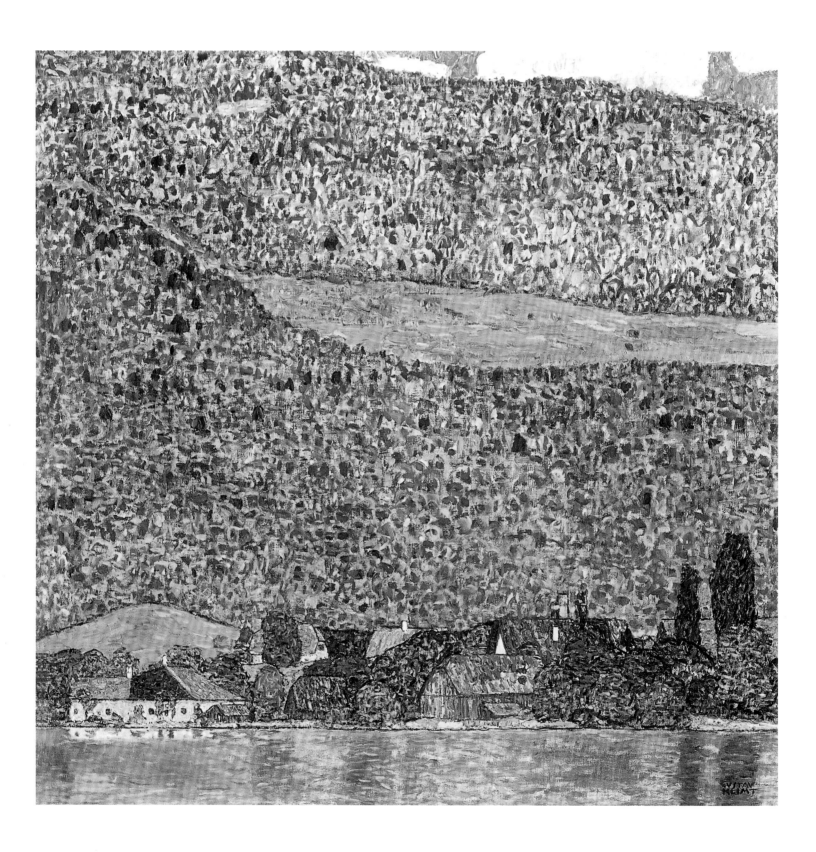

191
Gustav Klimt
Schloss Kammer on the
Attersee I c.1908
Oil on canvas, 110 x 110
Národní Galerie, Prague

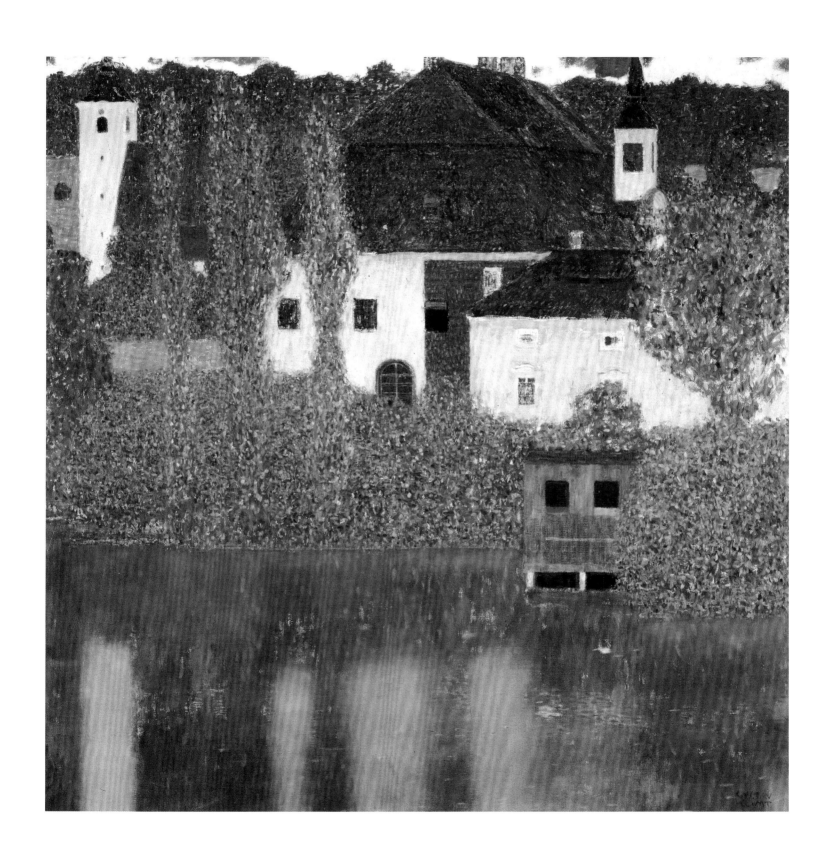

The World in Female Form

In earning his reputation as an *homme à femmes* (a ladies' man), Gustav Klimt was also operating, albeit indirectly, as an *homme à hommes* (a man at ease with other men). For the images of women that predominate in his work served, and in Klimt's day were expected to serve (the rare exception simply proving the rule), as a commodity in transactions between men. It is this that bestows an effectively 'public', or at least 'social', dimension on even the most intimate artistic manifestation of Klimt as *homme à femmes*: the prolific and increasingly uninhibited drawings that record his investigation and celebration of the bodies of the female models with whom he intermittently shared his Josefstädterstrasse and Feldmühlgasse studios (on which see pp.192–9).

Research has revealed that rather more than was once supposed of the Klimt drawings that we might still characterise as erotic, even pornographic, were publicly exhibited in Vienna within his lifetime, though these of course represented only a tiny fraction of his total output of such work. And they were in addition to the drawings selected,

with Klimt's approval, precisely for their perceived erotic/pornographic character, for reproduction as an enticing accompaniment to Franz Blei's 1907 German translation of a text by the Hellenistic satirist Lucian, *Dialogues of the Courtesans* (fig.203). Moreover, as has been demonstrated by Alice Strobl's four-volume catalogue raisonné of the Klimt drawings (published during the 1980s), the vast majority of these were made in direct or indirect connection with specific painted compositions, which were themselves publicly exhibited and which can be found to derive much of their impact from both the exuberant range and the obsessive thoroughness of Klimt's drawn preparations.

The case of Klimt's *Beethoven Frieze*, forming part of the Viennese Secession's 'Klinger Beethoven' exhibition of spring 1902 (see pp.80–99), is one of the earliest where we can still easily understand what his contemporaries found so shocking (above all as regards the female nudes in the middle, Hostile Powers segment, fig.65, middle row, and pp.90–1), as well as something of how Klimt used his drawn studies and sketches to achieve precisely the effects that provoked

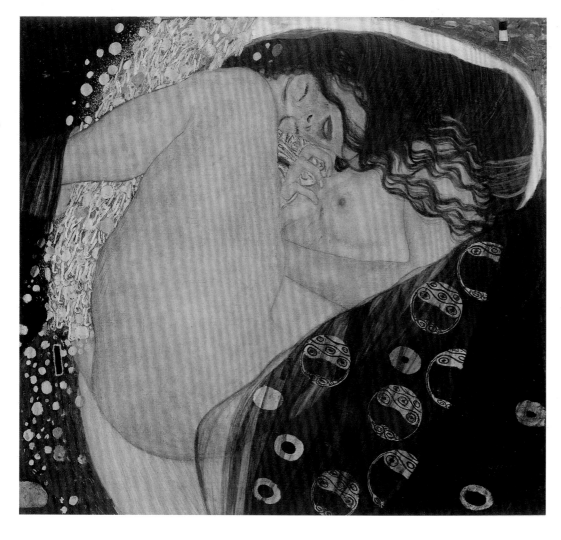

such a reaction. Two devices were essential to his approach here. The inventive manipulation of undulating line might serve, as in the earlier studies for the perilously seductive Three Gorgons, to plot the rippling curves of a naked back (Strobl 776), or to capture the luxuriance of tumbling hair (fig.64, Strobl 799); but it could also be used, as in a study for the seated allegorical figure of Lewdness (Strobl 811), to simultaneously caress and conceal the as yet inadmissable space between parted thighs. Simplification and reiteration of the figure might serve, here as elsewhere in the *Beethoven Frieze*, to reinforce narrative; but they could also be used, as in the schematised notation of the Three Gorgons (fig.63, Strobl 802), to reduce the nude to the most efficient application of a formula.

Klimt's true beginnings as an erotic draughtsman may be dated to the studies made in direct or indirect connection with the two versions of *Water Serpents* of 1904–7 (fig.141). It was from among these drawings that the images for the aforementioned edition of Lucian were selected, constituting a cross-section of what was to be found there: standing figures in still almost 'respectable' undress (Strobl 1182a), sensitively rendered sleeping nudes (Strobl 1388), and some of Klimt's first surviving drawings of half-clothed models absorbed in auto-erotic reverie (fig.198, Strobl 1395). Similarly, among the numerous unpublished drawings of this group, models posed in frank invitation to an implicit spectator are found alongside those whose erotic dimension may be registered incidentally, if at all (fig.196, Strobl 1400).

During the later 1900s, particularly in the studies for the column of intertwined nudes in the large allegorical composition *Death and Life*, Klimt appears to have sought a far more compelling sense of vitalist immediacy. The models appearing here are fuller-figured, seemingly older, and posed in an often disconcertingly 'blunt' fashion that potentially de-eroticises the outcome (fig.200, Strobl 1947). The inclusion of such drawings in a one-man show at the Viennese Galerie Miethke in 1910 led to public denunciations of Klimt as a 'pornographer'. These were in turn largely responsible for his resolve to retire from exhibiting in Vienna – though he was in fact to take part in a large group show of graphic work in 1913, eliciting a similar response. The redoubled commitment to emphatically private, and hence all the more uninhibited, exploration of the compositional and expressive possibilities of the female nude would eventually guide Klimt towards the radical transformation seen in the drawings of what were to prove his final years.

Klimt's output as a draughtsman in the earlier 1910s contains the greatest concentration of erotic images and the largest group of these to appear unrelated, or only very tenuously related, to his concurrent work as a painter. The almost exclusive focus here on a single activity is compensated through the range in mood and related pose, from the nonchalant (fig.199, Strobl 2307) to the quasi-acrobatic (fig.202, Strobl 2311). Red or blue crayon

is now employed not only for accentuation or contrast but also to render all or most of a figure in a continuous, 'seismographic' coloured line (fig.204, Strobl 2234). In the drawings of 1916/17 the continuity of bodily mass, form and contour is increasingly dissolved; and drapery, often picked out in white highlighting, assumes a far more dynamic role. Improbable combinations of covered and uncovered flesh effectively disassemble the posed model into freshly objectified head, breasts, thighs (Strobl 2969). And there are striking departures from conventional *mise en place*, with figures veering off to left or right as if in abrupt, irresistible motion (Strobl 2968). In Klimt's remarkable last drawings the 'activated' drapery and figural 'displacements' evolve into what appears a radically new approach to the female nude. As if in an ecstatic dance, these figures have an indeterminacy of position – seeming to hover, now below and now above us – that at length calls into question our own (fig.201, Strobl 2986).

Elizabeth Clegg

193
Gustav Klimt
Standing Figure (Study for 'Judith II') c.1908
Pencil on paper, 56 × 37
Kunsthaus Zug, Stiftung Sammlung Kamm

194
Gustav Klimt
Judith II (Salome) 1909
Oil on canvas, 178 × 46
Musei Civici Veneziani, Galleria Internazionale d'Arte Moderna di Ca' Pesaro, Venice

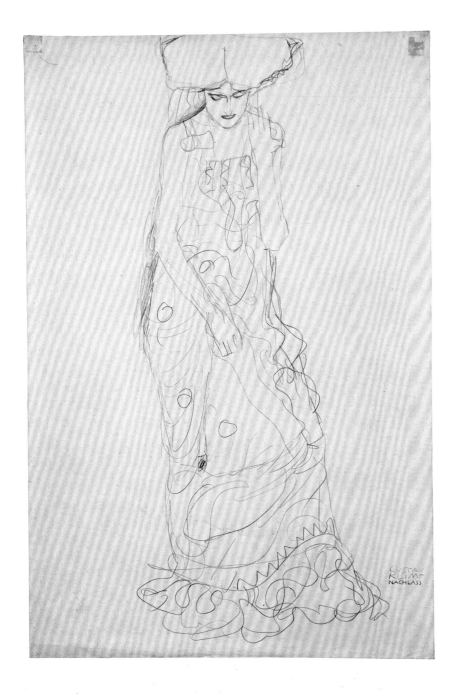

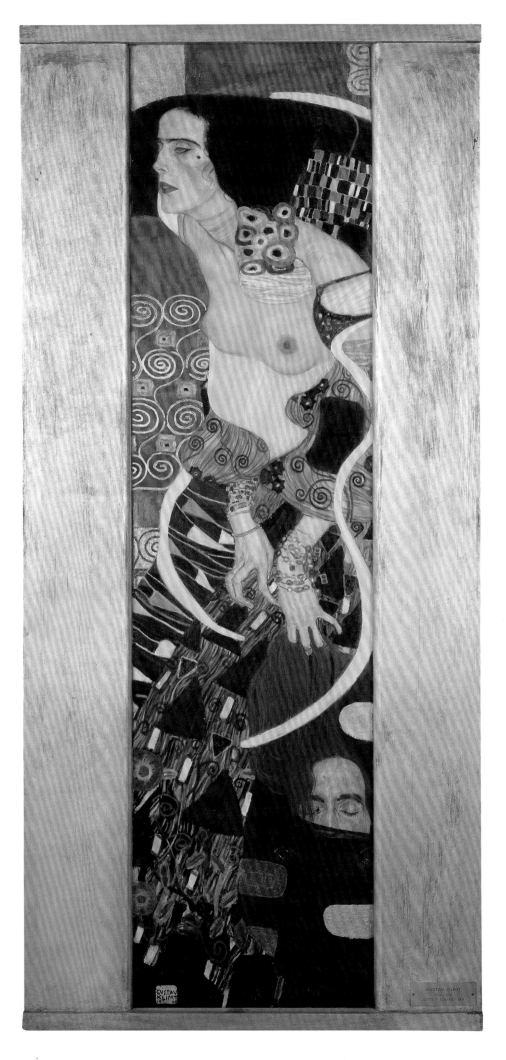

195
Gustav Klimt
Reclining Semi-Nude 1916–17
Pencil on paper, 37.5 × 56
Private Collection, Courtesy
Richard Nagy Ltd, London

196
Gustav Klimt
*Reclining Semi-Nude Facing Left
(Study for 'Water Serpents I')* c.1904
Pencil on paper, 34.9 × 55.1
Wien Museum, Vienna

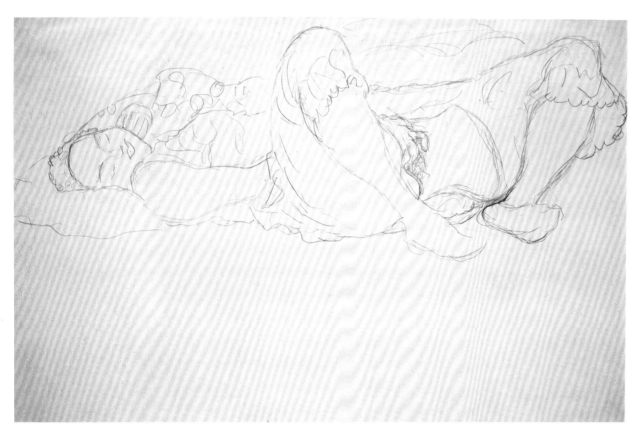

197
Gustav Klimt
Lovers with Cushions c.1913
Pencil on paper, 37.2 × 56.5
Private Collection, Courtesy
of Richard Nagy Ltd, London

198
Gustav Klimt
*Reclining Semi-Nude with
Right Leg Raised* 1904–5
Pencil on paper, 35 × 55
Albertina, Vienna

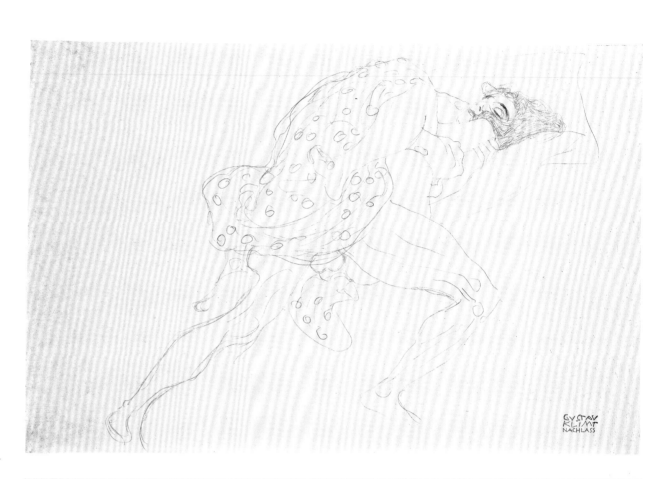

199
Gustav Klimt
Reclining Semi-Nude with Spread Thighs 1912–13
Blue crayon on paper, 37 × 55.9
Kunsthaus Zug, Stiftung
Sammlung Kamm

200
Gustav Klimt
Seated Semi-Nude Resting on Raised Right Knee 1909–10
Pencil with red and blue crayon on paper, 56.1 × 37.1
Leopold Museum, Vienna

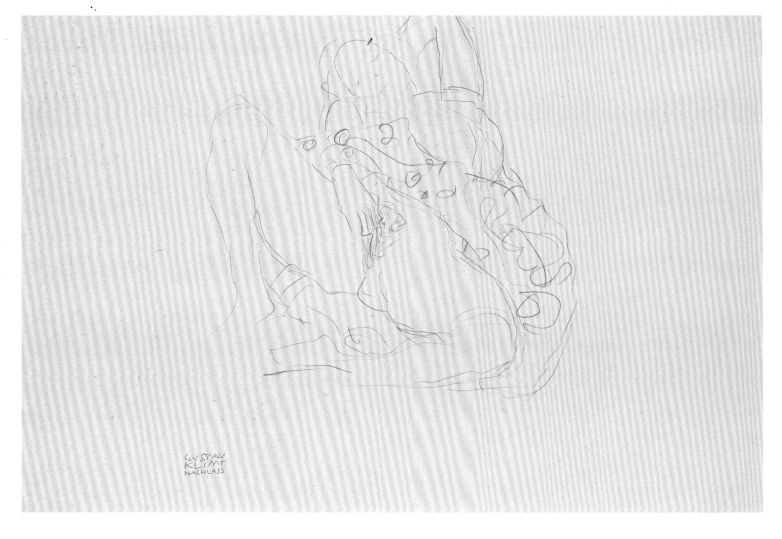

GVSTAV
KLIMT
NACHLASS

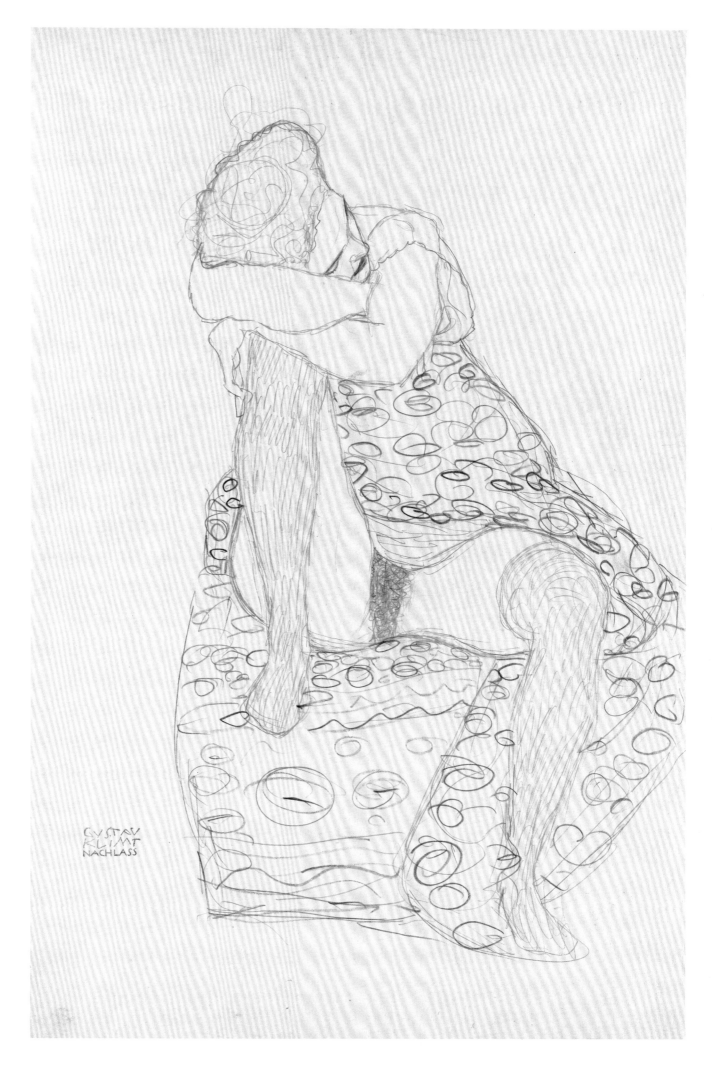

GVSTAV
KLIMT
NACHLASS

201
Gustav Klimt
Study for 'The Bride' 1917–18
Pencil on paper, 56.6 × 37
Albertina, Vienna

202
Gustav Klimt
Semi-Nude with Left Leg Raised
1912–13
Pencil on paper, 37.1 × 56
Albertina, Vienna

203
Gustav Klimt
Die Hetärengespräche des Lukian (Lucian's Dialogues of the Courtesans)
Published by Verlag Julius Zeitler, Leipzig 1907
German translation by Franz Blei with fifteen drawings by Gustav Klimt, 38 × 30.5
Private Collection, Vienna

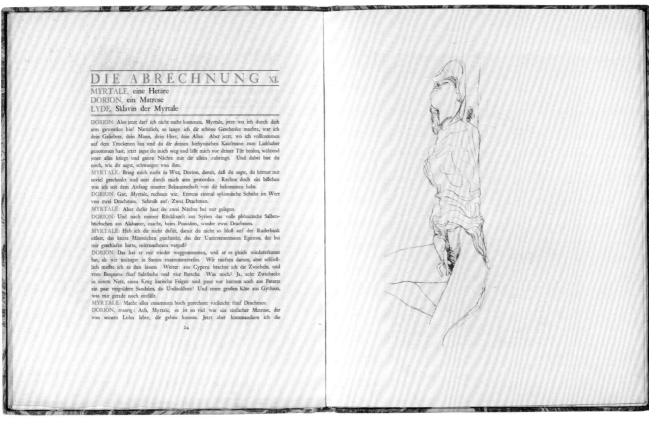

204
Gustav Klimt
Reclining Woman c.1913
Blue crayon on paper, 37.2 × 56
Wien Museum, Vienna

224 — 225

205
Gustav Klimt
Ria Munk on her Deathbed 1912
Oil on canvas, 50 × 50.5
Private Collection, Courtesy
of Richard Nagy Ltd, London

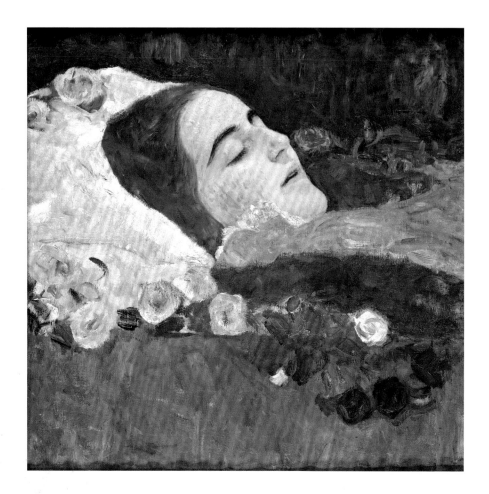

206
Gustav Klimt
Portrait of a Lady
1917–18 (unfinished)
Oil on canvas, 67 × 56
Lentos, Kunstmuseum Linz

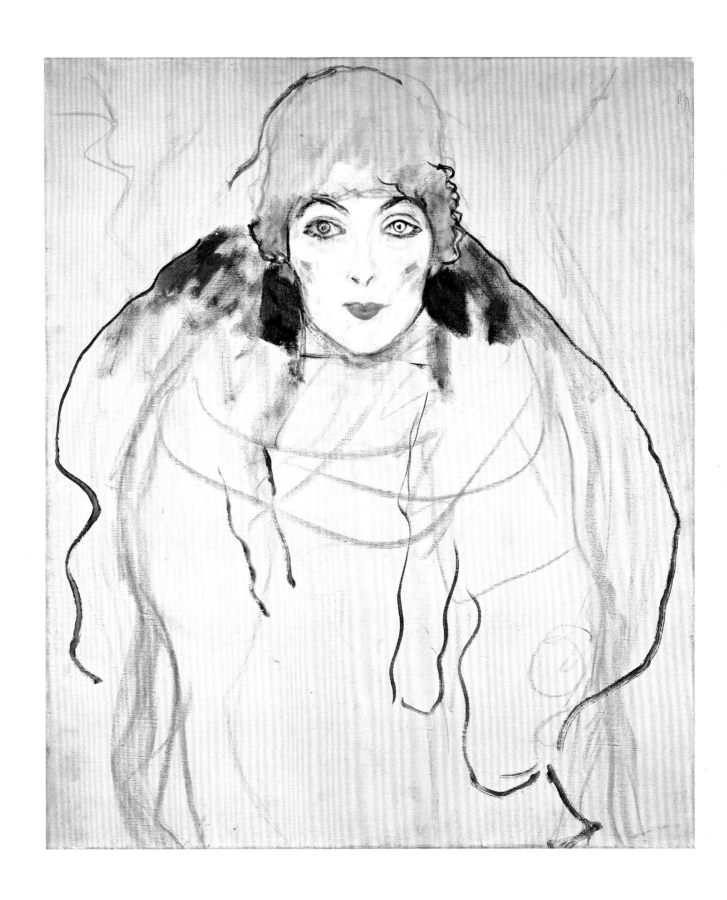

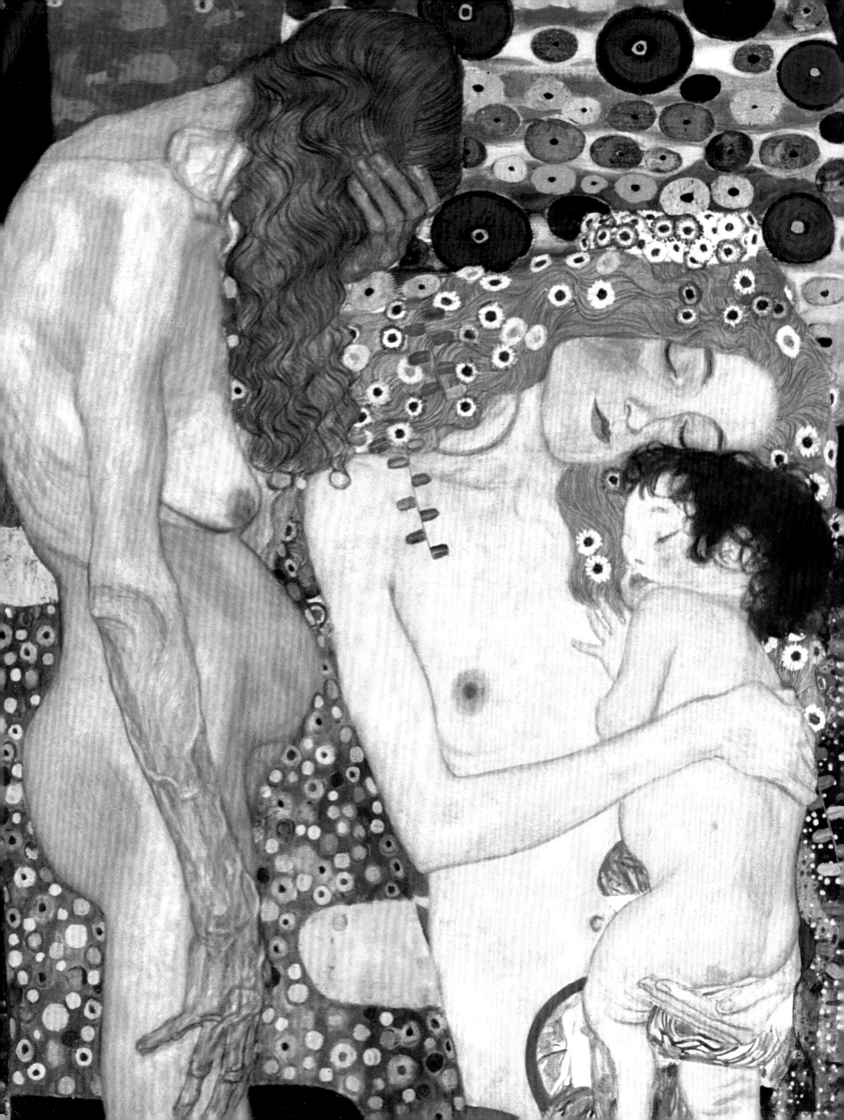

207
Gustav Klimt
The Three Ages of Woman 1905
Oil on canvas, 180 × 180
Galleria Nazionale d'Arte Moderna
e Contemporanea, Rome

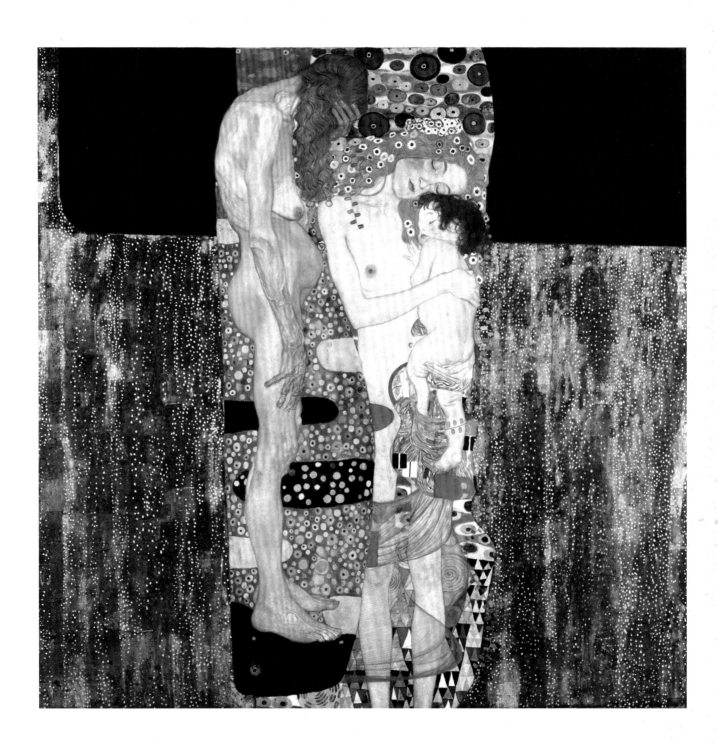

208
Gustav Klimt
*Seated Semi-Nude in
Three-Quarter Profile* 1904–5
Blue crayon on paper, 56 × 37
Kunsthaus Zug, Stiftung
Sammlung Kamm

209
Gustav Klimt
*Lovers Reclining to the
Right* c.1905–10
Pencil on paper, 37 × 56.5
Private Collection, Courtesy
Richard Nagy Ltd, London

210
Gustav Klimt
Lovers 1907–8
Pencil on paper, 37.2 × 56.5
Private Collection, Courtesy
Richard Nagy Ltd, London

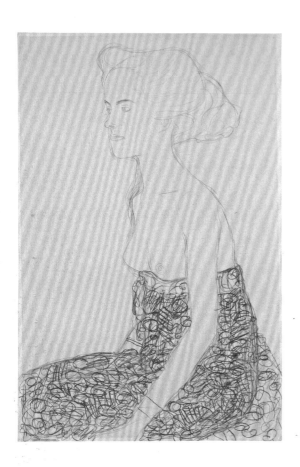

211
Gustav Klimt
Adam and Eve 1917–18
(unfinished)
Oil on canvas, 173 × 60
Belvedere, Vienna

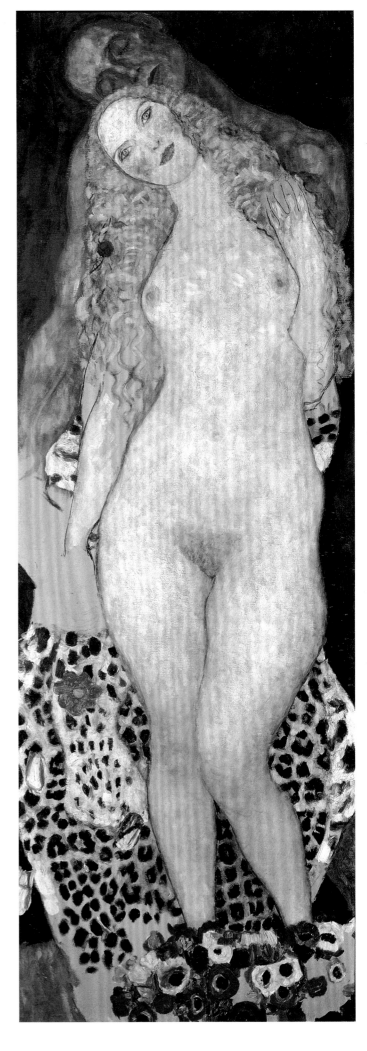

Pauline Hamilton
*Photograph of Gustav Klimt
in Profile* c.1909
Silver gelatin print, 45 × 35
Private Collection, Salzburg

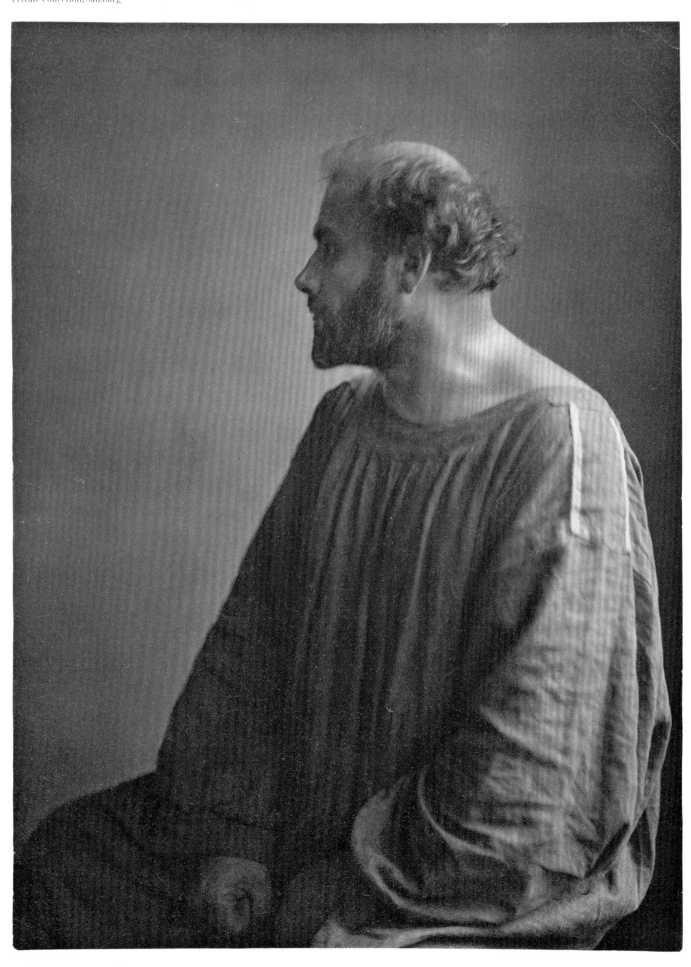

Chronology

Tobias G. Natter

1862—76 Family/Childhood

Gustav Klimt was born on 14 July 1862 at 247 Linzerstrasse in Baumgarten, a rural suburb of Vienna, which later became the fourteenth district. He was the second of seven children born to Ernst and Anna Klimt, née Finster. Klimt's father (1834–92), an engraver with a relatively modest income, moved to Baumgarten in the 1840s from Drabschitz near Leitmeritz in largely German-speaking northern Bohemia (now Travčice near Litoměřice, in the Czech Republic). Klimt's mother (1836–1915) came from an impoverished Viennese family with artistic ambitions.

1876—83 Education

In October 1876 Gustav Klimt enrolled at the recently founded Wiener Kunstgewerbeschule. Since renamed as the Universität für angewandte Kunst, the Kunstgewerbeschule had been set up along the lines of the South Kensington School in London. Gustav's two younger brothers, Ernst (1864–92) and Georg Klimt (1867–1932), studied at the same college. Klimt spent seven years there, two in foundation courses and the next five pursuing special subjects: drawing with Ferdinand Julius Laufberger (1828–81), and decorative painting with Julius Victor Berger (1850–1902). His initial goal was to become a teacher of drawing in a junior high school. During his youth, the Klimt family was obliged to move a number of times, most notably due to the financial losses suffered by Klimt's father following the Vienna Stock Exchange Crash in 1873. The family's circumstances only improved in the 1880s when the sons found paid work.

In 1879, on the recommendation of Professor Laufberger, Gustav and Ernst were engaged to work on the procession – masterminded by Hans Makart (1840–84) – to mark the silver wedding celebrations of Emperor Franz Joseph I and Empress Elisabeth. In 1880 they were employed in their own right to create four decorative ceiling paintings with allegories of the arts for the sumptuous residence of a Viennese architect.

1883—92 The Painters' Company

At college Gustav and Ernst Klimt found a kindred spirit in their fellow-student Franz Matsch (1861–1942), and the three friends decided to join forces as the Painters' Company (Künstler-Compagnie). At the time Vienna was in the grip of a construction boom, and magnificent buildings were springing up along the Ringstrasse – including the Votive Church, the Opera, the Stock Exchange, the Parliament building and the two Imperial Museums – radically raising the standard of large, imposing, ideologically informed buildings in Vienna. The strong economy and huge demand for interior decoration during the late nineteenth century were greatly to the benefit of the Painters' Company. The three young painters were recommended to the extremely successful theatre architects Hermann Helmer and Ferdinand Fellner, for whom they carried out numerous commissions. Their first in 1882 at the Municipal Theatre in Reichenberg, Bohemia (now Liberec, Czech Republic) led to more work the following year in Fiume

(now Rijeka, Croatia) and to yet more in 1884 at the Crown-land Theatre in Karlsbad (now Karlovy Vary, Czech Republic). On the recommendation of Professor Berger, Klimt also contributed numerous designs to the pattern book *Allegories and Emblems*. The Painters' Company made rapid progress, and in 1885 its three members designed and realised a scheme with Shakespearean motifs for a room in the Villa Hermes, a luxurious new residence near Vienna commissioned by Emperor Franz Joseph I as a present for his wife. This was followed by an even more prestigious commission for the stairwell in the new Burgtheater. The assignment was issued by the Court Building Committee on 20 October 1886; the clear division of labour underlined Klimt's dominant position in the Painters' Company. Klimt painted five murals in total, including *Shakespeare's Theatre (The Globe Theatre in London)* and *The Ancient Theatre in Taormina*. The latter in particular was clearly influenced by English salon painting in general and more specifically by the work of Sir Lawrence Alma-Tadema (1836–1912). The murals were well suited to these buildings, in which architecture took precedence over its sister arts painting and sculpture.

In 1888, at only twenty-six years of age, Klimt was awarded the highest imperial honour, the Golden Order of Merit (with Crown). This was followed in 1890 by the Emperor's Prize worth four hundred guilders, for his painting of the *Auditorium in the Old Burgtheater in Vienna*, a multi-figure composition with over two hundred miniature portraits. In 1891 the Painters' Company was commissioned to create the spandrel paintings in the stairwell in the newly construct-ed Kunsthistorisches Museum. That same year Klimt became a member of the Künstlerhaus-Genossenschaft, at that time the only professional association representing Austrian artists.

1892—7 In Search of Modern Truths

Klimt moved into a new studio at 21 Josefstädterstrasse in the eighth district where he was to stay until 1912. The death of his brother Ernst on 9 December sealed the end of Klimt's collaboration with Franz Matsch, following a period in which artistic differences between the two had become increasingly obtrusive. Ignoring the prospect of a distinguished career as a 'state-approved artist', Klimt – already known as 'the new Makart' – struck out in a new artistic direction. Having previously been known for the speed of his invention and execution as a decorative artist, the tempo of his artistic creativity markedly slowed down following the completion of the commission for the Burgtheater. Klimt's main aim now was to extricate himself from the 'golden cage' of the elite establishment centred on the Ringstrasse. His progress as he made this change of direction can be traced in the Faculty Paintings commissioned by the University of Vienna on 4 September 1894. These paintings would take him over ten years to complete and each picture he delivered was increasingly at variance with the client's expectations. An art scandal loomed on the horizon, and when the press lit the touch paper it soon engulfed the whole of Vienna. Having previously produced 'cultivated' paintings with salon-style learned themes and cultural allusions, from this point on his motifs became much more individual and took on a more complicated symbolism that resisted interpretation. His work was no longer in keeping with the positivist self-image of the nine-teenth century. Now 'individual artistic sensibilities' – so important to the members of the Viennese Secession – collided head-on with the prevailing taste for traditional, bourgeois cultural values.

1897–8 The Founding of the Viennese Secession

The growing dissatisfaction of the artistic community with their situation in Vienna led to the founding of an association of visual artists, the Vereinigung bildender Künstler Österreichs (Secession). On 3 April 1897 the founders drew up a constitution and the first general assembly followed on 21 June. Gustav Klimt was elected President. Other founder members included the painter Carl Moll (1861–1945), the designer Koloman (Kolo) Moser (1868–1918) and the architects Joseph Maria Olbrich (1870–1956), Otto Wagner (1841–1918) and Josef Hoffmann (1870–1956). The aim of this new group was to find an alternative to the dominant aesthetic of the Ringstrasse and to expose what they viewed as its stylistic pretensions. The newly founded journal of the association came up with a Latin name – Ver Sacrum – for this proclaimed new 'spring' of the arts, and the hope was that Austrian artists would forge much closer connections with progressive artists abroad. The new dawn was signalled by a programme of exhibitions on a scale that has not been seen since. From March to June 1898 the Secession rented the necessary premises and presented its first exhibition; the main focus in this presentation was international art. Meanwhile, on the Karlsplatz the Secession was having its own exhibition space built by the German-Silesian architect Joseph Maria Olbrich. The grand inauguration of the finished building on 12 November 1898 marked the birth of a new landmark. Even conservative critics were dumbfounded: 'Today the Viennese Secessionists invited their friends and acquaintances to a preview of the inaugural exhibition in their new home which will open tomorrow. In truth, it would be more accurate to say their new "temple", since this strange building – with its far-Eastern forms, its mausoleum-like impenetrability and the symbolist ornament on the external walls – above all creates the impression of a mysterious place of worship for the cult of new art ... The cupola with its gleaming covering of foliage has already become a Viennese attraction and local wits have christened the building "The Golden Cabbage". People have of course been very curious to see the interior of this bewildering building and to view the new Secessionist works, which is why this morning – despite the bad weather and the parlous state of the roads – the rooms were soon crowded with guests.'[1]

1900 The Apotheosis of Exhibition Design

The two figureheads in Vienna at the turn of the century, Gustav Klimt and Sigmund Freud, were similarly preoccupied with a 'voyage intérieur',[2] travelling deep into their own psyches. Each presented his findings in his own way: while Sigmund Freud published his Interpretation of Dreams, Klimt sparked off a heated debate with his Faculty Paintings. The first of these, Philosophy, was shown at the seventh Secession exhibition but did not find favour with the public. Eighty-seven professors from the University of Vienna signed a petition demanding that the Ministry of Education revoke the commission. However, when the same painting was shown in Paris at the Exposition Universelle, Klimt was awarded a gold medal. Matters took a turn for the worse with the presentation of Medicine at the tenth Secession exhibition, and the Viennese authorities blocked Klimt's proposed appointment to a Chair at the Akademie der bildenden Künste (Academy of Fine Arts). It was in the fourteenth exhibition, the so-called 'Beethoven Exhibition' from April until June 1902, that the Secessionists' interest in 'spatial art' (Raumkunst) came to a climax. The focal point

of the presentation was a life-sized figure of Beethoven on a coloured marble throne by the German painter and sculptor Max Klinger (1857–1920). There was no mistaking the pseudo-sacred character of the event and Ludwig Hevesi (1843–1910), the most important critic to champion the Secession, commented: 'It is a church to art that one enters in search of edification and leaves as a believer.'[3] Gustav Klimt presented a painted frieze on the theme of Beethoven's Ninth Symphony. In artistic terms, Klimt's work broke new ground, successfully synthesising monumentality and ornament.

1903–5 The Founding of the Wiener Werkstätte – and the Flöge Salon

Inspired by the British Arts and Crafts movement, the architect Josef Hoffmann, the painter Koloman Moser and the industrialist Fritz Waerndorfer together founded the Wiener Werkstätte (Viennese Workshop). Their aim was to renew the concept of art by reassessing and revaluing the role of the applied arts and by 'ennobling' everyday life. The members of the Wiener Werkstätte produced objects – everyday items, jewellery, furniture etc. – that aspired to the ideals of the Gesamtkunstwerk. Designers and craftsmen alike were given free rein, and they were to use only the 'best materials' regardless of financial implications.

The Wiener Werkstätte was soon receiving commissions for major projects. In 1904 the industrialist Viktor Zuckerkandl contracted the designer Josef Hoffmann to plan and realise a scheme for the Purkersdorf Sanatorium near Vienna. The sanatorium was more a hotel than a hospital and was the first building with an interior designed exclusively by the Wiener Werkstätte. Another example is the Palais Stoclet in Brussels, for which Gustav Klimt realised a mozaic frieze for the dining room. Unlike the Purkersdorf Sanatorium, the Palais Stoclet has survived intact since its completion in 1911. On 1 July 1905, Klimt's lifelong companion Emilie Flöge opened a fashion salon with her sisters in Mariahilferstrasse, not far from the Kunsthistorisches Museum. All the latest fashions passed through their salon, as did the supporters of 'reform clothing' in Vienna who advocated, amongst other things, free-flowing forms and an end to the corset.

1905 Watershed

Three major changes came about in Klimt's life in 1905. Firstly, he came to a decision regarding the dispute that had raged around his Faculty Paintings for years. Having relinquished the commission in April, he refunded all the monies paid to him so far and requested that the finished works be returned to him: 'Enough of censorship. I am taking things into my own hands. I want to make my escape. I want to reclaim my freedom and leave behind me all this unpleasant pettiness, which only keeps me from my work. I no longer wish for the support of the state, in any form whatsoever.' And he concluded with the words: 'The state should have no right to play the grand patron of the arts when it is – at best – merely making charitable donations.'[4] Secondly, Klimt and his supporters left the Viennese Secession after a crucial vote. Thirdly, his appointment to a chair at the Akademie der bildenden Künste was finally vetoed.

1906 Klimt in England

Klimt, who spoke no foreign languages, travelled with Fritz Waerndorfer to Brussels (in connection with his frieze for the Palais Stoclet) and to London for the Earl's Court Imperial

Royal Austrian Exhibition in London. His Exhibitor's Season Ticket survives. On 5 May, the day of the opening, he met the Scottish architect and designer Charles Rennie Mackintosh (1868–1928). On 7 May he sent his mother a postcard of Whitehall and on 8 May he sent a postcard of Westminster Abbey to his sister. As always, these communications from the notorious 'non-writer' are terse to say the least and do no more than touch on the weather and his health.

1908—9 The Two Kunstschau Exhibitions

In 1908, Klimt and the artists who left the Secession with him had their first chance to show work as a group at the Kunst-schau Wien. The architectural design of the show was entrus-ted to Josef Hoffmann, who created a stunning exhibition area in the open space next to the Konzerthaus. Regarded by many as a 'ceremonial gown around Klimt', the exhibition contained only the work of Austrian artists. In fact, the concept of the Gesamtkunstwerk was never realised with greater panache, and the artistic exhibits on show covered every area of life, from the cradle to the grave – even down to a specially designed cemetery. Gustav Klimt, who opened the Kunstschau as its President, publicly put so-called high art on a par with the applied arts. In his opening address he also commended the 'ideal community of the creators and the connoisseurs of works of art'. One of the youngest participants was Oskar Kokoschka, just twenty-two years old, whose inclusion Klimt had expressly supported: 'Oskar Kokoschka is the leading talent of the younger generation. And even if we are running the risk of having our "Kunstschau" demolished, that would simply be the end of it. But at least we would have done our duty.'[5] The Austrian state bought The Kiss by Gustav Klimt, which was on show in the exhibition and a key work in his 'golden style'. At the same time, the Galerie Miethke – Vienna's leading progressive gallery – embarked on the publication of the folio Das Werk Gustav Klimts, one of most outstanding examples of typography and printing from that time.

This first exhibition was followed in 1909 by the Internationale Kunstschau, devoted to contemporary European painting. Among the most interesting artists who made their debut in this show was Egon Schiele, who was keen to become more closely acquainted with Klimt, the artist and the man.

1910—14 Klimt's International Reputation

The architect and cultural pioneer Adolf Loos published Ornament and Crime, a sharp critique of the love of ornament that pervaded the Wiener Werkstätte with which Gustav Klimt was closely involved. However, this did no harm to Klimt's growing reputation abroad, above all in Italy. He showed work at the ninth Venice Biennale and, in summer 1911, at the Esposizione Internazionale in Rome where he was awarded First Prize. The following year his work was seen at the Grosse Kunstausstellung in Dresden, and in 1913 he accepted an invitation from the Bund Österreichischer Künstler to exhibit his work in Budapest.

When Klimt moved into a new studio in Feldmühlgasse in the thirteenth district, he once again turned it into a hortus conclusus – as he had done in Josefstädterstrasse – only his closest colleagues and friends being welcome. Egon Schiele later recalled the situation and the look of the studio: 'Each year Klimt had bedding plants put into the garden around the house – it was a delight to find oneself, on arrival, in the midst of flowers and old trees. Outside the door of the house were two beautiful heads, modelled by Klimt. Inside the house, you

would first find yourself in an ante-chamber; the door on the left led into his reception room in the middle of which stood a square table; on the walls Japanese woodcuts rubbed shoulders with two rather large Chinese paintings, on the floor were negro sculptures, in the corner by the window there was a set of black-and-red Japanese armour. The right-hand door in the ante-chamber led initially into a room with two skeletons standing in it, this was followed by a room with a single, built-in display cupboard on one of the long walls filled with the most beautiful Chinese and Japanese garments. It was from here that you had access to the actual workshop.'[6]

1914—18 The First World War

A month after the assassination of the heir to the Austrian throne, Archduke Franz Ferdinand, on 28 June 1914 in Sarajevo, the Austro-Hungarian Empire declared war on Serbia; this in effect marked the outbreak of the First World War. At the time Klimt was enjoying his annual summer break at the Attersee, which was always a source of inspiration to him for his magnificent landscape paintings. Artistic life in Vienna virtually came to a halt with the outbreak of war. On 6 February 1915 Klimt's mother died. For the first time in his adult life, Klimt had financial worries. He turned for help to Serena Lederer, his most important patron at the time, and for whom he was currently painting a portrait of her daughter: 'Most honoured lady! A silly letter – sorry? You know all about fate! Your painting will be finished on Tuesday or Wednesday – and the "paltry remainder" of my fee will be due – I am thirsting for it like the Devil for some poor soul! That I may just spe ... But there are still some miserable days until that moment comes. Could you possibly advance me two to three thousand crowns – or even just one thousand, it's all the same – so that at least in one respect I may finish the painting relatively free from care. Such a paltry thing! – and the "exigencies of war" are little comfort! Once again please accept my apologies. Maybe it might then even be possible for my manservant to bring a "little something" immediately. Otherwise I will have to break into my very small "golden fund", which I have set aside for only the most extreme emergencies. Your ever faithful servant, Gustav Klimt.'[7]

In 1917 the Akademie der bildenden Künste in Vienna elected Klimt as Honorary Member. Not long afterwards the Munich Academy followed suit. On 12 September the poet Peter Altenberg composed an 'Address' to Klimt: 'Gustav Klimt, as a painter of vision you are also a modern philosopher, a wholly modern poet! When you paint, in an instant you transform yourself – as though in a fairytale – into the "most modern person", someone that you are perhaps not at all in the cool light of day!'

1918

On 11 January Klimt suffered a stroke in his apartment, and was left paralysed down the right-hand side of his body. Following a short stay in hospital, Klimt died from pneumonia on 6 February. Egon Schiele made a last drawing of him in the morgue of the General Hospital and later recalled that moment: 'I found him very changed, smooth shaven, I barely recognised him lying on the bier. Klimt was stocky, rugged and burnt brown by the sun ...'[8] Gustav Klimt was buried three days later next to his mother in the Hietzinger Cemetery in Vienna.

Translated from the German by Fiona Elliott

Notes

References to Fritz Novotny and
Johannes Dobai, *Gustav Klimt, with a
Catalogue Raisonné of his Paintings*,
London and New York 1968 are
abbreviated to ND.

Tobias G. Natter pp.13–23

1 Christian M. Nebehay, *Gustav
Klimt: Dokumentation*, Vienna 1969,
p.382. The Neue Galerie New York
is to be particularly commended for
its consistent efforts to break new
ground in this respect.

2 Kolo Moser, 'Mein Werdegang',
in *Velhagen & Klasings Monatshefte*,
vols. 31/32, 1916, pp.254–62.

3 See Ursula Prokop, 'Das britische
Paradigma in Konflikt der Wiener
Moderne zwischen Dekorativismus
und Purismus. Zur unterschiedlichen
Rezeption der Arts and Crafts
Bewegung bei Josef Hoffmann und
Adolf Loos', in Johann Dvořák (ed.),
*Radikalismus, demokratische
Strömungen und die Moderne in der
österreichischen Literatur*, Bremer
Beiträge zur Literatur- und
Ideengeschichte, vol.43, Frankfurt
am Main 2003, pp.293–307.

4 On the Wiener Werkstätte see,
in particular, Peter Noever (ed.), *Der
Preis der Schönheit. 100 Jahre Wiener
Werkstätte*, Ostfildern-Ruit 2003,
pp.50ff.

5 Josef August Lux in the first press
report on the Wiener Werkstätte
in *Deutsche Kunst und Dekoration*,
Darmstadt, vol.8, part 1, October
1904.

6 From the 'mission statement'
of the Wiener Werkstätte, Vienna,
1905, unpaginated.

7 Fritz Waerndorfer on 17 March
1903 in a letter to Josef Hoffmann,
Archive of the Universität für
angewandte Kunst, inv. no.3999.

8 Ibid.

9 Other examples are the portrait
painted by Klimt in 1905 and 1907 of
Margaret Stonborough-Wittgenstein
(ND no.142) and of Adele Bloch-Bauer
(ND no.150). See Noever, *Der Preis der
Schönheit*, pp.110 and 153.

10 Ludwig Hevesi, 'Bilder von Gustav
Klimt', in *Altkunst – Neukunst. Wien
1894–1908*, Vienna 1909, p.213.

11 Ibid.

12 For more detail on the Galerie H.
O. Miethke as the leading progressive
gallery in the Austro-Hungarian

Empire see Tobias G. Natter, *Die
Galerie Miethke. Eine Kunsthandlung
im Zentrum der Moderne*, Vienna
2003.

13 On the sale of works by Klimt
at the Galerie Miethke see ibid.,
in particular p.253. See also Hevesi,
'Bilder von Gustav Klimt', on a
'painted mosaic' (p.213); he saw the
painting in the Galerie Miethke with
an official sale price of 5,000 guilders
(i.e. 10,000 crowns).

14 Arthur Roessler, *Erinnerungen
an Egon Schiele*, Vienna 1948, p.26.

15 With particular reference to the
situation in Viennese art around
1900, see Eva Mendgen, 'Kunst oder
Dekoration. Bild und Rahmen im
Werk von Franz von Stuck und
Gustav Klimt', in Eva Mendgen (ed.),
*In Perfect Harmony. Bild + Rahmen,
1850–1920*, Amsterdam 1995,
pp.97–126.

16 See Gustav Klimt in a letter to
Marie Zimmermann in August 1903;
as cited in Christian M. Nebehay,
'Gustav Klimt schreibt an eine Liebe',
in *Mitteilungen der Österreichischen
Galerie, Sonderheft Klimt-Studien*,
Salzburg 1979, vol.22/23, no.66/67,
pp.110f.

17 On Waerndorfer as a collector
of works by Gustav Klimt see, most
recently, Tobias G. Natter, *Die Welt
von Klimt, Schiele und Kokoschka.
Sammler und Mäzene*, Cologne 2003,
pp.54–71.

18 The furniture was recently shown
in New York. See Renée Price (ed.),
*Gustav Klimt. The Ronald S. Lauder
and Serge Sabarsky Collections*,
Munich 2007.

19 The objects cited here are
illustrated in Nebehay, *Gustav Klimt*,
p.465.

20 For more on two items of
jewellery for Emilie Flöge, see
Wolfgang Georg Fischer, *Gustav
Klimt und Emilie Flöge. Genie
und Talent, Freundschaft und
Besessenheit*, Vienna 1987, pp.63f.
and illustrations on p.71. In his most
recent research Michael Huey has
identified a total of seventeen items
of jewellery from the Wiener
Werkstätte that Klimt bought up
until 1906. See Michael Huey, 'Das
ästhetisierte Individuum. Das Subjekt
und seine Objekte im Wien der
Jahrhundertwende', in Renée Price
and Wilfried Seipel (eds), *Wiener
Silber. Modernes Design 1780–1918*,
Ostfildern-Ruit 2003, pp.343–52,
particularly p.351, note 14.

21 Information kindly supplied
by Paul Asenbaum, 25 July 2007.

22 For more on the Board see
Werner J. Schweiger, *Wiener
Werkstätte. Kunst und Handwerk
1903–1932*, Vienna 1982, p.263.

23 Max Eisler, for one, regarded
Klimt's Stoclet Frieze as marking
his 'final farewell to monumental
freedom and grandeur, as he retreats
back into the applied arts where
the artistic material is dominant.
On the other hand, this elevated and
ennobled modern applied arts in
Vienna as never before.' See Eisler,
Gustav Klimt, Vienna 1920, p.36.

24 Berta Zuckerkandl, 'Die
Vergrößerung der Wiener Werk-
stätte', in *Wiener Allgemeine
Zeitung*, 3 October 1905.

25 Ibid.

26 Lisa Fischer, 'Geschlechter-
asymmetrien der Wiener Moderne',
in Tobias G. Natter and Gerbert Frodl
(eds.), *Klimt und die Frauen*, Cologne
2000, pp.32–7, particularly p.36.

27 For more on this see Dieter
Bogner, 'Die geometrischen Reliefs
von Josef Hoffmann', in *alte und
moderne Kunst*, vol.27, nos. 184/185,
1982, pp.24ff; and most recently,
see Markus Brüderlin, 'Architekt-
onische Abstraktion und die Vision
der Moderne' in Price and Seipel,
Wiener Silber, pp.336–42.

28 Tobias G. Natter, 'Gustav Klimt
and The Dialogues of the Hetaerae.
Erotic Boundaries in Vienna Around
1900', in Price, *Gustav Klimt*,
pp.131–43.

29 Franz Servaes, 'Klimt. Zu seinem
50. Geburtstag', in *Merkur*, Vienna,
vol.3, 3rd quarter, p.544.

30 Ludwig Hevesi, *Acht Jahre
Sezession (März 1897–Juni 1905).
Kritik-Polemik-Chronik*, Vienna
1906, p.444.

31 Natter/Frodl, *Klimt und die
Frauen*, p.102.

32 Although there are contemporary
sources that refer to Klimt as a
fashion designer, this is erroneous.
This misapprehension derives in part
from the journal *Deutsche Kunst und
Dekoration*, In vol.19, October 1906–
March 1907, it links fashion designs
with designs that were in fact by
Emilie Flöge. For more on this see
Angela Völker, 'Vom Ball-Entrées,
Neoempire, Reformkleidern,
Drachenroben und slowakischer

Stickerei. Gustav Klimt und die Mode
der Damen', in Natter/Frodl, *Klimt
und die Frauen*, pp.43–9.

33 Niklas Luhmann, *Die Kunst der
Gesellschaft*, Frankfurt am Main
1997, p.195.

34 For more on the long-under-
estimated importance of ornament
for abstract art see Markus Brüderlin
(ed.), *Ornament und Abstraktion.
Kunst der Kulturen, Moderne und
Gegenwart im Dialog*, Cologne 2001.

35 Josef Strzygowski, *Die Bildende
Kunst der Gegenwart. Ein Büchlein
für Jedermann*, Leipzig 1907, p.92.

36 *Kunst und Kunsthandwerk*,
Vienna, vol.17, 1905, p.73.

37 As a possible source of
inspiration see also Gustav Klimt,
Goldfische 1901/02, now in the
Kunstmuseum Solothurn, Dübi-
Müller-Stiftung (ND no.124).

38 Ludwig Hevesi, 'Gustav Klimt
und die Malmosaik', in Hevesi,
'Bilder von Gustav Klimt', pp.210–14,
here p.213. A similar idea is found
in *Kunstchronik*, 1903/04, p.373:
'Unfortunately in this exhibition [the
tenth exhibition of the Viennese
Secession] there are also a number
of pseudo-Klimts. All sorts of actually
gifted younger artists now want
to Klimtify themselves at all costs.'

39 Josef August Lux, 'Kunstschau-
Wien 1908', in *Deutsche Kunst und
Dekoration*, vol.23, 1908/09, pp.44–6.

40 Werner Hofmann, *Moderne
Malerei in Österreich*, Vienna 1965,
p.36.

41 Wilhelm Dessauer, 'Zwanzig
Jahre nach Klimts Tod', *Wiener Freie
Presse*, as cited in Nebehay, *Gustav
Klimt*, p.390.

42 Hevesi, 'Bilder von Gustav
Klimt', p.210.

43 *Wiener Allgemeine Zeitung*,
6 June 1908.

44 See the catalogue of the
Internationale Kunst-Ausstellung,
Mannheim 1907.

45 As cited in Roland Scotti,
*Die "Internationale Kunst-Ausstel-
lung" 1907 in Mannheim* (series:
Kunst und Dokumentation, vol.9),
Städtische Kunsthalle Mannheim,
1985, p.31.

46 There are various overtones
in the name Bloch found in Austro-

German, meaning woodblock, and also in Austro-German usage in the verb 'blochen', meaning to polish. It is impossible to say for certain who coined this phrase, see Natter/Frodl, *Klimt und die Frauen*, p.115.

47 Anton Faistauer, *Neue Malerei in Österreich. Betrachtungen eines Malers*, Zurich 1923, p.13.

48 This caricature is illustrated in *Die Muskete*, Vienna, vol.6, 1908, particularly part 144, p.326.

49 For more on the exhibition in general see Scotti, *Die "Internationale Kunst-Ausstellung" 1907 in Mannheim*.

50 Ibid.

51 Peter Gorsen, Josef Hoffmann 'Zur Modernität eines konservativen Baumeisters', in Alfred Pfabigan (ed.), *Ornament und Askese im Zeitgeist des Wien der Jahrhundertwende*, Vienna 1985, p.80.

52 Carl Moll, 'Erinnerungen an Gustav Klimt', in *Neues Wiener Tagblatt*, Vienna, 24 January 1943.

53 Wilhelm Dessauer, 'Zwanzig Jahre nach Klimts Tod', *Wiener Freie Presse*; as cited in Nebehay, *Gustav Klimt Dokumentation*, p.390.

54 Sabine Forsthuber, *Moderne Raumkunst. Wiener Ausstellungsbauten von 1898 bis 1914*, Vienna 1991.

55 Moser, 'Mein Werdegang'.

56 Karl Scheffler, untitled, in *Kunst und Künstler. Illustrierte Monatsschrift für Kunst und Kunstgewerbe*, Berlin, vol.5, 1907, p.459. Karl Scheffler (1869–1951), the son of a painter's assistant, was obliged to earn his living between 1895 and 1906 as a decorative and ornamental painter in a wallpaper factory.

57 Ibid., p.460

58 Lux, 'Kunstschau – Vienna 1908', vol.23, 1908/09, p.44.

59 It actually makes little difference whether this was written by Klimt or for him; the latter seems more likely bearing in mind his notorious reluctance to write letters or to put pen to paper at all.

60 Klimt's opening address is reprinted in the catalogue of the *Kunstschau*, Vienna 1908, pp.2–5.

61 From the 'mission statement' of the Wiener Werkstätte.

62 It has so far gone unnoticed that an almost identical turn of phrase exists elsewhere, namely in the 1906 statement issued by the German Expressionist artists of the Brücke. Klimt's original German reads: 'Und weit wie den Begriff "Kunstwerk" fassen wir auch den Begriff "Künstler". Nicht nur die Schaffenden, auch die Genießenden heißen uns so, sie, die fähig sind, Geschaffenes fühlend nachzuerleben und zu würdigen. Für uns heißt

"Künstlerschaft" die ideale Gemeinschaft aller Schaffenden und Genießenden.' Compare this with the Brücke declaration: 'Mit dem Glauben an Entwicklung, an eine neue Generation der Schaffenden wie der Genießenden rufen wir alle Jugend zusammen, und als Jugend, die die Zukunft trägt, wollen wir uns Arm- und Lebensfreiheit verschaffen gegenüber den wohlangesehenen älteren Kräften. Jeder gehört zu uns, der unmittelbar und unverfälscht wiedergibt, was ihn zum Schaffen drängt.' [With our belief in progress, in a new generation of creative artists and of art lovers, we call the young people of our time together, and as young people ourselves, with the future in our hands, we want to claim our own freedom to do and live as we wish, setting ourselves apart from the highly respected older hands. We count among our number each of those who communicates directly and honestly what it is that urges him to create art.]

63 For more about these collectors see Natter, *Die Welt von Klimt, Schiele und Kokoschka*, Cologne 2003.

64 See Huey, 'Das ästhetisierte Individuum. Das Subjekt und seine Objekte im Wien der Jahrhundertwende', pp.334 and 343.

65 See also the polemical texts and lectures published by Loos: *Die Potemkinsche Stadt, 1898; Der arme reiche Mann, 1900; Das Wiener Weh (Wiener Werkstätt) – Eine Abrechnung*, Vienna 1927.

66 Christian Witt-Dörring, 'Introduction', in Witt-Dörring (ed.), *Josef Hoffmann. Interiors 1902–1913*, Munich 2006, p. 14.

67 Klimt 1908 (as note 60). The change is most evident when Klimt paints a second portrait of Adele Bloch-Bauer in 1912. But, unlike the portrait made five years earlier, in this one Klimt decides to turn his attention to colour and completely abandons the earlier extremely ornamental approach to both form and composition.

68 Siegfried Gideon in a letter to Josef Hoffmann, 11 December 1950, private collection Zug, Switzerland.

Esther da Costa Meyer pp.25–31

1 Éric Michaud, 'Oeuvre d'art totale et totalitarisme', in *L'Oeuvre d'art totale*, Jean Galard, Julian Zugazagoitia et al., (eds.), Paris 2003, p.35.

2 For the revolution of 1848 in Dresden and its participants, see Richard Wagner, *My Life*, New York 1935, particularly pp.474–81.

3 Richard Wagner, 'Art and Revolution', in *The Art-Work of the Future and Other Works*, trans. W. Ashton Ellis, Lincoln, Nebraska 1993, p.52.

4 Wagner, 'The Art-Work of the Future', in *The Art-Work of the Future*, p.207.

5 Ibid., p.81.

6 Ibid., pp.208.

7 'The great United Art-work [Gesamtkunstwerk], which must gather up each branch of art to use it as a mean, and in some sense to undo it for the common aim of all, for the unconditioned, absolute portrayal of perfected human nature, – this great United Art-work he cannot picture as depending on the arbitrary purpose of some human unit, but can only conceive it as the instinctive and associate product of the Manhood of the Future.' Wagner, 'The Art-Work of the Future', p.88. Emphasis in the original.

8 Wagner, 'Art and Revolution', p.53.

9 '[I]f, by the choice of his subjects and his dramatic method, Wagner comes close to antiquity, by the passionate energy of his expression he is in our day the most genuine representative of modern man.' Charles Baudelaire, 'Richard Wagner and *Tannhäuser* in Paris', in *Selected Writings on Art and Literature*, trans. P.E. Charvet, London 1992, p.355; Friedrich Nietzsche, 'The Case of Wagner', in *The Birth of Tragedy and The Case of Wagner*, trans. Walter Kaufmann, New York 1967, pp.156, 166, 176, 188.

10 Wagner, 'Art and Revolution', p.49.

11. Wagner, 'The Art-Work of the Future', p.72.

12 Ibid., p.97.

13 Georg Simmel, 'Sociology of the Senses' (2007), in *Simmel on Culture*, ed. David Frisby and Mike Featherstone, London 1997, pp.109–20. Sigmund Freud, *Civilization and its Discontents* (1930), ed. and trans. James Strachey, New York, 1961, pp.46–7. Significantly, Marx also talks about the emancipation of the senses in a text Wagner could not have known, the *Economic and Philosophic Manuscripts of 1844*, unpublished until the twentieth century. See *The Marx-Engels Reader*, Robert C. Tucker (ed.), New York 1978, pp.87–8.

14 The book, *Psyche: Zur Entwicklungsgeschichte der Seele* (Pforzheim 1846) began with a famous opening sentence: 'The key to the knowledge of the nature of the soul's conscious life lies in the realm of the unconscious.' Quoted in Henri F. Ellenberger, *The Discovery of the Unconscious*, New York 1970, p.207.

15 Klaus Eggert, 'Der Begriff des Gesamtkunstwerks in Sempers Theorie', in *Gottfried Semper und die Mitte des 19. Jahrhunderts*, Basel 1976, pp.122–8

16 'Preliminary Remarks on Polychrome Architecture and Sculpture in Antiquity', now in Gottfried Semper, *The Four Elements of Architecture and Other Writings*, trans. Harry Francis Mallgrave and Wolfgang Herrmann, intro. Harry Francis Mallgrave, Cambridge 1989, pp.45–73. Semper's somewhat hasty conclusions concerning the

polychrome were skewered by the classicists of his day.

17 The point and the citation are made by Mallgrave, 'Introduction', in Semper's *The Four Elements of Architecture and Other Writings*, p.2.

18 In particular Harry Francis Mallgrave, in his *Gottfried Semper: Architect of the Nineteenth Century*, New Haven, Connecticut and London 1996; Josef Bayer, *Baustudien und Baubilder. Schriften zur Kunst*, Robert Stiassny (ed.), Jena 1919.

19 Mallgrave, *Gottfried Semper: Architect of the Nineteenth Century*, p.129.

20 'As a cosmic art, tectonics [his new name for architecture] forms a triad with music and dance inasmuch as they are not imitative arts either'. Semper, 'The Attributes of Formal Beauty', now in Wolfgang Hermann, *Gottfried Semper: In Search of Architecture*, Cambridge, Massachusetts 1989, p.220. This essay was originally given as a lecture in Zurich, where Semper arrived in 1855 as a professor at the Eidgenössischen Technische Hochschule.

21 For a good background on this issue, see Werner Hofmann, 'Gesamtkunstwerk Wien', in *Der Hang zum Gesamtkunstwerk*, exh. cat., Kunsthaus Zürich, Zurich 1983, pp.84–92.

22 For Wagner's followers in Vienna, see William J. McGrath, *Dionysian Art and Populist Politics in Austria*, New Haven, Connecticut and London 1974.

23 Camillo Sitte, 'Gottfried Semper: zum 70. Geburtstage', *Neues Wiener Tagblatt*, 29 November 1873; Camillo Sitte, 'Gottfried Semper [obituary]', *Salzburger Gewerbeblatt* 3, nos. 3–4, 1879, pp.22–4; Camillo Sitte, 'Eine Handschrift Gottfried Sempers; Ein Beitrag zur Baugeschichte Wiens', *Neues Wiener Tagblatt*, no. 19, 9–10 January 1885; Camillo Sitte, 'Gottfried Semper und der moderne Theaterbau', *Neues Wiener Tagblatt*, 17 January 1885.

24 *Camillo Sitte: The Birth of Modern City Planning [Der Städtebau nach seinen künstlerischen Grundsätzen]*, trans. George R. Collins and Christiane Crasemann Collins, New York 1986.

25 For Wagner's influence on Sitte, see Carl E. Schorske, *Fin-de-Siècle Vienna: Politics and Culture*, New York 1980, pp.64–72.

26 *Camillo Sitte: The Birth of Modern City Planning*, p.321.

27 Otto Wagner, *Modern Architecture*, trans. and with an intro. by Harry Francis Mallgrave, Santa Monica, California 1988, p.109.

28 Ernst Mach, *The Analysis of Sensations*, trans. C.M. Williams, New York 1959, p.14. For an interesting parallel between Mach's ideas and art, albeit in another context, see Rudolf Arnheim,

'Sketching and the Psychology of Design', *Design Issues*, vol.9, no.2, Spring 1993, pp.15–19.

29 Hermann Bahr, *Prophet der Moderne. Tagebücher 1888–1904*, Reinhard Farkas (ed.), Vienna 1987, p.48.

30 Sigmund Freud, *Civilization and Its Discontents*, p.15.

31 For the emergence of a cult of the self and its connection to Art Nouveau, see Debora L. Silverman, *Art Nouveau in Fin-de-Siècle France: Politics, Psychology, and Style*, Berkeley, California 1989, pp.75–106.

32 Josef Hoffmann, "Einfache Möbel," in *Das Interieur*, vol.II, 1901, pp.199–200.

33 Wagner, 'The Art-Work of the Future', p.86.

34 Equally important was the Austrian Museum for Art and Industry, founded in emulation of the South Kensington Museum. Its director, Arthur von Scala, a member of the Secession, had close connections to Britain.

35 Characterised by its petit-bourgeois domesticity, the Biedermeier style (1815–48) was an important precursor of modern attempts to reconfigure middle-class furnishings in Austria.

36 Georg Simmel, 'The Metropolis and Mental Life', in Simmel, *On Individuality and Social Forms*, Donald N. Levine (ed.), Chicago, 1971, p.338.

37 Mackintosh goes on to say however, that '[l]ater ... you can emerge boldly into the full light of the world, attack the factory-trade on its own ground, and the greatest work that can be achieved in this century, you can achieve it: namely the production of objects of use in magnificent form and at such a price that they lie within the buying range of the poorest' Edward F. Sekler, 'Mackintosh and Vienna', *The Anti-Rationalists*, Toronto 1973, p.140.

38 Adolf Loos, 'The Poor Little Rich Man', in *Spoken into the Void: Collected Essays 1897–1900*, Cambridge, Massachusetts 1982, p.125.

39 Ibid., p.126.

40 To be fair, after 1920, the Wiener Werkstätte began to work with other companies to mass-produce their designs in small quantities. Yet these editions were limited and expensive. See *Yearning for Beauty: The Wiener Werkstätte and the Stoclet House*, ed. Peter Noever, exh. cat. MAK, Vienna 2006, pp.18–19.

41 Quoted in Hans M. Wingler, *The Bauhaus: Weimar, Dessau, Berlin, Chicago*, trans. Wolfgang Jabs and Basil Gilbert, Cambridge, Massachusetts 1969, p.36. Ellipsis in original.

42 For the history of the cultural forces opposing the Gesamtkunst-

werk, see Martin Puchner, *Stage-Fright: Modernism, Anti-Theatricality & Drama*, Baltimore 2002.

43 Mallgrave, *Gottfried Semper: Architect of the Nineteenth Century*, pp.349–50. Nietzsche calls Semper (without naming him) 'the most significant living architect'. Nietzsche, 'Das griechische Musikdrama', in *Sämtliche Werke*, vol.I, ed. Giorgio Colli and Mazzino Montinari, Munich 1999, p.522.

44 Nietzsche, 'Nietzsche Contra Wagner', *The Portable Nietzsche*, trans. Walter Kaufman, New York 1969, pp.664–5.

45 Nietzsche, 'Nietzsche Contra Wagner', p.673.

46 Theodor Adorno, *In Search of Wagner*, trans. Rodney Livingstone, London 1985, p.104.

47 This is the gist of Guy Debord's critique in *The Society of Spectacle*, trans. Donald Nicholson-Smith, London 1994.

48 Hitler tried unsuccessfully to get into Vienna's Academy of Fine Arts twice: in 1907, into the art school; and in 1908, into the school of architecture.

49 Albert Speer, *Inside the Third Reich*, trans. Richard and Clara Winston, New York 1970, p.41. See also *Die Tagebücher von Joseph Goebbels*, Elke Fröhlich (ed.), vol.I, Munich 1998, p.298. In the entry for 31 August 1940, Goebbels says Hitler wanted to build a new opera based on Semper's design for the old opera house at Dresden.

50 Quoted in Peter Paret, *An Artist Against the Third Reich: Ernst Barlach, 1933–1938*, Cambridge 2003, p.10.

51 For the aestheticisation of politics, see Philippe Lacoue-Labarthe, *Musica ficta (Figures of Wagner)*, trans. Felicia McCarren, Stanford, California 1994, p.17; Fritz Stern, *The Politics of Cultural Despair*, Berkeley, California 1974, p.135.

52 Siegfried Kracauer, 'The Mass Ornament', in *The Mass Ornament: Weimar Essays*, trans., ed. and with an intro. by Thomas Y. Levin, Cambridge, Massachusetts 1995, pp.75–86. Originally written for the *Frankfurter Zeitung* in 1927, Kracauer's essay compared the rigid choreography of the Tiller girls to Taylorism.

53 Michaud, 'Oeuvre d'art totale et totalitarisme', p.35.

Christoph Grunenberg pp.33–41

1 Karl Kraus, 'Eine Kulturtat', *Die Fackel*, vol.9, no.236, 18 November 1907, p.6.

2 *Katalog der I. Kunst-Ausstellung der Vereinigung Bildender Künstler Österreichs*. Vienna 1898, pp.3–5.

3 Ernst Stöhr, 'Unsere XIV. Ausstellung', *Max Klinger Beethoven.*

XIV. Ausstellung der Vereinigung Bildender Künstler Österreichs Secession, Vienna 1902, p.9. For an excellent documentation of exhibitions in Vienna around 1900 see Sabine Forsthuber, *Moderne Raumkunst. Wiener Ausstellungsbauten von 1889 bis 1914*, Vienna 1991.

4 Elenora Louis, 'The Defection of the Klimt Group', *Secession 1897–2000*, CD-ROM, Vienna 2001.

5 Max Burckhard, 'Ver Sacrum', *Ver Sacrum*, vol.I, no.1, 1898, pp.1–3.

6 Hermann Bahr, 'Zur IX. Ausstellung', *Ver Sacrum*, vol.IV, 1901, p.80.

7 Quoted in Christian M. Nebehay, *Gustav Klimt: Dokumentation*, Vienna 1969, p.394.

8 *Katalog der I. Kunst-Ausstellung*, p.7.

9 Ludwig Hevesi, 'Die Ausstellung der Sezession' (28 March 1898), reprinted in Hevesi, *Acht Jahre Sezession (März 1897–Juni 1905). Kritik-Polemik–Chronik*. Vienna 1906, p.13.

10 Ibid.

11 Ibid.

12 Hermann Bahr, 'Erste Kunstausstellung der Vereinigung Bildender Künstler Österreichs', (March/April 1898), reprinted in Bahr, *Secession*, Vienna 1900, p.15.

13 Hevesi, 'Die erste Ausstellung der Vereinigung bildender Künstler Österreichs' (10 May 1898), reprinted in *Acht Jahre Sezession*, p.38.

14 Carl E. Schorske, *Fin-de-Siècle Vienna: Politics and Culture*, New York 1980, p.220.

15 Hevesi, "Verkannte Kunstwerke" (19 November 1898), reprinted in *Acht Jahre Sezession*, p.81.

16 Bahr, 'Meister Olbrich' (October 1898), reprinted in *Secession*, p.61.

17 Otto Karpfinger, 'Des Kunsttempels Traumlandsherkunft', in Susanne Koppensteiner (ed.), *Secession: Die Architektur*. Vienna 2003, p.47. Hevesi, 'Das Haus der Secession', reprinted in *Acht Jahre Sezession*, p.63.

18 Joseph Maria Olbrich, 'Das Haus der Secession', in *Der Architekt*, vol. V, January 1899, p.5.

19 Bahr, 'Meister Olbrich', pp.62–3.

20 Wilhelm Schölermann, 'Neuere Wiener Architektur', in *Deutsche Kunst und Dekoration*, vol.II, 1899, pp.205, 210.

21 Ibid., p.212.

22 Hevesi, 'Ver Sacrum' (15 February 1898), reprinted in *Acht Jahre Sezession*, p.7ff.

23 Klimt's poster also alludes to the small statue of Athena by Arthur

Strasser, which was to be placed to right of the entrance in a protective crystal glass case. Hevesi, 'Aus dem Wiener Kunstleben: Das Haus der Secession', in *Kunst und Kunsthandwerk*, vol.I, 1898, p.406.

24 Bahr, 'Meister Olbrich', p.61.

25 Quoted in Werner Hofmann, 'Luxus und Widerspruch', in Hofmann, *Gegenstimmen: Aufsätze zur Kunst des 20. Jahrhunderts*, Frankfurt am Main 1979, p.57; Bahr, 'Erste Kunstausstellung', p.35.

26 Quoted in *Secession 1897–2000*.

27 Berta Zuckerkandl, 'Koloman Moser', *Die Kunst*, vol.10, 1903/04, pp.341, 344.

28 Karl Widmer, 'Zur Mannheimer Jubiläumsausstellung', in *Deutsche Kunst und Dekoration*, vol. 20, 1907, p.302.

29 Karl Scheffler, *Kunst und Künstler*, vol.5, 1907, p.460; quoted in Roland Scotti, *Die 'Internationale Kunstausstellung' 1907 in Mannheim* (series: *Kunst und Dokumentation*, vol.9) Städtische Kunsthalle Mannheim, 1985, p.22.

30 Berta Zuckerkandl, *Zeitkunst. Wien 1901–1907*, Vienna/Leipzig 1907, p.159; quoted in Forsthuber, *Moderne Raumkunst*, p.101.

31 Karl Scheffler, *Kunst und Künstler*, p.460; quoted in Scotti, *Die 'Internationale Kunstausstellung' 1907 in Mannheim*, p.22.

32 This term is used in Forsthuber, *Moderne Raumkunst*, p.100.

33 Ibid., pp.101–2.

34 'Aus Klinger's Schrift "Malerei und Zeichnung"', in *Max Klinger Beethoven. XIV. Kunstausstellung*, p.18.

35 Berta Zuckerkandl, 'Die XXIII. Ausstellung der Wiener Sezession', in *Die Kunst für Alle*, vol. 20, 1 July 1905, p.441.

36 Quoted in Nebehay, *Gustav Klimt: Dokumentation*, p.394.

37 Carl E. Schorske, "Cultural Hothouse," *New York Review of Books*, 11 December 1975, p.41; quoted in Robert Jensen, 'A Matter of Professionalism: Marketing Identity in Fin-de Siècle Vienna', in Steven Beller (ed.), *Rethinking Vienna 1900*, New York/Oxford 2001, p.198.

38 Hevesi, 'Gustav Klimt und die Malmosaik' (August 1907), reprinted in Hevesi, *Altkunst—Neukunst. Wien 1894–1908*, Vienna 1909, p.211.

39 Otto Stoessl, 'Kunstschau', *Die Fackel*, vol.10, no.259–60, 13 July 1908, pp.25–6.

40 Oskar Stauf von der March, 'Die Neurotischen' (1894), reprinted in Gotthard Wunberg (ed.), *Die Wiener Moderne: Literatur, Kunst und Musik zwischen 1890 und 1910*, Stuttgart 1981, pp.239–40.

41 Georg Simmel detected in the 'Social life in the city ... a great preponderance of occasions to *see* rather than to *hear* people. ... [A] reason of special significance is the development of public means of transportation.' In 'Sociology of the Senses: Visual Interaction', in Robert E. Parks, Ernest W. Burgess (eds.), *Introduction to the Science of Sociology*, second edition, Chicago 1924, p.360.

42 Hans Schmidkunz, 'Raumkunst und Traumkunst', *Der Architekt*, XIII, 1907, p.17. Walter Benjamin described the interior as 'the place of refuge for Art. The collector was the true inhabitant of the interior. He made the glorification of things his concern. To him fell the task of Sisyphus, which consisted of stripping things of their commodity character by means of his possession of them. ... The collector dreamed that he was in a world which was not far-off in distance and time, but which was also a better one, in which to be sure people were just as poorly provided with what they needed as in the world of everyday, but in which things were free from the bondage of use-value'. In 'Paris – Capital of the Nineteenth Century', in Benjamin, *Charles Baudelaire: A Lyric Poet in the Era of High Capitalism*, London, New York 1983, pp.168–9.

43 Josef August Lux, *Die Moderne Wohnung und Ihre Ausstattung*, Vienna/Leipzig 1905, p.28.

44 Lux, 'Die Erneuerung der Ornamentik', *Innen-Dekoration*, vol.XVIII, 1907, p.286.

45 Lux, *Die Moderne Wohnung und Ihre Ausstattung*, p.28.

46 Peter Altenberg, 'Werdet Einfach!', in *Fechsung*, Berlin 1915, p.218

47 Quoted in Jensen, 'Professionalism', p.217, no.34.

48 Hevesi, 'Aus dem Wiener Kunstleben', in *Kunst und Kunsthandwerk*, vol.I, 1898, pp.114–15; Zuckerkandl, 'Sezession', in *Wiener Allgemeine Zeitung*, 6 January 1904, p.3.

49 'Eine Kulturtat', *Die Fackel*, 18 November 1907, vol.9, no.236, p.9.

50 Schmidkunz, 'Raumkunst und Traumkunst', p.18.

51 Leo Popper, 'Der Kitsch', *Die Fackel*, vol.12., nos.313–14, 31 December 1910, p.40.

52 Schmidkunz, 'Raumkunst und Traumkunst', p.19.

53 Werner Hofmann, 'Das Fleisch erkennen', in Alfred Pfabigan (ed.), *Ornament und Askese im Zeitgeist des Wien der Jahrhundertwende*, Vienna 1985, p.122.

54 Jacques Le Rider, 'Narziß und das Ornament. Anmerkungen zur Literatur und Kunst um 1900 (Lou-Andreas Salomé, Gustav Klimt und Richard Beer-Hofmann)', in Cornelia Klinger and Ruthard Stäblein (eds.), *Identitätskrise und Surrogatidentitäten*. Frankfurt am Main 1989, p.209.

55 As Jenny Anger has demonstrated, at the turn of the century essential form manifested itself not necessarily in the 'high art' media of painting or sculpture but 'in the outside, adjunct *parerga*' (i.e. ornament), in our case the abstract and geometric reductionism of the architecture and design of the Wiener Werkstätte with its emphasis on ascetic form. 'Forgotten Ties: The Suppression of the Decorative in German Art and Theory, 1900–1915', in Christopher Reed (ed.), *Not at Home: The Suppression of Domesticity in Modern Art and Architecture*, London 1996, p.142.

Beatriz Colomina pp.43–51

1 Adolf Loos, 'Architecture' (1910), trans. W. Wang, in *The Architecture of Adolf Loos*, exh. cat., The Arts Council of Great Britain, London 1985, p.106.

2 Ibid.

3 'Adolf Loos über Josef Hoffmann', *Das neue Frankfurt*, February 1931 [my translation].

4 In 1894 The Austrian government had commissioned Klimt to paint three allegorical paintings for the ceiling of the University of Vienna on the themes of 'Philosophy', 'Medicine' and 'Jurisprudence'. Klimt began work around 1897 and as he completed the paintings, he exhibited them at the Secession and in other exhibitions internationally, even obtaining a gold medal for the 'Philosophy' panel at the Paris *Exposition Universelle* of 1900. In Vienna, the work was praised by some and viciously attacked by others: university professors, some members of the Parliament, journalists and the general public. Serge Sarbarsky, *Gustav Klimt*, exh. cat., Isetan Museum of Art, Tokyo 1981, no page nos. Carl Schorske has pointed to the role of the 'new anti-Semites' in the controversy, which went on for many years; see Carl E. Schorske, *Fin-de-Siècle Vienna: Politics and Culture*, New York 1980, p.227. In the spring of 1905 Klimt decided to return the fee and repossess the painting, rather than compromise his work.

5 'Dans l'afffaire Klimt, nous vîmes s'allier une bande de professeurs et de harangères du Naschmarkt don't la devise était: A bas "l'individualité".' Adolf Loos quoted in Burkhardt Rukschcio and Roland Schachel, *Adolf Loos: Leben und Werk*, Salzburg/Vienna, 1982, p.108. There is no reference for this quote. Loos' published writings do not include any reference to Klimt.

6 Karl Kraus, *Die Fackel*, no.147, 21 November 1903, p.10. Quoted in Schorske, *Fin-de-Siècle Vienna*, p.251.

7 Kraus, *Die Fackel*, no.89, December 1901, p 24. Quoted in Elenora Louis (ed.), *Secession: Permanence of an Idea*, Vienna 1997, p.119.

8 Kraus, *Die Fackel*, no.29, January 1900, p.16.

9 Hermann Bahr, *Secession, Vienna 1900*, p.2. Quoted in Werner J. Schweiger, *Wiener Werkstätte: Design in Vienna, 1903–1932*, New York 1984, p.11.

10 Loos, 'Vom armen reichen Mann', in *Neues Wiener Tagblatt*, 26 April 1900.

11 Kraus, *Die Fackel*, 13 October 1913. Quoted in Schweiger, *Wiener Werkstätte*, p.90.

12 Fredric Bedoire, *The Jewish Contribution to Modern Architecture 1830–1930*, Jersey City, New Jersey 2004, p.332.

13 Kraus, *Die Fackel*, no.41, 1900. Quoted in Rukschcio and Schachel, *Adolf Loos*, p.70.

14 Bedoire, *The Jewish Contribution to Modern Architecture*, p.332. See also Schorske, *Fin-de-Siècle Vienna*, p.227.

15 Adolf Loos, 'Die Emanzipation des Judemtums', 1900, in Adolf Loos, *Escritos I 1897/1909*, Madrid 1993, p.251. This collection of Adolf Loos's writings in two volumes is the most comprehensive to date. It is based on the first editions of all Adolf Loos's published texts, as the texts published in his collected works have been extensively altered.

16 Ibid.

17 Hugo and Lilly Steiner, Gustav Turnovsky, Dr. Otto Stoessl, Theodor Beer, Leopold Goldman, Tristan Tzara. His pupils Richard Neutra, Paul Engelmann, Josef Frank, Oskar Wlach, Frederick Kiesler. See Bedoire, *The Jewish Contribution to Modern Architecture*, pp.333–9. Loos's closeness to the Jewish milieu has made people assume that Loos himself was a Jew. He was even offered the possibility to settle in Palestine, but he declined. He wrote to his last wife, Claire Beck: 'I am an anti-Semite. All Christians should marry Jews and vice versa ... I am on my second Jewish wife.' Claire Loos, *Adolf Loos privat*, Vienna 1936, p.101. Quoted in Rukschcio and Schachel, *Adolf Loos*, p.295.

18 Loos, 'Das Wiener Weh', lecture as quoted in *Neues Wiener Journal*, 23 April 1927, and *Neues Wiener Tagblatt*, 21 April 1927. Cited in Schweiger, *Wiener Werkstätte*, p.118.

19 Schweiger, *Wiener Werkstätte*, p.120.

20 As Janet Wolff has pointed out, the literature of modernity describes the experience of men: 'The influential writings of Baudelaire, Simmel, Benjamin and, more recently, Richard Sennett and Marshall Berman, by equating the modern with the public, thus fail to describe women's experience of modernity'; see 'The Invisible Flâneuse: Women and the Literature of Modernity,' *Theory, Culture and Society*, 1985, 2 (3), pp.37–48. See also Susan Buck-Morss, 'The Flâneur, the Sandwich-Man and the Whore: The Politics of Loitering', *The New German Critique* vol. 39 (Autumn 1986), pp.99–140, where she presents the argument that the most significant female figure of modernity is the whore.

21 Loos, 'Ornament and Crime' (1908), in *The Architecture of Adolf Loos*, p.103.

22 Loos, 'Die Überflüssigen' (1908), in *Sämtliche Schriften*, I, Vienna/Munich 1962, p.269.

23 Adolf Loos, 'Ornament und Erziehung' (1924), in *Sämtliche Schriften*, I, pp.395–6.

24 Adolf Loos, 'Ornament and Crime' (1908), in *The Architecture of Adolf Loos*, p.100.

25 Adolf Loos, 'Underclothes', in Neue Freie Presse, 25 September 1898, translation in *Spoken into the Void: Collected Essays by Adolf Loos, 1897–1900*, Cambridge, Massachusetts and London 1987, p.75. The 'pre-tied ties', that Loos goes on and on about are cardboard-inset ties which Hoffmann later accused Loos of having used himself. See also 'The Leather Goods and Gold- and Silversmith Trades', *Neue Freie Presse*, 15 May 1898, translation in *Spoken into the Void*, pp.7–9.

26 Fritz Novotny and Johannes Dobai, *Gustav Klimt*, Salzburg, 1971, p.70. Cited in Schorske, *Fin-de-Siècle Vienna*.

27 Loos, *Architektur* (1909), in *The Architecture of Adolf Loos*.

28 Richard Neutra, 'Review of *Adolf Loos: Pioneer of Modern Architecture*, by L. Münz and G. Künstler', *Architectural Forum*, vol. 125, no.1, July–August 1966, p.89.

29 Quoted by Eduard F. Sekler in, *Josef Hoffmann: The Architectural Work*, Princeton, New Jersey 1985, p.11.

30 Ibid.

31 Loos, 'Die Potemkin'sche Stadt', *Ver Sacrum*, July 1898.

32 See for example, 'Eine Concurrenz der Stadt Wien', ('A Competition for the City of Vienna'), *Die Zeit*, Vienna, 6 November 1897, where Loos defends the entries of Olbrich and Hoffmann, even if he already recriminates their 'sincere "Rabitznian" architecture'. (Rabitz was the inventor of a system of construction that raised entire buildings with iron, wire netting and plaster). See also Loos, 'Ein Wiener Architekt', *Dekorative Kunst*, 1898, an article on Hoffmann in which Loos praised two of Hoffmann's buildings, even if he 'can't, in any way, agree with his furniture'; see Loos, *Escritos I*, pp.16–19 and 112–113.

33 'Unsere Jüngeren Architekten', *Ver Sacrum*, July 1898. Rainald

Franz, 'Josef Hoffmann and Adolf Loos: The Ornament Controversy in Vienna', in *Josef Hoffmann Designs*, ed. Peter Noever, New York 1992, p.12.

34 Rukschcio and Schachel, *Adolf Loos*, p.52. Adolf Loos, 'Meine Bauschule', *Der Architekt*, vol. 19, October 1913.

35 Loos, 'Meine Bauschule', *Der Architekt* vol. 19, October 1913.

36 Josef Hoffmann, undated manuscript from the 1920s, quoted in Sekler, *Josef Hoffmann*, p.232.

37 *Neues Wiener Journal*, 2, July 1927, quoted in Schweiger, *Wiener Werkstätte*, p.117.

38 Adolf Loos, 'Keramika', *Die Zukunft*, 13 February 1904. In Loos, *Escritos I*, p.311. In this article, Loos also writes about how a lady had asked him to accompany her to the Secession to give her advice, and he had recommended a 'small block of marble by Rodin', p.312.

39 Peter Behrens, 'The work of Josef Hoffmann', in *Journal of the American Institute of Architects*, October 1924, p.426.

40 See for example, Loos, 'Die Interieurs in der Rotunde' (1898), and 'Interiors in the Rotonda', *Spoken into the Void*, pp.22–7.

41 Behrens, 'The Work of Josef Hoffmann', p.421.

42 Loos, 'Heimatkunst', 1914.

43 While Loos does not refer to it directly, the Ringstrasse was predominantly inhabited by Jews and built by Jewish developers. A popular city guide referred to the Ringstrasse as 'Zionstrasse von Neu-Jerusalem … the most splendid street of the Imperial city. The palaces adorning it nearly all belong to millionaires of the chosen people; only a few belong to Christian intruders.' See Bedoire, *The Jewish Contribution to Modern Architecture*, p.321.

44 Georg Simmel, 'Zur Psychologie der Mode', *Die Zeit*, 12 October 1895; translated as 'Fashion', in *International Quarterly*, New York, October 1904, p.130–55.

45 Loos, 'Ornament and Crime' (1908), in *The Architecture of Adolf Loos*, p.103.

46 See Hubert Damisch, 'L'Autre "Ich" ou le désir du vide: pour un tombeau d'Adolf Loos', *Critique*, 'Vienne, debout d'un siècle', vol. 31, nos. 339–40, August–September 1975, p.811.

47 Karl Kraus, *Sprüche und Widersprüche*, Munich 1909, p.83.

48 Sigfried Giedion, *Space, Time and Architecture*, Cambridge, Massachusetts 1941, p. 321.

49 On the atectonic character of Hoffmann's architecture, see Eduard Sekler, 'The Stoclet House by Josef Hoffmann', in *Essays in the History of Architecture Presented to Rudolph Wittkower*, London 1967.

50 Ibid.

51 Peter Vergo, 'Between Modernism and Tradition', in *Gustav Klimt: Modernism in the Making*, ed. Colin B. Bailey, New York 2001, p.147.

52 Adolf Loos, 'The Principle of Cladding' (1898), in *Spoken into the Void*, p.66.

53 Vergo, 'Between Modernism and Tradition', p.20.

54 Jane Kallir, 'High and Low in Imperial Vienna', in *Gustav Klimt: Modernism in the Making*, p.61.

55 Benedetto Gravagnuolo, *Adolf Loos: Theory and Works*, New York 1982, p.125.

56 Vergo, 'Between Modernism and Tradition', p.161.

57 Loos married Lina Obertimpfler in 1902, when she was eighteen, twelve years younger than him. Envious of her success as an actress, he tried to discourage her from following her career. She divorced him after two years. He met his second wife, Elsie Altmann, a dancer, when she was seventeen and thirty years younger than him. His third wife, Klara-Franziska Beck, Claire, a photographer, was thirty-five years younger than him.

58 Janis Staggs, 'The Inside: A Female Realm. Abandoning the Corset to Express Individual Character', in *Josef Hoffmann Interiors*, Christian Witt-Dörring (ed.), New York/Munich 2006, p.106.

59 Elsie Altmann-Loos, *Adolf Loos: Der Mensch*, Vienna/Munich 1968, p.154. Quoted in Rukschcio and Schachel, *Adolf Loos*, p.305.

Elizabeth Clegg pp.53–7

I am most grateful to Gunnel Lindelöv in Stockholm and to Patrick Kragelund in Copenhagen for their generous assistance in my longer-term research into the touring 'peace propaganda' exhibition of 1917–18, which is discussed at the end of this essay.

1 Chief among these were the bureaucrats of the Ministry of Religion and Education (Ministerium für Cultus und Unterricht). This functioned, in its 'educational' capacity, as what would now be understood as a Ministry of Culture for the Austrian half of the Dual Monarchy (Hungary possessing its own, equivalent Minisztérium). Numerous state-sponsored or state-supported cultural ventures of the period 1900–18 also came under the auspices of further official bodies, such as those overseeing diplomacy or international trade or, in the years 1914–18, war-related propaganda.

2 According to the figures established by what was to prove the last census in Austria-Hungary, carried out in 1910, the population of its Austrian half was then approximately 28,572,000 (out of an approximate total of 51,390,000 for the Dual Monarchy as a whole). This

Austrian half was made up of the following percentages of recognised (linguistically differentiated) 'nationalities': Austro-Germans 35.6%; Czechs, Slovaks, Poles and Ruthenes (the 'Northern Slavs') 53.4%; Serbs, Croats and Slovenes (the 'Southern Slavs') 7.3%; Italians 2.7%; Romanians 1.0%. Within the population of the Hungarian half of the Dual Monarchy those registered as 'Magyar' at this date accounted for around 48.1%. Figures as cited in Robert A. Kann, *The Multi-National Empire: Nationalism and National Reform in the Habsburg Monarchy 1848–1918*, New York 1950, II, pp.300, 302, 305.

3 Greater attention is paid here to the reception of the Stockholm/Copenhagen show because this has largely been ignored by art historians.

4 Respectively: Vereinigung bildender Künstler Österreichs (Secession); Spolek Výtvarných Umělců Mánes (named after the mid-nineteenth-century Czech-Bohemian painter and illustrator Josef Mánes, and in existence as a non-exhibiting society by the late 1880s); and Towarzystwo Artystów Polskich Sztuka ('sztuka' meaning 'art').

5 Respectively: Genossenschaft bildender Künstler Wiens (Vienna); Kunstverein für Böhmen / Krasoumná Jednota (Prague); and Towarzystwo Przyjaciół Sztuk Pięknych (Cracow).

6 See *Exposition Universelle Internationale de 1900 à Paris. Catalogue des Sections Autrichiennes*, Vienna 1900, II: *Groupe II: Oeuvres d'art*, pp.43–51 ('Association des artistes viennois'), pp.57–9 ('Association des artistes autrichiens "Secession"'), pp.51–5 ('Groupe des artistes autrichiens habitant Paris'). This last category included the Czech-Moravian Alfons Mucha (also a member of the Viennese Secession) and the Czech-Bohemian František Kupka, resident in Paris since 1888 and 1895, respectively. Mucha moved to the United States in 1904, returning to Bohemia/Moravia in 1909. Kupka remained in Paris throughout the rest of his career.

7 See *Exposition Universelle Internationale de 1900 à Paris*, pp.62–7 ('Artistes bohèmes'), pp.60–2 ('Artistes polonais'). Though widely regretted, this perceived 'relegation' of Czechs and Poles did not result in a notably lower success rate than that of the other three groups in terms of prizes and medals awarded to Austria in the four categories of Beaux-Arts. See K. K. Österreichischen General-Commissariate (eds.), *Berichte über die Weltausstellung in Paris 1900*, Vienna 1902, II, supplement, pp.8–13.

8 Visible in fig. 31 are, from left to right: Max Kurzweil, *Guéri* (cat. no.9, *Restored to Health*), Józef Mehoffer, *La Chanteuse* (cat. no.8, *The Singer*), Gustav Klimt, *Pallas-Athénée* (cat. no.7; ND 93), Edmund Hellmer, *Portrait* (cat. no.6, depicting his pupil the sculptor Teresa Feodorowna Ries), and Gustav Klimt, *La Philosophie* (cat. no.5; ND 105). Among the other twelve exhibits

included in this room was Klimt's *Portrait* (cat. no.2; ND 91, depicting Sonja Knips).

9 The recognised importance of this aspect of Hoffmann's arrangement is suggested by the detail provided in the extended captions to the photographic record collectively titled 'Ausstellung der Vereinigung in Paris', in *Ver Sacrum*, vol. 3, 1900, pp.287–90.

10 Even in superficial or largely negative commentary on the Austrian display at the Grand Palais these two works occasioned positive remarks. See, for example, Léonce Bénédite, 'L'Exposition Décennale: La Peinture Étrangère', *Gazette des Beaux-Arts*, 3rd series, vol.24, no.522, 1 December 1900, pp.577–92, here p.591. Mehoffer's *Singer*, painted in 1896, had been included in the first exhibition mounted by the Viennese Secession, in March–June 1898 (as cat. no.41, *Portrait*), and can be securely identified through its reproduction in *Ver Sacrum*, vol.1, nos.5–6, May–June 1898, p.23. In Paris it won a gold medal (one of three awarded to Austria for painting). It is now in the L'vivs'ka Halereya Mystetstv, L'viv.

11 Franz Servaes, 'Die österreichischen Installationen', in K. K. Österreichischen General-Commissariate (eds.), *Berichte über die Weltausstellung in Paris 1900*, II, pp.72–9, this phrase on p.78. Evidence of prowess in installation design being identified with 'Austrian Art' in its entirety is to be found in British responses to the Fine Arts section of the *Imperial Royal Austrian Exhibition* at Earl's Court, London, in the summer of 1906. See, for example, anon., 'Art Exhibitions at Earl's Court', *Observer*, no.6000, 20 May 1906, p.7; and anon. 'Art Exhibitions', *The Times*, no.38037, 4 June 1906, p.12.

12 *Esposizione Internazionale di Roma. Mostra di Belle Arti*, Bergamo 1911, pp.114–45: 'Padiglione dell'Austria'. While 'large' for an international exhibition of 'Austrian Art', with 392 catalogued items, the display was in fact not so by the standards of this event. Those presented, for example, by Hungary, Germany, France, Russia and Great Britain (with, respectively, 604, 611, 554, 502 and 1221 exhibits) were all larger.

13 This had culminated in the erection, in 1909, of a separate Hungarian pavilion (an emphatically Magyarising design by Géza Maróti and only the second national pavilion to be added to the exhibition grounds) and in the strong representation of Austria, the following year, in the form of a widely remarked Czech and Polish display and a large one-man show by Klimt. See *IX. Esposizione Internazionale d'Arte della Città di Venezia 1910. Catalogo*, Venice 1910, pp.58–60: 'Sala 10. Mostra individuale di Gustav Klimt', cat. nos.1–22; pp.85–8: 'Sala dell'arte Czeco-Polacca', cat. nos.1–39. For an appreciative account of both, see Vittorio Pica, 'L'Arte Mondiale alla IX. Esposizione di Venezia, IV',

Emporium, vol.32, no.192, December 1910, pp.451–66.

14 The Hagenbund, led at this time by Josef Urban, mounted an exhibition to mark the occasion comprising work by its own members and by those of Mánes and of Sztuka. All three groups had featured prominently in the London exhibition of 1906 (as in note 11), and the Hagenbund and Mánes had also shared a large room at the 1907 Venice *Biennale*.

15 See 'Gustav Klimts Rede bei der Eröffnung der Ausstellung', in *Katalog der Kunstschau*, Vienna 1908, pp.2–5, this passage on p. 4. See also pp.59–60 for Klimt's own display, of sixteen paintings, in Room 22.

16 For Metzner at the *Kunstschau*, see *Katalog der Kunstschau*, pp.15–18, Rooms 6–7. Metzner had already been promoted internationally as the 'greatest hope' of contemporary Austrian sculpture in the volume published to coincide with the London exhibition of 1906. See Hugo Haberfeld, 'Modern Plastic Work in Austria', *The Art-Revival in Austria*, special issue of *The Studio*, Spring 1906, pp.Bi–Bviii, here Bviii.

17 Hanak's *Creative Force of Austria*, comprising a seated male giant and smaller standing male and female nudes, was joined in Rome by two of his earlier female allegories, *Uplift* and *Prayer* (both visible in fig.32), here conveniently reinterpreted as allusions to *Morning* (east) and *Evening* (west). On Hoffmann's 'purely functional' and 'unostentatious' pavilion design, see Kurt Rathe, 'Österreich auf der Internationalen Kunstausstellung in Rom 1911', *Die Kunst für Alle*, vol.27, no.4, 15 November 1911, pp.77–88, here p.77. The 'Austria' pavilion was acclaimed as a 'model' for all those engaged in devising and building exhibition and museum galleries in Vittorio Pica, *L'Arte Mondiale a Roma nel 1911*, Bergamo 1913, II, pp.civ–cxii, here p.civ.

18 In addition to one-man shows by Klimt at the 1908 Viennese *Kunstschau* (as in note 15) and at the 1910 Venice *Biennale* (as in note 13), there had also been a smaller individual exhibition at the 1909 Viennese *Internationale Kunstschau*. In Rome Klimt showed three unidentified drawings (cat. nos.105, 107 and 119) in addition to the following paintings: *Le sorelle* (cat. no.102; ND 139, *Water Serpents I*), *La paura della morte* (cat. no.106; ND 183, *Death and Life*), *Paesaggio* (cat. no.109; ND 165, *The Park*), *Ritt. Signora Wittgenstein* (cat. no.110; ND 142, *Portrait of Margaret Stonborough-Wittgenstein*), *La giustizia* (cat. no.112; ND 128, *Jurisprudence*), *Ritratto* (cat. no.114; ND 126, *Portrait of Emile Flöge*), *Paesaggio* (cat. no.115; ND 166, *Schloss Kammer on the Attersee II*), *Vecchia* (cat. no.117; ND 141, *The Three Ages of Woman*), and *Il baccio* (cat. no.118; ND 154, *The Kiss*). See *Esposizione Internzaionale di Roma*, pp.124–5.

19 Klimt was awarded a gold medal, the Rome exhibition's supreme accolade, for *The Three Ages of Woman*, subsequently acquired by the city's Galleria (later Galleria Nazionale) d'Arte Moderna.

20 See, respectively: *Liljevalchs Konsthall Katalog No. 8: Österrikiska Konstutställningen. September 1917*, Stockholm 1917; and *Den Frie Udstilling: Østrigsk Kunstudstilling (Maleri – Plastik – Kunstgenstande) December 1917 – Januar 1918*, Copenhagen 1917. Scholars have in the past erroneously confused this exhibition with the quite different one shown in Amsterdam and The Hague in autumn 1917 as *Oostenrijksche en Hongaarsche Schilders en Beeldhouwers (Austrian and Hungarian Painters and Sculptors)*.

21 Karl I was the great nephew of Franz Joseph, who had been predeceased by no fewer than three designated heirs. The Österreichisches Komitee für Edelarbeit, formed in early 1917 to oversee 'peace propaganda', had effectively ceased operations by the spring of 1918 when Karl had been called to account to Germany for his parallel secret diplomatic intrigues towards the same end. The exhibition organised by Carl Moll and opening at the Kunsthaus Zürich in early May 1918, as *Ein Jahrhundert Wiener Malerei (A Century of Viennese Painting)*, thus had a localised and ostensibly historical focus, though in fact also managing to embrace some superb recent work, and rather less of a hidden agenda.

22 The touring presentation by around a dozen Viennese fashion houses had visited Copenhagen before arriving in Stockholm.

23 Other advertisements were designed by Wieselthier's colleague, and fellow ceramicist, Anny Schröder. A further design by Schröder was used as a cover for the Copenhagen catalogue. The popularity of the show's applied arts section in Copenhagen (where it became a welcome additional source of Christmas and New Year gifts) is affirmed in –dan, 'Den øgstrigske Udstilling', *Politiken*, vol.83, no.354, 20 December 1917, p.9. The Wiener Werkstätte was simultaneously mounting its own *Weihnachts-ausstellung (Christmas Exhibition)* in Vienna. Informed coverage of the applied arts section of the *Austrian Art Exhibition* in the Stockholm press can be found in K.A., 'Strövtåg på den österrikiska Kunstutställningen', *Dagens Nyheter*, no.261, 27 September 1917, p. 13, which notes the important Wiener Werkstätte contribution.

24 A number of commentators, among them the author of the most compelling critical response to the show, took issue with this non-committal stance. See Andreas Lindblom, 'Gustav Klimt och Egon Schiele', *Stockholms Dagblad*, no.261, 27 September 1917, p.7, who singles out these two artists as exceptional.

25 On Hanslik in Stockholm, see anon., 'En österrikisk vecka i Stockholm. Österrikisk konst hos Liljevalchs', *Dagens Nyheter*, no.239, 5 September 1917, p.8; and anon., 'Den österrikiska konstutställningen. Centraleuropa i verksamhet hos Liljevalchs', *Svenska Dagbladet*, no.239, 5 September 1917, p.8. Hanslik's arguments, as expressed in his publications of this period such as the 1917 volume *Österreich. Erde und Geist*, were an idiosyncratic elaboration on long established patterns of Austro-German thinking about Austria, given added urgency by the advent of war and most famously summarised by Hugo von Hofmannsthal in 'La vocation de l'Autriche', *La Revue d'Autriche*, vol.1, no.1, 15 November 1917, pp.8–9; also published as 'Die österreichische Idee', *Neue Zürcher Zeitung*, 138, no. 2273, 3rd Sunday edn., 2 December 1917, p.1.

26 On Egger-Lienz: A.B–s., 'Österrikiska Konstutställningen. En första öfverblick', *Svenska Dagbladet*, no.243, 9 September 1917, p.11. On Faistauer: Knut Barr, 'Den österrikiska Konsten i Konsthallen', *Stockholms-Tidningen*, no.242, 8 September 1917, p.5.

27 See anon, 'Österrikarna ha vernissage', *Dagens Nyheter*, no.243, 9 September 1917, p.7; and anon., 'Den øgstrigske Kunstudstilling', *København*, no.354, 20 December 1917, pp. 6–7, here p.7.

28 See, respectively, A.B–s., 1917, p. 11, where Schiele's 'fantastical obsession with death' is compared to that of Einar Nielsen; and Andreas Lindblom, 'Österrikarna i Konsthallen', *Stockholms Dagblad*, no.243, 9 September 1917, p.8.

29 According to the Stockholm catalogue (*Liljevalchs Konsthall Katalog No. 8: Österrikiska Konstutställningen. September 1917*), p.15, and the photographic record preserved in the archives of the Liljevalchs Konsthall, Klimt here exhibited: *Porträtt av en ung flicka* (cat. no.97; ND 179, *Portrait of Mäda Primavesi*), *Porträtt, Fröken B* (cat. no.98; ND 196, *Portrait of Friederike Maria Beer*), *Kärlek od Död* (cat. no.99; ND 183, *Death and Life*, given in the Swedish as 'Love and Death'); *Landskap I* (cat. no.100; ND 165 *The Park*), *Landskap II* (cat. no.101; ND 182, *Forester's House at Weissenbach on the Attersee*), *Landskap III* (cat. no.102; ND 198, *Church at Unterach on the Attersee*), *Landskap IV* (cat. no.103; ND 214, *Italian Garden Landscape*), *Porträtt fru L.* (cat. no.104; ND 188, *Portrait of Elisabeth Lederer*), *Leda* (cat. no.105; ND 202, *Leda*), *Barn* (cat. no.106; ND 221, *Baby*), *Blondin* (cat. no.107; ND 197, *The Fur Collar*), *Illerpäls* (cat. no.108; ND 206, *The Polecat Fur*), *Porträtt* (cat. no.109; ND 191, *Portrait of Barbara Flöge*), and *20 teckningar* (cat. no.110; twenty unidentified drawings). According to the Copenhagen catalogue (*Den Frie Udstilling: Østrigsk Kunstudstilling*, 1917–18), p.8, five of the paintings were shown at this second venue: Stockholm cat. nos.99, 105 and 108 and two of the four landscapes 100–103. These were, respectively, Copenhagen cat. no.34 *Kaerlighed od Død* (as in Stockholm, titled 'Love and Death'), cat.35

Leda, cat. no.37 *Ilderpels*, cat. no.36 *Landskab*, and cat. no.38 *Landskab*.

30 See anon., 'Österrikarna ha vernissage', 1917, p.7, detecting 'symbolic motifs' in the 'bizarre' backgrounds; and anon., 'Den østrigske Kunstudstilling', 1917, p.6, with praise for the 'wonderfully refined treatment of colour' in *The Polecat Fur*.

Eva Winkler pp.80–5

1 Hevesi reports that the time leading up to the delayed completion of the Klinger sculpture – which had originally been planned for November 1901 – had to be filled with two exhibitions, the twelfth and the thirteenth. (Ludwig Hevesi, 'Aus dem Wiener Kunstleben', in *Kunst und Kunsthandwerk*, vol.5, 1902, p.190).

2 Ernst Stöhr, 'Unsere XIV. Ausstellung', in *Max Klinger Beethoven. XIV. Ausstellung der Vereinigung Bildender Künstler Österreichs*, exh. cat., Secession, Vienna 1902, pp.9–12.

3 'This concerted interplay of all the visual arts corresponds to what Wagner was striving for and attained in his music dramas', as Klinger says in the excerpts of his text 'Malerei und Zeichnung', published in *Max Klinger Beethoven*, p.20. The full text has been translated into English by Fiona Elliott and Christopher Croft as *Max Klinger, Painting and Drawing*, Birmingham 2005, here p.16.

4 For the exhibition layout and the names of the rooms, see *Max Klinger Beethoven*, pp.4, 25, 39, 47, 64, 68.

5 Ibid, p.25.

6 For details see ibid, pp.25–6.

7 Marian Bisanz-Prakken, *Der Beethovenfries. Geschichte, Funktion und Bedeutung*, Salzburg 1977, which is still the standard work on the *Beethoven Frieze*. That Wagner's influence is evident in the programme of the frieze has long been accepted in the literature on this work. The main source of this assumption is the renaming of the last section of the frieze at Klimt's one man show of 1903, where the lines 'Freude, schöner Götterfunke' 'Diesen Kuß der ganzen Welt!' were replaced by the quote from the Bible 'Mein Reich ist nicht von dieser Welt' ['My kingdom is not of this world'], which plays a key role in Wagner's 1870 essay on Beethoven. See Johannes Dobai, 'Gustav Klimts Gemälde "Der Kuß"', in *Mitteilungen der Österreichischen Galerie*, vol.12, 1968, no.56, p.108; see also Bisanz-Prakken, *Der Beethovenfries*, pp.32–4.

8 Richard Wagner, 'Bericht über die Aufführung der neunten Symphonie von Beethoven im Jahre 1846 in Dresden (aus meinen Lebenserinnerungen ausgezogen) nebst Programm dazu', in *Gesammelte Schriften und Dichtungen von Richard Wagner*, vol.II, 3rd edn., Leipzig 1904 (1st edn. 1871), pp.56–63.

9 Ibid., pp.50–1, 56–7.

10 Ibid., p.57.

11 Ibid., pp.58–9.

12 The 'human voice with the clear, certain eloquence of language meets the tumult of the instruments ... And with these words light enters chaos', ibid., pp.61–2.

13 With grateful thanks to Michaela Seiser for this information.

14 At the fourteenth exhibition, clause 17 of the Secession Statutes comes into force, whereby the working committee was able delegate the organisation of the summer exhibition to a smaller group, in this case led by Alfred Roller. For more on the Statutes, see *I. Ausstellung der Vereinigung Bildender Künstler Österreichs*, exh. cat. Gartenbaugesellschaft, Vienna 1898, pp.3–22; for more on clause 17, see ibid., p.21; for more on the organisation committee for the fourteenth exhibition see *Max Klinger Beethoven*, p.73; Roller's role is discussed in Bisanz-Prakken, *Der Beethovenfries*, pp.19–20.

15 Letter from Alfred Roller to Max von Morold (pseudonym of Max von Millenkovich), 5 April 1898, Handschriftensammlung der Stadt Wien, I. N. 74.852, as cited in Marian Bisanz-Prakken, *Heiliger Frühling. Gustav Klimt und die Anfänge der Wiener Secession 1895–1905*, Vienna/Munich 1999, p.15. On Roller's position in the early days see ibid., p.15.

16 Compare this to the role of *Ver Sacrum*, as a vehicle for mediating the art and programme of the Secession, which reached a turning point in 1900, in Bisanz-Prakken, *Heiliger Frühling*, pp.13–19, 97–9, 109–111.

17 See Marian Bisanz-Prakken, 'Der Beethovenfries von Gustav Klimt in der XIV. Ausstellung der Wiener Secession (1902)', in *Traum und Wirklichkeit. Wien 1870–1930*, exh. cat. Historisches Museum der Stadt Wien, Vienna 1985, p. 28. At the opening of the exhibition Mahler conducted a theme from the Ninth Symphony specially arranged for trombones. Ludwig Hevesi, *Acht Jahre Sezession (März 1897–Juni 1905) Kritik–Polemik–Chronik*, Klagenfurt 1984 (1st edn. Vienna 1906), p.383.

18 See Ferdinand Andri's *Mannesmut und Kampfesfreude*, and *Gesammelte Schriften und Dichtungen von Richard Wagner*, pp.62–3.

19 Among the twenty-one artists in the collective there was just one woman, Elena Luksch – married to Richard Luksch – although she does not appear on the frequently published group photograph (reproduced in Christian Michael Nebehay, *Gustav Klimt: Dokumentation*, Vienna 1969, p.281, fig.390). See *Max Klinger Beethoven*, p.75.

20 Koller and Bisanz-Prakken, writing independently, were the first to point out the pragmatic nature of this technique. During his time at the Wiener Kunstgewerbeschule Klimt received a thorough training in historical wall-painting techniques and was able to draw on this when it came to realising the *Beethoven Frieze*. Manfred Koller, 'Klimts Beethovenfries. Zur Technologie und Erhaltung', in *Mitteilungen der Österreichischen Galerie*, vols. 66/67; *Klimt-Studien*, vol.22/23 (1978/9), p.218; see also Marian Bisanz-Prakken, 'Gustav Klimt und die "Stilkunst" Jan Toorops', in ibid., p.198.

21 See Ludwig Hevesi, *Acht Jahre Sezession*, p.392, in his chronicle of the Secession: 'If it [the *Beethoven Frieze*], like the rest of the exhibition, is really only intended to serve the present Beethoven purpose and then be destroyed, Austrian art would suffer a severe loss. A masterpiece would go up in smoke on the altar to Beethoven.'

22 *Max Klinger Beethoven*, p.77, see Marian Bisanz-Prakken, *Traum und Wirklichkeit*, p.542, footnote 5.

23 In a manuscript, parts of which were published by Nebehay in 1987 and which is now owned by the Lederer family, Erich Lederer recounts the story of the purchase by Carl Reinighaus: 'The day after the exhibition closed, Carl Reinighaus came to the Secession to see the frieze one last time. When he saw workmen with pickaxes ["tools", added above the line] he asked in horror what was happening and the secretary answered that the exhibition was finished and now the frieze was to be broken up; Reinighaus was outraged and declared that something so splendid and unique ["the sensation of the exhibition", added above the line] could not ["simply", added] be destroyed and several days and many discussions later the frieze became the property of Carl Reinighaus.' See Christian M. Nebehay, *Gustav Klimt, Egon Schiele und die Familie Lederer*, Bern 1987, pp.38–9, and Tobias G. Natter, *Die Welt von Klimt, Schiele und Kokoschka. Sammler und Mäzene*, Cologne 2003, p.167.

24 It is also clear from a note in the 1903 catalogue that 'parts of Room III in the fourteenth exhibition have survived intact', *Kollektiv-Ausstellung Gustav Klimt. XVIII. Ausstellung der Vereinigung Bildender Künstler Österreichs*, exh. cat. Secession, Vienna 1903, p.11.

25 See Nebehay, *Gustav Klimt: Dokumentation*, p.39; see also Stephan Koja, ' ... just about the nastiest women I have ever seen ... ', in *Creative Destruction. Gustav Klimt. The Beethoven Frieze and the Controversy over the Freedom of Art*, exh. cat. Fondación Juan March, Madrid/Munich 2006/07, p.102; see also Manfred Koller, 'The technique and conservation of the Beethoven

Frieze', in ibid., p.164.

26 Weixlgärtner (Apard Weixlgärtner, 'Gustav Klimt', in *Die Graphischen Künste*, vol. 35, 1912, p.55) regrets the circumstances of the work's storage in the single-storey repository in Michelbeuern, where the frieze was 'starting to crumble at the base' because of the vibrations of passing trams.

27 For more on the purchase date, see Theodor Brückler (ed.), *Kunstraub, Kunstbergung und Restitution in Österreich 1938 bis heute*, Vienna 1999, pp.244, 252, as cited in Koller, *Creative Destruction*, p.164; Egon Schiele mediated between Carl Reinighaus and the Lederer family. The receipt acknowledging payment on 6 February 1918, by Reinighaus to Schiele, of the final amount due, has survived: as note 19, no.1377.

28 See Nebehay, *Gustav Klimt: Dokumentation*, p.40.

29 Carl Moll, 'I', in *Ausstellung von Erwerbungen und Widmungen zu Gunsten der öffentlichen Sammlungen 1912–1936 sowie von Kunstwerken aus Privatbesitz*, exh. cat. Secession, Vienna 1936, pp.7–8, cat. no.1. Nebehay, *Gustav Klimt: Dokumentation*, pp.40–1, does not mention this exhibition.

30 This exhibition to mark Klimt's eightieth birthday in 1942 took place from 7 February–7 March 1943. On display were *Die Sehnsucht nach Glück* (no.39) and *Mein Reich ist nicht von dieser Welt* (no.46). *Gustav Klimt-Ausstellung*, exh. cat. Ausstellungshaus Friedrichstraße, formerly Secession, Vienna 1943, unpaginated.

31 See Nebehay, *Gustav Klimt: Dokumentation*, p.41.

Paul Asenbaum pp.170–2

1 I should like to express my sincere gratitude to the following for all their help with my research for this text: Pierre and Françoise Stonborough for visual materials and useful information; Elisabeth Schmuttermeier for all her help with my research in the Archive of the Wiener Werkstätte; Ernst Ploil for factual information; Peter and Isabella Frick for finalising the text.

2 During the first two years of the existence of the Wiener Werkstätte alone, the Wittgensteins, their relatives and family members by marriage bought 'around 224 silver and silver-plated items for a whole number of town houses, apartments, villas and country residences', see Michael Huey, 'Das ästhetisierte Individuum', in Renée Price and Wilfried Seipel (eds), *Wiener Silber – Modernes Design 1780–1918*, Ostfildern-Ruit, 2003, p. 334

3 Theodor Ritter von Taussig (1849–1909), Governor of the Bodencreditanstalt, President of the Austro-Hungarian Railway Company and Member of the Board of the Wiener Kultusgemeinde.

4 Karl Kraus, *Die Fackel*, vol. 17, 1899.

5 Tobias G. Natter, *Die Welt von Klimt, Schiele und Kokoschka. Sammler und Mäzene*, Cologne, 2003, pp. 42–43.

6 Ursula Prokop, *Margaret Stonborough-Wittgenstein*, Vienna, 2003, p. 25

7 Hermine (1874–1949), Hans (1877–1902), Kurt (1878–1918), Helene (1879–1956), Rudi (1881–1904), Margarethe (1882–1958), Paul (1887–1961), Ludwig (1889–1951).

8 Natter, *Die Welt von Klimt, Schiele und Kokoschka*, pp. 48 ff.

9 Thomas Zaunschirm, *Gustav Klimt – Margarethe Stonborough Wittgenstein*, Frankfurt am Main, 1987, pp. 11 ff.

10 Tea pot, S 378; coffee pot, S 386; cream jug, S 390; small tea pot, S 497.

11 See illustration in Peter Noever, *Preis der Schönheit: 100 Jahre Wiener Werkstätte*, Ostfildern-Ruit, 2003, p. 36.

12 The raised 'knop decoration' shown in the design sketch on the lid of the tea pot but not realised on the finished article harks back to a formal vocabulary that Hoffmann had already used in 1903.

13 *Deutsche Kunst und Dekoration*, vol. 16, 1905, p. 544.

14 The sugar bowl (S 391), also listed with the name 'Gretl Wittgenstein/ Kupelwieser', was made on 8 February 1905. In the volume WWMB – S 4, there is also another entry for 10 August 1905 for a small tea pot (S 497) and on 17 December 1905 for a samovar (S 637) – both ordered and/or purchased by Margaret's mother 'Poldy' (Leopoldine) Wittgenstein.

15 The wedding took place in Vienna in the Evangelical Church in Dorotheergasse.

16 Karl Kupelwieser (1841–1925) married Karl Wittgenstein's sister Bertha. His brother Paul Kupelwieser (1843–1919) was a close business associate of Karl Wittgenstein and together the two founded what was to become an iron-and-steel manufacturing empire.

17 Letter from Margaret Stonborough-Wittgenstein to her mother on 18 April 1905, as cited in Prokop, *Margaret Stonborough-Wittgenstein*, 2003, p. 56.

18 Margarethe von Rémy-Berzenkovich, née Hellmann, was the sister-in-law of Fritz Waerndorfer, one of the co-founders of the Wiener Werkstätte.

19 Although Margaret was an American citizen through her marriage to Jerome Stonborough, she was stripped of her Austrian properties.

Chronology pp.233–5

1 *Neue Freie Presse*, 12 November 1898.

2 Carl E. Schorske, *Geist und Gesellschaft im Fin de Siècle*, Frankfurt am Main 1982, p.195.

3 Ludwig Hevesi, *Acht Jahre Sezession. Kritik-Polenik-Chronik*, Vienna 1908.

4 Berta Zuckerkandl, 'Die Klimt-Affäre', in *Wiener Allgemeine Zeitung*, 12 April 1905.

5 Berta Zuckerkandl, 'Als die Klimtgruppe sich selbständig machte', in *Neues Wiener Journal*, 10 April 1927.

6 Ida Foges, 'Klimt. Persönliche Erinnerungen Egon Schieles', in *Wiener Journal*, 4 March 1918.

7 This letter is privately owned in Vienna. For more on this see Tobias G. Natter, *Die Welt von Klimt, Schiele und Kokoschka. Sammler und Mäzene*, Cologne 2003, p. 122 and illustration p. 126.

8 Foges, 'Klimt. Persönliche Erinnerungen Egon Schieles'.

Select Bibliography

Le arti a Vienna dalla secessione alla caduta dell'impero Asburgico, exh. cat., Palazzo Grassi, Venice, 1984

Hermann Bahr, *Gegen Klimt: Historisches. Philosophie, Medizin, Goldfische, Fries*, Vienna, Leipzig 1903

– *Prophet der Moderne. Tagebücher 1888–1904*, Vienna 1987

– *Secession*, Vienna 1900, reprinted Weimar 2007

Colin B. Bailey (ed.), *Gustav Klimt: Modernism in the Making*, exh. cat., National Gallery of Canada, Ottawa/New York 2001

Daniele Baroni, Antonio d'Auria, *Josef Hoffmann e la Wiener Werkstätte*, Milan 1981

François Baudot, *Vienna 1900: The Viennese Secession*, New York 2006

Edwin Becker, Sabine Grabner (eds.), *Wien 1900: Der Blick nach innen*, exh. cat., Van Gogh Museum, Amsterdam and Von-der-Heydt-Museum, Wuppertal/Zwolle 1997

Steven Beller (ed.), *Rethinking Vienna 1900*, New York and Oxford 2001

Hans Bisanz (ed.), *Emilie Flöge und Gustav Klimt: Doppelporträt in Ideallandschaft*, exh. cat., Historisches Museum der Stadt Wien, Vienna 1988

Hans Bisanz and Robert Waissenberger (eds.), *Ver Sacrum: Die Zeitschrift der Wiener Secession, 1898–1903*, exh. cat., Historisches Museum der Stadt Wien, Vienna 1982

Marian Bisanz-Prakken, *Der Beethovenfries: Geschichte, Funktion und Bedeutung*, Salzburg 1977

– *Heiliger Frühling: Gustav Klimt und die Anfänge der Wiener Secession 1895–1905*, exh. cat., Graphische Sammlung Albertina, Vienna 1998

– *Toorop/Klimt – Toorop in Wenen: inspiratie voor Klimt*, exh. cat., Gemeentemuseum, The Hague/Zwolle 2006

Franco Borsi, *Vienna 1900: Architecture and Design*, New York 1986

Iaroslava Boubnova et al. (eds.), *Vienna Secession: 1898–1998*, Munich 1998

Jean-Paul Bouillon, *Klimt: Beethoven—The Frieze for the Ninth Symphony*, Geneva 1986

Christian Brandstätter, *Klimt and Fashion*, New York 2003

– *Wonderful Wiener Werkstätte 1903–1932*, London 2003

– (ed.), *Vienna 1900 and the Heroes of Modernism*, London 2005

Otto Breicha (ed.), *Gustav Klimt: Die Golden Pforte. Werk—Wesen—Wirkung. Bilder und Schriften zu Leben und Werk*, Salzburg 1978

Emil Brix, Patrick Werkner (eds.), *Die Wiener Moderne*, Munich 1990

Markus Brüderlin (ed.), *Ornament and Abstraction*, exh. cat., Fondation Beyeler, Riehen, Basel/Cologne 2001

Michael Buhrs et al. (eds.), *Kabarett Fledermaus 1907 bis 1913: Ein Gesamtkunstwerk der Wiener Werkstätte. Literatur, Musik, Tanz*, exh. cat., Österreichisches Theatermuseum, Vienna 2007

Jean Clair (ed.), *Vienne, 1880–1938: l'Apocalypse joyeuse*, exh. cat., Centre Georges Pompidou, Paris 1986

– *Le nu et la norme. Klimt et Picasso en 1907*, Paris 1988

Elizabeth Clegg, *Art, Design and Architecture in Central Europe 1890–1920*, New Haven, Connecticut and London 2006

Alessandra Comini, *Gustav Klimt*, London 1975

Patricia A. Cunningham, *Reforming Women's Fashion, 1850–1920: Politics, Health, and Art*, Kent, Ohio 2003

Christine Dixon, *Secession: Modern Art and Design in Austria and Germany 1890s-1920s*, exh., cat., National Gallery of Australia, Canberra, 2002

Johannes Dobai, *Gustav Klimt: Landscapes*, London, 1988

Hanna Egger, *Ein moderner Nachmittag: Margaret Macdonald Mackintosh und der Salon Waerndorfer in Wien*, Vienna 2000

Max Eisler, *Gustav Klimt*, Vienna 1920

Gabriele Fahr-Becker, *Wiener Werkstätte 1903–1932*, Cologne 1994

Werner Fenz, *Kolo Moser: Internationaler Jugendstil und Wiener Secession*, Salzburg 1976

María Ocón Fernández, *Ornament und Moderne. Theoriebildung und Ornamentdebatte im deutschen Architekturdiskurs (1850-1930)*, Berlin 2004

Wolfgang Georg Fischer, *Gustav Klimt und Emilie Flöge: An Artist and his Muse*, Woodstock, New York 1992

Gottfried Fliedl, *Gustav Klimt 1862–1918: The World in Female Form*, Cologne, 1997

Sabine Forsthuber, *Moderne Raumkunst: Wiener Ausstellungs-bauten von 1889 bis 1914*, Vienna 1991

Gerbert Frodl, *Klimt*, London 1992

Jean Galard, Julian Zugazagoitia (eds.), et al., *L'Oeuvre d'art totale*, Paris 2003

Benedetto Gravagnuolo, *Adolf Loos: Theory and Works*, New York 1982

Delano Greenidge, *Josef Hoffmann: Furniture, Design and Objects*, New York 2003

Susanne Häni et al., (eds.), *Der Hang zum Gesamtkunstwerk: Europäische Utopien seit 1800*, exh. cat., Kunsthaus Zürich/Aarau and Frankfurt am Main 1983

Ludwig Hevesi, *Acht Jahre Sezession (März 1897–Juni 1905). Kritik— Polemik—Chronik*, Vienna 1906; reprinted Klagenfurt 1984

– *Altkunst—Neukunst: Wien 1894–1908*, Vienna, 1909; reprinted Klagenfurt 1986

Werner Hofmann, *Gustav Klimt*, London 1972

– (ed.), *Experiment Weltunter-gang: Wien um 1900*, exh. cat., Hamburger Kunsthalle/ Munich 1981

Allan Janik and Stephen Toulmin, *Wittgenstein's Vienna*, New York 1973

William M. Johnston, *The Austrian Mind: An Intellectual and Social History 1848-1938*, Berkeley, California 1983

Josef Hoffmann: Architect and Designer, exh. cat., Galerie Metropol, Vienna and New York 1981

Jane Kallir, *Viennese Design and the Wiener Werkstätte*, New York 1986

Claudia Klein-Primavesi, *The Primavesi Family and the Wiener Werkstätte: Josef Hoffmann and Gustav Klimt as Friends and Artists*, Vienna 2006

Klimt & Vienna: Drawings by Gustav Klimt. Glass, Textiles, Furniture and Designs of the Wiener Werk-stätte, Fischer Fine Art, London 1989

Stephan Koja (ed.), *Gustav Klimt: Landscapes*, Munich 2006

– (ed.), *Gustav Klimt: The Beethoven Frieze and the Controversy over the Freedom of Art*, Munich 2007

Susanne Koppensteiner (ed.), *Gustav Klimt: Beethovenfries*, Vienna 2002

– (ed.), *Secession: Die Architektur*, Vienna 2003

Markus Kristan (ed.), *Josef Hoffmann. Bauten & Interieurs*, Vienna 2002

– *Josef Hoffmann. Villenkolonie Hohe Warte*, Vienna 2004

Terence Lane, *Vienna 1913: Josef Hoffmann's Gallia Apartment*, exh. cat., National Gallery of Victoria, Melbourne 1984

Serge Lemoine, Marie-Amélie zu Salm-Salm (eds.), *Klimt, Schiele, Moser, Kokoschka: Vienna 1900*, exh. cat., Galeries Nationales du Grand Palais, Paris/ Aldershot, Hampshire and Burlington, Vermont 2005

Rudolf Leopold and Gerd Pichler (eds.), *Koloman Moser 1868–1918*, exh. cat., Leopold Museum, Vienna/ Munich 2007

Elisabeth Lichtenberger, *Vienna: Bridge between Cultures*, London and New York 1993

Sophie Lillie, *Was einmal war: Handbuch der enteigneten Kunstsammlungen Wiens*, Vienna 2003

Adolf Loos, *Sämtliche Schriften*, I, Vienna and Munich 1962

– *Spoken into the Void: Collected Essays 1897–1900*, Cambridge, Massachusetts and London 1987

Eleonora Louis (ed.), *Secession: The Vienna Secession from Temple of Art to Exhibition Hall*, Ostfildern-Ruit 1997

William J. McGrath, *Dionysian Art and Populist Politics in Austria*, New Haven, Connecticut and London 1974

Eva Mendgen (ed.), *In Perfect Harmony: Picture and Frame 1850–1920*, exh. cat., Van Gogh Museum, Amsterdam 1995

Rainer Metzger, *Gustav Klimt: Drawings and Watercolors*, Vienna 2006

Manu von Miller, *Sonja Knips und die Wiener Moderne: Gustav Klimt, Josef Hoffmann und die Wiener Werkstätte gestalten eine Lebenswelt*, Vienna 2004

Michael Müller, *Die Verdrängung des Ornaments*, Frankfurt am Main 1977

Tobias G. Natter, *Die Galerie Miethke: Eine Kunsthandlung im Zentrum der Moderne*, exh. cat., Jüdisches Museum der Stadt Wien, Vienna 2003

– *Die Welt von Klimt, Schiele und Kokoschka. Sammler und Mäzene*, Cologne 2003

Tobias G. Natter and Gerbert Frodl, *Carl Moll (1861–1945)*, exh. cat., Österreichische Galerie Belvedere, Vienna/Salzburg 1998

– (eds.), *Klimt's Women*, New Haven, Connecticut and London 2000

Tobias G. Natter and Max Hollein (eds.), *The Naked Truth: Klimt, Schiele, Kokoschka and other Scandals*, exh.cat., Schirn Kunsthalle Frankfurt/Munich 2005

Jürgen Nautz and Richard Vahrenkamp (eds.), *Die Wiener Jahrhundertwende: Einflüsse, Umwelt, Wirkungen*, Vienna 1993

Christian M. Nebehay, *Gustav Klimt: Dokumentation*, Vienna 1969

– *Ver Sacrum: 1898–1903*, Vienna 1975

– *Gustav Klimt: Sein Leben nach zeitgenössischen Berichten und Quellen*, Munich 1976

– *Gustav Klimt, Egon Schiele und die Familie Lederer*, Bern 1987

– *Gustav Klimt. Das Skizzenbuch aus dem Besitz von Sonja Knips*, Vienna 1987

– *Gustav Klimt: From Drawing to Painting*, London 1994

Peter Noever (ed.), *Josef Hoffmann Designs*, exh. cat., MAK—Austrian Museum of Applied Art, Vienna/ Munich 1992

– *Der Preis der Schönheit: 100 Jahre Wiener Werkstätte*, exh. cat., MAK, Vienna/Ostfildern-Ruit 2003

– *Yearning for Beauty: The Wiener Werkstätte and the Stoclet House*, exh. cat., Palais des Beaux-Arts, Brussels/Ostfildern-Ruit 2006

Peter Noever and Oswald Oberhuber, *Josef Hoffmann 1870–1956: Orna-ment zwischen Hoffnung und Verbrechen*, exh. cat., MAK—Austrian Museum of Applied Art, Vienna/Salzburg 1987

Fritz Novotny and Johannes Dobai, *Gustav Klimt, with a Catalogue Raisonné of his Paintings*, London and New York 1968

Oswald Oberhuber, Julias Hummel (eds.) *Kolo Moser (1868–1918)*, exh. cat., Hochschule für Angewandte Künste and Österreichisches Museum für Angewandte Kunst, Vienna 1979

Susanna Partsch, *Gustav Klimt: Maler der Frauen*, Munich and New York 1994

Oskar Pausch, Petra Helm-Müller, et al., *Nuda Veritas Rediviva: Ein Bild Gustav Klimts und seine Geschichte*, Vienna 1997

Alfred Pfabigan (ed.), *Ornament und Askese im Zeitgeist des Wien der Jahrhundertwende*, Vienna 1985

Emil Pirchan, *Gustav Klimt: Ein Künstler aus Wien*, Vienna and Leipzig 1942

Michael Pollak, *Vienne 1900: Une identité blessée*, Paris 1992

Renée Price (ed.), *Gustav Klimt: The Ronald S. Lauder and Serge Sabarsky Collections*, exh. cat., Neue Galerie, New York/Munich 2007

Renée Price and Wilfried Seipel (eds.), *Viennese Silver: Modern Design 1780–1918*, exh. cat. Kunsthistorisches Museum, Vienna and Neue Galerie, New York/Ostfildern-Ruit 2003

Ursula Prokop, *Margaret Stonbo-rough-Wittgenstein: Bauherrin, Intellektuelle, Mäzenin*, Vienna 2003

Jacques Le Rider, *Modernity and Crises of Identity: Culture and Society in Fin-de-Siècle Vienna*, London 1993

Maria Rennhofer, *Koloman Moser: Master of Viennese Modernism*, London 2002

Arthur Roessler, *Erinnerungen an Egon Schiele*, Vienna 1948

Burkhard Rukschcio and Roland Schachel, *Adolf Loos: Leben und Werk*, Salzburg 1982

Serge Sabarsky, *Gustav Klimt*, exh. cat., Isetan Museum of Art, Tokyo 1981

– (ed.), *Gustav Klimt: Drawings*, London 1984

Debra Schafter, *The Order of Ornament, the Structure of Style: Theoretical Foundations of Modern Art and Architecture*, Cambridge 2003

Carl E. Schorske, *Fin-de-Siècle Vienna: Politics and Culture*, New York 1979

Sabine Schulze (ed.), *Sehnsucht nach Glück: Wiens Aufbruch in die Moderne, Klimt, Kokoschka, Schiele*, exh. cat., Schirn Kunsthalle Frankfurt/Ostfildern-Ruit 1995

Werner J. Schweiger, *Wiener Werkstätte: Design in Vienna 1903–1932*, London 1984

– *Meisterwerke der Wiener Werkstätte: Kunst und Handwerk*, Vienna 1990

Eduard F. Sekler, *Josef Hoffmann: The Architectural Work*, Princeton, New Jersey 1985

Toni Stooss and Christoph Doswald (eds.), *Gustav Klimt*, exh. cat., Kunsthaus Zürich, 1992

Alice Strobl, *Gustav Klimt: Zeichnungen und Gemälde*, Salzburg 1962

– *Gustav Klimt: Die Zeichnungen*, 4 vols., Salzburg 1980–9

Edward Timms, Ritchie Robertson (eds.), *Vienna 1900: From Altenberg to Wittgenstein*, Edinburgh, 1990

Kirk Varnedoe, *Vienna 1900: Art, Architecture and Design*, exh. cat., The Museum of Modern Art, New York 1986

Peter Vergo, *Art in Vienna 1898–1918: Klimt, Kokoschka, Schiele, and their Contemporaries*, London 1975

– *Vienna 1900: Vienna, Scotland and the European Avant-Garde*, exh. cat., National Museum of Antiquities, Edinburgh 1983

Vienna: A Birthplace of 20th Century Design. Part I: 1900–1905. Purism and Functionalism, "Konstruktiver Jugendstil", exh. cat., Fischer Fine Art, London 1981

Angela Völker, *Textiles of the Wiener Werkstätte, 1910–1932*, London 1994

Nike Wagner, *Geist und Geschlecht: Karl Kraus und die Erotik der Wiener Moderne*, Frankfurt am Main 1982

Robert Waissenberger, *Vienna Secession*, London 1977

– (ed.), *Traum und Wirklichkeit: Wien 1870–1930*, exh. cat., Historisches Museum der Stadt Wien, Vienna 1985

– *Vienna 1890–1920*, New York 1984

Alfred Weidinger, *Klimt*, Munich 2007

Alfred Weidinger and Renate Vergeiner, *Inselräume: Teschner, Klimt und Flöge am Attersee*, Seewalchen am Attersee 1988

Patrick Werkner, *Austrian Expressionism: The Formative Years*, Palo Alto, California 1993

Robert Weldon Whalen, *Sacred Spring: God and the Birth of Modernism in Fin-de-Siècle Vienna*, Grand Rapids, Michigan 2007

Frank Whitford, *Klimt*, London 1990

Christian Witt-Dörring (ed.), *Josef Hoffmann Interiors 1902–1913*, exh. cat., Neue Galerie, New York/Munich 2006

Gotthard Wunberg (ed.), *Die Wiener Moderne: Literatur, Kunst und Musik zwischen 1890 und 1910*, Stuttgart 1981

Thomas Zaunschirm, *Gustav Klimt—Margarethe Stonborough-Wittgenstein*, Frankfurt am Main 1987

Berta Zuckerkandl, *Zeitkunst Wien 1901–1907*, Vienna and Leipzig 1908

Walter Zednicek, *Josef Hoffmann und die Wiener Werkstätte*, Vienna 2006

Exhibited Works

Measurements are in centimetres, height before width and depth, followed by inches in brackets.

Catalogue raisonné references are included for all exhibited Klimt paintings and drawings. Novotny/Dobai numbers relate to the catalogue of paintings: Fritz Novotny and Johannes Dobai, *Gustav Klimt, with a Catalogue Raisonné of his Paintings*, London and New York 1968. Strobl numbers refer to the catalogue of drawings: Alice Strobl, *Gustav Klimt: Die Zeichnungen*, 4 vols., Salzburg 1980–9.

Gustav Klimt

Fable 1883
Oil on canvas
84.5 × 117 (33 1/4 × 46 1/16)
Wien Museum, Vienna
(Novotny/Dobai 18)
fig.38

Final Drawing for The Fairy Tale 1884
Black chalk, ink and wash with white highlights on paper
63.9 × 34.3 (25 3/16 × 13 1/2)
Wien Museum, Vienna
(Strobl 93)
fig.40

Final Drawing for the Allegory of Sculpture 1896
Black chalk, pencil and wash, with gold highlights on paper
41.8 × 31.3 (16 7/16 × 12 5/16)
Wien Museum, Vienna
(Strobl 276)
fig.39

Portrait of Joseph Pembauer 1890
Oil on canvas
68.2 × 55.2 (26 7/8 × 21 3/4)
Tiroler Landesmuseen Ferdinandeum, Innsbruck
(Novotny/Dobai 58)
fig.43

Two Girls with an Oleander
c.1890–2
Oil on canvas
55 × 128.5 (21 5/8 × 50 9/16)
Wadsworth Atheneum Museum of Art, Hartford, Connecticut. The Douglas Tracy Smith and Dorothy Potter Smith Fund and The Ella Gallup Sumner and Mary Catlin Sumner Collection Fund (Novotny/Dobai 59)
fig.41

Portrait of a Lady (Frau Heymann)
c.1894
Oil on wood
39 × 23 (15 3/8 × 9 1/16)
Wien Museum, Vienna
(Novotny/Dobai 65)
fig.42

Sketch Book for Sonja Knips
used between 1897 and 1903
Bound in red leather
14.3 × 9.2 (5 5/8 × 3 5/8)
Belvedere, Vienna

Final Poster Design for the First Secession Exhibition 1898
Pencil underdrawing, pen, ink with corrections in opaque white on paper
130 × 80 (51 3/16 × 31 1/2)
Wien Museum, Vienna
(Strobl 327)
fig.48

Portrait of a Child, owned by the Primavesi Family 1898
Pencil on paper
In a silver frame, designed by Josef Hoffmann
Frame 46.3 × 36.3 (18 1/4 × 14 5/16)
Primavesi Family Collection
fig.169

Portrait of Helene Klimt 1898
Oil on cardboard
60 × 40 (23 5/8 × 15 3/4)
Private Collection, Courtesy Kunstmuseum Bern
(Novotny/Dobai 92)
fig.37

Poster for the First Secession Exhibition – Censored Version 1898
Printed by A. Berger, Vienna
Colour lithograph on paper
97 × 70 (38 3/16 × 27 9/16)
Wien Museum, Vienna
fig.49

Poster for the First Secession Exhibition – Uncensored Version 1898
Printed by A. Berger, Vienna
Colour lithograph on paper
97 × 70 (38 3/16 × 27 9/16)
Wien Museum, Vienna
fig.46

Calm Pond 1899
Oil on canvas
74 × 74 (29 1/8 × 29 1/8)
Leopold Museum, Vienna
(Novotny/Dobai 108)
fig.99

Nuda Veritas 1899
Oil on canvas
252 × 56.2 (99 3/16 × 22 1/8)
Österreichisches Theatermuseum, Vienna
(Novotny/Dobai 102)
fig.44

Ex-Libris for the Viennese Secession with 'Pallas Athene' Logo c.1900
Black lithograph on paper
10.3 × 5.2 (4 1/16 × 2 1/16)
Imagno / Collection Christian Brandstätter, Vienna

*Ex-Libris for the Viennese Secession
with 'Pallas Athene' Logo* c.1900
Red lithograph on paper
10.2 × 5.2 (4 × 2 1/16)
Private Collection, Vienna
fig.47

*Portrait of Rose von
Rosthorn-Friedmann* 1900–1
Oil on canvas
140 × 80 (55 1/8 × 31 1/2)
Private Collection
(Not in Novotny/Dobai)
fig.113

*Study for Portrait of Rose von
Rosthorn-Friedmann* 1900–1
Pencil on paper
44.5 × 32.5 (17 1/2 × 12 13/16)
Private Collection, Salzburg
(Strobl 494)

Pine Forest I 1901
Oil on canvas
90 × 90 (35 7/16 × 35 7/16)
Kunsthaus Zug, Stiftung
Sammlung Kamm
(Novotny/Dobai 120)
fig.184

*Embracing Lovers – Beethoven
Frieze* 1901–2
Black chalk on paper
45 × 30.8 (17 11/16 × 12 1/8)
Albertina, Vienna
(Strobl 853)
fig.66

Portrait of Marie Henneberg
1901–2
Oil on canvas
140 × 140 (55 1/8 × 55 1/8)
Stiftung Moritzburg, Kunstmuseum
des Landes Sachsen-Anhalt, Halle
(Novotny/Dobai 123)
fig.112

*Seated Man from Rear, Study
for Strife (for 'Medicine')* 1901–7
Black chalk on paper
41 × 29 (16 1/8 × 11 7/16)
Albertina, Vienna
(Strobl 603)

*Study for the Beethoven Frieze:
Female Figure Turned to the
Right* 1901–2
Black chalk on paper
44.8 × 31.3 (17 5/8 × 12 5/16)
Albertina, Vienna
(Strobl 835)

*Study for the Figure 'Nagging Care' –
The Beethoven Frieze* 1901–2
Black chalk and pencil on paper
39.8 × 29.9 (15 11/16 × 11 3/4)
Albertina, Vienna
(Strobl 824)
fig.67

The Beethoven Frieze 1901–2/1984
Casein, gold foil, chalk, graphite,
plaster with decorative applications
including gilded gypsum, coloured
gem stones, curtain rings and
mother-of-pearl disks
Overall length 34.14m (left and right
walls 13.92m; front wall 6.30m;
height 2–2.15m)
Belvedere, Vienna
(Novotny/Dobai 127)
fig.65

*Two Sketches for the Three Gorgons –
The Beethoven Frieze* 1901–2
Pencil on paper
29.9 × 39.7 (11 3/4 × 15 5/8)
Albertina, Vienna

(Strobl 802)
fig.63

*Composition Sketch with Central
Gorgon and Two Other Heads –
The Beethoven Frieze* 1902
Black chalk and wash on paper
43.5 × 31 (17 1/8 × 12 3/16)
Wien Museum, Vienna
(Strobl 799)
fig.64

Portrait of Marie Moll c.1902
Black chalk, coloured chalks with
white pastel on paper
45.2 × 31.4 (17 13/16 × 12 3/8)
Wien Museum, Vienna
(Strobl 1152)

Beech in the Forest c.1903
Oil on cardboard
22.5 × 24.5 (8 7/8 × 9 5/8)
Private Collection, courtesy
Museum der Moderne Salzburg
fig.182

Life Is a Struggle (The Golden Knight)
1903
Oil, tempera and gold on canvas
103.5 × 103.7 (40 3/4 × 40 13/16)
Aichi Prefectural Museum of Art,
Nagoya
(Novotny/Dobai 132)
fig.144

Portrait of Hermine Gallia 1903–4
Oil on canvas
170 × 96 (67 1/8 × 37 3/4)
The National Gallery, London
(Novotny/Dobai 138)
fig.125

*Poster for the Klimt Exhibition
at the Viennese Secession* 1903
Printed by A. Berger, Vienna
Colour lithograph on paper
94 × 31 (37 × 12 3/16)
Wien Museum, Vienna

Study for Hope I c.1903
Black chalk on paper
44.9 × 30.6 (17 5/8 × 12 1/16)
Albertina, Vienna
(Strobl 3511a)

*Reclining Semi-Nude Facing Left
(Study for 'Water Serpents I')*
c.1904
Pencil on paper
34.9 × 55.1 (13 3/4 × 21 11/16)
Wien Museum, Vienna
(Strobl 1400)
fig.196

*Reclining Semi-Nude with
Right Leg Raised* 1904–5
Pencil on paper
35 × 55 (13 3/4 × 21 5/8)
Albertina, Vienna
(Strobl 1395)
fig.198

*Seated Semi-Nude in Three-
Quarter Profile* 1904–5
Blue pencil on paper
56 × 37 (22 1/16 × 14 9/16)
Kunsthaus Zug, Stiftung
Sammlung Kamm
(Strobl 1292)
fig.208

Water Serpents I 1904–7
Mixed media on parchment
50 × 20 (19 11/16 × 7 7/8)
Belvedere, Vienna
(Novotny/Dobai 139)
fig.141

*Schematic Drawing for the Stoclet
Frieze* 1905–11
Indian ink on paper
21.9 × 75.3 (8 5/8 × 29 5/8)
Wien Museum, Vienna
(Strobl 1693)
fig.81

*Study for Portrait of Margaret
Stonborough-Wittgenstein* 1905
Pencil on paper
54.5 × 35 (21 7/16 × 13 3/4)
Private Collection
(Strobl 1264)
fig.154

The Three Ages of Life (also known
as *The Three Ages of Woman*) 1905
Oil on canvas
180 × 180 (70 7/8 × 70 7/8)
Galleria Nazionale d'Arte Moderna
e Contemporanea, Rome
(Novotny/Dobai 141)
fig.207

Lovers Reclining to the Right c.1905–10
Pencil on paper
37 × 56.5
Private Collection, Courtesy Richard
Nagy Ltd, London
(Strobl 3611)
fig.209

Gustav Klimt
Die Hetärengespräche des Lukian
(Lucian's *Dialogues of the Courtesans*)
Published by Verlag Julius Zeitler,
Leipzig, 1907
German translation by Franz
Blei with fifteen drawings
by Gustav Klimt
38 × 30.5 (14 15/16 × 12)
Example of Edition A (Premium
Deluxe Edition):
No.31/50, Private Collection, Vienna
Examples of Edition B:
No.12/100, Kunsthaus Zug,
Sammlung Kamm
No.63/100, Wien Museum, Vienna
No.81/100, Österreichische
Nationalbibliothek, Vienna
No.86/100, Private Collection, Vienna
No.97/100, Christian M. Nebehay
GmbH, Vienna
fig.203

Lovers 1907–8
Pencil on paper
37.2 × 56.5 (14 5/8 × 22 1/4)
Private Collection, Courtesy Richard
Nagy Ltd, London
(Strobl 1794)
fig.210

*Schloss Kammer on the
Attersee I* c.1908
Oil on canvas
110 × 110 (43 5/16 × 43 5/16)
Národní Galerie, Prague
(Novotny/Dobai 159)
fig.191

*Standing Figure (Study for
'Judith II')* c.1908
Pencil on paper
56 × 37 (22 1/16 × 14 9/16)
Kunsthaus Zug, Stiftung
Sammlung Kamm
(Strobl 1702)
fig.193

Judith II (Salome) 1909
Oil on canvas
178 × 46 (70 1/16 × 18 1/8)
Musei Civici Veneziani, Galleria
Internazionale d'Arte Moderna
di Ca' Pesaro, Venice

(Novotny/Dobai 160)
fig.194

The Park 1909–10
Oil on canvas
110.4 × 110.4 (43 1/2 × 43 1/2)
The Museum of Modern Art,
New York, Gertrud A. Mellon
Fund, 1957
(Novotny/Dobai 165)
fig.185

Apple Tree I c.1912
Oil on canvas
109 × 110 (42 5/16 × 43 5/16)
Private Collection
(Novotny/Dobai 180)
fig.188

*Reclining Semi-Nude with Spread
Thighs* 1912–3
Blue crayon on paper
37 × 55.9 (14 9/16 × 22)
Kunsthaus Zug, Stiftung Sammlung
Kamm
(Strobl 2307)
fig.199

Semi-Nude with Left Leg Raised
1912–13
Pencil on paper
37.1 × 56 (14 5/8 × 22 1/16)
Albertina, Vienna
(Strobl 2311)
fig.202

Ria Munk on her Deathbed 1912
Oil on canvas
50 × 50.5 (19 11/16 × 19 7/8)
Private Collection, Courtesy
Richard Nagy Ltd, London
(Novotny/Dobai 170)
fig.205

*Stone Head owned by the
Primavesi Family* 1912–13
20.5 × 33 × 18 (8 1/16 × 13 × 7 1/16)
Primavesi Family Collection
fig.170

*Study for Portrait of Eugenia
Primavesi* 1912–13
Pencil on paper
56.6 × 37 (22 5/16 × 14 9/16)
Albertina, Vienna
(Strobl 2150)

*Study for Portrait of Eugenia
Primavesi* 1912–3
Pencil on paper
56.6 × 37 (22 5/16 × 14 9/16)
Albertina, Vienna
(Strobl 2155)
fig.163

Lovers with Cushions c.1913
Pencil on paper
37.2 × 56.5 (14 5/8 × 22 1/4)
Private Collection, Courtesy
Richard Nagy Ltd, London
(Strobl 2442)
fig.197

Portrait of Eugenia Primavesi
1913–14
Oil on canvas
140 × 85 (55 1/8 × 33 7/16)
Toyota Municipal Museum of Art
(Novotny/Dobai 187)
fig.164

Reclining Woman c.1913
Blue crayon on paper
37.2 × 56 (14 5/8 × 22 1/16)
Wien Museum, Vienna
(Strobl 2234)
fig.204

Litzlberg on the Attersee 1915
Oil on canvas
110 × 110 (43 5/16 × 43 5/16)
Museum der Moderne Salzburg
(Novotny/Dobai 147)
fig.190

*Garden Landscape with
Hilltop* 1916
Oil on canvas
110 × 110 (43 5/16 × 43 5/16)
Kunsthaus Zug, Stiftung
Sammlung Kamm
(Novotny/Dobai 216)
fig.189

Reclining Semi-Nude 1916–17
Pencil on paper
37.5 × 56 (14 3/4 × 22 1/16)
Private Collection, Courtesy
Richard Nagy Ltd, London
(Strobl 2964)
fig.195

*Three Standing Female
Nudes* 1916–7
Pencil on paper
57 × 37.3 (22 7/16 × 14 11/16)
Kunsthaus Zug, Stiftung
Sammlung Kamm
(Strobl 2799)

Baby (Cradle) 1917
Oil on canvas
110 × 110 (43 5/16 × 43 5/16)
National Gallery of Art, Washington,
D.C., Gift of Otto and Franciska
Kallir with the help of the Carol
and Edwin Gaines Fullinwider Fund
(Novotny/Dobai 221)
fig.171

Adam and Eve 1917–18
(unfinished)
Oil on canvas
173 × 60 (68 1/8 × 23 5/8)
Belvedere, Vienna
(Novotny/Dobai 220)
fig.211

Portrait of a Lady 1917–8
(unfinished)
Oil on canvas
67 × 56 (26 3/8 × 22 1/16)
Lentos, Kunstmuseum Linz
fig.206

*Sketch Book used by Gustav
Klimt* 1917
17 × 12 × 2 (6 11/16 × 4 3/4 × 13/16)
From the Estate of Gustav Klimt
Private Collection

Study for 'The Bride' 1917–18
Pencil on paper
56.6 × 37 (22 5/16 × 14 9/16)
Albertina, Vienna
(Stobl 2986)
fig.201

Max Benirschke

*Room Arrangement by Josef
Hoffmann for the Viennese Secession
Exhibition in Düsseldorf* 1902
38.5 × 30.5 (15 3/16 × 12)
Pen and coloured pencil
on cardboard
Viennese Secession

Carl Otto Czeschka

*Niccolò Bonbon Box for Margaret
Stonborough-Wittgenstein* 1905
Made by the Wiener Werkstätte
Silver
Height 9.4 (3 11/16),
diameter 10.7 (4 3/16)

Private Collection
fig.158

Small Box 1906
Made by the Wiener Werkstätte
Wood and leather
9 × 13 × 13 (3 9/16 × 5 1/8 × 5 1/8)
Ernst Ploil, Vienna
fig.77

Pauline Hamilton

*Photograph of Gustav Klimt
in Profile* c.1909
Silver gelatin print
45 × 35 (17 11/16 × 13 3/4)
Private Collection, Salzburg
fig.212

*Photograph of Gustav Klimt
in the Garden of his Studio* c.1909
Silver gelatin print
45 × 35 (17 11/16 × 13 3/4)
Private Collection, Salzburg

Josef Hoffmann

*Chair made for the Fifth Viennese
Secession Exhibition* 1899
Green-stained wood with
padded leather seat
76 × 61 × 44 (29 15/16 × 24 × 17 5/16)
Collection Hummel, Vienna
fig.53

*Reconstruction of the Sopraporta
for the Installation of the Fourteenth
Exhibition of the Viennese Secession
(The Beethoven Exhibition)* 1902/1985
White-painted wood
94 × 96 × 15 (37 × 37 13/16 × 5 7/8)
Reconstruction by Willi Kopf, 1985
Collections of the University of
Applied Arts, Vienna

*Toilet Paper Holder for the
Villa Waerndorfer* c.1902
Zinc, silver and iron
25.5 × 21 × 7 (10 1/16 × 8 1/4 × 2 3/4)
Ernst Ploil, Vienna
fig.107

Design for Bent Wood Chair
c.1903–5
Pencil, ink and crayon on
squared paper
20.5 × 33.5 (8 1/16 × 13 3/16)
Kunsthaus Zug, Sammlung Kamm

*Sketch for Purkersdorf
Sanatorium* 1903–4
Ink, crayon and pencil
on squared paper
20.4 × 33.4 (8 1/16 × 13 1/8)
Kunsthaus Zug, Stiftung
Sammlung Kamm
fig.71

*Table from Gustav Klimt's
Studio* 1903–4
Oak
69.5 × 70 × 75.3
Ernst Ploil, Vienna
fig.176

*Cabinet from the Flöge Sisters'
Fashion House* 1904
Made by the Wiener Werkstätte
Ebonised and white-painted wood
234 × 145 × 39 (92 × 57 × 15.2)
Courtesy Gallerie Yves Macaux,
Brussels
fig.84

Piggy Bank for the Palais Stoclet 1904
Made by the Wiener Werkstätte
(Alfred Mayer) 1905
Silver, amethyst and ebony

Height 8.4 (3 1/4), diameter 10.3 (4)
Courtesy Gallerie Yves Macaux,
Brussels

Fruit Basket c.1904
Made by the Wiener Werkstätte
Electroplated silver
12 × 21 × 21 (4 3/4 × 8 1/4 × 8 1/4)
Victoria and Albert Museum,
London
fig.69

Fruit Basket c.1904
Made by the Wiener Werkstätte
Silver
27 × 23 × 23 (10 5/8 × 9 1/16 × 9 1/16)
Victoria and Albert Museum,
London
fig.74

*Bookcase from the Reading Room at
the Purkersdorf Sanatorium* 1904–5
Made by the Wiener Werkstätte
Oak, silver oak, white paint on
doors, leaded glass, packfong
171.5 × 144.3 × 39
(67 1/2 × 56 13/16 × 15 3/8)
Ernst Ploil, Vienna
fig.70

*Cigarette Box from the Gallia
Apartment* c.1904–5
Made by the Wiener Werkstätte
(Augustin Grötzbach)
Electroplated silver and onyx
8.5 × 15.1 × 12 (3 3/8 × 5 15/
16 × 4 3/4)
National Gallery of Victoria,
Melbourne. Samuel E. Wills
Bequest, 1976
fig.135

*Model of the Purkersdorf
Sanatorium* 1904/1985
Limewood, pearwood, Finnish
birch
41 × 180.6 × 112.7 (16 1/8 ×
71 1/8 × 44 3/8)
Scale 1:50
Collections of the University
of Applied Arts, Vienna

*Selection of 24 pieces from 106-piece
Cutlery Set for twelve with the
Monogram of Lili and Fritz
Waerndorfer* 1904–8
Made by the Wiener Werkstätte
Silver and steel
3 × table knives, length 21.5 (8 7/16);
3 × table forks, length 21.5 (8 7/16);
3 × tablespoons, 21.8 (8 9/16);
3 × fish knives, length 19.3 (7 9/16);
3 × fish fork, length 19.2 (7 9/16);
3 × dessert forks, length 18.2 (7 1/4);
3 × teaspoons, length 10.2 (4); 3 ice
cream spoon, length 10.5 (4 1/8)
MAK – Austrian Museum of Applied
Arts/Contemporary Art, Vienna
fig.104

*Tea and Coffee Service for Margaret
Wittgenstein-Stonborough* 1904
Silver, coral and onyx, ebony
Made by the Wiener Werkstätte
by Adolf Erbrich, Josef Holi, Josef
Hoßfeld and Josef Wagner, Model
nos. S 314 (tray), 386 (coffee pot),
388 (milk jug), 389 (tea pot), 390
(cream jug), 391 (sugar box). Marked:
WW, rosemark, JH (Josef Hoffmann),
JH (Jose Holi), AE (Adolf Erbrich),
JW(Josef Wagner), Vienna hallmark
(except the sugar tongs)
Tray 9.2 × 70.5 35.5 (3 5/8 × 27 3/4 ×
14); Coffee Pot 23.7 × 16.5 × 22 (9 5/16
× 6 1/2 × 8 11/16); Tea Pot 18.3 × 18.5
× 24.4 (7 3/16 × 7 5/16 × 9 5/8); Milk
Jug 14.5 × 12.2 × 19.3 (5 11/16 × 4

13/16 × 7 5/8); Cream Jug 6 × 10.2 ×
15.1 (2 3/8 × 4 × 5 15/16); Sugar Box
14.5 × 9.3 × 11.2 (5 11/16 × 3 11/16 ×
4 7/16); Sugar Tongs Length 11 (4
5/16), width 1.9 (3/4)
Asenbaum Collection
fig.148

*Chair from the Dining Room of
Margaret and Jerome Stonborough's
Berlin Residence* 1905
Made by the Wiener Werkstätte
Silver oak and black-stained oak
98.5 × 47 × 47
(38 3/4 × 18 1/2 × 18 1/2)
Ernst Ploil, Vienna
fig.159

Basket 1905
Electroplated silver and glass
6.8 × 8 × 1.8 (2 11/16 × 3 1/8
× 11/16)
Victoria and Albert Museum,
London

*Coal Scuttle owned by Paul
Wittgenstein* 1905
Made for the Wiener Werkstätte
(Thomann Co.)
Wrought iron, nickel handle
with oxidised copper shovel
Bucket height 53.6 (21 1/8); Shovel
length 45 (17 11/16)
Ernst Ploil, Vienna
fig.160

Design for Desk with Armchair
c.1905–8
Pencil and crayon on squared paper
20.8 × 33.2 (8 3/16 × 13 1/16)
Kunsthaus Zug, Sammlung Kamm

*Design for the 'Atila' and
'Tegethof' Chairs* c.1905–8
Pencil, ink and crayon
on squared paper
20.9 × 28.9 (8 1/4 × 11 3/8)
Kunsthaus Zug, Sammlung Kamm

*Design for the 'Radetzky'
Chair* c.1905–8
Pencil, ink and crayon
on squared paper
20.9 × 21.8 (8 1/4 × 8 9/16)
Kunsthaus Zug, Sammlung Kamm

Flower Table c.1905
Made by the Wiener Werkstätte
Iron, painted white
Height 72.5 (28 9/16), diameter 38
(14 15/16)
Ernst Ploil, Vienna

*Fruit Basket from the Gallia
Collection* c.1905
Made by the Wiener Werkstätte
Silver, ivory
16.1 × 19.5 × 15.3 (6 5/16
× 7 11/16 × 6)
National Gallery of Victoria,
Melbourne. Samuel E. Wills
Bequest, 1976
fig.133

*Model of the Palais Stoclet
(Ground Floor)* 1905–11/1984
Limewood, pearwood, Finnish
birch veneer
54 × 164.4 × 130
(21 1/4 × 64 3/4 × 51 3/16)
Scale 1:50
Collections of the University of
Applied Arts, Vienna

*Table Centrepiece owned by Fritz
und Lili Waerndorfer* 1905
Made by the Wiener Werkstätte
Silver with lapis lazuli cabochon

Height 13.5 (5 5/16)
Kunsthaus Zug, Sammlung Kamm
fig.105

*Pot with Lid, owned by Fritz
and Lili Waerndorfer* 1906
Made by the Wiener Werkstätte
Silver with turquoise stones
14 × 20.4 × 13.8
(5 1/2 × 8 1/16 × 5 7/16)
Kunsthaus Zug, Stiftung
Sammlung Kamm
fig.103

*Sketch for the Ground Floor of the
Palais Stoclet* c.1906
Pen and ink on paper
20.5 × 31 (8 1/16 × 12 3/8)
Kunsthaus Zug, Sammlung
Kamm
fig.82

Vase from the Gallia Collection c.1906
Made by the Wiener Werkstätte
(Josef Holi)
Silver and glass, 10.9 × 22.1 × 10.2
(4 5/16 × 8 11/16 × 4)
National Gallery of Victoria,
Melbourne. Samuel E. Wills
Bequest, 1976
fig.137

*Chair for the 'Cabaret
Fledermaus'* c.1907
Black-and-white-painted
beechwood with leather upholstery
73.5 × 55 × 44
(28 15/16 × 2 3/16 × 1 3/4)
Victoria and Albert Museum,
London
fig.109

(Josef Hoffmann and Carl
Otto Czeschka)
Card Table for Karl Wittgenstein
1907
Macassar ebony, various carved
woods inlaid, gilding, ivory
and mother-of-pearl
75 × 59 × 59 (29 1/2 × 23 1/4 × 23 1/4)
Asenbaum Collection
fig.145

*Model of the 'Cabaret
Fledermaus'* 1907/2003
Finnish birch, limewood, paper,
polyamide, majolica, miniature
painting
112.4 × 119.4 × 29.5
(44 1/4 × 47 × 11 5/8)
Scale 1:25
Collections of the University
of Applied Arts, Vienna

*Sketch for the 'Kunstschau' Small
Country House* 1908
Ink, crayon and pencil
on squared paper
33.8 × 20.7 (13 5/16 × 8 1/8)
Kunsthaus Zug, Stiftung
Sammlung Kamm
fig.73

Adjustable Armchair c.1908
Made by J. & J. Kohn, Austria
Steam-bent beechwood frame,
stained mahogany colour, plywood
geometric pattern, brass pole
110 × 62 × 83 (43 5/16 × 24 7/16
× 32 11/16)
Victoria and Albert Museum,
London
fig.79

*Fruit Basket from the Gallia
Apartment* c.1908
Made by the Wiener Werkstätte
Electroplated silver

16.6 × 14.5 × 14.3 (6 9/16 × 5 11/16
× 5 5/8)
National Gallery of Victoria,
Melbourne. Samuel E. Wills
Bequest, 1976
fig.138

Design for Balcony Chair c.1908–10
Pencil, crayon and ink on squared
paper
17 × 21 (6 11/16 × 8 1/4)
Kunsthaus Zug, Sammlung Kamm

Design for a Table c.1908–10
Pencil, crayon and ink on squared
paper
17 × 21 (6 11/16 × 8 1/4)
Kunsthaus Zug, Sammlung Kamm

Belt Buckle 1909
Made by the Wiener Werkstätte
Silver, gilt with mother-of-pearl
5.5 × 6.5 (2 3/16 × 2 9/16)
Kunsthaus Zug, Sammlung Kamm
fig.88

Belt Buckle 1910
Made by the Wiener Werkstätte
Silver, Diameter 6 (2 3/8)
Ernst Ploil, Vienna
fig.87

Smoking Table 1910
Made by the Wiener Werkstätte
White enamelled zinc (re-finished)
with a light grey-blue top
Height 68 (26 3/4),
diameter 41 (16 1/8)
Victoria and Albert Museum,
London
fig.80

Writing Desk Set 1910
Mother-of-pearl with ebony fillets
Made by the Wiener Werkstätte
Ink stand 7 × 25 × 12.5 (2 3/4 × 9
13/16 × 4 15/16); candlestick 10.5 × 4
(4 1/8 × 1 9/16); pen holder, length
10.5 (4 1/8); seal 10.5 × 4 (4 1/8 × 1
9/16); card holder 4.5 × 7.5 × 13.5
(1 3/4 × 2 15/16 × 5 5/16)
Victoria and Albert Museum,
London
fig.83

Biscuit Tin for Gustav Klimt 1912
Made by the Wiener Werkstätte
(Alfred Mayer) for the 50th Birthday
of Gustav Klimt
Silver, gilt and ivory
Height 18.5 (7 1/4)
From the Estate of Gustav Klimt
Private Collection
fig.78

*Armchair from the Hall
of the Gallia Apartment* c.1912
Made by Johann Soulek
Ebonised wood, other materials
90.1 × 59.3 × 53.3 (35 1/2 × 23 3/8 × 21)
National Gallery of Victoria,
Melbourne. Samuel E. Wills
Bequest, 1976

*Chair from the Boudoir
of the Gallia Apartment* c.1912
Made by Johann Soulek
Painted wood, gilt, other materials
91.1 × 48.3 × 49.5 (35 13/16
× 19 × 19 1/2)
National Gallery of Victoria,
Melbourne. Samuel E. Wills
Bequest, 1976
fig.131

*Bureau from the Boudoir
of the Gallia Apartment* 1913
Made by Johann Soulek

White-enamelled wood, glass, silk
179.5 × 111 × 64.6 (70 11/16 × 43
11/16 × 25 7/16)
National Gallery of Victoria,
Melbourne. Samuel E. Wills
Bequest, 1976
fig.129

*Design for Boudoir Carpet
of the Gallia Apartment* 1913
Pencil, gouache and crayon
on tracing paper
129 × 86.5 (50 13/16 × 34 1/16)
Backhausen Archive, Vienna
fig.132

*Design for Dining Room Rug
of the Gallia Apartment* 1913
Pencil, gouache, ink and crayon
on blueprint with rubber stamp
53.3 × 46.5 (18 5/16 × 21)
Backhausen Archive, Vienna

*Design for Dining Room Rug
of the Gallia Apartment* 1913
Pencil, gouache, ink and crayon
on blueprint with rubber stamp
24.5 × 32.6 (9 5/8 × 12 13/16)
Backhausen Archive, Vienna

*Design for Drawing Room Carpet
of the Gallia Apartment* 1913
Pencil, gouache, ink and crayon
on blueprint with rubber stamp
98 × 108 (38 9/16 × 42 1/2)
Backhausen Archive, Vienna

*Design for Salon/Music Room
Rug of the Gallia Apartment* 1913
Pencil, gouache, ink and crayon
on blueprint with rubber stamp
101.5 × 109 (39 15/16 × 42 15/16)
Backhausen Archive,
Vienna

*Design for Salon/Music Room
Rug of the Gallia Apartment* 1913
Pencil, gouache, ink and crayon
on blueprint with rubber stamp
47.8 × 41.8 (16 7/16 × 18 13/16)
Backhausen Archive, Vienna

*Design for Smoking Room Carpet
of the Gallia Apartment* 1913
Pencil, gouache, ink and crayon
on blueprint with rubber stamp
42 × 49.2 (16 9/16 × 19 3/8)
Backhausen Archive, Vienna

*Dining Table from the Hall
of the Gallia Apartment* 1913
Made by Johann Soulek
Ebonised wood
78 × 127 × 92.5 (30 11/16
× 50 × 36 7/16)
National Gallery of Victoria,
Melbourne. Samuel E. Wills
Bequest, 1976
fig.139

*Model of the Skywa-Primavesi
Residence* 1913–15/1983
Limewood, pearwood, Finnish
birch
43 × 146.4 × 112.4 (16 15/16
× 57 5/8 × 44 1/4)
Scale 1:50
Collections of the University
of Applied Arts, Vienna

*Occasional Table from the Boudoir
of the Gallia Apartment* 1913
Made by Johann Soulek
Painted wood, gilt, marble
75.6 × 90 × 50 (29 3/4 × 35 7/
16 × 19 11/16)
National Gallery of Victoria,
Melbourne. Samuel E. Wills

Bequest, 1976
fig.130

Vase from the Gallia Apartment
c.1913
Made by the Wiener Werkstätte
(Alfred Mayer)
Silver, 12.7 × 29.3 × 25.2
(5 × 11 9/16 × 9 15/16)
Private Collection, Melbourne.
fig.136

*Hand Mirror with the Monogram
of Mäda (Eugenia) Primavesi* 1914
Made by the Wiener Werkstätte
Silver
26.3 × 12.5 × 1.2 (10 3/8 × 4 15/
16 × 1/2)
Primavesi Family Collection

Dora Kallmus (d'Ora)

*Three Photographs of Gustav
Klimt* 1908–9
Silver gelatin prints
Each 45 × 35 (17 11/16 × 13 3/4)
Private Collection, Salzburg

*Emilie Flöge wearing a Reform
Dress in the Flöge Sisters'
Fashion Salon* Autumn 1910
Silver gelatin print
20.6 × 8.2 (8 1/8 × 3 1/4)
Imagno/Collection Christian
Brandstätter, Vienna
fig.91

*Emilie Flöge wearing a Reform
Dress with Muff in the Flöge Sisters'
Fashion Salon* Autumn 1910
Vintage silver gelatin print
19 × 8.5 (7 1/2 × 3 3/8)
Imagno/Collection Christian
Brandstätter, Vienna
fig.90

Charles Rennie Mackintosh

*Design for a Smoker's Cabinet
owned by Hugo Henneberg*
1899
Pencil and watercolour
on laid paper
32.2 × 35 (12 11/16 × 13 3/4)
Hunterian Museum and Art
Gallery, University of Glasgow
fig.100

*New Year Greetings Card, from
Lili Waerndorfer to Charles
Rennie Mackintosh and Margaret
Macdonald Mackintosh,
Glasgow* c.1901
Ink on paper, 13.9 × 8.9 (5 1/2 × 3 1/2)
Hunterian Museum and Art
Gallery, University of Glasgow

*Design for a Writing Cabinet
owned by Fritz and Lili Waerndorfer*
1902
Pencil and watercolour on paper
15.3 × 28.5 (6 × 11 1/4)
Hunterian Museum and Art
Gallery, University of Glasgow
fig.101

*Design for a Gesso Panel for the
Waerndorfers' Music Room* c.1903
Pencil and watercolour on
brown tracing paper
36 × 90.6 (14 3/16 × 35 11/16)
Hunterian Museum and Art
Gallery, University of Glasgow

*Drawing for Jewellery Ornaments
for the Gesso Frieze 'The Return
of Prince Marcellus'* c.1906
Pencil and watercolour on paper

51 × 63.9 (20 1/16 × 25 3/16)
Hunterian Museum and Art
Gallery, University of Glasgow

Margaret Macdonald Mackintosh

*Photograph of a Gesso Panel
'The Opera of the Sea' from
the Piano of the Waerndorfers'
Music Room* 1900–2
Vintage photograph
18.6 × 19 (7 5/16 × 7 1/2)
Hunterian Museum and Art
Gallery, University of Glasgow

*Photograph of a Gesso Panel
'The Opera of the Winds' from
the Piano of the Waerndorfers'
Music Room* 1903
Vintage photograph
15.7 × 11.7 (6 3/16 × 4 5/8)
Hunterian Museum and Art
Gallery, University of Glasgow

Frances Macdonald MacNair

*Four Photographs of an
Embroidered Panel* c.1900–10
Vintage photographs
Each 12.6 × 10.2 (4 15/16 × 4)
Hunterian Museum and Art
Gallery, University of Glasgow

Carl Moll

Hohe Warte 1903
Black, grey-green, pink and
yellow woodcut print
32.7 × 43.2 (12 7/8 × 17)
Albertina, Vienna

*My Living Room (Anna Moll
at the Desk)* 1903
Oil on canvas
100 × 100 (39 3/8 × 39 3/8)
Wien Museum, Vienna
fig.119

Terrace of the Villa Moll c.1903
Oil on canvas
100 × 100 (39 3/8 × 39 3/8)
Wien Museum, Vienna
fig.117

*The Artist's House on the
Hohe Worte* 1905
Oil on canvas
81.5 × 80 (32 1/16 × 31 1/2)
Collection Essl, Klosterneuburg
fig.122

Self Portrait (In My Studio) c.1906
Oil on canvas
100 × 100 (39 3/8 × 39 3/8)
Gemäldegalerie der Akademie
der bildenden Künste, Vienna
fig.116

Koloman Moser

*The Guest Room of the Villa Moser
on the Hohe Warte* 1901
Wood, black and white paint,
glass, mirror and ceramic tiles
Height 180 (70 7/8); long wall 393
(154 3/4); short wall 273 (107 1/2)
Private Collection
fig.120

*Cabinet from the Salon
of Marie Henneberg* 1902
Made by J. W. Mueller
or Wenzel Hollmann
Cherry wood, brass fittings, lead-
glass windows, polished glass,
glass columns, ruby decoration
221 × 90 × 61.5 (83 1/8 × 35 7/
16 × 24 3/16)

Bel Etage Kunsthandel GmBH, Vienna
fig.115

*Desk and Integrated Armchair
for Eisler von Terramare* 1903
Made by the Wiener Werkstätte
(Casper Hradzil)
Deal, oak and mahogany,
veneers of thuya wood, inlaid
with satinwood and brass
Desk 144 × 120 × 60 (56 11/16 × 4 3/4
× 23 5/8); armchair 67 × 60 × 60
(26 3/8 × 23 5/8 × 23 5/8)
Victoria and Albert Museum,
London
fig.76

*Pen Wiper owned by the
Primavesi Family* 1903
Made by the Wiener Werkstätte
(Johann Blaschek)
Copper and silver
Height 5 (1 15/16), diameter 13 (5 1/8)
Primavesi Family Collection
fig.168

*Ink Pot owned by the
Primavesi Family* 1903
Made by the Wiener Werkstätte
Copper and silver
Height 10.5 (4 1/8),
diameter 17.5 (6 7/8)
Primavesi Family Collection
fig.167

*Paper Weight owned by the
Primavesi Family* 1903
Made by the Wiener Werkstätte
(Johann Blaschek)
Copper and silver
Height 7 (2 3/4), diameter 15 (5 7/8)
Primavesi Family Collection

*Bottle Support owned by the
Primavesi Family* 1904
Made by the Wiener Werkstätte
Silver, lapis lazuli
Height 1.1 (7/16), diameter 10.5 (4 1/8)
Primavesi Family Collection

*Bread and Fruit Basket owned
by the Primavesi Family* 1904
Made by the Wiener Werkstätte
(Meister BA)
Silver, 6.5 × 25 × 28.5
(2 9/16 × 9 13/16 × 11 1/4)
Primavesi Family Collection

Draft Design for a Tiara 1905–6
Pencil and opaque colours on paper
22 × 32 (8 11/16 × 12 5/8)
Collection Hummel, Vienna

*Sugar Bowl with Spoon
for Margaret Stonborough-
Wittgenstein* c.1905
Made by the Wiener Werkstätte
Silver
Bowl 12.5 × 11 (4 15/16 × 4 5/16);
spoon 14.5 × 2.5 (5 11/16 × 1)
Private Collection
fig.156

*Sweet Basket with Monogram
HG (Hermine Gallia)* c.1905
Made by the Wiener Werkstätte
(Josef Holi)
Silver, shell, lapis lazuli
14.8 × 19.4 × 8.6 (5 13/16 × 7 5/
8 × 3 3/8)
National Gallery of Victoria,
Melbourne. Samuel E. Wills
Bequest, 1976
fig.134

*Guest Room of the Apartment
of Dr Hermann Wittgenstein,
Salesianergasse, Vienna* 1906

Grey and white painted soft wood
with brass fittings
Table 75 × 85 × 60 (29 1/2 × 33 7/
16 × 23 5/8)
Wash Stand 99 × 85 × 58
(39 × 33 7/16 × 22 13/16)
Bed 100 × 207 × 90
(39 3/8 × 81 1/2 × 35 7/16)
Bedside Table 74 x 40 x 37
(29 1/8 × 15 3/4 x 14 9/16)
Collection Hummel, Vienna
fig.155

*Photo Album for Lili
Waerndorfer* 1906
Made by the Wiener Werkstätte
Leather, gold embossed
13 × 14.3 (5 1/8 × 5 5/8)
Ernst Ploil, Vienna
fig.106

Moritz Nähr

*Emilie Flöge and Gustav
Klimt* c.1905
Gravure print
28.6 × 24.2 (11 1/4 × 9 1/2)
Lentos, Kunstmuseum Linz
fig.85

*Gustav Klimt wearing his
Painter's Smock in front of his Studio,
holding one of his Cats* c.1912
Vintage albumin print
38.7 × 30 (15 1/4 × 11 13/16)
Imagno / Collection Christian
Brandstätter, Vienna
frontispiece

Joseph Maria Olbrich

*Armchair for the Music Room
of the Villa Spitzer* c.1898–9
Stained maple, with upholstery
and brass feet
79 × 54 × 49.5 (31 1/8 × 21 1/
4 × 19 1/2)
Victoria and Albert Museum, London
fig.121

*Model of the Viennese Secession
(Cross Section)* 1898
Deal, oak and mahogany,
veneers of thuya wood, inlaid
with satinwood and brass
84.3 × 104.3 × 52.5 (33 3/16 × 41 1/
16 × 20 11/16)
Scale 1:50
Vienna Secession

Bruno Reiffenstein

The Gallia Family c.1903
Vintage print
19.5 × 25.2 (7 11/16 × 9 15/16)
Private Collection
fig.124

*The Hall of the Gallia
Apartment* c.1916
Vintage print
25.2 × 19.5 (9 15/16 × 7 11/16)
Private Collection
fig.126

*The Boudoir of the Gallia
Apartment* c.1916
Vintage print
25.2 × 19.5 (9 15/16 × 7 11/16)
Private Collection
fig.127

*The Dining Room of the Gallia
Apartment* c.1916
Vintage print
19.5 × 25.2 (7 11/16 × 9 15/16)
Private Collection
fig.128

*The Salon/Music Room of the
Gallia Apartment* c.1916
Vintage print
25.2 × 19.5 (9 15/16 × 7 11/16)
Private Collection

*The Smoking Room of the
Gallia Apartment* c.1916
Vintage print
19.5 × 25.2 (7 11/16 × 9 15/16)
Private Collection

Alfred Roller

Study for the Mural 'Nightfall' 1902
Pencil, watercolour with opaque
silver and gold colouring on paper
66.2 × 61.4 (26 1/16 × 24 3/16)
Österreichisches Theatermuseum,
Vienna

*Poster for the Fourteenth Exhibition
of the Viennese Secession
(The Beethoven Exhibition)* 1902
Colour lithograph
95.5 × 63 (37 5/8 × 24 13/16)
Wien Museum, Vienna
fig.59

Egon Schiele

*The Hermits (Self-Portrait
with Gustav Klimt)* 1912
Oil on canvas
181 × 181 (71 1/4 × 71 1/4)
Leopold Museum, Vienna
fig.173

Anton Josef Trčka

*Photograph of Gustav Klimt
in his Working Coat* 1914
Silver gelatin print
Frame 36 × 28 × 4.5 (14 1/8 × 11 × 1 3/4)
Private Collection, Salzburg

Friedrich Walker

*Emilie Flöge in a Chinese
Dress* 1910/c.1980
Colour exhibition print
from autochrome plate
12.7 × 17.8 (5 × 7)
Imagno / Collection Christian
Brandstätter, Vienna

*Emilie Flöge in a Reform
Dress* 1910/c.1980
Colour exhibition print from
autochrome plate
19 × 11.1 (7 1/2 × 4 3/8)
Imagno / Collection Christian
Brandstätter, Vienna

Documents, printed matter
and other objects

*Catalogue of the First Secession
Exhibition* 1898
Figure of Pallas Athene
by Gustav Klimt
Photo lithographic publication
29.3 × 10.5 (11 9/16 × 4 1/8)
Kunsthaus Zug, Sammlung Kamm
fig.36

*Postcard with a View of the Secession
after a Drawing by Josef Maria
Olbrich* 1898
Printed by A. Berger, Vienna
Brown and gold lithograph
14 × 9 (5 1/2 × 3 9/16)
Private Collection, Vienna

*Postcard with a View of the Secession
after a Drawing by Josef Maria
Olbrich* 1898
Printed by A. Berger, Vienna

Green and gold lithograph
14 × 9 (5 1/2 × 3 9/16)
Private Collection, Vienna
fig.51

Ver Sacrum – Organ der Vereinigung
bildender Künstler Österreichs,
volume 1, number 3, 1898
Title page by Gustav Klimt
Printed publication
30 × 30 (11 13/16 × 11 13/16)
Österreichische Nationalbibliothek,
Vienna
fig.35

Gold Laurel Leaves presented
to Rudolf von Alt on the Occassion
of the Foundation of the Viennese
Secession c.1898
Gold laurel leaves mounted on wood
26 × 17.5 × 3 (10 1/4 × 6 7/8 × 1 3/1)
Private Collection
fig.143

Four Postcards with Views of the
Viennese Secession 1898–1901
Photo postcards
Each 9 × 14 (3 9/16 × 5 1/2)
Private Collection, Vienna
fig.50

Thirteen Viennese Secession
Postcards with Views of Exhibition
Installations 1898–1902
Photo postcards
Orientation varies,
each 9 × 14 (3 9/16 × 5 1/2)
Private Collection, Vienna
fig.54

Photograph of the Naschmarkt
with the Secession in Background
c.1900
Albumin print
16 × 22.5 (6 5/16 × 8 7/8)
Private Collection, Vienna
fig.34

Photograph of the Eighth
Secession Exhibition, Vienna 1900
Vintage photograph mounted
on card
18.8 × 15.6 (7 3/8 × 6 1/8)
Hunterian Museum and Art
Gallery, University of Glasgow
fig.102

Berta Zuckerkandl
Zeitkunst Wien 1901–1907 signed by
the author
Book with slipcase, published 1908
18.8 × 14.5 × 2.2
(7 3/8 × 5 11/16 × 7/8)
From the Estate of Gustav Klimt
Private Collection

Catalogue for the Fourteenth
Viennese Secession Exhibition
(The Beethoven Exhibition) 1902
Printed publication
17.8 × 15.9 (7 × 6 1/4)
Wien Museum, Vienna

Letter from Fritz Waerndorfer
to Josef Hoffmann, 23 December
1902
20.3 × 25.4 (8 × 10)
Collections of the University
of Applied Arts, Vienna
fig.95

Postcard with view of Litzlbergkeller
sent by Gustav Klimt to Anna Klimt
in Lower Austria 1902
Picture postcard
10.5 × 15 (4 1/8 × 5 7/8)
Private Collection

Twenty Vintage Photographs of
the Installation of the Fourteenth
Exhibition of the Viennese Secession
(The Beethoven Exhibition) 1902
Vintage prints
Orientation and size varies, each
c.17.9 × 25.5 (7 1/16 × 10 1/16)
Österreichische Nationalbibliothek –
Bildarchiv, Vienna
figs.56, 60, 61, 62

Catalogue of the Gustav Klimt
Exhibition at the Viennese
Secession 1903
Printed publication
25.5 × 24 (10 × 9 7/16)
Private Collection, Vienna

Smock Owned by Gustav
Klimt c.1903
Indigo blue linen, white
embroidery on shoulder
Length 143 (56 5/16)
Wien Museum, Vienna
fig.178

Three Wiener Werkstätte
Presentation Books 1903
Scrapbooks with illustrations
from technical periodicals
showing works by Josef Hoffmann
and Koloman Moser
Linen bound, unpaginated
Each 31.5 × 21.5 (12 3/8 × 8 7/16)
Kunsthaus Zug, Sammlung Kamm

Postcard with view of Litzlberg
on the Attersee sent by Gustav
Klimt to Julius Zimpel 1904
Picture postcard
10.5 × 15 (4 1/8 × 5 7/8)
From the Estate of Gustav Klimt
Private Collection

Oskar Münsterberg, Japanische
Kunstgeschichte, 3 volumes,
Braunschweig 1904–7
With 90 plates and numerous
text illustrations
Each approx 22 × 28 × 3.8 (11 × 8
11/16 × 1 1/2)
From the Estate of Gustav Klimt
Private Collection

Postcard with view of Seewalchen
on the Attersee sent by Gustav Klimt
to Julius Zimpel 31 March 1905
10.5 × 15 (4 1/8 × 5 7/8)
From the Estate of Gustav Klimt
Private Collection

Postcard with a view of
Purkersdorf Sanatorium c.1905
Photo postcard
9 × 14 (3 9/16 × 5 1/2)
Private Collection, Vienna
fig.72

Three Photograph Albums
containing Photos of Karl
Wittgenstein and his Family c.1905
Made by the Wiener Werkstätte
Leather bound albums with
gold inlaid cover
Each 21 × 25 × 6.3
(8 1/4 × 9 13/16 × 2 1/2)
Private Collection

Gustav Klimt's Signed Exhibition
Ticket for the Imperial Royal
Austrian Exhibition, Earl's Court,
London 1906
Machine print in black and
red with pen and ink
8 × 11.5 (3 1/8 × 4 1/2)
Albertina, Vienna

Postcard with view of Seewalchen
on the Attersee sent by Gustav
Klimt to Julius Zimpel and family,
Vienna 3 August 1906
Picture postcard
14.4 × 9.2 (3 5/8 × 5 11/16)
Private Collection, Salzburg

Postcard showing the Secession
after a Drawing by Ferdinand
Andri 1906
Brown, blue and gold lithograph
14 × 9 (5 1/2 × 3 9/16)
Private Collection, Vienna
fig.52

Deutsche Kunst und Dekoration,
volume XIX, October 1906 –
March 1907
Includes ten photographs
of Emilie Flöge modelling
Reform Dresses
29 × 22 (11 3/8 × 8 5/8)
Österreichische Nationalbibliothek,
Vienna
fig.89

Brochure for the Opening of
the 'Cabaret Fledermaus' 1907
Made by the Wiener Werkstätte,
cover design by Berthold Löffler
15.4 × 15.4 (6 1/16 × 6 1/16)
Kunsthaus Zug, Sammlung Kamm

First Programme for the
'Cabaret Fledermaus' 1907
Cover design by Carl Otto Czeschka;
illustrations by Oskar Kokoschka,
Bertold Löffler and Fritz Zeymer
24.5 × 23.5 (9 5/8 × 9 1/4)
Kunsthaus Zug, Sammlung Kamm

Wiener Werkstätte Postcard
Nr. 67 (The Theatre of the 'Cabaret
Fledermaus') 1907
Colour postcard after a design
by Josef Hoffmann
9 × 14 (3 9/16 × 5 1/2)
Collection R.H.

Wiener Werkstätte Postcard
Nr. 74 (Bar and Wardrobe Areas of
the Cabaret Fledermaus) 1907
Colour postcard after a design
attributed to Josef Diveky
14 × 9 (5 1/2 × 3 9/16)
Collection R.H.
fig.108

Wiener Werkstätte Postcard
Nr. 75 (Bar Area, of the 'Cabaret
Fledermaus') 1907
Colour postcard after a design
attributed to Josef Diveky
14 × 9 (5 1/2 × 3 9/16)
Collection R.H.
fig.108

Catalogue for the Kunstschau
Wien 1908 1908
Printed publication
16.5 x 15 (6 1/2 x 5 7/8)
Private Collection, Vienna

Postcard with view of Schloss
Kammer on the Attersee sent
by Gustav Klimt to Anna Klimt
c.1908
Picture postcard
14.4 × 9.2 (3 5/8 × 5 11/16)
Private Collection, Salzburg

Postcard with view of Schloss
Kammer on the Attersee sent
by Gustav Klimt to Julius Zimpel,
Vienna August 1910
Picture postcard

14.4 × 9.2 (3 5/8 × 5 11/16)
Private Collection, Salzburg

Catalogue for the Austrian
Pavilion Display at the Esposizione
Internazionale, Rome 1911
Printed publication
25.3 × 25 (9 15/16 × 9 13/16)
Private Collection, Vienna

Black Suit from the Flöge Sisters'
Fashion Salon c.1914
Silk, partially quilted velvet
Jacket length 83 (32 11/16), shoulder
33 (13), skirt length 91 (35 13/16),
waist 92 (36 1/4)
Wien Museum, Vienna
fig.86

Scarf for Mäda (Eugenia)
Primavesi c.1914–16
Made by the Wiener Werkstätte
Black silk with silk embroidery
230 × 45 (90 9/16 × 17 11/16)
Primavesi Family Collection
fig.165

Typewritten translation of a letter
from Josef Hoffman to William
Davidson concerning the Memorial
Exhibition, McLellan Galleries,
Glasgow, testifying to the importance
of Mackintosh to Viennese artists,
15th May 1933
Blue typewriter ribbon ink on paper
28.2 × 23 (11 1/8 × 9 1/16)
Hunterian Museum and Art Gallery,
University of Glasgow

African Figure with Nail
late 19th Century
Wood
15.5 × 3.7 × 3 (6 1/8 × 1 1/2 × 1 3/16)
From the Estate of Gustav Klimt
Private Collection

Chinese Painting Qing Dynasty,
late 19th Century
Central figure shows Guandi,
the God of Wealth, accompanied
by (left) Guan Ping and (right)
Zhou Cang.
Tempera on paper
170 × 91 (66 15/16 × 35 13/16)
From the Estate of Gustav Klimt
Private Collection

Female Figure of an Ancestor
late 19th Century
Probably Bari/South Sudan
Wood with animal teeth
Height 41.5 (16 5/16); shoulder
breadth 9.5 (3 11/16); head diameter
6 (2 3/8)
From the Estate of Gustav Klimt
Private Collection
fig.180 (left)

Male Figure of an Ancestor
late 19th Century
Probably Bari/South Sudan
Wood and animal teeth with
leather strip
Height 37 (14 9/16); shoulder breadth
6 (2 3/8); head diameter 5.5 (2 3/16)
From the Estate of Gustav Klimt
Private Collection
fig.180 (right)

Smiling Buddha early 20th Century
Red soapstone
9.5 × 6.5 × 3.5 (3 3/4 × 2 9/16 × 1 3/8)
From the Estate of Gustav Klimt
Private Collection

Buddha late 20th Century
Yellow green soapstone

9 × 7 × 3.5 (3 9/16 × 2 3/4 × 1 3/8)
From the Estate of Gustav Klimt
Private Collection

Buddha date unknown
Black soapstone
14.5 × 9.3 (5 11/16 × 3 11/16)
From the Estate of Gustav Klimt
Private Collection

*'GK' Monogram Stamp made
as a present for Gustav Klimt
by his father Ernst* date unknown
Brass
4.7 × 2 (1 7/8 × 13/16)
From the Estate of Gustav Klimt
Private Collection

Noh Mask date unknown
Wood
21 × 13 × 6 (8 1/4 × 5 1/8 × 2 3/8)
From the Estate of Gustav Klimt
Private Collection

Portfolio owned by Gustav Klimt
date unknown
Made by the Wiener Werkstätte
Card covered with linen, gold
lined interior, exterior embossed
with gold 'GK' monogram
42 × 62 × 4 (16 9/16 × 24 7/
16 × 1 9/16)
Collection Hummel, Vienna

*Portfolio from the Estate of
Gustav Klimt* date unknown
Made by the Wiener Werkstätte
Card covered with linen, gold
lined interior, exterior embossed
with gold 'GK' monogram
42 × 62 × 4 (16 9/16 × 24 7/
16 × 1 9/16)
From the Estate of Gustav Klimt
Private Collection
fig.175

*Postcard with view of Litzlberg
on the Attersee sent by Gustav
Klimt to Julius Zimpel* date
unknown
Picture postcard
10.5 × 15 (4 1/8 × 5 7/8)
From the Estate of Gustav Klimt
Private Collection

*Postcard with view of Seewalchen
on the Attersee sent by Gustav Klimt
to Julius Zimpel* date unknown
Picture postcard
10.5 × 15 (4 1/8 × 5 7/8)
From the Estate of Gustav Klimt
Private Collection

*Soapstone Stamp with Animal
Motifs* date unknown
Light soapstone
20.5 × 6.6 (8 1/16 × 2 5/8)
From the Estate of Gustav Klimt
Private Collection
fig.179

View Finder used by Gustav Klimt
date unknown
Cardboard
9.5 × 5.6 (3 3/4 × 2 3/16)
From the Estate of Gustav Klimt
Private Collection

Lenders and Credits

Index

Sponsors and Donors

Arts & Business
Arts Council England
BT
DLA Piper
The French Institute
The Guardian
The Hemby Trust
The Henry Moore Foundation
KPMG Foundation
Liverpool Culture Company
Milligan
North West Business Leadership Team
Northwest Regional Development Agency
Perrier Jouet
Rensburg Sheppards Investment Management
The Sir Jules Thorn Charitable Trust
Tate Liverpool Members
Tate Members
The Times

Tate08 Partners

Cains Brewery
City Loft Developments Ltd
DLA Piper
Manchester Airports Group

Corporate Partners

David M Robinson (Jewellery) Ltd
DLA Piper
DWF
Ethel Austin Property Group
Hill Dickinson
HSBC Bank Plc
Laureate Online Education
Liverpool Hope University
Liverpool John Moores University
Mason Owen & Partners
Shore Capital & Corporate Ltd
Unilever UK
The University of Liverpool

Corporate Members

Alliance & Leicester Commercial Bank
Andrew Collinge Ltd
Arup
Alder Hey Imagine Appeal, supported by Assura Group
Bank of Scotland Corporate
Barlows Plc
Beetham Organization Ltd
Brabners Chaffe Street
Broadway Malyan
Bruntwood
Building Design Partnership
EMX Company Ltd
Grant Thornton
Grosvenor
Individual Restaurant Company Plc
KPMG
Lees Lloyd Whitley
Lime Pictures
Novartis Vaccines & Diagnostics Ltd
The Rainbow Property Company Ltd
The Riverside Group
Royal Bank of Scotland
Silverbeck Rymer
Taylor Young Ltd
Tilney Private Wealth Management
Uniform

Patrons

Ann Alexander
Diana Barbour
David Bell
Tom Bloxham MBE
Peter Bullivant
Jim Davies
Olwen McLaughlin
Barry Owen
Dougal Paver